VISUALIZING DISEASE

VISUALIZING DISEASE

The Art and
History of
Pathological
Illustrations

DOMENICO BERTOLONI MELI

The University of Chicago Press
Chicago and London

The University of Chicago Press, Chicago 60637
The University of Chicago Press, Ltd., London
© 2017 by The University of Chicago

Published 2017

Printed in China

26 25 24 23 22 21 20 19 18 17 1 2 3 4 5

ISBN-13: 978-0-226-11029-5 (cloth)
ISBN-13: 978-0-226-46363-6 (e-book)
DOI: 10.7208/chicago/9780226463636.001.0001

Library of Congress Cataloging-in-Publication Data
Names: Bertoloni Meli, Domenico, author.
Title: Visualizing disease : the art and history of pathological illustrations
 / Domenico Bertoloni Meli.
Description: Chicago : The University of Chicago Press, 2017.
 | Includes bibliographical references and index.
Identifiers: LCCN 2016057353 | ISBN 9780226110295 (cloth : alk. paper)
 | ISBN 9780226463636 (e-book)
Subjects: LCSH: Medical illustration—History. | Medicine and art—History.
 | Anatomy, Artistic—History.
Classification: LCC R836 .B47 2017 | DDC 610.22/2—dc23
LC record available at https://lccn.loc.gov/2016057353

♾ This paper meets the requirements of ANSI/NISO Z39.48-1992
(Permanence of Paper).

A physician, in looking at his patient, ought, in imagination, to turn him inside out.

ANNE HOPE, *Memoir*

THIS BOOK IS DEDICATED TO THE MEMORY OF ALL

THOSE PATIENTS WHOSE MEDICAL CONDITION

FOSTERED THE STUDY OF DISEASE

CONTENTS

PREFACE

Illustrated anatomy treatises originated in the Renaissance and became an established genre soon after *De humani corporis fabrica* (1543) by Andreas Vesalius. The situation with regard to diseased states is different and full of surprises calling for a closer analysis: although some visual representations can be found in the early modern period and in growing numbers in the eighteenth century, we have to wait until Eduard Sandifort's *Museum anatomicum* (Leiden, 1793), exactly a quarter of a millennium after Vesalius's *Fabrica*, to find a conscious affirmation of the birth of a new medical genre, the illustrated pathology treatise.[1]

There is a long and distinguished tradition of scholarship on anatomical illustrations going back at least to Ludwig Choulant in the nineteenth century. Recently scholars such as Martin Kemp and Sachiko Kusukawa have written important works on the fabric of the body and its visual representation.[2] By and large, however, the scholarship has focused on the healthy rather than the diseased body; although some works have discussed pathological illustrations, overall this area is still in its infancy. In fact, we know more about representations of disease in religious or artistic contexts, as for plague or leprosy saints, for example, than in medical ones. While it would seem almost inconceivable to investigate the history of anatomy ignoring illustrations, this is how we have been studying the history of pathology. Yet pathological illustrations are among the most striking and sophisticated ones of the entire history of medicine and science and rival anatomical ones in intellectual significance and artistic accomplishment; they played a key role in the identification of common features and patterns of disease, calling for a study of this crucial area.[3]

Today we may take it for granted that pathology is a visual science and that pathology works are illustrated, though matters were not always so. When and why did illustrations of diseased states start to be produced? Who were the protagonists of these developments, both medical men and artists? Which were the practical and epistemic conditions for the production of those images? How were they used? Did they emerge homogeneously across all areas of pathology, or did they take different forms in different areas at different times? What role did they have in changing notions of disease? While addressing these questions, *Visualizing Disease* provides an analytic study of the emergence and significance of pathological illustrations.

The verb "to visualize" is often used in the sense of making something visible to the mind or the imagination. However, it can also be used in the sense of making visible to the eye through several means, including technical devices. Here I use the verb in the latter sense, emphasizing the active intervention required in pathological anatomy to make a hidden lesion visible to the eye.

Visualizing Disease covers themes from the early modern period to the first decades of the nineteenth century. Representations of diseased states occurred from the early Renaissance in relatively small numbers, at times in ephemeral publications, later in collections of *Observationes* and in philosophical and medical journals. The emphasis in these early works was not on common cases but on rare, remarkable, and even "monstrous" ones, however defined.[4] Early types of lesions that could be represented visually ranged from polyps and tumors to fractures and aneurisms. The first sizeable collections including pathological images date from the early seventeenth century, such as the *Observationes* by Bern surgeon Guilhelmus Fabricius Hildanus, who also established a surgical museum with an anatomical/pathological focus. Around 1700 Amsterdam anatomist Frederik Ruysch created the most celebrated anatomical and pathological museum of his time and also published several works with extensive illustrations, including many of diseased states. The link between museums and images of disease was not accidental, as we are going to see.

In the *Avant-propos* to *Anatomie pathologique* (1829–42), Paris pathologist Jean Cruveilhier saw Sandifort's *Museum anatomicum* as the beginning of a new genre and called him "le père de l'iconographie pathologique." I see Sandifort's work both as the culmination of a scholarly tradition and as the beginning of a new one. At the other endpoint, Cruveilhier's work was the first comprehensive treatise illustrating the diseases of the human body in color and represents a useful marker in a rapidly changing field. Pathological illustrations did not change overnight and the representation of diseased organs and body parts continues to the present day; however, mid-nineteenth-century developments such as the rise of microscopy, cellular pathology, the germ theory of diseases, photography, and chromolithography transformed the field in significant ways, requiring a different study.[5]

Here I privilege extensive illustrated treatises rather than publications with a small number of pathological illustrations, at times even a single one. There are specific problems associated with large illustrated treatises rather than ephemeral pamphlets or articles; since the authors had to have at their disposal a large sample of cases, many relied on collections of preserved specimens, either dry such as bones, wet kept in jars, or injected. Many preservation techniques, however, affected texture and obliterated color. Other treatises relied on recent postmortems, though this required swift action after death. While an essay on an individual case or a limited number of them could be produced extemporaneously, a more extensive and comprehensive work based on recently deceased patients required a huge number of cases, almost invariably through a hospital, and careful planning over several years, possibly decades, and it involved a different set of problems. What was needed was a sustained effort to record the features of many cases in words and through images, something that would have required professional artists available at very short notice, preferably shorter than one day and ideally within a few hours.

True to its title, *Visualizing Disease* takes into account both medical and artistic aspects. Thus besides medical men—anatomists, physicians, surgeons, and pathologists who occupied the first pathology chairs at European universities—I discuss draftsmen and engravers. While seeking to integrate historical perspectives on medical practice and changing notions of disease, I also focus on the conceptual and technical aspects of visual representations. The interactions among these fields proved crucial: How did techniques of preservation and representation of pathological specimens change? In what way did medical men and artists interact and how did their interaction affect the illustrations they produced? The emergence of a new genre such as the illustrated pathology treatise calls for a study of the intellectual, social, and technical conditions of its production, and of its impact.

A work of such broad chronological and geographic scope cannot aim at being comprehensive. However, I hope to document key stages in the development of pathological illustrations. The introduction provides a preliminary framework for reflecting on key concepts and issues, such as the availability and nature of bodies and specimens for pathological inquiry, changing notions of disease and its classification, different forms of visualization, and the technologies for the production of images. Collections, museums, and hospitals offered indispensable resources with different features and problems. Moreover, the separate traditions of pathology and nosology played a key role and merged in the decades around 1800. The introduction discusses these matters in broadly theoretical terms, while the following chapters are organized both chronologically and thematically.

The first chapter introduces a number of themes central to pathological illustrations in the early modern period. I discuss early illustrated works based on postmortems, such as collections of *Observationes* and essays in the new

medical and scientific journals of the time; the rise of surgery, including the first elections of surgeons to membership of the Royal Society and the Paris Académie, for example; and the development of preservation methods leading to the establishment of collections, such as the museums by Fabricius Hildanus and Ruysch, which included anatomical and pathological curiosities spanning from humans to animals.

A number of anatomists from the end of the eighteenth to the beginning of the nineteenth century, from Sandifort to Pierre Rayer, singled out osteology as a prominent area in pathology and especially pathological iconography. It is not surprising that bones played such an important role, given their easy preservation compared to soft body parts. At no time was the pathological iconography of bones so prominent as in the eighteenth century, especially in the period from *Osteographia* (1733) by London surgeon William Cheselden to Sandifort's *Museum* (1793). Chapter 2 locates Sandifort simultaneously at the end of the eighteenth-century tradition of the representations of bone diseases and at the opening of a new one, consciously focusing on pathological illustrations more broadly.

From the very end of the eighteenth century, soft parts, too, mainly preserved in alcohol, became the focus of sustained study in the works first by Matthew Baillie in London and then by Johann Friedrich Meckel the Younger in Halle and Jan Bleuland at Utrecht. Unlike Padua anatomist Giovanni Battista Morgagni, who relied only on case histories, they all had extensive museum holdings at their disposal, but, unlike Ruysch, they focused squarely on pathology, as I argue in chapter 3.

In the aftermath of Baillie's work, a number of surgeons and physicians published treatises focusing on specific diseases, such as Edinburgh surgeon James Wardrop on *Fungus Hæmatodes*; on the diseases of specific body parts, such as John Hunter's brother-in-law Everard Home on the prostate; or even on new practices, such as mediated auscultation for lungs and heart diseases with René Laennec's *De l'auscultation médiate*. These works, discussed in chapter 4, share a focus on the investigation and representation of the early stages of lesions.

Cutaneous diseases were easily accessible to medical eyes and were key to the emergence of early colored representations, as I argue in chapter 5. These efforts stem from the nosological tradition and sought to classify cutaneous diseases by relying mainly on their external characteristics; in 1798, developing a modified form of the classification proposed by Austrian surgeon Joseph Plenck, London physician Robert Willan started issuing a series of installments illustrating all the types of cutaneous diseases in color. His work was completed by his pupil Thomas Bateman, while Alibert and Rayer pursued the topic in France, and Wilhelm Gottlieb Tilesius in Germany. Their works opened new horizons to the visual representation of disease and set striking examples in the pathological literature and techniques of color representation.[6]

Although some works in pathological anatomy included colored plates, by and large none did so extensively until the second half of the 1820s, when ambitious treatises appeared, likely inspired by the early works on cutaneous diseases; they included both engravings and lithographs produced at considerable expense by John Richard Farre, Thomas Fawdington, Robert Hooper, Richard Bright, Astley Cooper, James Annesley, and John Armstrong. Britain was the cradle of this high-end genre, possibly because of its outstanding natural history tradition. Their works are discussed in chapter 6.

Cruveilhier's huge work, published in forty installments over fourteen years, stems from a Parisian context of medical men, patients, hospitals, and artists; it relied overwhelmingly on hand-colored lithographs. In this respect he was followed in the 1830s by French-trained pathologists James Hope and Robert Carswell. The last chapter brings together these three works produced and printed between Paris and London, relying overwhelmingly on the same printing technique, and seeking to provide comprehensive accounts of diseases of the entire body.

The structure of *Visualizing Disease* highlights the peculiar patterns in which pathological illustrations developed with respect to different body parts and forms of representation. While the seven chapters follow a broadly chronological and thematic structure, they can be grouped in different ways: chapter 1 focuses on early publications favoring extraordinary and remarkable cases; chapters 2 and 3 deal with works based on preserved specimens, whether wet or dry, from museums and collections; chapter 4 is an intermezzo devoted to a special issue; chapter 5 relies on observations of live patients at dispensaries and hospitals; chapters 6 and 7 deal with works based on postmortems of recently deceased patients from large hospitals. As to color, the chapters fall naturally in two groups: 1–4 are based on black and white woodcuts, intaglios, or lithographs; 5–7 rely on color images.

Most chapters share a common structure combining thematic and biographic concerns: I trace the main actors and their practices, especially their professional activities, whether in surgery or medicine, in dispensaries and hospitals. I am interested in the museums and collections they could rely on, as well as in their artistic interests and skills. Secondly, I examine the books they produced, how those books circulated and, when possible, their cost, and the artists involved in drawing, engraving, and lithography, seeking to identify their expertise and background. Lastly, I outline changing conceptions of diseases and lesions as well as evolving nosological schemes, trying to locate the study of images within a broader epistemic or intellectual context.[7]

A brief conclusion highlights the different phases in the development of pathological illustrations in relation to changing horizons in pathological anatomy; the special features of pathological iconography; and the cognitive role of pathological images. The images in recent treatises of gross pathology were not always there but have a complex history that we are just beginning to

unravel; without engaging with that history, we would fail to understand key features of the transformations of pathology and medicine more broadly.

Introduction

BODIES, DISEASES, IMAGES

The transition from anatomical to pathological illustrations poses a number of problems requiring careful handling. They concern the availability of bodies for dissection, but also of living patients and preserved specimens or preparations. As in comparative anatomy or paleontology, for example, museums and collections enabled the investigation and classification of specimens. Further, notions of disease, forms of visualization, and methods for the production of images changed over the centuries covered by this study. For example, an older tradition emphasized the study of disease in relation to its location and cause; from this perspective, the specific manifestations of a condition may depend on the vagaries of the case at hand and would not be especially instructive to the physician. Practitioners with different professional affiliations, however, such as surgeons who wished to extirpate a growth, or physicians wishing to provide a classification of diseases based on the appearance of lesions, needed to know their exact conformation. Hence the need to consider images in relation to different approaches to pathology and nosology. While this material will be discussed in specific contexts in the following chapters, here I provide a brief introduction to some main themes and debates.

BODIES AND THEIR AVAILABILITY

There is no treatise in pathology without patients, dead or alive; in fact, it is necessary to have a large number of them in order to study and compare a broad spectrum of cases and diseases. It is not easy to determine how many bodies of recently deceased patients were available for postmortem investigation, whether privately or at medical institutions, at different European loca-

tions. Whilst an older scholarship identified a quantum leap with the French Revolution, more recent research has pointed to continuous changes, with a growing trend from the early modern period to the eighteenth century.[1]

A key early figure in the history of postmortems was Florence physician Antonio Benivieni, who left at his death in 1502 a cache of case histories with some postmortem reports published posthumously in 1507. A feel for those published in the following couple of centuries can be gained from the imposing two folio volumes of reports the indefatigable Geneva physician Théophile Bonet (1620–89) assembled and annotated in *Sepulchretum* (Geneva, 1679). His work consists of excerpts from the literature and cases examined by Bonet and his correspondents, followed by his own comments. In the preliminary material Bonet lists his sources in three columns over nearly two and a half folio pages. The book consists of a series of *Observationes* starting from the head and proceeding down the body, ending with the genitalia and a miscellany of various ailments. Bonet often included a brief clinical history but no illustrations; in fact, according to Morgagni's ungenerous analysis, Bonet failed even to mention whether illustrations were provided by his sources.[2]

From Benivieni's pioneering work through the treatise on apoplexy by Swiss physician Johann Jakob Wepfer and that on brain disease by Thomas Willis, to the most recent reports in the medical journals of the time, few published accounts escaped Bonet's eye, though of course many remained unpublished. Thus his huge tomes provide a conservative estimate of how frequently postmortems were performed in the early modern period. However, they also provide evidence of the perceived need to collect, organize, and comment on medical and pathological reports. His work met with favor, since his equally indefatigable successor, the Geneva physician Jean-Jacques Manget, issued a much-expanded edition in three folio volumes (Lyon and Geneva, 1700), though he too omitted illustrations.[3]

Sepulchretum was not the only work of its kind by Bonet. Just a few years later he published another monumental sylloge of medical and natural history material in two folio volumes, *Medicina septentrionalis collatitia* (Geneva, 1684–85). Bonet included publications from Northern Europe, especially the philosophical and medical journals and collections of medical cases.[4] Unlike *Sepulchretum*, *Medicina collatitia* reproduced in over two dozen folio plates the illustrations that had appeared in the original publications; many pertained to anatomy and natural history, though some were relevant to pathology. The lack of illustrations in *Sepulchretum* and the fact that those in *Medicina collatitia* juxtaposed human and comparative anatomy, healthy and diseased states, highlights the ambiguous and problematic state of visual representation of diseased conditions at the time.

Giovanni Battista Morgagni's *De sedibus* (Venice, 1761) was a celebrated monumental treatise directly inspired by Bonet's work; it was based on case histories and postmortem reports from his teacher Antonio Maria Valsalva

and Morgagni himself, which were compared to others found in the litera-
ture. Thus although Morgagni's work was published in the second half of
the eighteenth century, many reports date from around 1700. These works
highlight that throughout the early modern period thousands of postmortems
were carried out with the intent of identifying the location and hidden cause
of disease.

The large number of early modern postmortems came from patients who
wished their bodies to be dissected after death, from their families, or through
hospitals, which provided a growing number of cadavers of paupers or people
with no relatives. Many bodies dissected by Valsalva and referred to by Mor-
gagni in *De sedibus*, for example, stemmed from Bolognese hospitals. Often
institutional and patronage connections proved crucial: the systematic post-
mortems following the high number of sudden deaths recorded in Rome in
the early 1700 century and investigated by pontifical archiater Giovanni Maria
Lancisi, for example, were commissioned by the pope.[5]

At times bodies were available for university instruction before and after
death; the ideal teaching clinic envisaged by Herman Boerhaave had twelve
beds, six for male and six for female patients; by the end of the eighteenth
century the numbers of clinical patients had grown and, more significantly,
physicians had access to the entire hospital population amounting to hundreds
of patients at any one time, leading to thousands of corpses available over the
years. By the early 1800s Aloys Vetter in Vienna had dissected several thou-
sand bodies by the age of thirty-six, though his case was exceptional. Although
at the end of the Napoleonic wars Paris was a magnet for medical students
from different counties, in 1828—four years before the anatomy act that regu-
larized the practice of dissection and greatly increased the number of bodies
available in Britain—London physician Robert Hooper claimed that he had
dissected over four thousand bodies over thirty years; Hooper was first apoth-
ecary and then physician to the Marylebone Infirmary. In the British colonies
postmortems were performed routinely.[6]

Traditionally the hospital morgue has been seen as the prime location for
pathology investigations. However, other venues were also significant. As
London physician and lecturer Matthew Baillie put it in 1793, he had access to
relevant material because he could rely on the large collection of preparations
assembled by his uncle William Hunter, he was physician to a large hospital
(St. George's), and he lectured at an anatomy school. Baillie's claim is a useful
starting point to review the venues available for postmortems. Such venues
should not be seen in isolation, since collections of preparations, for example,
could develop from hospital resources. Moreover, many argued that although
relying on large numbers of cadavers was important, memory was problem-
atic and the knowledge gained from dissection was fleeting unless it could be
recorded not only in the form of a written report but also through the preserva-
tion of items and the production of drawings or wax models.[7]

Anatomy schools, especially popular ones like that at Windmill Street established by William Hunter in London and inherited by Baillie, provided extensive opportunities for investigating diseased states. At the turn of the century, London, which lacked a university until well into the nineteenth century, had several such schools that served a large number of students by providing extensive theoretical and practical instruction in a number of subjects ranging from chemistry to surgery. In Edinburgh too, despite the presence of one of the most distinguished universities of the time, students had the opportunity of attending extramural lectures.[8]

In addition, several private and university-based anatomical collections with pathological preparations were established in the early modern period, especially after the discovery of effective preservation methods in the late seventeenth century—indeed, too many to enumerate. Some of those we will encounter were located at Leiden and Utrecht in the Netherlands, Halle and Berlin in Germany, and Edinburgh and London in Britain. Often such collections started as private enterprises, grew over decades, were donated to or acquired by universities, and were increasingly enshrined in printed catalogues, at times with illustrations. It is easy to see why medical men relied on preparations: diseases appear at random times, patients die of their own accord, and affected body parts deteriorate rapidly after death. By contrast, wet, dry, and injected specimens preserved in fluid-filled jars or on cabinet shelves lasted, enabling medical men to compare hundreds of preparations; in this way lesions could be investigated in a new and systematic way. Medical historian Erwin Ackerknecht identified four major venues intersecting over different historical periods: the bedside, the library, the hospital, and the laboratory. From the seventeenth century and especially in the eighteenth century and beyond, the museum of anatomical and especially pathological preparations played a crucial role as a fifth venue in the study of health and disease. As in comparative anatomy, where museums proved key in allowing the systematic study and comparison of different species, in pathology too museums enabled the systematic study and comparison of lesions.[9]

CHANGING NOTIONS OF DISEASE

Of course, the problem was not simply one of availability of body parts, whether fresh or preserved, but involved broader issues as well, such as changing notions of disease. This is a complex and multifaceted matter that can be dealt with only in broad strokes here; we shall examine it further in the chapters that follow. The understanding of disease changed dramatically during the time I discuss. While occasionally I refer to modern views, especially in the footnotes, overall I privilege my protagonists' perspectives.

The definition of disease is problematic: throughout the period covered here diseases were seen less as fixed species than as processes that could

morph one into the other, much like today we worry that an apparently innocuous mole could turn malignant. Inflammation in particular was seen as the source of many different conditions that could develop in different forms over time. This was one of the reasons why bloodletting to reduce inflammation, especially if applied at an early stage, was deemed an effective remedy.

Another issue concerns the status of many remarkable cases and portents: in the sixteenth century Padua physician Gianbattista Da Monte, for example, pointed out that it would be inappropriate to characterize a sixth finger in the hand as a *morbus*. Sixteenth-century surgeon Leonardo Botallo published an illustrated report on what is today descriptively called a horseshoe kidney, which he described as "monstrous." In 1678 English anatomist Edward Tyson published an illustrated report on a similar case but questioned whether this peculiar conformation was inconvenient to the patient, thus highlighting his concerns with the boundaries among diseased states, anomalies, congenital malformations, and nature's variability, further showing that similar cases could be described in different ways at different times.[10]

The issue of "monsters" presents difficulties at many levels, starting from the usage of the term; in the Renaissance it was associated with portents showing God's wrath, usually involving congenital malformations such as conjoined twins, "cyclopes," and "hermaphrodites." At times the term was also used rather loosely: a very large growth could be described as "monstrous," for example. While this usage clearly pertains to my project, the status of the former is more problematic. Overall, there was no homogeneous treatment of monsters in the former sense across time by my protagonists: some, such as Amsterdam physician Gerardus Blasius, Sandifort, and Baillie, discussed "monsters" as belonging to a separate category, either in the same work in which they discussed diseased organs or in separate publications; others, such as Cruveilhier, considered vices of conformation as "maladies du foetus" or "pathological phenomena" and discussed them as an integral part of their treatises. While his installments were appearing, zoologist Isidore Geoffroy Saint-Hilaire published his fundamental treatise on teratology, in which he provided a taxonomy related to the developmental process and the laws of organization.[11] In such circumstances it seems impossible to adopt a uniform approach to monsters; therefore I will discuss them only in those cases when they play a significant role in the author's views about disease, as with Johann Friedrich Meckel the Younger.

The main focus of this work is pathological anatomy, or the lesions found in a cadaver at postmortems. At times I consider external conditions, such as growths, that would have been treated by surgical means. Bone lesions too play a significant role, even though fractures and growths would have occurred in live patients rather than cadavers. There are notable differences between pathological anatomy, whether involving fresh or preserved specimens, and the study of lesions in live patients, as for cutaneous diseases, for example,

which were often treated separately, thus emphasizing the distinction between the two genres.[12] The course of internal lesions in pathological anatomy is usually precluded because lesions become accessible only after death; by contrast, the course of cutaneous diseases can be followed day by day in the living patient. On the other hand, the distinction between skin and internal diseases is problematic, because many conditions affect many body parts crossing from the inside of the body to the skin and vice versa; moreover, both relied on large medical institutions such as dispensaries and hospitals, both concerned the classification of disease, and both exploited related forms of representation, at times relying on the same artists. Thus it is advantageous to study visual representations of diseased body parts together, including cutaneous diseases, which played a key role in visual representations more generally.

According to a now classic view whose main advocates included Ackerknecht and Michel Foucault, notions of disease changed suddenly and dramatically through developments in revolutionary France around 1800, especially the medical reforms of 1794 that instituted a largely common training for surgeons and physicians, extensive clinical experience, and systematic physical examinations and postmortem dissections. The year 1794 figures even in the title of Ackerknecht's work. While Paris was unquestionably a crucial site in many respects, this neat periodization and the precise site, nature, and extent of the changes occurring in the medical world have been questioned. Lawrence Brockliss, for example, has identified elements of continuity in pre- and postrevolutionary French medical education, while Othmar Keel has challenged the extent of the transformations in clinical teaching and in the localization and understanding of disease.[13]

The first aspect I wish to consider is the shift from a notion of disease based on patients' narratives to one relying on physical examinations and postmortems. Before 1800, diseases were allegedly identified through patients' narratives and their subjective feelings—such as pain; physical examinations were performed at best cursorily; and anatomy had little to do with medicine and especially disease. In fact, extensive practices of physical examination can be traced to earlier times, as Michael Stolberg has recently shown, while different bedside practices and notions of disease coexisted. The interplay among subjective symptoms, physical examination, and postmortems was more complex than some historians have argued. Although the old practice of uroscopy may not count as a form of physical examination in a strict sense, for example, it certainly was not a form of patients' narrative. Traditional accounts face serious difficulties at many levels, including making sense of works such as Bonet's *Sepulchretum* and Morgagni's *De sedibus*. The reception of Morgagni's work is a complex task, but the 1769 English translation, the 1771–76 German one, and the many Latin editions that appeared across Europe in just a few years point to a wide circulation and readership. Postmortems were routinely

employed to investigate the causes of death and the seats of diseases, as Maria Pia Donato has recently argued.[14]

Changes in the precise site of diseases too have proved contentious, with the role of Xavier Bichat being especially problematic: following a nineteenth-century mostly French tradition, Ackerknecht and Foucault saw him as a turning point introducing a radical shift in the localization of lesions. More recently, however, others have identified a number of earlier traditions at different centers focusing on tissues and membranes, both in their normal and pathological states, much like Bichat and his inspirational source Philippe Pinel were later to do. The tradition inspired by William and John Hunter included surgeons and physicians who had already identified five fundamental types of tissues: cellular, serous, mucous, and fibrous membranes, and skin, each with its peculiar type of inflammation. Amsterdam anatomist and surgeon Andreas Bonn and Johann Gottlieb Walter at Berlin were also moving in the same direction with their focus on identifying different membranes of the body, for example. Thus the time between Morgagni and Bichat was one of profoundly original investigations in anatomy; Bichat's works, such his *Traité des membranes* (Paris, 1799), extended and radicalized a growing body of research that had been carried out over several decades at Edinburgh, London, Amsterdam, and Berlin.[15]

Further, since Bichat localized disease in the tissues rather than the organs, one membrane could be affected while contiguous body parts were not, at least in the early stages of a disease; moreover, the same types of tissues would exhibit analogous affections because they present the same vital properties even though they could be located in different body parts, such as the pleura covering the lungs, the pericardium for the heart, and the peritoneum for the abdominal cavity—all being serous membranes. The shift from an anatomy of organs to one of systems of membranes and tissues led to a different map of disease. The issue, however, was not simply one of finer localization from organs to tissues but involved the recognition that the same body parts could be affected in different ways that had to be identified, distinguished, and compared. While Bichat sought to frame disease within the rigid grid of tissue localization, Baillie focused on the differences among lesions in a more empirical fashion that was not rigidly anchored to tissues.[16]

Thus instead of a linear development from organs, to tissues, and eventually to cells, it seems more appropriate to consider a growing awareness of the need for a careful study and differentiation—involving identification, distinction, and classification—of lesions as a key aspect of changing notions of disease. The issue of differentiation broadly resembles the changing understanding of cancer in recent decades. Older views localized cancer in the prostate or breast, for example; at most the cancers would be characterized as aggressive or benign. More recently, however, we have come to appreciate that localiza-

tion is insufficient because the same body part can be affected by different types of cancer, due to different genetic mutations: some grow rapidly, others slowly; some respond to hormonal treatment, others do not; some metastasize rapidly, others remain localized. Analogously, in the decades around 1800 anatomists such as Baillie showed that, in the study of disease, simple localization was insufficient because many different lesions could affect the same organs or tissues and different body parts could be affected by the same lesions, which had to be identified and distinguished.[17]

The conceptualization of disease was also related to different perspectives between surgeons and physicians. Physicians usually relied on the conditions observed in the patients to identify causes, whether based on humoral doctrines, as in the Galenic tradition, or on the acid/alkali imbalance, in a seventeenth-century fashion. From both perspectives therapies traditionally went back to causes, which were routinely tackled through diet. By contrast, surgeons adopted different cognitive parameters; with their interest in the specific form of the lesions they had to deal with, surgeons focused less on causes and more on the visual characteristics of lesions. At times, however, different notions and practices coexisted: in late eighteenth-century London, for example, surgeon Percivall Pott followed traditional views in attributing the cause of cancer to the fluids of the body having become "acrimonious" with time in older men and in women after menstruations have ceased. In the same short and celebrated work, *Cancer scroti*, he also followed physician Bernardino Ramazzini in tying a type of cancer of the lower portion of the scrotum to a specific profession, in his case that of chimney sweep. In 1700 Ramazzini had argued that several diseases could be related to the patients' profession, if these involved dangerous activities such as breathing dust or exerting violent motions, for example. Pott identified the cancer's cause in the soot lodging in the scrotal rugae of young boys. He also distinguished by careful inspection this condition from venereal sores, arguing that it was characterized by "hard and rising edges," and advocated its swift surgical removal. He did not include images in this case, though he did so discussing other surgical conditions.[18]

PATHOLOGY AND NOSOLOGY

Let us discuss briefly pathological anatomy, the field that studies disease through the lesions found at postmortems. The titles of the three key collections merit attention: Benivieni's *On Some Hidden and Wonderful Causes of Illnesses and Healings* (*De abditis nonnullis ac mirandis morborum et sanationum causis*, 1507) highlights wonder, hidden causes, and healing. The subtitle of Bonet's *Grave-yard or Practical Anatomy of Cadavers that Died of a Disease* specified that he was *Setting Forth Histories and Observations of Virtually All Illnesses of the Human Body, and Revealing Their Hidden Causes* (*Sepulchretum sive anatomia practica ex cadaveribus morbo denatis, proponens historias et*

observationes omnium humani corporis affectuum, ipsorumque causas reconditas revelans, 1679). Lastly, Morgagni highlighted the role of anatomy in revealing the locations of disease, or *On the Seats and Causes of Diseases Investigated by Anatomy* (*De sedibus et causis morborum per anatomen indagatis*, 1761). Bonet and Morgagni eschewed Benivieni's sense of "wonder" and emphasis on healing, though all three mentioned "causes," leading to the lesions of the organs revealed by anatomy, hence "hidden," as specified by Benivieni and Bonet and implied by Morgagni. These features would become even more prominent in Morgagni's work.

Here I would like to single out three strategies of pathological investigation, which are especially helpful from my perspective: the first could be characterized as clinical pathology, with an emphasis on the correlation between the patient's symptoms as part of the case history and the lesions found in the cadaver, with the aim of envisaging better cures based on the exact knowledge on the location, progression, and nature of the lesion. The second approach privileges an accurate description of the lesion and can be characterized as "morbid anatomy" in a strict sense, which is to pathology as anatomy is to physiology. The last approach can be seen as physiological, in that it focuses on the relevant processes and modes of formation of the lesions, such as inflammation or abnormal growth. With regard to physiology, Morgagni was closer to the mechanistic worldview prevalent at Bologna at the time of his formation and talked of the body as a machine; most protagonists of my study, however, shared some version of vitalism that was prevalent around 1800 and that was developed in different guises with Paul Joseph Barthez in France, Johann Friedrich Blumenbach in Germany, and John Hunter in Britain. Overall, most pathologists I examine focused at least as much, and often more, on the detailed features of lesion and disease than on lofty philosophical discourses.[19]

There are several specific problems associated with pathology in particular, as opposed to anatomy, requiring close scrutiny; they can be captured by a series of dichotomies, which I am going to review in turn. The first is that between rarity and availability: as Cruveilhier pointed out in the *avant-propos* to *Anatomie pathologique*, healthy body parts can be seen once, twice, or twenty times. By contrast, some pathological cases may show up once in a lifetime; *carpe diem*, one may tell the pathologist. Similar remarks apply to the availability of images: even if at times it may have been difficult to obtain a fresh cadaver, anatomy had a long and vibrant visual tradition enabling the investigator to rely on treatise after treatise from the mid-sixteenth century; by contrast, pathology lacked a comparable tradition and relied on occasional publications on this or that remarkable case in broadsides and articles in the medical and scientific journals of the time.[20]

A second related issue concerns scale; whereas a few bodies sufficed for an illustrated anatomy treatise, for pathology the scale of the enterprise was larger because the number of lesions affecting all the body parts involved a

different order of magnitude. The number of patients medical men could visit and especially dissect after death increased enormously from the time of Vesalius to the end of the eighteenth century. In 1543 Vesalius could produce *De humani corporis fabrica* aged twenty-eight, but for lack of bodies he would not have been able to produce a comparable pathology treatise so young, possibly at all. Over two centuries later Morgagni was nearly eighty when he published the imposing two-volume treatise *De sedibus*, for which he relied on material assembled during his entire professional career and on reports collected by Valsalva.

Thirdly is the issue of disentangling cause and effect. Postmortems show the final stage of disease: Is that stage the ultimate cause of the condition, an intermediate cause dependent on more remote ones but responsible for symptoms and visible signs, or merely the visible effect of other causes that have remained obscure and been mangled by the ravages of disease, especially chronic ones? This was one of the fundamental objections to pathological anatomy and to the value of postmortems as a tool to understand disease.

Fourthly is the tension between living and dead. Dissecting a body with the intention of localizing the lesions and identifying the cause of death was no simple matter, starting from the timing of the dissection: in the early decades of the nineteenth century pathologists were becoming increasingly aware of the inadequacy of preparations and sought to investigate and reproduce the lesions as faithfully as possible, including color. Timing proved crucial and contentious; East India Company surgeon James Annesley provided the time elapsed between the death of the patient and the postmortem, usually just a few hours—a sensible precaution given the Indian climate. Following John Hunter, Robert Carswell identified some lesions as the effect of gastric juice after death and even performed experiments on rabbits to prove his point, while criticizing Cruveilhier and Pierre Louis for having failed to realize this effect.[21]

Lastly is the problem of regularity and order: anatomy and physiology are the realm of regularity and therefore treatises proceed following a certain order, either from head to toes, for example, or based on organs, tissues, and systems. Whether disease would follow rules and patterns of its own or what these would be was a debated question to be answered on a case-by-case basis; diseases could come in a fashion of their own, imposing a different order on the body and also on the text, at times migrating from body part to body part and creating problems at many levels, both medically and for the organization of a work. Syphilis, for example, was known since the Renaissance to affect the genitalia, but in later stages it affected also the skin, bones, and other internal organs in a way that was hard to predict; scrofulous growths found in many parts of the body, from the brain to the lymphatic system, were progressively identified as being similar to the pulmonary lesions found in consumption; similarly, cancer could originate at one location and migrate in seemingly

unpredictable ways elsewhere in the body.[22] In the light of these remarks it is not surprising if the history of pathological illustrations differs so extensively from that of anatomical ones.

Let us briefly consider another tradition crucial to pathological illustrations: nosology is the attempt to classify disease, much like taxonomic botany seeks to classify plants. English physician Thomas Sydenham is a key early figure in nosology, though this tradition underwent profound transformations in the period covered by this study. While Sydenham was skeptical of the utility of anatomy and conceived his project disregarding lesions and postmortems, progressively nosology became less hostile to pathological anatomy. Major figures in eighteenth-century nosology include the physicians and botanists Carl Linnaeus at Uppsala and François Boissier de Sauvages at Montpellier, William Cullen at Edinburgh, and Philippe Pinel in Paris. Much like Morgagni's contemporary treatise, the taxonomy of diseases outlined by Linnaeus in *Genera morborum* (Uppsala, 1759) and Sauvages in *Nosologia methodica* (Amsterdam, 1763), had no illustrations, despite nosology's explicit imitation of botany, where refined illustrations had been used for well over two centuries. An edition of Sauvages's work (Leipzig, 1790–97) by the physician Christian Friedrich Daniel, however, included some colored plates, thus introducing images in the nosological tradition. Also *Synopsis nosologiae methodicae* (Edinburgh, 1769), by the Edinburgh physician and chemist William Cullen, contained no illustrations. In the 1790s, however, Cullen's student Robert Willan started publishing a comprehensive treatise on cutaneous diseases inspired by nosological concerns and profusely illustrated. Thus, in the case of skin diseases, nosology was crucial to pathological illustrations.[23] By the early nineteenth century pathological anatomy, nosology, and pathological illustrations came together. Clearly perceptions shifted around the turn of the century, calling for a closer study of such profound transformations.

The growth of nosology raises two potentially relevant issues to pathological illustrations, the erosion of the notion of the individuality of disease and the progressive shift away from the overwhelming emphasis on causes; the very notion of nosology as a descriptive endeavor involves a weaker causal component. Older notions of disease could be tied to individual patients, whose constitution and imbalance of the humors were addressed on a one-by-one basis. Common patterns, however, were identified already in antiquity with regard to critical days and the periodicity of fevers, for example. Moreover, the existence of names for specific conditions, such as consumption or the "sacred disease," for example, highlights common elements going beyond the peculiar constitution of an individual. Over time there was a growing emphasis on the identification of common features and patterns in the symptoms and lesions. In some contagious diseases, such as the plague in antiquity and especially from the mid-fourteenth century, or syphilis from around 1500, for example, many were affected irrespective of constitution, age, or sex. Those common

features and patterns, however, could be problematic and contentious; astrological conjunctions, for example, were frequently seen as significant until the seventeenth century.[24]

The growing focus on identifying similarities or even an identity among local manifestations of disease made pathological images more significant; conversely, those images, produced for a variety of reasons, highlighted remarkable structural similarities among seemingly different cases. The notions of organic or anatomical lesion, localization, and visualization were profoundly intertwined.[25]

FORMS OF VISUAL REPRESENTATION

Pathological researches have a broad scope and while in many regards the French were in the vanguard in the early 1800s, as with René Laennec's stethoscope and auscultation, in pathological illustrations they lagged behind, as Cruveilhier argued. In the *avant-propos* to *Anatomie pathologique* he stated that images were not simply useful but actually indispensable to pathological anatomy. At the time of the first treatise with a collection of postmortems by Benivieni, three dozen years before Vesalius, anatomical illustrations were barely emerging and pathological illustrations did not yet exist. Surgery had a visual tradition, but initially it focused more on instruments and procedures than lesions. By the third quarter of the eighteenth century, however, the situation was different and anatomical illustrations were an established genre. Yet Morgagni's *De sedibus*, like Bonet's *Sepulchretum*, contained no illustrations. In other works, starting from his 1706 *Adversaria anatomica prima*, Morgagni himself had relied on them, thus raising the question of this puzzling dichotomy between anatomy and pathology. Morgagni was not opposed to the use of pathological illustrations and at times referred to those featured in previous treatises and journal articles, though overall he privileged organ localization over a careful description, differentiation, and classification of lesions.[26]

Morgagni's position differed profoundly from Bichat's, according to whom anatomical plates are monuments to luxury hiding an intellectual void, almost issuing a negative moral judgment that Cruveilhier was swift to challenge. Bichat had in mind one of the most luxurious productions in this area, the huge folio by the personal physician to Queen Marie Antoinette, Felix Vicq d'Azyr, *Traité d'anatomie et de physiologie* (Paris, 1786), dedicated to Louis XVI and including remarkable color prints of the brain. Compared to Vicq d'Azyr's sumptuous work, Bichat's austere octavo volumes, with their simple blue covers, look as if they came from a different era, and indeed they did. Bichat had also cognitive reasons against illustrations applying to anatomy but also pathology: each image can present a preparation from one angle only, unless one shows each item from multiple sides, further multiplying expenses. Bichat went as far as to question three-dimensional wax models as well, arguing that

even they could not provide the sensation of touch that was crucial to anatomy. At the time Paris boasted major wax modelers: besides the celebrated Madame Tussaud, surgeon André-Pierre Pinson was producing anatomical and pathological wax models for the Paris École de Santé.[27]

Bichat was not the first to question the role and utility of illustrations; in the early modern period anatomists as diverse as Jacobus Sylvius and William Harvey had questioned the role of images for a range of reasons, such that touch is a more important sense for anatomy and images inevitably involve distortions and cannot be a substitute for *autopsia* or seeing for oneself.[28] *Pace* Bichat, from the 1790s illustrations were seen as playing an increasingly key role in the study of disease and were employed more and more extensively and systematically; they could show the same preparations from different angles and also at different stages of dissection, for example. The financial issue was partly addressed by relying on installments, which spread the cost over time and also enabled authors to include a number of cases as they presented themselves.

Besides the problem of whether to have illustrations, pathologists often faced the issue of which types of images to produce. Here too, as in our reflections on disease, it is helpful to work with a number of dichotomies. Since the Renaissance, artists were trained in anatomical drawing and focused on the harmony, beauty, and proportion of the human body; anatomical illustrations had an established esthetic dimension. By contrast, these aspects seemed alien and indeed antithetical to pathological illustrations, which often highlighted precisely the disruption and destruction of harmony, beauty, and proportion. Artists were not trained to study diseased body parts nor were they often found in hospitals and morgues drawing ulcers, tumors, and tubercles, yet some distinguished artists, painters, and engravers of portraits of kings and queens produced illustrations of such unsightly items.[29]

One option was to depict individual items, on the example of the "counterfeyt" or individual portrait, versus idealized representations of a type. The scope of many anatomical illustrations from Vesalius to Bernhard Siegfried Albinus was to represent an ideal or abstract case, one capturing the key features of organs and body parts—with Govert Bidloo's *Anatomia* (1685) and William Hunter's *Anatomy of the Gravid Human Uterus* (1774) being notable exceptions. By contrast, the scope of pathological illustrations, especially those of diseases that had not been thoroughly investigated, was to display the specific lesions observed *hic et nunc*. In the nineteenth century, however, some pathological images belong to the ideal type: the iconic plate of lung tubercles in Laennec's treatise on auscultation, for example, display all seven stages of tubercles in a single idealized portion of a lung (illustration 4.5); some representations of skin diseases by Rayer too fall under the same category. These, however, were exceptions rather than the rule.[30]

There is a related dichotomy concerning individual items, which were represented with different purposes in mind: some could be selected because of

their extraordinary or even unique nature; alternatively, some could be chosen because they were typical or representative, thus precisely because they were not extraordinary. The role of images would be correspondingly different: in the former case, they may document the existence of the item, at times accompanied by a list of witnesses and other corroborating evidence—thus the image would be certifying the authenticity of the report. In the latter case, the representative nature of the items made the issue of authenticity redundant. In this regard too there was an overall shift toward more representative specimens: of course, remarkable cases are still being reported today, but in the eighteenth and nineteenth centuries there emerged a concern for mapping and representing disease in a systematic way, whether rare or common. The celebrated plates of kidney disease in Richard Bright's *Reports of Medical Cases*, for example, were individual portraits giving the name of the patient, yet their aim was to identify and serve as exemplars of classes of lesions.[31]

These comments highlight that images could be produced for a range of reasons. My main focus here is on epistemic aspects, whose role was routinely emphasized by my protagonists, though one could look at the issue from different angles. As we are going to see, the illustrated works by Andreas Bonn and Sandifort, for example, involved civic and institutional pride about museums and collections; Paris dermatologist Jean-Louis Alibert too highlighted through striking color images the resources of the Hôpital St. Louis, which he had made into a major center for the study of skin diseases. More generally, pathological collections and images could add to the reputation of medical men in the eyes of other medical men and perhaps patients, even if pathological anatomy per se rarely contributed to therapies.

Significant differences in the types of images produced involved preserved specimens, live patients, and recently deceased ones. Whereas isolated plates could come from any of the three categories, initially extensive collections of images were based on preparations, whether wet or injected soft parts, or dry, such as bones. We mentioned above that while preservation allowed the accumulation of a large number of preparations, it also affected their texture and especially color of soft parts and was therefore deemed problematic. At the end of the eighteenth century Robert Willan played a key role in providing visual representations of cutaneous lesions in color. In addition, some dermatologists took advantage of the fact that, since the patient was alive, one could study and represent the entire progress of the disease stage after stage. Moreover, facing the patient directly allowed the artist to show not simply diseased organs or lesions but suffering individuals, with their facial features, clothing, and social standing, as in many plates in the works by Alibert. The shift to color images involved tonal printing and artists with a specific expertise and background, notably in novel printing techniques and natural history.[32]

In the decades around 1800 we encounter a few cases of color images of body parts from recently deceased patients appearing in print, but it was not

until the late 1820s that the new form became more widespread, first with treatises devoted to specific body parts or diseases, then with more ambitious works dealing with the entire body and a wide range of diseases. Their production was especially costly and technically demanding, testifying to the significance pathologists attached to them. Since these works relied on fresh cadavers, the role of large hospitals became crucial and went alongside collections and museums; some hospitals had both resident artists and museums. The new form of color representation saw the interplay between cognitive and medical concerns on the one hand and artistic ones on the other—whether relying on color engravings or lithographs colored by hand.

Regardless of their provenance, the preparations to be studied and depicted were not a given but were selected and arranged so as to highlight their significance. This process was neither neutral nor straightforward: preparing body parts was carefully planned—they were sectioned in appropriate ways, for example, or injected with often colored fluids in order to highlight certain parts and preserve them; they were displayed from appropriate angles and in suitable lighting conditions—with a source of light behind a membrane, for example, in order to highlight its vascular structure. In the course of the eighteenth century the art of representing wet preparations changed: at the beginning it was not uncommon for authors such as Ruysch to show wet specimens in their fluid-filled jars, in a way that may have impaired the legibility of the image; by the end of the century preparations were no longer represented that way, suggesting that they were extracted and depicted before the jar was refilled and resealed. Some authors, such as Bright, were especially forthcoming in providing precious details about the manipulations and preparations of the specimens involved and explaining their significance. Others, such as James Hope, explained that his drawings illustrated the opinions of the French school he followed. These comments highlight that images should not be seen in isolation from the text but in relation to legends, case histories, and theories as well.[33]

Since color could be especially revealing, from around 1800 at least color drawings and wax models were used often together with preparations as research and teaching tools at universities, medical schools, and hospitals. Edinburgh professor of surgery John Thomson used in his classroom colored anatomical and pathological drawings by Carswell, who was to hold the first chair of pathological anatomy in Britain at University College, London. At Thomson's instigation and with his support, Carswell spent several years in France in order to avail himself of large hospitals to perform postmortems and to complete pathological watercolors. Carswell had already produced delineation of healthy and morbid parts for his teacher, Glasgow professor of anatomy James Jeffray. At Edinburgh around the turn of the century surgeon Charles Bell relied on wax models of healthy and diseased parts as teaching tools.[34] In late eighteenth-century Paris the École de Santé employed wax modeler

Pinson alongside painter Anicet-Charles Lemonnier to reproduce anatomical and pathological states. Starting from 1826, Guy's Hospital had artist James Canton and wax modeler Joseph Towne on its payroll in order to produce color drawings and models of healthy and diseased parts. Although wax models had a limited circulation compared to prints, these practices testify to a growing interest in the significance not only of color but also of three-dimensional renderings.[35]

It is not surprising that, since the illustrations depict diseased body parts and were intended for contemporary medical readers, many are disturbing to us, the more so the more easily one can identify the diseased body part or the face of the patient; many plates would make the powerful animal carcasses painted by Francis Bacon look like evening entertainment for distressed children by comparison. Of course, perceptions change depending on several factors; I have found no evidence that contemporary readers found the illustrations offensive or gratuitous. At times the organs and body parts are easily identifiable even by non-medically trained readers; in some cases, however, the plates depict such unusual and peculiar structures that even the medically trained would have difficulties identifying them without the legends. If at times the body part is hard to identify, the same is even truer for the nature of the disease, even combining visual and written resources. Besides the known problems of retrospective diagnosis, often the lesion depicted is at such an advanced state that no practitioner today would have seen anything similar. Medically trained colleagues with whom I inspected some plates were puzzled by them because, as they put it, "we do not let things go to that stage nowadays."

Here I have avoided disturbing illustrations for their own sake and sought compelling reasons to include those I present. I discuss both representative and exceptional images, trying to strike a balance between them while pointing through cross-references to what could be called "iconographic dialogues." More specifically, I seek to include images of what the historical protagonists considered, or at times would have considered, as related conditions; occasionally I also include images that we, twenty-first-century viewers, understand as being related. Regardless of whether my protagonists or later historians see a connection among images, these associations highlight shifting concerns, styles, and conventions at play at different places and times: there was nothing automatic or unproblematic in the selection of a lesion or preparation and in the specific way medical men and artists chose to represent it.[36]

THE PRODUCTION OF IMAGES AND ITS TECHNOLOGIES

The process of producing pathological illustrations involved several steps. A close collaboration between medical men and artists was essential at many

levels, since artists lacked pathological training and would not have known what to depict. First came the original image of the specimens, which were usually rendered in pencil or watercolor. The conditions of the specimens may change rapidly after death with regard to structure, texture, and color, as we have seen above, requiring artists to act speedily if their rendering had to be reliable. Medical men at times held portfolios of pathological images for their own record. The lucky survival of drawings and watercolors, and at times even of instructions or letters between artists and medical men, often documents these early stages.[37]

Once the drawing was executed, it had to be transferred onto a surface to be printed. There were different techniques for doing that, involving different features and costs. The decades around 1800 saw the development and dissemination of novel printing practices with one or several colors. My focus here is not on printing in general but on the techniques that proved especially significant to pathology. In pathology, as in anatomy, the production of the printed image involved conventions, styles, and techniques; different techniques, for example, had textural qualities that made them suitable to represent different conditions.[38]

Woodcut, whereby the woodblock is carved leaving the lines to be inked in relief, was used occasionally in the early stages (illustration 1.1); despite the advantage that text and image could be printed together, overall it was rather uncommon because it was difficult to achieve a high quality and the number of copies that could be printed was comparatively low. The most widespread printing methods involved intaglio techniques, which required separate procedures and presses from those used for printing the text. Intaglio refers to a set of practices sharing a common feature, that the image is produced by a plate where the ink has been applied in a recessed or sunk design; by pressing the plate on the paper, the ink leaves a trace of the design while the entire plate leaves an impression of its edges. The traditional way of rendering shades or textures relied on hatching, involving a set of parallel lines, or more sets meeting at an angle to produce a darker tone through cross-hatching; these could be obtained by means of a sharp tool called a burin through lines engraved directly on a metal plate—usually copper, at times from about 1820 steel—or through etching. In etching a metal plate is covered by a protecting layer of wax, on which the artist draws with an etching needle, removing the wax, thus allowing an acid to bite into select portions of the plate. Often the terms "engraving" and cognates were used in the works we shall be dealing with in a broad sense, referring to any intaglio technique; in the following I will call "line engraving" the process of incising lines directly on to the plate with a burin. Line engraving generally produced sharper lines and involved more labor compared to etching, which produced softer lines and—when mastered—would take less time. At times etching and line engraving were combined on the same plate, each technique capturing different textural qual-

ities, especially with bone surfaces. Line engraving could exceed the cost of etching in a ratio of about six or seven to one.[39]

Over the centuries cross-hatching had been developed in an exceedingly sophisticated way, but even so it was less than ideal for rendering textures, especially in anatomy; for example, some lines may give the impression of fibers, when in fact there were none. Often these techniques were used in conjunction with other more effective ones in rendering gradations of shades and textural effects.[40]

There were different ways of rendering gradations of tone: stippling involved not lines but small dots, produced by a stippling burin or an etching needle. By changing the size of the dots, their density, and the time the prepared plate was kept in the acid bath, one could obtain subtle variations in tone. Stipple engraving was introduced in the early sixteenth century by the Padua painter and engraver Giulio Campagnola, but, as with other innovative techniques, it was not extensively adopted until the eighteenth century, especially in France and in England. Stipple engraving was the most common form of tonal printing in pathology (illustration 5.2).

Another effective technique for rendering gradations in texture was mezzotint, or *la manière anglaise*, dating from the mid-seventeenth century. It consists of preparing a plate with a rocker (*berceau* in French), a tool resembling a toothed *mezzaluna*, that roughens its surface by covering it with tiny dots and lines; if printed at this stage, the plate would produce a solid black image, hence the French name *la manière noire*. The image is created by smoothening or burnishing the portions of the plate that should appear lighter, so they take less ink; in this way the image is produced from dark to light.[41] Alternatively, one could create an image by roughening a blank plate selectively, over a smaller surface, as was the case for the plates we are going to encounter later (illustration 6.5). Either way, the tone was often deeper than that produced by stippling, which could produce softer effects.

The last intaglio technique I am going to outline here is aquatint, which was already used in the mid-seventeenth century by a Dutch engraver, Jan van de Velde IV, then forgotten and rediscovered over a century later, when Jean-Baptiste Leprince perfected it in France in the mid-1760s. It consists in covering select portions of a plate with the fine powder of an acid-resistant resin; initially the powder was made to stick to the copper with a sugary fluid and then it was made to adhere to the plate with heat, forming a rough surface. When the plate is immersed in an acid bath, the acid bites into the areas not covered by the resin, forming a fine reticulate pattern resembling lace. By using powders whose grains have different sizes, one could modulate the effect of the acid and create differences in tone; the finer the powder, the closer aquatint resembled watercolor (illustration 5.5). The process could be repeated several times, leading to progressively darker tones.[42]

These methods were employed using traditional black ink. When wishing

to introduce color, however, new techniques had to be employed. The simplest was to add color by hand: generally low-rank artists were paid to color individually all the plates—usually not more than a few hundred. The cost varied depending on the refinement and complexity of the task. Some plates involved coloring in such simple form that even an unskilled laborer would have been able to accomplish the task, either because the coloring was simple per se (illustration 5.1) or because the tone was provided by the underlying engraving. Most plates in James John Audubon's celebrated *Birds of America*, for example, were elaborate intaglios with extensive aquatint, for which a uniform application of color sufficed to achieve the desired effect from the underlying black and white print. In other cases, however, the task required greater skills in that color had to be applied providing details and tone, which was more challenging and time-consuming. Occasionally, as in two plates in Richard Bright's *Reports of Medical Cases* (London, 1827–31), the artist that colored them—Charles James Canton—was possibly the same one that had drawn or printed them in the first place, as he pointed out when he signed them.[43] The processes of preparing the plates and coloring them were not independent, in that knowing in advance that a plate would be hand-colored introduced constraints—for example, avoiding very dark tones.

Other techniques involved color printing; for our purposes we can distinguish those involving one or more plates. Color printing using multiple plates was used only occasionally before the eighteenth century, had a celebrated phase especially relevant to anatomy in the eighteenth century, but did not take off commercially until well into the nineteenth century. Early in the eighteenth century Jacob Christoph Le Blon devised a method for color printing inspired by Newton's theory involving three plates, each with a separate color (red, blue, and yellow). The plates had to be perfectly registered, though since the paper stretched after the first impression, special care had to be paid in order to maintain the registration. Others, such as Jan L'Admiral, Jacques-Fabien Gautier-Dagoty, and his sons, adopted similar techniques, at times adding a fourth plate for black. Overall, they relied on mezzotint and produced images strongly resembling oil paintings. The Dutch engraver Johann B. Kobell produced illustrations of the fine structure of the tunics of the intestine seen through the microscope in Jan Bleuland's work on intestinal vessels relying on as many as three plates. Other artists too relied on multiple plates to render a range of colors but eschewed mezzotint in favor of aquatint and stippling: Alexandre Briceau and his daughter Angélique, for example, produced remarkable plates for Vicq d'Azyr's *Traité d'anatomie et de physiologie* using at times as many as three plates; theirs are likely the first major anatomical plates relying on color printing in aquatint. This technique proved especially effective in rendering the delicate convolutions of the cerebral cortex in a sectioned preparation as if in watercolor; this is an example of different techniques proving especially suited to representing specific body parts.[44]

A different technique called *à la poupée* (*poupée* being the French for dolly) involved only one plate to which different colors were applied selectively in different areas with a dolly, a cloth, or even a paintbrush: the plate could be prepared relying on the various techniques we have seen thus far. The Dutch engraver Johann Teyler was an especially prominent practitioner of this technique at the end of the seventeenth century. Inking *à la poupée* required great care in the application of colors and in preventing their mixing; whereas the process of inking with one color could be performed mechanically, complex cases of inking *à la poupée* were best dealt with by the artist. As in other techniques, it was difficult to control the tone, though the *à la poupée* method avoided the problems of register among different plates, it was cheaper, and in some regards it was simpler than methods involving multiple plates. At times, if the plate had one predominant color, it was more effective to print it using only one color, thus simplifying the task of those finishing the image by hand (illustration 6.3). Often printing techniques involved secrets developed and closely guarded in a specific atelier, making an exact reconstruction of the processes involved impossible. Recent research has shown that eighteenth-century France was a cradle for color printing based on a range of techniques; artists and engravers were able to produce striking images relying on a combination of advanced printing techniques and hand coloring.[45]

Prints produced with only black ink were generally due to artists who had a background or expertise in anatomy and pathology; for color prints, however, pathologists often relied on engravers with a background in botany and to some extent ornithology, both privileged areas for the careful observation of nature and attention to color As we are going to see in chapter 6, for example, William Say, who engraved most of the plates in Bright's *Reports of Medical Cases*, had virtually no anatomical background but had produced a number of mezzotints and stipple engravings of fruit and flowers printed in color and finished by hand immediately before embarking on his collaboration with Bright. At the time remarkable botanical color engravings were produced in mezzotint, stipple engraving, and aquatint, either using multiple plates or, more frequently, relying on a particularly sophisticated usage of the *à la poupée* method finished by hand, with stunning results.[46]

All the methods discussed thus far, especially if they involved color, required highly specialized skills and expensive labor; it may take a skillful artist months to engrave a large, highly detailed image using only black ink, like those produced by Robert Strange for William Hunter, *The Anatomy of the Human Gravid Uterus*. Only rarely would those who wrote the text have the artistic skills to draw highly demanding images; almost never would they be so skilled as to produce an engraving. Since the engraving was considerably more expensive than the initial drawing, the production cost of illustrations was often high, leading to high prices for the books, which affected their circulation; for most of our cases no more than a few hundred copies were pro-

duced. Nor were financial matters of minor importance: after all, Le Blon went bankrupt and had to flee London to escape his creditors.[47]

At the very end of the eighteenth century the Bavarian playwright Alois Senefelder developed a new technique based on printing from a suitably prepared surface of limestone, or lithography: by drawing with an oily crayon on the slab, wetting it, and then applying a sponge dipped in ink, only the portions drawn by the crayon turned black, because the ink was repelled by the water but had an affinity to oily substances. In this way the stone could be used for printing by repeating the same process as many times as one wished. Whereas in a woodcut the inked image was in relief and in an intaglio print it was recessed, in lithography it was on the surface or at the same level as the plate, hence the technical term of "planographic prints"; unlike intaglio prints, lithographs left virtually no mark of the stone on the paper. Behind this very elementary outline, there were relevant features of lithography at two main levels, artistic and economic. Despite its unpromising beginnings—the method was invented by an impecunious author who could not afford to have his plays printed in some other way—eventually lithography allowed for considerable subtleness in tone and effectiveness in representing textures. In addition, the process was simpler, cheaper, and more direct than producing intaglio prints, corrections were easier, and more copies could be printed without wear: some physicians such as James Hope not only produced drawings of diseased body parts but also transferred them onto lithographic stone themselves, thus cutting cost.[48]

Senefelder obtained patents in Bavaria and England while lithography took root throughout Europe. Paris became an especially active center that from the 1820s saw the production of several illustrated anatomical treatises, as well as Cruveilhier's *Anatomie pathologique* (illustrations 7.1–7.6).[49]

The production of pathological images was expensive, challenging, and generally collaborative. At times one finds teams of practitioners expert in the different aspects of image production working together; occasionally those collaborations carried through generations, from father to son or from master to pupil. The striking quality of many of the images produced testifies to the artistic and intellectual efforts of artists and medical men.

In the following chapters we will encounter several concrete examples of the cases we have here discussed in the abstract, concerning both theoretical aspects in the history of medicine and practical ones to do with drawing and printing.

ONE

VISUALIZING DISEASE IN THE EARLY MODERN PERIOD

This chapter explores some key themes related to the visual representation of disease in the early modern period by combining a thematic and a biographical approach. I focus on three major aspects; the new genre of *Observationes* and the cognate *Historiae* and *Curationes*, especially those marked as *chirurgicae*, offered a venue for focusing on case histories. The establishment of anatomical museums and collections including pathological specimens provided valuable material for instruction and comparison; this practice accelerated in the last third of the seventeenth century, with the development of novel preservation techniques. Finally, the rise of surgeons socially and in the main scientific societies of the time favored what I call a "doubly localistic" approach valuing visualization; while of course visual representations of diseased states were not the exclusive prerogative of surgeons, it was surgeons who played an especially prominent role both directly and indirectly, by promoting and advocating their perspective. These developments intersected and reinforced each other.

Two figures emerge as particularly significant at the endpoints of my account, Guilhelmus Fabricius Hildanus in the first third of the seventeenth century and Frederik Ruysch in the decades around 1700. While Ruysch is well known and has attracted a considerable amount of scholarship in recent years, Fabricius has been far less studied, despite his reputation at the time. Their activities touched on the three themes I have identified: despite major differences in the preservation methods available at their respective times, both established museums that have been carefully documented; Fabricius was a leading surgeon, while Ruysch was lecturer to surgeons; their publica-

tions include collections of *Observationes*, rely on their museums, and present a large number of illustrations, including pathological ones.

PREAMBLE: EARLY BROADSIDES AND SURGICAL TREATISES

Publications with illustrations of diseased states came in different formats, from folio to duodecimo and from large collections to small ephemeral broadsides. Here I wish to provide a few introductory remarks about very early developments with no pretense to offering a comprehensive treatment. It may come as no surprise that up to the sixteenth century the most common form representation associated to disease was the uroscopy chart, often depicted in the form of a wheel with many beautifully hand-colored urine flasks. Such charts provided a careful description of color, whose role in ascertaining disease was discussed in the text in relation to the four humors, blood, yellow bile, black bile, and phlegm. The many editions and translations of *Fasciculus medicinae* (*editio princeps*, Venice, 1491) by German physician Johannes de Ketham, for example, included a uroscopy chart with over twenty flasks. Such charts, however, represent diseased states only in an indirect way; although their role declined in the sixteenth century, they show that physicians included images, even colored ones, when they perceived them to be intellectually significant to their practice.[1]

Broadsides were a popular print form often announcing monsters, portents, and marvels. The spread of the French pox at the end of the fifteenth century constituted a dramatic development; the depiction attributed to Albrecht Dürer of a victim of the disease in a 1496 broadside by the Nuremberg town physician Theodoricus Ulsenius was probably the first of its kind. It shows the victim flanked by Nuremberg's coats of arms under a zodiac sign with the year 1484, pointing to the astrological cause of the condition. Even when the broadside was hand-colored, the visual clues remained rather general at best. In the early Renaissance broadsides rarely provided detailed visual representations of diseased states; their main focus was elsewhere, often with congenital malformations perceived as monstrous.[2]

Surgery is the medical specialty with an especially strong association with visual representation. Unlike physicians, surgeons used many mechanical tools and took pride in them: instruments are often given a prominent role in their treatises. Procedures too are often featured and provide rich documentation about wider issues such as venues and social status. Surgical operations before the mid-nineteenth century were limited: they involved removing external growths and tackling external and rarely some internal conditions, such as those associated with syphilis, for example, the urinary system, amputations, and bone afflictions. Moreover, surgeons were often the ones responsible for dissections and would therefore have been in the front line at postmortems. Overall, however, early surgical works focused more on instruments

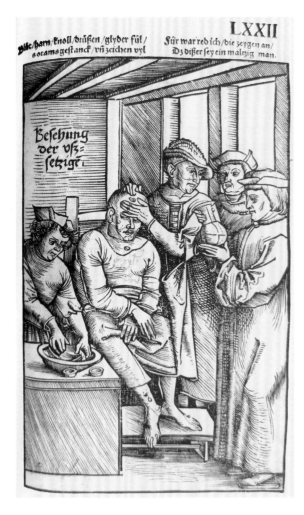

Illustration 1.1
Gersdorff, *Feldbüch*,
1517, [Hans Wächt-
lin?], page lxxii,
leprosy. Woodcut.

and procedures than on diseased states as such, and when these do appear, they tend to be rather schematic, though matters progressively changed.[3]

At a time when images in medical books were emerging, they may have served a variety of didactic and practical purposes: the precise shape of surgical instruments would be practically relevant but also advertise the surgeon's skill and equipment. Images of successful cures would obviously advertise the medical man's skill. Procedures would show the proper set-up for patients and surgeons in a way that could be difficult to describe in words. Lastly, some images may have had a decorative or a mnemonic purpose, as the "woundman," with his impossibly large number of conditions, frequently shown in surgical works.

Feldtbüch der Wundtartzney (Strassburg, 1517) by military surgeon Hans von Gersdorff (ca. 1455–1529) is remarkable as an early example of both anatomical and pathological illustrations. Several plates in this surgery book show unusual attention to pathological conditions in live patients. Historian Luke

Demaitre has argued that the woodcut of a leprosy patient in the *Feldtbüch* shows several procedures that would have unlikely occurred simultaneously (illustration 1.1). On the left possibly a barber surgeon washes a cloth that has been soaked in the patient's blood; finding a sandy residue, or perhaps adherence of the blood to its container, would be a sign of leprosy. The two small cups in the foreground possibly contained salt and vinegar for assaying the blood by ascertaining whether it dissolved salt and whether vinegar changed its color. The patient, dressed in loose garments and in a pose reminiscent of Jesus surrounded by his tormentors, is being examined by a surgeon palpating his forehead while turning away to confer with the other people in attendance; his expression seems to express disgust at the patient's stench, this being another diagnostic sign. Nodules are shown at different locations on his body, especially on the face, where they were deemed indicative of leprosy, but they are rendered schematically and without much detail. The next person on the right may be another physician or a public official; the last one on the right is a physician shown canonically while examining the urine flask.[4] Overall, the nature of the condition is identified more by the text and setting than the actual lesions.

The later sixteenth century witnessed the appearance of major surgical works from such iconic figures as Ambroise Paré, surgeon to several French kings, Guido Guidi, active between Italy and France, Venice surgeon Giovanni Andrea della Croce, and Dresden oculist Georg Bartisch. Despite the exceptional quality and interest of some of the plates, overall their subjects eschew detailed representations of lesions. Guidi's *Chirurgia* (Paris, 1544), for example, is an edition of ancient surgical works including images of conditions such as dislocations from the original manuscripts. Bartisch's *Ophthalmodouleia, oder Augendienst* (1583), an ophthalmology treatise with numerous illustrations drawn by the author, includes images of instruments and procedures and occasionally also representations of eye diseases.[5]

COLLECTING AND VISUALIZATION IN FABRICIUS HILDANUS

An especially significant figure in my story is Guilhelmus Fabricius from Hilden, or Hildanus (1560–1634), a prominent learned surgeon of his time. His publications in both Latin and the vernacular and extensive epistolary exchanges with prominent figures testify to his status. Fabricius lived a large portion of his life in Switzerland, first Geneva, then Payerne, and eventually Bern, where he became town surgeon and physician. Starting from the end of the sixteenth century, he published several works, notably a series of six *centuriae* of *Observationes et curationes chirurgicae* with many illustrations, and treatises on gangrene and dysentery; his Latin *Opera* (Frankfurt/M, 1646) was translated into French by Bonet in 1669, and a new revamped Latin edition appeared as late as 1713.[6]

Fabricius followed contemporary practices of learned physicians by publishing collections of *Observationes* and establishing a museum; in both areas, however, he adopted a surgical approach to documenting his practices and perspectives. He was among the first to characterize his *Observationes* as *chirurgicae* as opposed to *medicae*. *Observationes* were a new genre that emerged in the mid-sixteenth century, as Gianna Pomata has shown. They stem from the empirical tradition and focus on individual cases; they could make an unusual condition known to the medical community or advertise the success of the medical man in a difficult case. While following this tradition, Fabricius also developed it in new ways. Unlike their medical counterpart, surgical *observationes* focused on the manual intervention of the surgeon, often involving specially designed instruments that were illustrated together with the specific form of a growth, whether still attached to the body or removed; stones found in the bladder, kidneys, gallbladder, or other body parts; and broken or healed bones. Similarly, following the example of several Italian medical men and contemporary physicians and correspondents at Basel, such as Felix Platter (1536–1614), Caspar Bauhin (1560–1624), and Jacob Zwinger (1569–1610), Fabricius assembled a museum, which was located in his home; although we know that he also collected ancient coins, in his correspondence and publications he singled out a cohesive body of anatomical, surgical, and pathological items.[7]

Besides describing and at times providing images of several items in his *Observationes*, Fabricius left a detailed description of his museum in a letter to Leiden anatomist Pieter Paaw, including some of his preservation methods. At the time Leiden had an anatomical museum that Fabricius had visited. A few decades before Fabricius, Paré had used vinegar and alcohol for preservation, but his aim seems to have been embalming more than saving body parts for scholarly purposes. Fabricius relied on drying and stuffing cavities, from blood vessels to the digestive tract, with hemp and cotton. He also mentioned a white mole and a monstrous black sow preserved with aloe, myrrh, scordium, absinth, and hemp.[8]

With such limited preservation methods, it is not surprising that his museum consisted largely of stone formations and especially bones, both being largely surgical domains. All the items listed in his letter to Paaw were *naturalia*, except for an artificial eye he had constructed; he listed forty-eight individual items or collections of items—item twenty-three, for example, mentions more than thirty badly healed bones—for a total exceeding one hundred. The main organization criterion emerging from his letter to Paaw is the distinction between human and animal items: the first twenty-nine items list human parts, whether healthy or diseased, items thirty to forty-eight relate to a wide range of animals, which would display an analogy, proportion, and similarity with the human body. Very small animals display God's knowledge, providence, and goodness; thus Fabricius's museum joined cognitive and reli-

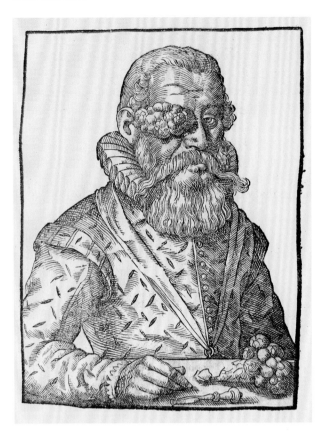

Illustration 1.2
Fabricius Hildanus,
Opera, 1646, page 2,
eye tumor. Woodcut.

gious motivations. One item, thirty-seven, consists of a "monstrous" pig with double parts; Fabricius also wrote a pamphlet on a monstrous sheep, though it was not included in his *Opera*, where overall monsters do not play a significant role.[9]

Fabricius included a large number of images in his works. Much like rare and remarkable specimens in his museum, or successful cures reported in *Observationes*, images enhanced his standing and provided valuable material for investigation and instruction. No doubt, they added to the appeal of a work for multiple reasons; in discussing the peculiar position of a fetus Fabricius defended their cognitive role, arguing that features that "are obscure from a description, can be better known from an image." Some passages point to Fabricius relying on draftsmen, at times including noted Bern artist Joseph Plepp.[10]

The first case in Fabricius's *Opera* dates from 1596 and discusses the eye tumor of Claude Mayor of Lutry, a small town on the lake near Lausanne. The prominence of the patient and the difficulty of the case led Fabricius to devote over twelve folio pages and several woodcuts to its description. He discussed the case history and instruments employed but also diet and evacuations in preparation for the operation, these being often the domain of physicians. The

woodcut (illustration 1.2) juxtaposes separate stages, showing the patient with his affected eye, the successfully extirpated tumor lying on the table, and one of the implements used. The status of the patient appears from his sumptuous robes, while the size of the tumor induces wonder in the viewer today, as it must have done at the time; both aspects were clearly self-advertisements. The plate is representative of early surgical works, which often included external growths that were among the main areas accessible to surgical treatment.[11]

This woodcut is lacking in the early 1598 and 1606 editions; it first appeared posthumously, leaving one to wonder whether Fabricius had a drawing made at the time or whether the image is a retrospective creation. Either way, its publication history reminds us that we should not take such images for granted. In fact, there are substantive differences between editions published during his lifetime and the posthumous 1646 *Opera*. Occasionally we have the drawings from which the printed images were produced, at times in color. For example, in 1611 Fabricius discussed a mola, a fleshy mass found in the pregnant uterus; although he could not reproduce it full size for reasons of space, it being almost the size of an infant's head and the book being a small octavo, he stated that the original could be seen in his museum. The *Opera* is much larger than the 1611 edition, and although the image takes only a portion of the page, the passage is unchanged. The 1646 image differs considerably from the original drawing and the 1611 version. Although the original report on the case dates from 1607, the mola is not mentioned in the description of his museum, possibly because it had decayed beyond redemption by then, since it was already "semiputrida" from the start.[12]

An intriguing woodcut raises questions about Fabricius's practices. It relates to an eleven-year-old girl from Köln who had died in 1595 but was first published in 1611, in the second *centuria* of *Observationes*. The girl suffered from a fever that was first ephemeral and then became hectic—involving daily spikes and night sweats. Several symptoms were explained by the postmortem, performed by Fabricius in the presence of a surgeon and an apothecary; difficulty in speaking, deglutition, and breathing, for example, were attributed to a fatty and fleshy lump attached to the trachea. The postmortem revealed an infestation of intestinal worms and a number of chalky formations affecting many parts; the lungs were filled with festering fatty matter, the size of a walnut or chestnut. The plate shows the longitudinally sectioned spleen with symmetric chalky formations that seemingly attracted the artist's attention (illustration 1.3). It is unclear whether this image was recreated from memory, or whether Fabricius had a drawing made at the time, thus suggesting that he collected not only specimens but also images of remarkable and unusual cases. We do not know why he chose the spleen, since several other body parts showed similar features. In the nineteenth century German pathologist Hermann Lebert convincingly characterized Fabricius as a surgeon rather than an anatomo-pathologist. Nonetheless, this plate is an especially early representa-

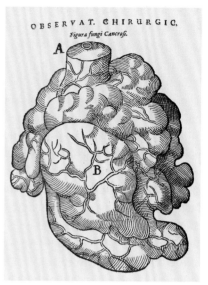

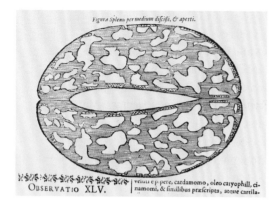

Illustration 1.3
Fabricius Hildanus, *Opera*, 1646, page 118, diseased spleen. Woodcut.

Illustration 1.4
Fabricius Hildanus, *Opera*, 1646, page 274, cancer of the penis. Woodcut.

tion of a diseased internal organ, and as such it calls for an explanation. Possibly Fabricius was intrigued by the peculiar pathological formations and their links with the patient's symptoms, or he saw these reports as an advertisement to his extensive experience in postmortems, which were routinely performed by surgeons. Either way, the plate is unique in Fabricius's published works and exceptional for the standards of the time.[13]

Several passages in his *Opera* refer to his museum's holdings; a cancer of the penis was too large to be reproduced life-size and was therefore shown in smaller scale, while the original could be seen in the museum (illustration 1.4). In this case the surgery proved especially challenging because the patient, ironsmith Pierre Perrod, needed to urinate safely; Fabricius proudly tells us that a few years after the operation Perrod could even eject urine at some distance, presumably a sign of manliness. Here Fabricius joined a didactic aim to an advertisement of his skills. Other specimens from his museum whose image was reproduced included two pairs of ribs from a sheep and a pig that had coalesced after fracture and a stone found in a brain that he must have valued highly since it was preserved "inter rariora."[14]

Fabricius's remarkable museum may have included a collection of drawings, or a paper museum, besides anatomical preparations; references in his correspondence and his surviving manuscripts testify to images of various portents and unusual occurrences being exchanged and collected. Much like his publications, his museum too would have served multiple purposes, from self-advertisement to investigative. It also had a pedagogical purpose; his

Opera frequently emphasizes the importance of anatomy to "tyrones," both surgical apprentices and young physicians seeking practical experience and attracted by his growing reputation.[15]

HISTORIAE AND OBSERVATIONES

Many publications with illustrations of diseased states appeared under the title of *Observationes*. Several examples we have encountered so far fall into this category: besides the *Observationes* by Fabricius Hildanus, every case in Bonet's *Sepulchretum* bore the title "Observationes," and *Medicina septentrionalis* included in the title the words *Exhibens observationes medicas*. Many articles in the philosophical and medical journals of the time, such as Thomas Bartholin's *Acta Hafniensia* or the German *Miscellanea curiosa*, belong to this genre; while the *Miscellanea curiosa* reflected the emphasis on curiosity of the Academia Naturae Curiosorum, or Leopoldina, other academies such as the Royal Society had a stronger emphasis on experiment, though many contributions to the *Philosophical Transactions* too shared a focus on curiosity.[16]

Amsterdam was the key center for illustrated collections of *Observationes*, fostered by an emphasis on practical matters, its thriving book and publishing trade, and the tradition of close observation of nature that was especially strong in the Netherlands as a whole. In the course of half a century nearly a dozen editions of *Observationes* appeared in the Dutch trading hub, all including illustrations of external conditions in live patients and internal ones found at postmortems, many in multiple editions and translations.[17]

In 1641 Nicolaas Tulp, the Amsterdam physician immortalized by Rembrandt as praelector to the surgeons' guild—the same post Ruysch later occupied—and burgomaster, authored *Observationes medicae*, which went through several editions. Tulp's *Observationes* discussed varied reports, often including the formation of stones and polyps, as well as one on an "orangutan."[18] His associates, surgeons Job van Meek'ren and Hendrik van Roonhuyse, published works with a stronger focus on medical and surgical cases in Dutch under the title of "medico-chirurgical" or "medical" "aanmerkkingen," a term rendered in contemporary translations as "observationes";[19] significantly, an edition of van Roonhuyse's collection was dedicated to Tulp.[20] The *Observationes* by Blasius (1677) and Ruysch (1691), discussed below, belong to the same genre.[21]

Here I discuss the title page of *Observationes medico chirurgicae* by van Meek'ren (ca. 1611–1666), with its unusually rich collection of pathological cases (illustration 1.5): it shows an unhappy congregation afflicted by a panoply of ailments that are then discussed in the text with similar illustrations in larger scale showing external growths on the eye, the shoulder, the face, the neck, and the abdomen. The female cadaver in the center was that of Ingitta Thoveling, first wife of the celebrated painter and Rembrandt pupil Govert

Illustration 1.5
van Meek'ren,
Observationes, 1682,
title page.

Flink. The figure on the left shows George Albes, a Spaniard whose skin was very loose and stretchy. As if that was not enough, several pictures of diseased states hanging under a collection of surgical instruments on the wall add gloom to the scene. Except for the cadaver on the table, the title page shows live patients, though the book includes images from postmortems as well. Live patients with growths on a shoulder or leg, for example, proved easier to represent even in small format; the body interior, such as an abscess on the spleen, for example, was more challenging to represent even on its own in larger format and was excluded from the title page. The anatomy theater at Delft included "paintings and drawings of marvels of Nature," including "strange tumours and diseases" that may have resembled van Meek'ren's title page.[22]

Many collections of *Observationes* and their cognates were ordered by *centuriae*, such as those assembled by the Copenhagen physician Thomas Bartholin, which could also be rather heterogeneous. Both his *Historiae* and *Epistolae* included several reports of remarkable and unusual cases, at times with illustrations. In his *Epistolae* Bartholin included a letter from Rome on the postmortem of Cardinal Cornelio Melzi, performed by the pontifical archiater

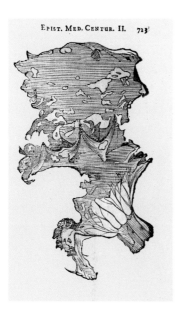

Illustration 1.6
Bartholin, *Epistolae*, 1663, page 723, aortal
ossification. Woodcut.

Giovanni Trullio in 1659. The letter, titled *Observationes anatomicae in cadavere Cardinal. Meltij*, briefly describes the case and includes a woodcut of a partly "ossified" aorta and semilunar valves found in the cadaver (illustration 1.6).[23] Here the artist faced the task of representing not altered structures but textures, a more challenging endeavor, especially in a woodcut. Medical historian Luigi Belloni remarked that conditions such as those shown here would have been relatively common, though they were not usually represented because at the time anatomists privileged rare and visually striking images over common ones. Others reported similar findings later in the century, tying the postmortem findings to the patient's shortness of breath. Marcello Malpighi, for example, identified two such cases; although he did not include images, the partly ossified aorta of one of them was preserved in the Aldrovandi Museum in Bologna, under Silvestro Bonfiglioli.[24]

Many *Observationes* appeared not as part of collections but in the journals of the time. A survey of the early decades of the *Miscellanea curiosa* reveals a large number of cases characterized as "monstrous," however defined, but generally with regard to size and rarity; the emphasis was on "curiosity" for extraordinary cases rather than on mapping the ordinary. Among the large number of reports on conjoined twins and bladder stones, I wish to examine a letter by Andreas Cleyer (1634–97/8). Although Cleyer may have studied medicine, he apparently did not hold a degree; nonetheless he held several medical offices in the Dutch colony of Batavia, and notably he was *protomedico* and physician to the leprosarium, which gave him easy access to affected patients. In his letter, dated Batavia, 25 November 1681, Cleyer argued that Java had been struck by the terrible disease about twenty years earlier. Cleyer queried to which genus the disease belonged and which would be the appropriate medications. Lucas

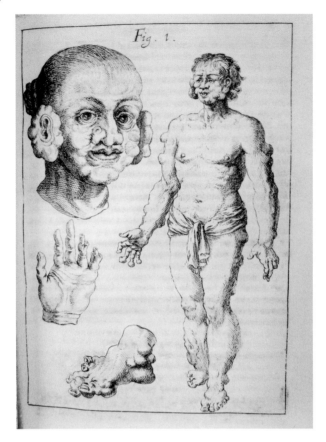

Illustration 1.7
Cleyer, "De
Elephantia Javæ
nova," *Miscellanea
curiosa*, 1684, plate
1, leprosy.

Schröck, a physician who later became editor of the *Miscellanea* and president
of the Academia, provided a learned scholium replete with references to the
literature in which he attributed the disease to an "elephantiac" effervescence
of the blood; it is striking to contrast the brief account and the image provided
by Cleyer, who worked at the leprosarium and must have been familiar with
many cases, to the much longer, highly confident, and more theoretical com-
mentary by Schröck, who may had never seen one. Yet presumably Cleyer did
not object to but actually sought and approved Schröck's learning.[25]

The plate (illustration 1.7) relies on two ink drawings that have remarkably
survived and are possibly due to a local artist; they are reproduced by Franz
Ehring and show the entire body of a woman affected by the disease with
details of her face, hand, and foot. The engraving in the *Miscellanea* combines
them on a single plate; in Ehring's opinion, it remained the most accurate
representation of leprosy for over a century. Although the face and especially
the areas behind the ears are not entirely convincing, the details of the hand
and foot highlight the dramatic effects of the disease. Even accounting for the
more advanced stage than in Gersdorff's case (illustration 1.1), it is clear that
Cleyer had a different agenda in mind: he wished to offer a reliable visual rep-
resentation of a condition, "eò meliùs morbus hic pateat," or "so that the dis-

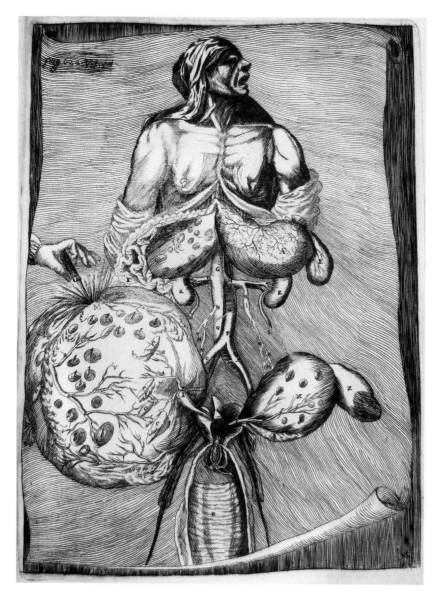

Illustration 1.8
Munnicks, *Historia,*
in *Bibliotheca*
anatomica, 1699,
volume 2, facing
page 624, ovarian
dropsy.

ease may be better known." Thus, the most detailed representation was pro-
duced only when leprosy had become uncommon in Western Europe. When
leprosy was more common, Gersdorff tried to document some of the identifi-
cation procedures, which involved a wide range of factors, such as assaying of
blood, palpation, bad odor, uroscopy, and also a coarse voice, among others;
strictly visual features of the lesion were only one aspect, and not an especially
crucial one, among a much more complex and multifaceted scene.[26]

One of the most unusual pathological plates I have encountered appeared in
an anatomical collection, the *Bibliotheca anatomica*, which explicitly excluded
"rare and monstrous affections," though the editors felt they could not omit

the present case. The "historia" was communicated by Utrecht anatomy and surgery professor Johannes Munnicks and concerned Cornelia Nicolaus, a very poor woman whose right female testicle, or ovary, had been growing over eighteen years, until she eventually succumbed in 1678 aged forty-three. The plate shows in brutal realism the dissected body with a multitude of affected organs (illustration 1.8); exceptionally, it also conveys the tension of the hugely enlarged ovary with a pointed knife puncturing it, leading to the impetuous discharge of what Munnicks described as a reddish humor. The stench prevented Munnicks from investigating the matter further.[27]

COLLECTIONS AND MUSEUMS

While postmortems and live patients were ultimately the source for visual representations, at times they must have seemed too precarious to medical men and artists; no one could predict when a patient would die and what a postmortem would reveal, while live patients offered a limited selection of lesions and presented a number of difficulties. Preserving specimens offered clear advantages in enabling investigators to freeze in time rare and delicate remains that may have otherwise lasted a few days at most. The cases I discuss here provide tantalizing information of what must have been a wider practice.

As Hal Cook has shown, many collections began in the sixteenth century, with dried animal skins and herbaria. The techniques available in the first half of the seventeenth century, however, did not allow for wide-ranging collections; soft parts in particular were too delicate to survive for any length of time or to be preserved in a way that retained their significant features. Moreover, diseased parts may have been retained for reasons different from pathological concerns: William Harvey, for example, kept the ossified descending aorta with its femoral branches from one of his patients in order to provide evidence of his views about the pulsation of the arteries, thus seemingly not for reasons associated with pathology. The second half of the century saw major transformations with the development of new preservation techniques allowing for wet as well as dry preparations, relying on alcohol and oil of turpentine. At the end of the 1650s Dutch amateur anatomist Lodewijk de Bils created a stir in the learned world with his elaborate and expensive embalming techniques, but in the end matters took a different turn in the 1660s thanks to two parallel developments: preservation in spirit of wine and injections. William Croone and Robert Boyle in England devised a method of conserving anatomical specimens in sealed jars filled with spirit of wine.[28]

While Boyle wrote on preservation in spirit of wine, Jan Swammerdam and Ruysch developed increasingly sophisticated injection techniques involving fluid substances that would harden rapidly, such as wax, and dyes that highlighted the fine vascular structure of body parts and also allowed bodies to

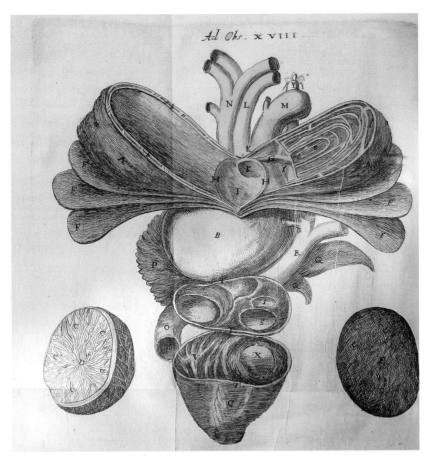

Illustration 1.9
Riva, "De paradoxico aneurismate aortico," *Miscellanea curiosa*, 1670, *Observatio* XVIII, aneurism.

be preserved as if still alive. In London Edward Tyson and William Cowper, for example, assembled a collection of anatomical preparations, including pathological and animal specimens, relying on injections of different fluids. Although in the course of the eighteenth century the quality of glass used to make jars improved and there was a constant search for better fluids used for injections, by about 1700 the key ingredients for the two preservation techniques that would dominate the scene until the second half of the nineteenth century were already in place.[29]

In the 1660s Physician Joachim Georg Elsner, a member of the *Academia curiosorum*, visited the museum of Guglielmo Riva (1627–77) in Rome, which included pathological specimens, notably an aneurysm preserved in "certum quodam liquore" and which he reproduced in the *Miscellanea curiosa*. Riva was a surgeon who also held a medical degree, practiced at Roman hospitals, taught anatomy, and also led an academy "ad indagandas morborum sedes," counting the future pontifical archiater Giovanni Maria Lancisi as one of his pupils. Presumably Riva preserved pathological specimens in spirit of wine. The relevant plate (illustration 1.9) shows a sectioned heart at the bottom with the enlarged aorta at B and layered aneurism A, with attached membranes,

and blood vessels above it; at the bottom right and left are separate images of its contents, whole and sectioned.[30]

About the same time in the Netherlands we find besides the celebrated Leiden anatomical museum, a little known collection assembled by Gerardus Blasius (ca. 1625–92).[31] The circumstances surrounding his work are especially interesting in that in the late 1660s he was given six beds at the Amsterdam town hospital, the Binnengasthuis, to instruct his students and, in case the patients died, to perform postmortems. Having graduated in medicine at Leiden in 1648, in 1660 he was appointed medical professor at the Amsterdam Athenæum. Each of the United Provinces was allowed one university only and from 1575 Holland already hosted Leiden, the oldest Dutch university, preempting Amsterdam. Thus the Athenæum, while being an institution of higher learning, could not confer degrees; its main purpose was to attract students and revenue by offering courses for a few years before students moved somewhere to complete their studies. Bedside instruction was available at the Cecilia Hospital in Leiden, where professors such as Franciscus Sylvius were renowned for their clinical teaching and were attracting large numbers of students. Presumably the Amsterdam civic authorities wished to compete on equal grounds. Blasius, however, did something Sylvius had not done: he published a collection of *Observationes medicae rariores* (1677), largely based on his clinical experience and including nine small plates largely devoted to pathology.[32]

Often surgeons and physicians emphasized remarkable and extraordinary cases; the frequent occurrence in titles of the terms "rariores" or "selectiores" highlights this point, as if medical men associated the value of their contribution to the rarity of its contents; like in a cabinet of curiosities, common occurrences had no appeal. In the address to the reader in his *Observationes*, for example, Blasius states that he wanted to include only the more uncommon cases. The same applies, perhaps even more strongly, to illustrations, since only some of the reports were illustrated and those included especially remarkable cases. These preliminary comments go some way toward explaining what was being collected and represented: early modern medical men did not feel that their colleagues and students would have benefitted from a comprehensive visual catalogue of cases, as if common ones would have been a distraction, though in a case of sandy particles found in the tongue Blasius claimed that he had often encountered similar occurrences, and thus in this instance at least he reported a relatively frequent case.[33]

Blasius's *Observationes* are a rich source of information about medical and anatomical practices. Although not all postmortems are dated, it appears that most originated from the late 1660s, from around the time when Blasius was given the beds for clinical instruction and the patients' bodies for postmortem investigation. A few cases, however, date from 1647, thus from his student

days at Leiden; both stem from the town hospital and involve the formation of stones; one extirpated from a lip by a surgeon, while the other found in a liver during a postmortem and peculiar in that it was black and had a spiral shape. Presumably Blasius preserved them or had a drawing of them, since he included illustrations of both.[34]

Possibly because of their potential unpleasantness, their instructional value, and the cognitive or legal need to have multiple witnesses, postmortems often were a collegial affair, involving a number of witnesses, usually physicians and surgeons. Blasius regularly names those present at the dissections he reported, thus providing us with a rich account of Amsterdam practices. Bonaventura van Dortmond, a physician inspector of the hospital and dedicatee of Blasius's *Observationes*, was often mentioned, and so was surgeon Hendrik van Roonhuyse; occasionally we find references to the then surgeon Govert Bidloo and to Ruysch.[35] Surgeons and physicians routinely worked side by side in such hospital environments.

Blasius presented an ordered collection of *Observationes*, which he organized in six sections, echoing an approach dating from the old Alexandria school: diseases involving magnitude, such as tumors, abscesses, hernias, and dropsy; defects of figure, such as cleft palate or closed uterus; defects of the parts contained in a given place, such as prolapsed uterus or the separate entrance of pancreatic and bile ducts in the intestine; diseases related to number, either lack of body parts, such as the hymen, female testicles, or kidney, or presence of extranumerary parts, such as a double stomach or gallbladder; diseases of the union or cohesion of parts, such as caries or ulcers; and lastly the presence of preternatural formations, such as polyps, ossifications, and stone formations.[36] Thus Blasius's *Observationes* were not strictly pathological and, much like many similar contemporary publications, should not be seen as a pathology treatise, despite the fact that many cases pertain to disease: the presence or lack of the hymen, an extra finger, or a peculiar conformation of the kidneys and the urinary vessels have a dubious status in pathology.[37]

Blasius produced several extensively illustrated works on anatomy and comparative anatomy. Unlike his other works, the illustrations to the *Observationes* are generally very small and rather undistinguished; at times he included nine or even twelve figures on a duodecimo page. The book includes a separate appendix on monsters, which are treated independently; the three plates in that section are larger and more accomplished. One plate from the *Observationes* is unique in that it includes a single figure showing the whole cadaver of a woman of thirty-five, placed on a mat rolled under her head on what seems like a stone slab. Although the diseases differed, the plate closely echoes that of Flinck's wife on van Meek'ren's title page (illustration 1.5), which was probably its visual source. The text contains several points of interest: Blasius says that at the touch her abdomen felt almost stony, though he does not say who

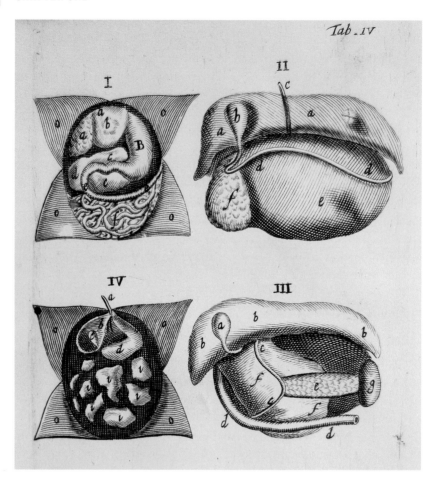

Tab. IV

Illustration 1.10
Blasius, *Observationes*, 1677, plate IV, diseased liver.

performed the physical examination on the patient. This is not the only reference to physical examination; on another occasion we read that van Dortmond frequently palpated the abdomen of a patient, causing severe pain.[38]

A more representative plate (illustration 1.10) includes six figures, four of which are shown here. Figures 1 and 4 follow the same conventions in showing the opened abdomen framed by four sail-shaped folded back coverings *oo*. Figures 1–3 are devoted to the same case shown in different settings; they highlight the efforts Blasius went through in seeking an effective representation. The figures pertain to the case of a woman of forty-two: figure 1 displays the body's interior, with the liver shown in situ at *a*; *b* is a steatoma—a fatty tumor—on its left side; *B* the stomach; *cc* and *dd* are portion of a scirrhus, or a growth, hard in *cc*, softer and festering in *dd*; *ee* and *ff* the intestine. Figure 2 is on a larger scale and shows the liver *aa* removed from the body, with the gall bladder at *b*; *c* is the folded umbilical ligament; *ee* and *ff* show the scirrhus, the latter portion being ulcerated, as shown by its uneven surface. Figure 3 presents at *bb* yet again the same liver with the parts slightly rearranged, *a* being the gall bladder, c the cystic duct leading to the intestine *dd*, *e* the pancreas,

ff the scirrhus, and *g* the spleen. The diminutive size of the figures and their charming simplicity required an extensive textual account, especially when Blasius had to describe the texture and condition of the parts.[39]

Figure 4 shows an abscess of the mesentery in a ten-year-old child; the liver and stomach are discernible at the top at *b* and *d*; some scrofulous formations *iii* are visible below and were described as white, ashen, and almost black. Figure 4 can be compared to Fabricius's plate of the diseased spleen (illustration 1.3): both seek to represent peculiar disease formations on internal organs. Blasius had described the same case in a previous work, *Miscellanea anatomica* (1673), from where we learn that in his museum he had preserved a portion of the child's intestine covered with scrofulous growths of various sizes. Elsewhere he published images of a preserved heart polyp and a stone found under a tongue, which were "in musæo meo" and at his house, "domi meæ," presumably where his museum was located. Unfortunately we do not know much about his collection and his methods of preservation, though we can presume that Blasius joined investigative and pedagogical concerns. Probably in this case too the rivalry with Leiden was on his mind.[40]

ANATOMISTS AND SURGEONS

In an essay published in the *Philosophical Transactions* for 1700–1701, Huguenot surgeon Paul Buissière, one of the first surgeons to be elected Fellow of the Royal Society, identified different cognitive horizons between surgeons and physicians, leading to differences in their practice:[41]

> [I]f Physicians were a little more careful to search, or cause to be searched in the bodies of them that dye of extraordinary distempers, they would find sometimes, that which they attribute to the alteration of the blood or humour, dependeth merely on an extraordinary conformation of parts.

The case in question concerned difficult urination, which was due to a peculiar conformation of the bladder, as revealed by the postmortem and illustrated by a plate Buissière included in his essay. Although the patient had seemingly died of a mangled exploration leading to a perforation of the bladder, Buissière took this opportunity to challenge the physicians' worldview and its emphasis on humoral imbalance, especially the composition of blood. Such views dated back to the Hippocratic and Galenic traditions but were still widely accepted in some variant in the early modern period.[42]

In the course of the seventeenth century different conceptions of disease had become prevalent, with a growing emphasis on an acid-alkali imbalance seen by Jan Baptiste van Helmont, Franciscus Sylvius, and many of their followers as the root of many ailments. According to such views, especially in Sylvius's more materialistic version, many bodily operations, such as digestion,

depended on chemical processes; the causes of disease were often attributed to an excess of acid and corrosive particles in the blood, which may affect several organs. From this perspective too, as from more traditional humoral doctrines, the specific manifestations visible in the solid parts were the effects of deeper causes. Thus while physicians may have examined the solid lesions, ultimately it was their cause, that is, the neo-humoral or acid-alkali imbalance, that had to be addressed to effect a cure. This was Buissière's concern: at times humoral imbalances could be irrelevant because diseases were due to structural causes independent of the composition of blood or other fluids.[43]

By advocating the investigation of the extraordinary conformation of the solid parts through postmortems, Buissière highlighted a major difference between physicians and surgeons. Even physicians who performed postmortems may have initially focused on localized lesions, though ultimately they sought the underlying causes, namely imbalances cured by diet; Malpighi's medical consultations are a notable example of such views. By contrast, surgeons routinely privileged both initially and ultimately the solid lesion rather than diet. Thus, although we can characterize some physicians' perspectives as "localist," it is helpful to talk of a "double localism" for surgeons, in that they focused and also acted on local lesions for their remedies. Visualization of the lesion played a more significant role for surgeons.[44]

It is not easy to assess the status of surgeons. An interesting perspective may be gained from membership to elite scientific societies, such as the Royal Society in London and the Académie des Sciences in Paris, both established in the 1660s, since medical and anatomical matters were of central importance to both.

The situation at the Royal Society is quite complex, because the professional role of some members is not immediately clear and some who were elected did not participate in the society's activities.[45] Edmund King, for example, was a practicing surgeon who also received a Lambeth medical degree of MB (Bachelor of Medicine) from the Archbishop of Canterbury in 1663; on that basis he was incorporated Cambridge MD in 1671. King put his surgical experience at the service of the society on several occasions, such as in the early blood transfusion experiments.[46]

A surgeon's publication tying surgical practice to anatomical research appeared in the *Philosophical Transactions*, although its author was never elected a fellow. In 1685 John Browne (1642–1702/3), surgeon at St. Thomas's Hospital and to Charles II, published an essay on a diseased liver; his contribution was deemed sufficiently important to be reissued in Latin translation in the influential *Acta eruditorum* of Leipzig. Browne discussed the case of a guard affected by dropsy, or the accumulation of fluid in the body. Despite his desperate attempt to alleviate the condition by draining the fluid, or paracentesis, the patient died. The postmortem revealed a liver consisting of enlarged "glands," visible in the figure drawn by artist William Faithorne, who

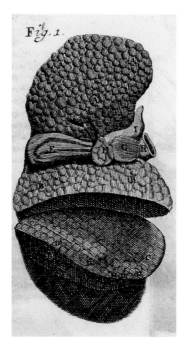

Illustration 1.11
Browne, *Acta eruditorum*, 1687, plate I,
facing page 28, diseased liver; first pub-
lished in the *Philosophical Transactions*,
1685. Drawn by Faithorne.

attended the dissection (illustration 1.11) together with other witnesses, such
as Royal Society Fellow and anatomist Edward Tyson. In the nineteenth cen-
tury Browne's plate was taken as the first illustration of liver cirrhosis due to
excessive alcohol consumption. Browne, however, drew conclusions about the
normal liver, which would consist of glands that would have been magnified
by disease. He was relying on Malpighi for both his specific conclusions about
the liver as well as methods. Malpighi too had relied on a case later tentatively
identified by Belloni as liver cirrhosis to reach similar conclusions; both used
disease as a microscope with an anatomical rather than a pathological aim.
Browne here joined anatomy with a defense of his surgical procedure.[47]

The status of surgeons at the Royal Society changed around 1700. Among
the most active surgeons were William Cowper and Buissière, both elected
fellows in 1699 and authors of several essays for the *Transactions*. Cowper was
the author of *The Anatomy of the Humane Bodies* (Oxford, 1698), a treatise with
numerous illustrations largely based on the plates for the Dutch translation of
Govert Bidloo's *Anatomia* (Amsterdam, 1690), with additional plates engraved
by Antwerp émigré Michael Vandergught. Vandergucht was responsible for
other anatomical and pathological engravings for Cowper, notably a "very
large diseased kidney" and a heart polyp; such peculiar formations found after
death in the heart and its adjacent vessels had been depicted in works by Cas-
par Bauhin, Tulp, and Thomas Bartholin. Luigi Belloni claimed that the study
of heart polyps highlights the early focus on showy and rare findings compared
to subtle and more common ones. Moreover, structural changes are easier to
represent than textural ones, such as ossification.[48]

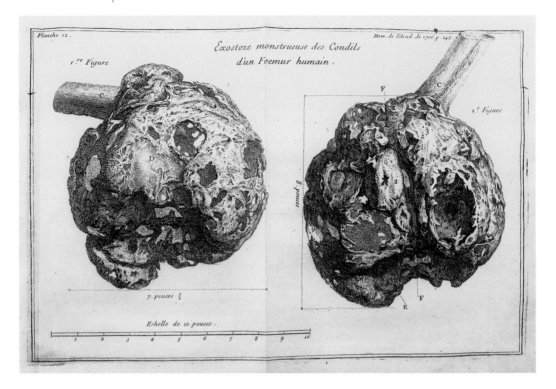

Planche 12.

*Exostoze monstrueuse des Condils
d'un Foemur humain.*

Mem.de l'Acad.de 1706 p. 248.

1.ʳᵉ Figure

2.ᵉ Figure

7. pouces ⁴⁄₅

Echelle de 10. pouces.

Illustration 1.12
Méry, "Exostose,"
*Memoires de l'Académie
Royale des Sciences,*
1706, facing page 248,
exostosis.

Besides the report on the triple bladder mentioned above, Buissière wrote an essay for the *Transactions* with an illustration of a polyp expelled from the lungs; he argued that the substance a boy of five coughed up about ten or twelve days before he died of consumption was a mucilaginous humor that had formed an incrustation inside the air vessels and not a blood vessel from the lungs, as some had claimed; relying on a postmortem examination, he could show that another similar incrustation was present and that both the air and blood vessels in the lungs were intact. The essay opened with a defense of the usefulness of postmortems to both physicians and surgeons, thus echoing his passage we discussed above.[49]

The Paris scene too presents motives of interest. The Académie Royale des Sciences counted surgeon Louis Gayant as a founding member in 1666. Besides being a surgeon, Gayant had gained prominence as an anatomy lecturer and with early experiments on blood transfusions; in 1672 he became chief military surgeon and died at the siege of Maastricht in the following year. Often the first surgeons to be elected to elite scientific societies had contacts with the royal houses, which helped break the mold of social and academic distinctions in the seventeenth century as it had in the sixteenth, as in the case of royal surgeon Ambroise Paré. In 1681 Jean Méry (1645–1722), surgeon at the Paris Hôtel-Dieu, entered the service of Queen Marie-Thérèse, first wife of the Sun King. Soon thereafter, in 1684, he was elected to the Académie, to whose *Mémoires* he contributed several essays, including an illustrated report

on a "monstrous exostosis," or bone tumor (illustration 1.12); here the term "monstrous" relates merely to its size. The case involved the amputation of the leg of a soldier, who had requested it because the condition was too painful. The plate shows the growth from two sides and includes a ruler giving its exact dimensions; not only the size but also location and texture are rendered quite effectively.[50]

Many members of the Académie in the class of anatomy, such as Joseph-Guichard du Verney and Alexis Littre, were physicians with anatomical interests, but Littre's pupil Jean-Louis Petit was a surgeon who became *élève* at the Académie in 1715. Petit went on to become director of the Académie Royale de Chirurgie in 1731. Pierre-Simon Rouhault was elected in 1712, though his tenure was short-lived because in 1718 he moved to Turin as surgeon to the King of Sardinia. Sauveur-François Morand was elected in 1722, the year Méry died; Morand was the son of a surgeon and devoted his entire career to this art, joining the Académie Royale de Chirurgie in 1731 as its secretary. Even though membership to the Académie des Sciences was much more restricted than that to the Royal Society, surgeons were routinely represented among its ranks from the late seventeenth century.[51]

The categories of surgeons and physicians were not mutually exclusive: despite their growing status and reputation, several surgeons trained in their art and also gained medical degrees, such as Edmund King. Notable examples from the Renaissance include Berengario da Carpi (1460–1530), who held a degree in philosophy and medicine from the University of Bologna, taught surgery and anatomy, and practiced as a surgeon; Niccolò Massa (1485–1569), who trained and practiced as a surgeon and later gained a medical degree from Padua; and Hieronymus Fabricius (1537–1619), who held a medical degree from Padua, where he taught anatomy and surgery, and practiced surgery.[52]

The trend continued in the seventeenth century: Johannes Scultetus (1595–1645) was a surgeon who took a medical degree at Padua in 1621 and became town physician in his own town, Ulm, while also practicing as a surgeon during the Thirty Years' War, being one of the most renowned of his time. His *Armamentarium chirurgicum* (Ulm, 1655, reprinted many times across Europe) was a classic of surgery focusing on the instruments and tools of the trade, in line with traditional surgical iconography.[53] Marco Aurelio Severino (1580–1656) held a medical degree from Salerno and taught anatomy and surgery at the University of Naples, where he also practiced as a surgeon at the Incurabili Hospital. His *De recondita abscessuum natura* (Naples, 1632) includes several engravings of abscesses and other external growths largely documenting his skill and success; an enlarged edition with additional plates appeared in Frankfurt in 1643. His work highlights the ties among images, surgical perspectives, and external conditions.[54] Riva was both a surgeon and physician in Rome, as we have seen above. Further, Dutch anatomist Bidloo (1649–1713) trained and practiced as a surgeon in Amsterdam and also at the service of William III;

he then gained his MD at Franeker in 1682 and in 1688 became professor of anatomy and surgery at the Collegium Anatomico-Chirurgicum at The Hague, then moving to a professorship of anatomy at Leiden in 1694; he became FRS in 1696. Bidloo was the author of the great anatomy work *Anatomia humani corporis* (Amsterdam, 1685), with remarkable plates drawn by the renowned artist Gerard de Lairesse; unlike the perfect idealized bodies in the Vesalian tradition, most of Bidloo's plates were starkly realistic and depicted the individual specimen at hand, warts, flies, and all. He later published a collection of *Exercitationes anatomico-chirurgicae* with some pathological plates.[55]

Lorenz Heister (1683–1758) followed a similar career pattern. He trained as a surgeon in Amsterdam, working with Ruysch and renowned surgeon Johannes Rau. Heister then moved to Leiden, where he studied with Bidloo, Bernhard Siegfried Albinus, and Hermann Boerhaave; he then took his MD at Harderwijk in 1709, practiced as a distinguished military surgeon, and became professor of medicine first at Altdorf and then Helmstädt. He became a member of the Academia Naturae Curiosorum, or Leopoldina, in 1715. Later in life he collaborated with another pupil of Ruysch, Abraham Vater, in editing a description of the collection of anatomical and pathological preparations partly purchased from Ruysch and partly assembled by Vater, involving injected and wet preparations, much like Ruysch.[56] Heister authored the classic German surgery work of his time, *Chirurgie* (Nürnberg, 1719), which went through many editions and translations; its growing number of illustrations included instruments, procedures, and occasionally lesions.[57] Many more cases could be mentioned; these examples, however, suggest that surgeons gained status by additionally holding medical degrees, yet they also point to an overlap between the two professions, with anatomy lying at the intersection between them.

Although matters such as the status of surgeons are quite complex and cannot be reduced to their election to elite scientific societies or taking a medical degree, both factors are symptomatic of social and intellectual shifts. Membership to scientific societies was significant both for the recognition gained by surgeons and their profession and also because it enabled them to take part to debates at the meetings and to present their perspectives to a wider learned audience, much as Buissière and his associates had done at meetings of the Royal Society and on the pages of the *Philosophical Transactions*. A medical degree provided status surgery partly lacked but also theoretical and especially anatomical knowledge relevant to practicing surgeons, while creating a select group joining different forms of expertise.

THE ANATOMICAL MUSEUM OF FREDERIK RUYSCH

In the decades around 1700 Amsterdam physician Frederik Ruysch (1638–1731) assembled the most striking anatomical museum of his time. In fact, he

did so twice over, since in 1716 he sold his collection to Peter the Great for 30,000 guilders and then—aged seventy-eight—started all over again, making enough preparations to fill eight more cabinets. His museum stemmed from his unparalleled skill in making anatomical preparations and his multiple civic roles: he was physician, instructor in anatomy to surgeons and midwives, municipal obstetrician, and forensic anatomist. His case was unusual both for the exceedingly wide range of sources of bodies he could rely on and for his unique skills at preserving them. Ruysch was also a prolific author whose works included one of the richest collections of pathological plates yet published, which in the nineteenth century gained him the epithet of "founder of pathological illustration" by Lebert.[58]

Few medical men matched Ruysch in longevity and industry. His multiple roles make him an ideal figure to reflect on collections and visualization. Ruysch started his medical activities as an apothecary in The Hague, and only subsequently did he take his medical degree at Leiden in 1664, settling back in The Hague as a physician. The following year he produced his first publication; relying on the insufflation of the lymphatic vessels with some tiny glass tubes, he could display their valves and preserve them at the same time, an achievement already displaying key features of his future research.[59]

In 1667 Ruysch moved to Amsterdam as lecturer to the surgeons' guild, a position previously held by Nicolaas Tulp, now one of Amsterdam's burgomasters. In 1669 he also replaced surgeon Hendrik van Roonhuyse as examiner of the city's midwives and was given the title of professor of anatomy. In 1672, following van Roonhuyse's death, Ruysch became city obstetrician. In 1674 he was given permission to dissect four female cadavers annually for the instruction of midwives and one for the instruction of surgeons; in addition, he was allowed to dissect bodies at the city hospital, though his right was often contested.[60] In 1679 Ruysch became forensic anatomist, thus strengthening his role as the most prominent Amsterdam anatomist.[61] These multiple roles provided him with so many opportunities for dissection that in 1699 he could talk of a "daily inspection of cadavers."[62] This was not all: although in 1685 Ruysch was appointed professor of botany and supervisor of the Amsterdam botanical garden, one of the major institutions of its genre in Europe at the time, it was in anatomy that he gave his main contributions, relying on increasingly refined techniques that enabled him to preserve fragile specimens in his museum and to make their fine structure visible.[63]

Towards the end of the century preservation techniques progressively shifted toward injections, especially in the Netherlands, where Ruysch had become the unrivaled master and had assembled a striking collection for which he was asking an entrance fee. Visitors reported on his renowned elaborate compositions of fetal skeletons in an artificial landscape of anatomical preparations and on how lifelike his specimens looked, including children with rosy cheeks and other marvels.[64] His museum included specimens from

human anatomy, with special emphasis on fetal development, together with exotic and unusual animal holdings, which were as numerous as the human ones, and even specimens from the vegetable world. In fact, the museum did not focus on pathological specimens and did not even separate them from anatomical ones; rather, Ruysch wished to entertain as much as to instruct and arranged his cabinets emphasizing variety, generally avoiding to group homogeneous preparations. He avoided distressing his visitors by discreetly placing disturbing specimens in a less prominent position.[65]

In one respect, however, Ruysch drew a sharper line between anatomy and pathology. We have seen that Malpighi and Browne had argued that the liver consisted of glands relying on pathological cases. Malpighi also referred to several hardened pathological specimens in the Aldrovandi Museum in Bologna not to study disease but mostly as evidence for his views about the glandular structure of many organs. Further, he took the remarkable kidneys shaped like a bunch of grapes found in two siblings as evidence of the glandular structure of the kidneys, where the individual grapes would be the enlarged glands. He was not alone to do so: Theodor Kerckring in Amsterdam and Littre at the Paris Académie compared analogous "monstrous" kidneys to glands and included illustrations in their works. Ruysch, however, rejected this approach and separated anatomy from pathology; for him one had to be more careful in drawing conclusions about a normal state from a diseased one. His museum holdings reflected these views: healthy states showed anatomical structures, while diseased states showed the effects of disease.[66]

While Ruysch's museum was a major attraction for those lucky enough to visit it in Amsterdam, most scholars would have known it through his publications, notably his 1691 *Observationes* and *Catalogus* and the ten *Thesauri*, or treasure cabinets, issued between 1701 and 1716, the year he sold his collection; there is an obvious continuity between these works, since the *Thesauri* provide a partial catalogue of the collection. Ruysch stated that he included plates of new things and of those that had not been accurately described by others; the subjects varied, but genitalia and the urinary system were especially well represented.[67]

Ruysch's works mark a significant shift in pathological illustrations with respect to previous publications, especially those published in Amsterdam in the previous decades. The engravings Tulp, van Meek'ren, van Roonhuyse, and Blasius had included in their works were relatively undistinguished; generally they were in small format and unsigned. Even the few relevant ones in Kerckring's work, though of better quality, were rather small. Whereas anatomy was an established area of artistic production—witness Bildoo's recent and astounding *Anatomia humani corporis* (Amsterdam, 1685)—pathological illustrations were often workmanlike and aimed at conveying basic factual information without great artistic pretensions. Ruysch's *Observationes* and *Thesauri*

changed all that: he treated his museum as a work of art just as much as a monument to knowledge, regardless of whether he was preserving human or animal, healthy or diseased parts. He took great care and pride in the arrangement of the specimens, the type of wood used for the cabinets and displays, and the color schemes, with lace and red and blue ribbons. Thus pathology plates were treated as artistic productions on a par with anatomy ones because all the items were part of his museum and therefore worthy of attention.[68] Size too mattered: whereas most previous works in the same genre were in octavo to duodecimo, Ruysch's were in quarto and he specified on the title page of the *Observationes* that the figures reproduced the specimens life-size—generally taking a whole page. Ruysch devoted care and expense to his work: when he deemed the quality of a plate of diseased bones that had appeared in 1691 inadequate, he had it engraved again by Cornelis Huyberts for the 1709 *Thesaurus octavo*.[69]

In line with these concerns, the plates in Ruysch's *Thesauri* were signed by recognized artists; initially in the *Observationes* Ruysch, who was a draftsman of some ability and the father of the renowned painter Rachel, did the drawing himself and the engravings were not signed.[70] The plates in the *Thesauri*, however, were engraved by Cornelis Huyberts, who figures prominently from the start until he died in 1712. Other artists included Joseph Mulder, who had been trained both as a draftsman and engraver, and Abraham de Blois, an engraver who also signed plates as a draftsman. In later works Ruysch relied on Arent Cant, who held a medical degree from Leiden and was also a good painter, the engraver Jacob Folkema, and the celebrated draftsman and engraver Jan Wandelaar, one of the great anatomical artists of all times. Wandelaar studied drawing with Gerard de Lairesse and engraving with Jakob Folkema; though he did not gain a medical degree like Cant, he also studied anatomy, thus joining specialized skills for all stages of production, from understanding the significance of specimens to their drawing and engraving.[71]

The following plate (illustration 1.13) highlights some key features of the *Museum Ruyschianum*: the central image (figure 1) shows the arm of a fetus in a liquid-filled jar; the hand holds a section of a prodigiously large human testicle transformed into cartilage. The description of the specimen gives the case history: after a contusion the patient's right testicle grew to the size of an infant's head, hindering his walking because of pain. Thus surgeon van Bortel removed the testicle, which weighed three pounds; Ruysch happily recounts that the patient survived and "pancratice vivit," or "lives like a fierce combatant." The arrangement in the jar serves several purposes: the tiny arm emphasizes the testicle's huge size. Notice also the decorative lid, as well as the lace and ribbon adorning the arm: such specimens were not meant to be removed from the jar for closer visual inspection. In the same jar, on the side, Ruysch placed a portion of a diseased uterus whose surface was covered with several black tubercles the size of pepper grains.[72]

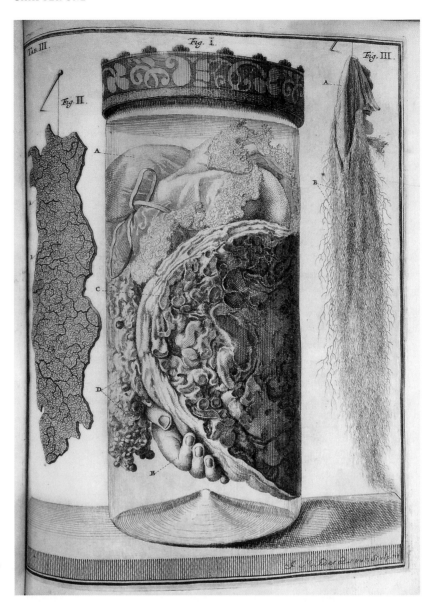

Illustration 1.13
Ruysch, *Thesaurus nonus*, 1714, plate III, miscellaneous preparations engraved by Joseph Mulder.

The central figure is flanked by two very different preparations: on the left (figure 2) is a preparation of the skin from the sole of a foot, showing a network of vessels so intricate that not even the tip of a needle could puncture it without damaging them.[73] The preparation on the right (figure 3) shows the subtlety of the vessels of human testicles; Ruysch emptied the vessels of seminal matter in order to highlight how their subtlety resembled a spider web. The vessels were preserved in a fluid-filled jar—thus either the artist omitted it or they were temporarily removed from their container. The plate exemplifies the arrangement of the museum and the conventions and difficulties involved with representing its holdings.[74]

In the early modern period some illustrations of diseased states saw the light in broadsides and ephemeral publications as well as in surgical treatises; many more could be found in collections of *Historiae* and *Observationes*, especially from the mid-seventeenth century, and others still were included in the new medical and philosophical journals of the time. They showed live patients, fresh specimens from recent postmortems, and preparations. The motivations for printing such images varied: some advertised the practitioner's successful cure, experience, and resources; others seemed to stem from genuine wonder and surprise at exceptional cases; in some cases the authors explicitly defended a crucial epistemic role for images over words.

The plates varied considerably in quality of execution: apart from early ones, such as those found in works by Gersdorff and early ones by Hildanus, which were woodcuts, most were intaglios. Some, like those in Blasius's *Observationes*, were rather crude and unsigned; at the opposite end of the spectrum, those in Ruysch's works were far more detailed, larger, and signed. External growths and structural features proved easier to represent, while only the most elaborate plates could convey any sense of textures; variations of texture in the internal organs proved challenging, even when Blasius had recourse to three separate figures to illustrate the same specimen.

Alongside printed collections, material collections assembled in museums, especially from the late seventeenth century, enabled scholars to study and wonder at the vagaries of nature and disease: Fabricius Hildanus assembled an exceptionally early and well-documented collection; Riva, Blasius, Tyson, Cowper, and Bonfiglioli, among others, also had personal collections or were responsible for civic ones, though Ruysch was the unquestioned leader. Interest in diseased specimens often accompanied interest in comparative anatomy.

From the Renaissance and to the practitioners who joined surgical training with a medical degree, to the first surgeons elected to the Royal Society or the Paris Académie, surgeons played a crucial role in promoting a "doubly localistic" view of disease that provided a key rationale for producing visual representations. While several of their works included pathological images, however, traditionally they focused more on instrumentation and procedures, especially early on.

The material we have seen leads one to question whether it is legitimate to talk of illustrated pathology as a genre to characterize early modern images of diseased body parts. Sure enough, there were several such images, though at least in some instances the motivation for producing them was anatomical rather than pathological, as we have seen in the case of the glandulous liver studied by Browne. Moreover, many pathological plates were part of larger collections including a broad range of cases such as preternatural formations—polyps, ossifications, and stone were especially popular—and congenital malformations, as well as exotic animals, thus joining anomalies broadly con-

ceived with comparative and pathological cases. The overriding criterion according to which these works were assembled was that of rarity, and indeed the terms "rariores" or "selectiores" often figured in the titles. Often cases were characterized somewhat loosely as "monstrous," often not in a rigorous sense but mainly to indicate an unusually large size or peculiar shape.

To a large extent, early modern collections of pathological images reflect the organization of contemporary cabinets of curiosities, in which the guiding principle centered on rarity and indeed curiosity. Overall, the emphasis was on discussing extraordinary cases rather than providing a comprehensive and representative study. As Lebert put it in the mid-nineteenth century, early modern representations, such as those assembled by Bonet, consisted of curious and isolated facts. One may add that Ruysch's representations were not very different in this regard; while Lebert's identification of Ruysch as the founder of "iconographie pathologique" is largely a retrospective judgment, the scale and quality of Ruysch's images—joined with his preservation skills—make him a nodal point in the history of pathological images.[75]

As we are going to see in the next chapter, the eighteenth century witnessed a slow shift toward more systematic collections of specimens and images, with bones playing a pivotal role in this process.

TWo

"SIC NATA EST ANATOME PATHOLOGICA PICTA"

The Diseases of Bones

In 1793 Eduard Sandifort boldly announced in his monumental *Museum anatomicum*, "Sic nata est anatome pathologica picta," or "thus is born illustrated pathological anatomy," self-consciously presenting himself as the herald of a new genre, the illustrated treatise of pathological anatomy. In the next century his treatise was recognized as a landmark by Johann Friedrich Meckel the Younger at Halle and Jean Cruveilhier in Paris, among others. Yet his work stemmed from a previous tradition: in his 1818 MD dissertation on the history of pathological anatomy, French physician Pierre Rayer pointed out that bone alterations had been especially well studied and mentioned several publications on them. Indeed, the eighteenth century saw a number of major works on the topic, often with striking illustrations.[1]

During the eighteenth century images of diseased body parts saw the light in many works, including the growing number of medical and scientific journals. At times medical men had private collections of pathological images; Florence physician Antonio Cocchi (1695–1758), for example, had diseases kidneys painted in watercolor. However, it is easy to see why bones would take a leading role in pathological illustrations, since they are the most easily preserved body part; although they are not as pretty as sea shells, their purpose is not entirely dissimilar and several medical men assembled collections of them, from Cheselden and his fellow London surgeons to Bernhard Siegfried Albinus and from Morgagni to those whose collections found their way to the Royal Cabinet in Paris. Collections of diseased bones could be found at many locations.[2] Sandifort went as far as to attribute a special place to bones because they would represent a foundation for pathology. Further, bones present relatively fewer problems to be represented compared to some soft body parts: they hold their

shape, color is usually not very significant, and cross-hatching could effective-ly render their textures. Bones too, however, required care both for prepara-tion and representation: John Hunter, for example, provided a description of the procedures to prepare them either by boiling or by having flies eat away the flesh. The condition of the bones, the amount of fat present, and the method of preparation employed affect their whiteness and general appearance.[3]

Following Sandifort and Rayer, I examine the visual representations of bone pathology by six authors: William Cheselden in London, Cornelis Tri-oen in Leiden, Christian Gottlieb Ludwig in Leipzig, Andreas Bonn in Amster-dam, Johann Peter Weidmann in Mainz, and Sandifort back in Leiden. Since Cheselden and Sandifort are especially prominent figures, I discuss their works somewhat more extensively in the opening and closing sections. While Trioen and Ludwig document the growing interest in bone diseases and their visual representations, Bonn and Weidmann share a concern with the process of regeneration.[4]

Mine is not a comprehensive survey of independent treatises; moreover, I do not discuss many smaller publications and essays in the scientific journals of the time. The works I have selected, however, stand out for the quality, size, and number of illustrations and provide a rich set of questions and themes for analysis. All the works I discuss here were published before 1794, the year that has been taken by many historians as the dawn of a new era in medicine because of its rapprochement with surgery, the rise of hospital medicine, the birth of the clinic, and a new emphasis on pathology and disease as opposed to patients. As we are going to see, many of these developments were well under way by then.[5]

While sharing a concern with the visual representation of diseased bones, the works I discuss here are quite heterogeneous in their format and style. Cheselden's *Osteographia* was unusual among the great anatomical treatises since Vesalius's *Fabrica* to include an extensive illustrated chapter on diseased states; most later works focused on the healthy body, while pathology, when it was discussed at all, was not necessarily illustrated—though man-midwife William Smellie included pathological plates on rickets in his celebrated 1754 treatise on midwifery.[6] Trioen's work belongs to the genre we have discussed in the previous chapter and presents a collection of *Observationes medico-chirurgicae* of pathological significance with large sections devoted to bones. The works by Ludwig and his students are pathological essays and disserta-tions generally devoted to individual cases. Those by Bonn and Weidmann were devoted primarily to specific processes, the formation of callus and bone regeneration following necrosis, respectively. Lastly, Sandifort's work, much like Bonn's, stemmed from a large institutional museum, though Bonn's appeared in installments, whereas Sandifort's first two volumes appeared together in all their might and sought to describe a broad selection of the Leiden Museum's holdings.

WILLIAM CHESELDEN: BONE PATHOLOGY AND THE RISE OF SURGERY

William Cheselden (1688–1752) was one of the most successful London surgeons in the first half of the century. He moved from his native Leicestershire to London about 1703, when he commenced a seven-year apprenticeship with James Ferne, surgeon to St. Thomas's Hospital. Cheselden studied and also lodged with the surgeon and anatomist William Cowper, a relationship that was to prove significant at a later stage. After passing the final examination of the Barber-Surgeons' Company, Cheselden started offering a course on anatomy and the animal economy, including surgical indications, which was later given at St. Thomas's Hospital. In 1711, on the example of his mentor Cowper, he was elected a Fellow of the Royal Society, to whose *Transactions* he made several contributions.[7]

In 1713 he published an illustrated students' manual, *The Anatomy of the Humane Body*, which went through thirteen London editions throughout the century. In 1718 Cheselden was appointed first assistant surgeon and soon thereafter chief surgeon at St. Thomas's Hospital. He was also appointed surgeon for the stone at the Westminster Infirmary and St. George's Hospital, this being his specialty. In 1720 he started taking art classes at the academy established by Louis Chéron and John Vanderbank, thus gaining skills in drawing and painting.[8] Cheselden attended Sir Isaac Newton and in 1728 became surgeon to Queen Caroline, the intermediary of the celebrated exchange between Leibniz and Samuel Clarke. Among Cheselden's most famous operations was that performed in 1728 on a young boy of thirteen born blind, who gained sight, contributing to a celebrated philosophical debate on vision and the senses; no other example could better capture the rising status of surgery in philosophical debate. In 1733 Cheselden published *Osteographia, or Anatomy of the Bones*, an impressive lavishly illustrated folio.

Dedicated to Queen Caroline, *Osteographia* was an ambitious and expensive work, seeking to portray all the bones of the human body life-size in fifty-six plates, including diseased bones, to which he devoted fifteen of them. Each plate was printed twice, first without and then with the lettering on the figures; Cheselden was keen for the letters not to spoil the beauty of the plates, remarkably even the pathology ones. Cheselden also included a number of smaller plates of animal skeletons used as decorations at the beginning and end of each chapter, in the tradition of comparative anatomy. He had originally envisaged three books covering all of human anatomy, of which *Osteographia* would have been the first, but lack of interest by subscribers and the public led him to scrap the other two. Since he stated that he was planning to have them too adorned with comparative anatomy plates, one may wonder whether he would have included pathological illustrations in the other volumes as well; after all, he did include the image of a tumor on a plate in a later edition of *Anatomy of the Humane Body*. Whatever his plans, *Osteographia*

was a novel work both because the plates of animal skeletons were in some instances the first such representations to be printed and for the inclusion of several pathological images in a luxury anatomy book. By showing diseased bones pertinent to surgery in folio not once but twice, Cheselden was treating them as art objects and at the same time marking the rising status of his profession. The frontispiece, showing Galen observing a skeleton of a criminal on a roadside, strengthened the message and highlighted the ancient pedigree and special status of human osteology.[9]

Cheselden had an entrepreneurial attitude to *Osteographia*: he stated that the book would cost four guineas to subscribers and six after it was printed, specifying that the plates would be destroyed after all the copies had been printed, three hundred for the English version and one hundred for possible Latin or French translations.[10]

He employed two artists, both active as draftsmen and engravers, Gerard Vandergucht and Jacob Shijnvoet, referred to as Shinevoet; in general, the former was responsible for the large plates of human bones, the latter for the smaller ones of animal skeletons. Vandergucht, who trained with his father Michael and with Chéron, was a leading London engraver who successfully combined line engraving directly on the plate with etching; Vandergught's father had engraved a number of plates in anatomy, comparative anatomy, and pathology for Cheselden's mentor Cowper. Since Cheselden lodged with Cowper, as we saw above, it seems plausible that he became acquainted with the Vanderguchts at that time; moreover, both Cheselden and Gerard Vandergucht had studied with Chéron. Thus Cheselden continued and expanded Cowper's work on pathology and comparative anatomy with the son of Cowper's engraver. These connections are helpful in examining Cheselden's plates: the anatomical ones echo those in *De humani corporis fabrica* by Andreas Vesalius with their focus on the ideal human body, at times even set in a landscape; however, the pathological ones, with their attention to the specimens' individual features, echo Bidloo's *Anatomia*. De Lairesse's plates in Bidloo's treatise can be seen as a bridge, through Cowper and Michael Vandergucht, toward individual pathological portraits; in Bidloo's work, however, we see props and material supports, whereas in Cheselden's the specimens float in space without even projecting shadows.[11]

Little is known about Shijnvoet: Cheselden reports that he had come from the Netherlands following some misfortune and while in London had engraved interior views of cathedrals that were published under other artists' names. He died soon after having completed his work for Cheselden, who praises his plates but presents them as inferior to Vandergucht's. Both had a background in architectural drawing and engraving, and indeed perspectival concerns were prominent in *Osteographia*; initially, in order to achieve accurate delineations, they measured carefully all the bones, a procedure that proved cumbersome and time-consuming, especially for rendering irregular

lines, perspective, and proportion. Subsequently, as shown on the title page of *Osteographia*, they relied on the camera obscura, though Cheselden intervened directly to perfect both the drawings and especially the engravings, arguing that such expert interventions were indispensable in anatomy. His art training coupled with his anatomical expertise no doubt proved useful here. In addition, he claimed credit for applying to bones the technique of combining single—often heavy—lines engraved directly on the plate with softer etched ones: line engraving was employed in order to render the smoothness of the contours of bones, while the other parts, often involving varied textures, were all etched. As it happens, Vandergucht was a leading figure in London in the new French fashion of combining line engraving with etching and had adopted it before.[12] We encounter here a correlation between technique of representation and features—specifically textural ones—of a body part; we will find other examples relevant to disease below.

Besides a chapter on diseased bones, Cheselden's *Osteographia* included other portions on material with unusual features. For example, a plate shows an example of variability of the sternum, one case displaying four bones and the other five;[13] another plate shows a bone exceptionally found in a human heart;[14] on yet other plates we find fragments of the skull of a girl who was cured at St. Thomas's Hospital, of the upper and lower jaws of a man who had lost all his teeth.[15] Thus Cheselden seemingly drew a line between diseased states and anomalies or variations. At times, however, not only was the boundary between normal and diseased or anomalous blurred, but also that between disease and therapy: for example, Cheselden devoted extensive treatment to ankylosis, or the coalescence of two or more bones that were originally distinct, arguing that in some cases when the cartilage has deteriorated and the articulation no longer works, ankylosis could actually be a remedy—as in bone fusion.[16]

Cheselden stated that he did not aim to provide a comprehensive survey and highlighted two general criteria for his selection of plates: the hope to enable fellow surgeons better to identify their cases and provide a treatment, for example by exfoliation or the removal of the surface of the bone—though a contemporary critic argued than many cases were incurable; and the emphasis on extraordinary cases. Extraordinary did not mean unique: commenting on a diseased os innominatus, for example, Cheselden states:[17] "This is not the only case of this kind that I have seen." Although Cheselden did not seek completeness and, like others before him, often selected extraordinary cases, his work differed from previous attempts in that he focused on bones and assembled a rather large number of cases with an extensive iconographic apparatus—more than a quarter of the human plates in his work. The size of his sample of pathological bones sets his work apart for its focus and range. Moreover, although *Osteographia* included animal skeletons, there was a clear distinction conceptually, graphically, and in execution between comparative and human anatomy, whether morbid or not.

The plates representing diseased states start with a female and male skull of patients who had died of syphilis, a sort of introduction to the Fall. Cheselden presented his work in a traditional fashion starting from the skull and proceeding down to the thorax and legs, even separating the bones belonging to the same individual: femur, humerus, shinbone, and fibula from the woman whose skull is shown in the first pathological plate appear much later; he states that the patient hardly had a sound bone. The different textures are treated very effectively, with the smooth parts rendered with heavy engraved lines, while the etched carious parts look convincingly corroded. Visual representation of texture was crucial to Cheselden's intended aim, since he argued that diseases in hard bones could be more easily cured than in spongy bones.[18]

Most plates are accompanied only by a description of the specimens. In a scathing critical pamphlet surgeon John Douglas criticized Cheselden's exceedingly brief texts on disease. Occasionally, however, Cheselden outlined a case history; one example describes the case of a young woman of thirteen who had a portion of the humerus removed by surgeon Goodrich from Ipswich and who healed so well as to be able to carry a pail of water thereafter.[19] At times there could be a striking disconnect between the pain felt and the visible lesions: cases of "white swelling" can be so painful that the surgeon may be forced to amputate, yet all one can find is that the bone endings are slightly larger and softer. Cheselden did include a plate illustrating such a baffling case.[20]

Cheselden relied on a personal collection of diseased bones, which included specimens acquired or inherited from other surgeons, but he also acknowledged several colleagues, largely fellow surgeons from London hospitals, for having shared their specimens. For example, two skulls of men who had died of the venereal disease stemmed from Mr. Palmer, late surgeon to the Lock Hospital; the jaw of a woman with a large exostosis, or bone growth, was communicated by Dr. Hoddy;[21] four figures on another plate were communicated by Mr. Ferne—Cheselden's early instructor, who must have shared his interest in collecting diseased bones—and the late Mr. Paul, both surgeons to St. Thomas's Hospital.[22]

A "most remarkable" exostosis or bone tumor of a tibia (illustration 2.1, figures 1 and 2), was communicated to Cheselden by Mr. Green, surgeon at St. Bartholomew's Hospital. Figure 3 on the left shows the fibula deformed by the exostosis of the nearby tibia. Diseased bones were preserved and exchanged by London surgeons; some of Cheselden's specimens ended in the collections of John and William Hunter, for example, and have survived till today, such as the specimens discussed here. Despite the expense involved, some diseased bones were shown from multiple sides, as in this case, offering perspectival views of especially remarkable specimens that could be at times potentially useful to surgeons.[23]

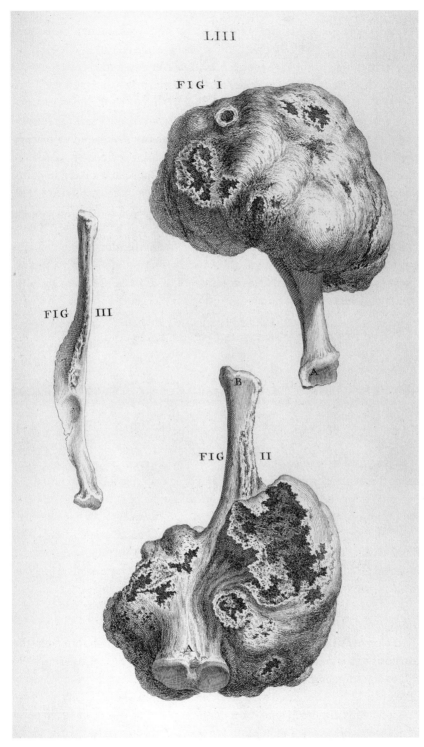

Illustration 2.1
Cheselden, *Osteographia*, 1733, plate
LIII, exostosis of the tibia. Drawing
and engraving by Gerard Vandergucht.

Cheselden's plate was referred to in later studies: French surgeon François Houstet, for example, compared it to a case he discussed and reproduced in a 1757 paper, arguing that his own was "une nouvelle espece d'exostose." Houstet based his claim on a review of the relevant literature, involving works by Ruysch, Méry, and Louis-Jean-Marie Daubenton, the naturalist and anatomist who collaborated with Buffon on the *Histoire naturelle* and catalogued the Paris royal cabinet, including healthy and diseased body parts. Daubenton tied the study of disease and their basic classification to museums and natural history. Under the heading "os difformes" he discussed bone diseases and identified four types: rickets, exostosis, ankylosis, and caries. His four plates illustrate the first three and callus, or the new growth joining broken bones. Houstet's reference to the literature highlights the importance of examining not only the background to the publication of pathological plates but also their usage; the emphasis in his title on a "new type" of exostosis documents a shift during the eighteenth century from Méry's "exostose monstrueuse" (illustration 1.12) and Cheselden's "extraordinary" cases to more systematic taxonomic concerns.[24]

CORNELIS TRIOEN AND CHRISTIAN GOTTLIEB LUDWIG: THE GROWTH OF BONE PATHOLOGY

Crossing the Channel to the Low Countries we encounter an almost exact contemporary of Cheselden, Cornelis Trioen (1686–1746): the son of a surgeon and apothecary, Trioen matriculated at Leiden University in 1706 and graduated MD in 1710 with a disputation on problematic childbirths dedicated to his father and to Bidloo. Although Cornelis held a medical degree, the topic of his dissertation was rather close to surgical concerns; following his father, he settled in surgical practice in Leiden, where he later became praelector and examiner of midwives. His main work, *Observationes medico-chirurgicae* (Leiden, 1743), highlights his double professional association and also his ties to civic authorities, since it was dedicated to the city burgomasters and aldermen. Trioen was one among several Dutch surgeon-physicians crossing professional boundaries between the seventeenth and eighteenth centuries, childbirth being a borderline area involving anatomical knowledge and manual experience—besides examination procedures and supervision.[25]

Compared to Cheselden's *Osteographia*, Trioen's *Observationes* was a more modest production in quarto rather than in folio, though the plates were folded so as to show the bones life-size. Whereas the chapter on diseases in *Osteographia* consisted of a collection of illustrations with occasional case histories, Trioen's *Observationes* was a collection of case histories with occasional illustrations. His work falls in the established genre of the collection of *observationes* on notable cases mainly encountered in his practice. His plates, however, thirteen in all, were of unusually high quality: his wife Elisabeth was

the granddaughter of the celebrated golden age genre painter Frans van Mieris and sister of Frans van Mieris the Younger, who was responsible for most of the drawings; the engravings were due to Johannes van der Spyk, who was responsible for other works in anatomy and natural history, his first recorded plates being in Bernhard Siegfried Albinus's edition of Harvey's *De motu cordis et sanguinis* (Leiden, 1736) and Swammerdam's *Biblia naturae* (Leiden, 1737–38). In the address to the reader, Trioen stated that the plates were engraved under the auspices of Jan Wandelaar, the celebrated artist and engraver who had studied anatomy with Ruysch and Albinus and had collaborated with Albinus. Wandelaar was responsible for the celebrated plates of *Tabulae sceleti et musculorum corporis humani* and other works, including some in pathology; Wandelaar even lodged with Albinus for several years while they were working together. In a contemporary anatomical work van der Spyk engraved and signed the plates adding at the bottom that they were produced under the direction of Jan Wandelaar, who must be counted as his teacher.[26] Trioen's plates were noteworthy for their quality and ties to Wandelaar and, as we are going to see, to Albinus himself; nine were devoted to bones.

Trioen's case histories often mentioned the name of the patient, including details of a woman made pregnant and then deceived, for example. It is difficult to find a common theme in Trioen's over sixty cases besides his concern with bridging the divide between surgery and medicine; his order probably depended on how the cases presented themselves. In the address to the reader Trioen put forward a mechanistic view whereby the human body or microcosm performs its operation *mechanice*; in practice, however, alternative philosophical standpoints may not have made much difference in the way bone diseases were treated and represented.[27]

Among the illustrated cases bones are especially prominent, including cases of ankylosis and a lengthy treatment of different cases of "spina"— "venenosa," "ventosa," and "mitiores," about which Trieon wrote a short treatise embedded in the *Observationes*. The plate (illustration 2.2) with a case of "spina ventosa" has no drawing attribution and may be due to van der Spyk, who worked both as engraver and draftsman. It shows the enlarged end of a femur lent by Albinus to Trioen so it could be reproduced; Albinus's involvement with Trioen parallels Wandelaar's with van der Spyk. The disease consists in the huge enlargement of the solid walls of the extremity of bones, with an empty space inside, at least in the preserved specimen—hence the characterization "ventosa," or "full of air": the plate highlights this feature by the insertion of a long needle through two apertures across the growth.[28] Despite the quarto paper, the bone is reproduced life-size on a folded plate by ideally cutting it in half, the upper healthy portion being shown in outline on the left. Like Cheselden, Trioen too often showed the same bone from different perspectives, highlighting the care and expense devoted to the representation of disease.[29]

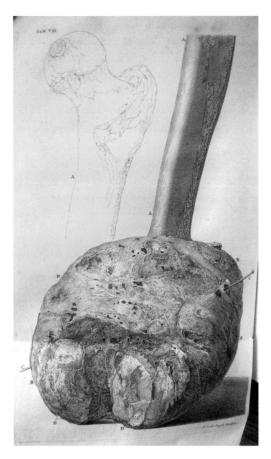

Illustration 2.2
Trioen, *Observationum*, 1743,
plate VII, "Spina Ventosa."
Engraving by Jan van der Spyk.

One generation younger than Cheselden and Trioen, Christian Gottlieb Ludwig (1709–1773) studied medicine at Leipzig from 1728 to 1737, when he obtained his degree. Between October 1731 and September 1733 Ludwig took part in a German expedition to North Africa as a botanist. In 1740 he was appointed extraordinary professor of medicine at Leipzig, and in 1748 he gained the chair of physiology, then moving up the academic hierarchy becoming professor of anatomy and surgery in 1754, then professor of pathology and dean in 1758. Ludwig held wide-ranging correspondences, with Albrecht von Haller and Carl Linnaeus among others, and published extensively in medicine and botany; for example, he issued an imposing series of textbooks on several medical subjects and even published a lavishly illustrated botanical work with color plates based on "Naturselbstdruck," or "nature printing," whereby a plant specimen was placed on the paper and covered with a dark dust; the outline of the plant was then colored usually from a combination of color printing and hand coloring.[30]

Between 1748 and the early 1770s Ludwig authored or directed twenty illustrated works on pathology, mostly though not exclusively devoted to bones. Some of the works were published independently; some appeared

as part of a collection in three volumes, *Adversaria medico practica* (Leipzig, 1769–74), which included both new contributions and excerpts from previously published academic orations and other similar works that had become difficult to find. Ludwig states that he had received several requests to reissue these works; hence he decided to include them in the *Adversaria*, with special attention to the illustrations. Later his son Christian Friedrich excerpted them, added an up-to-date commentary, and reprinted the plates, which he owned, on high quality folio paper in *De quarundam aegritudinum humani corporis sedibus et causis tabulae sedecim* (Leipzig, 1798), or *Sixteen Plates on the Seats and Causes of Some Illnesses of the Human Body*, a title echoing Morgagni's, except for the presence of plates. Christian Friedrich was professor of pathology, materia medica, therapy, and surgery at Leipzig.[31]

Several references in the texts point to Ludwig having assembled a collection of diseased specimens that he used in his work and that he lent to his students for their dissertations. Two of his students, Johann Gotthelf Herrmann and Johann Daniel Reichel, even wrote a joint piece on how to conserve specimens.[32] Working over such a long time span, predictably Ludwig and his students relied on a range of artists. Georg Christian Reichel, however, stands out as the chief draftsman; indeed, one could argue that Ludwig's collaboration with Reichel was at the core of his project. Reichel was a medical student of Ludwig's with an artistic talent, who added to his signature on the plates his qualification "M.D." or, before obtaining his degree, "Med[dicinae] Cult[or]"; clearly Reichel attached great significance to his double expertise. Frequent engravers were Johann Michael Stock and Christian Benjamin Glassbach, who had experience in botany and anatomy.[33]

The works authored and directed by Ludwig too, like Trioen's, were a collection of cases sharing a general concern for pathology and illustrations; their unity of purpose was highlighted by Christian Friedrich Ludwig's reissue with commentary. I discuss two essays in particular, the medical dissertation *De osteosteatomate* (Leipzig, 1767) by Johann Gotthelf Herrmann (1738–after 1775), directed by Ludwig, and one by Ludwig himself, "Tractatio de diaphysibus," which appeared in the *Adversaria medico practica* for 1772 and is chronologically the last item in Christian Friedrich's *De sedibus et causis*. Both include striking illustrations, while the second is especially pertinent to surgery.

Herrmann's dissertation provided a learned discussion of the nature, possible causes, and potential therapies for what he called "osteosteatoma," a peculiar tumor containing a fatty, tendinous, and cartilaginous substance mixed with bony particles distributed without any order. His work begins with a more theoretical section and then moves on to two case histories; the emphasis is not on uniqueness but rather on contrasting, comparing, and classifying. Herrmann cites a number of authors who had discussed and represented relevant cases, such as Cheselden, and even collections including related items, such as Hovius's collection in Amsterdam, which will be discussed below. He advo-

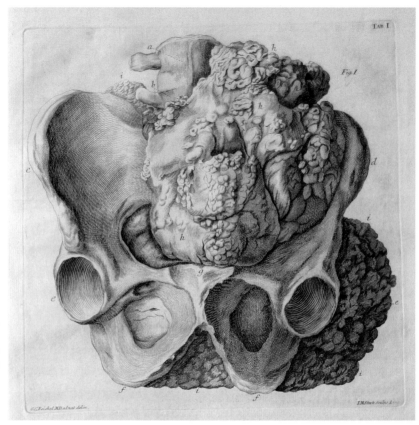

Illustration 2.3
Herrmann, *De osteosteatomate*, 1767, plate I, diseased pelvis. Drawing by Georg Christian Reichel; engraved by Johann Michael Stock. Reprinted in Ludwig, *Tabulae sedecim*, 1798.

cates surgical extirpation of the tumor, as occurred in a case when the clavicle was affected, though when the internal parts were involved this strategy was precluded and the prognosis was grim. Herrmann's discussion of causes joined surgical and medical concerns.[34]

While the first case relied on a report from Görlitz, east of Leipzig, the second was based on a local postmortem performed by Ludwig himself, who owned the specimen, and illustrated by Reichel with five plates of a pelvis affected by the disease: plates I and II show front and back of the pelvis with the tumor; III, quite exceptionally, is colored by hand and shows the substance of the tumor fresh and exsiccated—it is the only one in color in Christian Friedrich's reprint; IV and V show front and back of the pelvis with the tumor removed, and thus the specimen illustrated in the first two plates was no longer in the state shown. Illustration 2.3 shows the pelvis with the growth still attached: notice how the tumor has invaded front and back of the bone.[35]

After having gained his degree at Leipzig with Ludwig, Herrmann went on to become a physician in Chemnitz; he was the main translator of Morgagni's *De sedibus* into German, thus confirming his interest in pathological anatomy.[36]

Ludwig's "Tractatio" deals with two cases in which the diaphysis or shaft of a diseased tibia and femur were treated by surgeons; for this reason he

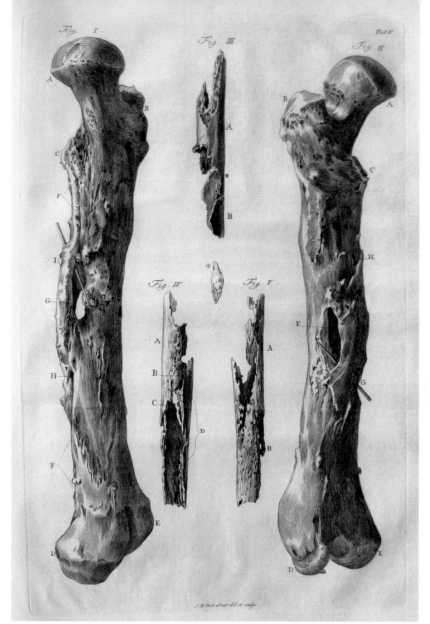

Illustration 2.4
Ludwig, "Tractatio," 1772, plate V, diseased and healed bones. Drawing and engraving by Johann Michael Stock. Reprinted in Ludwig, *Tabulae sedecim*, 1798.

wished to provide a German version accessible to those who did not read Latin. In both cases the bones were treated by surgeons and were healed by exfoliation, followed by the formation of callus. A portion of the tibia of the first case removed from the patient is shown in figures 4 and 5 of illustration 2.4. The second case is especially interesting because the patient died several years after the surgical intervention and this enabled Ludwig to inspect her femur. The case occurred in Ronneburg, south of Leipzig, and was communicated together with the bone by a local surgeon called Schroen. The first phase occurred between 1753 and 1754, when a nine-year-old girl whom we know by her initials I. C. H. had a growth in her left femur following a contusion and was treated not very successfully by a surgeon. In 1760 Schroen took over the case and surgically removed from her, by then fifteen, bone fragments, such as

the one shown as figure 3 below; by May 1761 I. C. H. could walk without limping. In December 1769, however, she fell on ice and died. Schroen managed to obtain from her relatives her femur, which is shown in figures 1 and 2; the cavities formed during an imperfect healing process, highlighted by the metal pin going across the bone, make us wonder in admiration that I. C. H. could walk without limping.[37]

Works by Trioen, Ludwig, and their circles testify to the growing interest in bone pathology, the importance of collections and visual representation, and the close connections between physicians and surgeons.

ANDREAS BONN AND JOHANN PETER WEIDMANN: BONE DISEASES AND REGENERATION

Authors such as Andreas Bonn (1738–1818) and Johann Peter Weidmann (1751–1819) joined the study of bone diseases with a focus on their regeneration; their concerns stemmed from typical eighteenth-century vitalistic perspectives.

Bonn came from an Amsterdam medical family, his father being an apothecary. He studied at the Amsterdam Athenaeum with the renowned anatomist Petrus Camper (1722–89), who taught anatomy, surgery, and medicine, and then in 1759 at Leiden University, where he took his MD in 1763 with an important dissertation on the membranes of the body, *De continuationibus membranarum*; his work contributed to the shift of emphasis from organs to their constituent tissues and membranes, best known from Bichat's later work. After having studied anatomy and surgery for one year in Paris, which was already a magnet for foreign students, Bonn settled in Amsterdam, where in 1771 he was appointed professor of anatomy and surgery at both the Athenaeum and the surgeons' guild; Camper had been the first to hold both posts. Camper, too, who had worked on childbirth under Trioen, had an interest in bone diseases and made drawings of them that were later published by Weidmann's student Carl Wenzel in a treatise on diseases of the spine; thus Camper ties together Trioen and Bonn generationally and intellectually. Two of Bonn's publications are especially relevant to our investigation: *Descriptio thesauri ossium morbosorum hoviani* (Amsterdam, 1783), is a catalogue without illustrations of the collection of pathological bones put together by the Amsterdam physician Jacob Hovius (1710–86). Subsequently Bonn published a work in three parts with twenty-three folio plates of some of the most significant holdings of the *Thesaurus hovianus*, especially for the formation of callus or new bone, *Tabulae ossium morbosorum* (Amsterdam, 1785–88). In 1790 Bonn was a founding member of the Society for the Advancement of Surgery, which sought to advance surgical knowledge and expertise. His last work on hernias appeared posthumously in 1828, edited by Gerard Sandifort, Eduard's son. Bonn too assembled a collection of preserved specimens, a portion of which went to Leiden University upon his death.[38]

Bonn's younger contemporary Weidmann matriculated in 1773 at the University of Würzburg, where he studied with the professor of anatomy, surgery, and obstetrics Carl Caspar von Siebold. While in Würzburg Weidmann worked as Siebold's assistant and gained clinical experience at the hospital, Siebold being a prominent figure in the early German clinical teaching. In 1779 Weidmann graduated MD with a dissertation on surgical obstetrics. Upon graduation, he obtained a position at Mainz University, but before taking up his post he undertook a *Bildungsreise* paid by the Mainz electoral prince, or Kurfürst, to the main medical and surgical centers in Northern Europe. Weidmann's journey lasted over four years and took him to Strasbourg, Paris, Rouen, London, and Kassel. Weidmann followed an example set by Siebold, who had undertaken a similar journey at the expense of his employer through Paris (where he had become acquainted with Bonn), Rouen, London, and Leiden, before taking up his position at Würzburg.[39]

Weidmann's longest stay was in Paris, where he became acquainted with surgeon Pierre-Joseph Desault and with the running of the main hospitals; he probably did not overlap with Neapolitan surgeon Michele Troja, who had spent a few years in Paris and, before returning to Naples, had published a treatise on his experiment on bone regeneration in animals, *De novorum ossium regeneratione experimenta* (Paris, 1775). At Rouen Weidmann had a short though profitable stay working with the surgeon Jean-Pierre David, who exactly at that time published a work on bone necrosis, *Observations sur une maladie d'os connue sous le nom de nécrose* (Paris, 1782), a topic that became the focus of Weidmann's research. In London Weidmann visited the main hospitals and became acquainted with the leading figures, such as Percivall Pott and William and John Hunter. Among his many publications, Pott counted *Farther Remarks on the Useless State of the Lower Limbs* (London, 1782), on a deformation of the spine related to scrofula, including six pathological plates; Pott's works were extremely popular and were translated into many European languages, including German. In addition to his surgical skills, John Hunter was renowned for his museum, which Siebold claimed was alone worth a trip to London. On behalf of the Kurfürst, Weidmann also purchased a copy of William Hunter's sumptuously illustrated *Anatomia uteri humani* (Birmingham, 1774), childbirth being a major area of interest to Weidmann. He also purchased copies of preparations by the anatomist and surgeon John Sheldon deemed especially useful to teaching anatomy. Unfortunately we do not know whether Weidmann made it to the Netherlands, as was in his plans, though in *Museum* (1793) Sandifort cited Weidmann's treatise *De necrosi ossium*, which appeared in the same year as his own work, as forthcoming, suggesting that they were in contact. After a stay in Bonn, Weidmann went to Kassel, to visit the renowned midwifery school. In addition, in all likelihood he became acquainted with the leading anatomy professor Samuel Thomas Soemmerring, who soon thereafter joined him in Mainz.[40]

Weidmann's initial appointment in Mainz was for anatomy, surgery, and obstetrics, though Soemmerring soon took over the anatomy chair. Weidmann's main work was *De necrosi ossium cum fig. ductis in aere* (Frankfurt/M, 1793), with fifteen folio plates. Those were very turbulent years for most of Europe as well as for Mainz, which was occupied by French armies. He lived long enough to witness Napoleon's defeat and the establishment of peace. Interestingly, Weidmann owned a collection of paintings and engravings impressive enough to attract visitors.[41]

Weidmann's focus on a special topic enabled him to produce an elegant yet manageable work in folio with large, nearly life-size plates whose printing he had arranged in advance at his own expense. Not surprisingly, given his travels for over four years at the electoral prince's expense, *De necrosi ossium* was dedicated to him. The plates were engraved by Georg Joseph Coentgen, court and university engraver at Mainz, who relied partly on drawings by Christian Koeck, a versatile artist active in anatomy and pathology, who was also responsible for the illustrations in works by Soemmerring.[42] Although occasionally Weidmann referred to color and its pathological significance, his illustrations were black and white engraving.

Weidmann focused on bone necrosis and the process whereby dead bones are separated and regeneration occurs. After some introductory remarks on bone formation and the correct identification and understanding of bone necrosis, Weidmann identifies three stages in this process: in the first inflammation, pain, swelling, and fever are persistent; in the second the dead part loosens, the inflammation declines, the tumor decreases, pus comes out, and the bone appears naked and dry; lastly, the disease declines and the loosened part is detached.[43] Weidmann often refers to a vital force as responsible for bone regeneration, a prominent theme in Johann Friedrich Blumenbach's philosophical stance, and, specifically for bones, Michele Troja, who is referred to by Weidmann.[44]

The dramatic plate (illustration 2.5) shows front and back of the knee of a young man with portions of the femur, tibia, and fibula; the lighter area across the top third of figure 2, marked *aaa*, shows a dead splinter. Weidmann states that his former teacher Siebold tried to save the leg but the continuous production of pus led him to attempt amputation, which saved the patient's life. The reference to Siebold suggests that Weidmann had access either to the bone or a drawing. On another plate he showed a tibia borrowed from Soemmerring's collection, pointing to a pattern similar to the one we have encountered with Cheselden in London.[45]

Bonn's osteological works share features with Weidmann's. They deal with the collection of diseased bones put together by Jacob Hovius; from the time when Hovius took his medical degree and became a physician in Amsterdam in 1736, he started collecting pathological specimens and especially bones, which are easily preserved. Since those found in cemeteries were in a poor

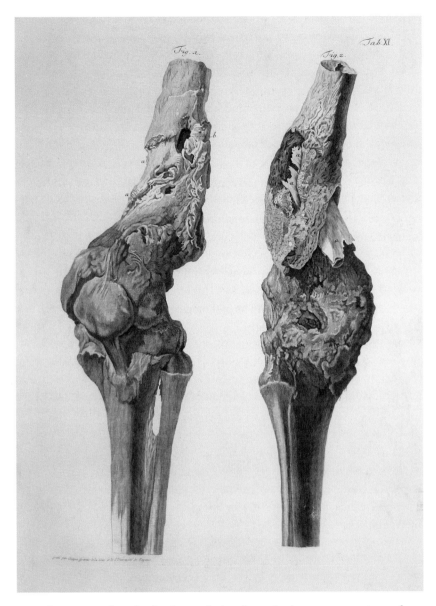

Illustration 2.5
Weidmann, *De necrosi ossium*, 1793, plate XI, diseased knee. Engraving by Georg Joseph Coentgen.

state, in 1752 Hovius obtained permission from the burgomasters to perform postmortems at the Buitengasthuis, a former plague hospital at the edge of the city with more than three hundred beds, as it was already happening at the other Amsterdam hospital, the Binnengasthuis. Over the years he assembled a collection of several hundred items, which in 1772 he left to the Collegium Chirurgicum, asking that they be kept behind glass and under lock, so that they could be inspected though not stolen; seemingly diseased bones were more sought-after than one may have thought. The Amsterdam burgomasters provided a repository for Hovius's donation, and Bonn's 1783 *Descriptio thesauri* was dedicated to them, thus underscoring the civic connections with

the donor and collection, which can still be seen today in its imposing original repository, surmounted by a portrait of Hovius.[46]

In addition, a number of surgeons donated to the Collegium pathological specimens, which Bonn wished to order and catalog. Bonn intended his work to be useful to both surgeons and physicians and therefore provided references to the literature and to illustrations, and also included case histories; he also wished to provide illustrations of the rarest specimens of the *Thesaurus hovianus* and of those he had personally collected.[47] In 1785 he started publishing the *Tabulae*, both in Latin and Dutch; this format resembles Ruysch's *Thesauri anatomici*, which also included descriptions in two languages. Whereas Ruysch may have had a broader audience in mind and published in quarto, by his own admission Bonn's intended readership was limited to medical men and his work was in folio. He wanted to represent the bones life-size but also wished his work to appear in a comfortable size to handle—possibly a veiled reference to the cumbersome size of works by Albinus and Camper.[48]

Bonn relied on the painter Martinus Houtman (the Elder, 1746–1819), who was responsible for all the drawings and who, as Bonn was keen to stress, had experience in anatomy; indeed, he had also drawn and engraved the plates for Bonn's previous publication *De humero luxato* (Leiden, 1782). Bonn encouraged him to engrave the plates as well, and he was indeed responsible for some of them, though others were due to Barent de Bakker, an engraver active in Amsterdam. The plates display a technique similar to that employed by Gerard Vandergucht, combining intaglio techniques; Bonn argued that even those with little knowledge in osteology would need no letters on the plates, which thus appear unblemished.[49]

Unlike previous works, Bonn's *Descriptio* of Hovius's collection follows a pathological structure from diseases of the spine and of the articulations to diseases due to external and internal causes. One chapter and the concluding essay, *De callo*, examined processes, very much like Ludwig had done in the essay we have seen above: Bonn focused on the way nature replaces the damaged or diseased bones in fractures and other instances with healthy ones, and the formation of new bone or callus. Bonn's *Descriptio* ended with two statements: imperfect callus has a membranous nature, which starts as flesh and then turns into corium; perfect callus becomes part of the bone formed from imperfect callus by the hardening of a membrane without going through the stage of cartilage, replacing a diseased bone, whether hard or softened or dissolved by caries. Bonn frankly admitted that the way these processes occur is unknown, though his interest is representative of contemporary concerns with regeneration processes, as in Troja's experiments.[50]

Bonn's *Tabulae* start with the very two statements ending *De callo*, a topic central to his concerns; although Cheselden too had illustrated a healed bone, such cases were not his main concern. The three fascicles deal with bones of the head, fractures of long bones, and their regeneration, respectively. Illus-

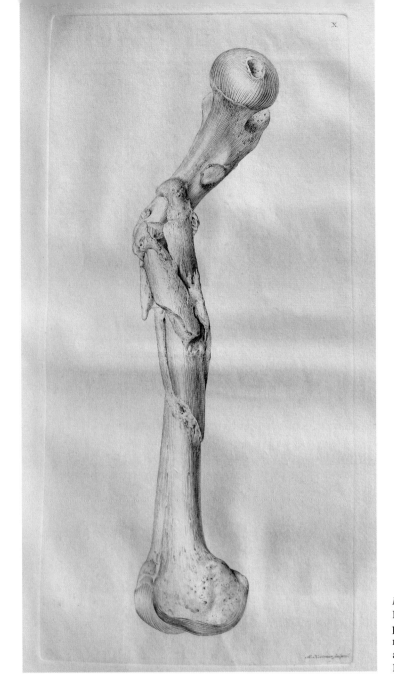

Illustration 2.6
Bonn, *Tabulae*, 1785,
plate X, fractured
right femur. Drawn
and engraved by
Martinus Houtman.

tration 2.6 shows a fractured right femur from *Thesaurus Hovianus*; although the bone was broken into more than ten pieces by the wheel of a loaded carriage and the fragments were dislocated, new callus joined them together into a firm bone. Since the healed femur was slightly shorter, the man was limping, though he could walk in what Bonn called an "Egregium naturae sanantis exemplum," a "remarkable example of nature's healing."[51]

The conclusion to the *Tabulae* echoes the opening sentences from *De callo*: Bonn argues that following a constant law of nature, corrupt and dead bones are separated from the healthy and alive ones and the growing membranous

substance with which the bone is regenerated resembles flesh, as several examples show.[52]

The last practitioner we are going to discuss is physician and anatomist Eduard Sandifort (1742–1814). Sandifort studied medicine at Leiden University, where in 1763 he took his MD with a dissertation on the dilatation of the pelvis in childbirth, just a few months after Bonn, whom he often refers to as a close friend. After a few years practicing medicine in The Hague, in 1772 he succeeded in the chair of anatomy and surgery his celebrated teacher Bernhard Siegfried Albinus, who had died in 1770. Later he also taught physiology, first with the surgeon and physician Wouter van Doeveren and then on his own; thus Sandifort was proficient both in medicine and anatomy. Sandifort produced several illustrated treatises on pathological anatomy that made him the most prolific author in this genre of his time. His justification for producing scores of pathology plates was their usefulness to anatomy and medicine: he started with two volumes of *Observationes anatomico-pathologicae* (Leiden, 1777–81), which were continued with two additional volumes, *Exercitationes academicae* (Leiden, 1783–85), devoted to pathology despite the title; *Opuscula anatomica* (Leiden, 1781–84) included cases of hernias and congenital malformations. Sandifort stated that the opportunity for these publications arose from his private and public dissections of a huge number of cadavers every year. Finally, his *Museum anatomicum* (Leiden, 1793) in two huge folio volumes was by far the largest illustrated pathological publication to that point and until the second quarter of the nineteenth century.[53] Appearing exactly two hundred and fifty years after Vesalius's *Fabrica* (Basel, 1543), Sandifort's treatise highlights major differences in the rise of illustrations in anatomy and pathology, as well as the crucial role of museums.

Unlike Bonn's and Weidmann's works, Sandifort's early pathological publications did not focus on a specific body part but ranged across organs and diseases. His *Observationes anatomico-pathologicae* deal with a series of notable cases as they presented themselves to the author both in his public and private dissections; a feel for their random nature can be gained from the preface, where Sandifort states that he wished to start from the plates of a gravid uterus that he had dissected publicly, but he changed his mind when he encountered an extremely rare case of a heart condition in an infant.[54] Each volume ended with an index, while the last volume had a comprehensive index for all *Observationes*, thus providing readers with a tool to use a collection where the material was arranged without any discernible order. These early works do not differ significantly from seventeenth-century collections published under the

titles of *Observationes* or *Historiae*, apart from more and better quality illustrations, fifty-one overall, and a progressively greater emphasis on bones. The illustrations were drawn by Abraham Delfos, who had studied under Jan Wandelaar, and engraved by Robert Muys. Delfos was a key figure because he was instructed in anatomy and was both a draftsman and an engraver; thus he understood the technical aspects of what was to be represented and served as a crucial link between the anatomist and the engraver, being able to direct him in his work.[55]

For anyone familiar with Sandifort's extensive illustrated publications on pathological anatomy from the mid-1770s, it will come as no surprise that he devoted his magnum opus to pathology. But *Museum anatomicum* was quite a different enterprise: its huge size—two large folio volumes over half a meter high—and sumptuous engravings speak to its celebratory nature and what must have been a substantive financial support received by the "most generous" university curators; the work was dedicated to them and to the city burgomasters.[56]

His book included material and plates from his previous publications—at times different plates were joined to fill a large folio. Most plates, however, were new; they must have been even larger than the huge folios, since most plate marks are not to be found and must have been trimmed with the binding.[57] Sandifort relied on the growing collection of the anatomical museum at Leiden University; surgeon Johannes Rau (1668-1719) had bequeathed to the university his collection of specimens, his bones being especially fine; in 1725 Albinus (1697-1770) cataloged Rau's collection and he too assembled one that was presented to the university by his widow; lastly, the collection by van Doeveren (1730-83) went to the university upon his death. As holders of medical, surgical, and anatomical chairs, they would have had ample access to corpses, on the example of Sandifort. This stratigraphy is reflected in the structure of Sandifort's *Museum*, which catalogs the holdings by Rau, Albinus, and van Doeveren separately; whereas Bonn had arranged his work following a pathological nomenclature, Sandifort grouped the specimens based on the collection and donor whence they originated.[58]

The drawings in Sandifort's *Museum* were due to Delfos and, after being approved by the "Academiae Patres," were engraved by Muys—the same artists responsible for his previous works—and Pieter de Mare, an engraver and draftsman student of Delfos. Well over one hundred plates were printed, dwarfing any previous attempt in the field. Delfos's preliminary drawings preserved at Leiden reveal a hand and cross-hatching leading to the burin; they seem to be drawn with the aim of guiding the engraver. In Sandifort's opinion, those lacking a collection of diseased parts would be especially pleased with his work, which he conceived as a paper museum of pathological cases and a reference tool for medical men; this statement, which was to become a topos

in pathological iconography, captures the purpose and intended audience of these works. Sandifort argued that some figures were self-explanatory; those that were not had letters keyed to his comments.[59]

We have encountered Sandifort, as a student of Albinus, collaborating with Delfos, a student of Albinus's artist Wandelaar, in the production of images of diseased body parts, significantly bones, much like Wandelaar had worked on the skeleton. Further, Albinus had studied with Bidloo, whose *Anatomia* was lavishly illustrated by Gerard De Lairesse, who had been Wandelaar's teacher, thus pushing the teacher/pupil relation back one generation. We find here an instructive parallel with the London scene; although in London there was a family relation as well, in that Michael Vandergucht was Gerard's father, in both cases not only expertise but also the ties between artists and anatomists were passed down across generations. Despite these apprenticeship and family connections, there were also significant differences in the iconographic projects, especially in the transition from anatomy to pathology: Wandelaar and Albinus were striving to represent the ideal, perfect human form, or the "homo perfectus," starting from a heterogeneous collection of bones from different bodies arranged so as to result in a body of 1.67 meters—suspiciously Albinus's own height. By contrast, the fact that *Museum anatomicum* was a catalog—and no doubt its pathological focus—led Sandifort and Delfos to represent the individual diseased specimens at hand rather than idealized ones; their illustrations portray and identify specific specimens in the Leiden museum. But just as anatomical illustrations, pathological ones too required considerable technical expertise and a close collaboration between artists and medical men.[60]

The proximity in time and place of publication leads one to suspect that Sandifort's *Museum* was related to Bonn's *Tabulae*; indeed, Sandifort stated that his own work followed Bonn's above all others. Leiden University, established in 1575, was the oldest in the Netherlands, while its museum and botanic gardens had been major centers of learning for nearly two centuries. The Leiden administrators and professors possibly felt upstaged by Bonn's publications: thus the work Sandifort deftly presented as the birth of the new genre of illustrated pathological anatomy, seen within the competitive world of medical education in the province of Holland, could be seen as Leiden's response to Amsterdam. In his preface, however, Sandifort deftly skipped over such petty rivalries and contrasted instead his work with Morgagni's *De sedibus*, stating tongue-in-cheek that Morgagni "quasi ob oculos ponit," or "almost displayed to the eyes," the nature of seats and causes of diseases; since the Italian had included no illustrations, Sandifort could more convincingly present his work as the birth of a new genre.[61]

Bonn's resources were limited compared to Sandifort's, whose *Museum* lists well over one thousand specimens of different types, including wet preparations and diseased bones. The heterogeneous provenance of the museum

holdings led to a different treatment of the specimens: for the older ones case histories would have been unavailable, whereas occasionally for some recent ones they were included.[62] Sandifort's treatment of skeletal diseases and malformations took up the lion's share of the work, with one hundred and three plates; the remaining twenty-four were devoted to the soft parts, stones found in the human body, and monsters.[63]

Sandifort states that he was stimulated to devote himself to pathological illustrations by his "venerandus præceptor" Bernhard Siegfried Albinus, who had told him that his work would be the more useful the larger the number of figures of pathological specimens; this remark ties nicely to Albinus having lent a pathological specimen to Trioen, so he could discuss it in his *Observationes*. Albinus's and Sandifort's emphasis on utility echoes Cheselden's concern. *Museum anatomicum* starts with three plates showing a diseased female torso—with an additional plate showing the pelvis—from the front and sides. The bones were very fragile and fractured easily, resulting in multiple deformations—so many, in fact, that Sandifort could barely describe all their defects. His opening plates showing frontal and side views of a torso echo what Albinus had done in anatomy with a complete human skeleton in his 1747 *Tabulae*. Sandifort's artists, however, eschewed Wandelaar's elaborate and controversial backgrounds, including tombs and a rhinoceros. As to execution, the bones appear very white, like ivory, shading being used mainly to add depth to the image, a technique similar to Wandelaar's.[64]

Museum follows a structure from skull to spine, and from pelvis to limbs, ending with some plates devoted to ankylosis. One of the plates shows a collection of bones deformed by rickets, an English specialty since the time of Francis Glisson. Another plate, showing hip bones and femurs, is quite unusual in that Sandifort explains that the bones were cleaned, macerated, and dried, thus offering a rare, however brief, account of preparation techniques.[65]

No fewer than four plates show different full views of a torso affected by scoliosis; probably nobody had used so much copper to illustrate a diseased state, either before or after. Scoliosis was especially well represented in the Leiden collection; two plates are remarkable in that they show front and back of a torso affected by scoliosis and also by a tumor in the lower spine (illustration 2.7). Here the artist combined smooth sinuous lines to capture the deformed curvature of the bones with dense broken ones to render the composite texture of the tumor. There is a striking contrast between the regularity and elegance of the rather formal cross-hatching and the attempt to render the disordered growth of the tumor.[66]

This is not the only plate in which the artist had to render different textures. All three figures in illustration 2.8 show the same diseased right femur; figures 1 and 2 show front and back, while figure 3 shows a partial cross section. Notice the hole at the bottom of figure 2, shown in cross section in figure 3, as well as the difference among the corroded internal part; the smooth, much thickened,

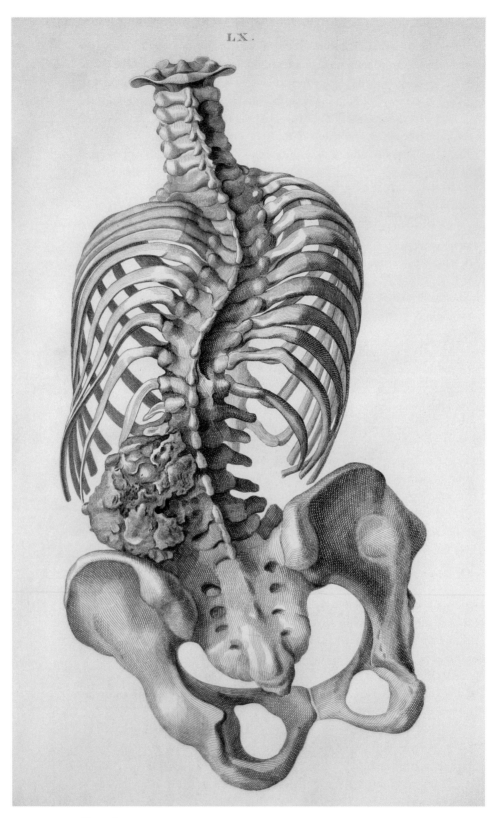

Illustration 2.7
Sandifort, *Museum*, 1793, volume 2, plate LX,
scoliosis and tumor. Drawing by Abraham Delfos,
engraving by Robert Muys/Pieter de Mare.

and very hard portion enclosing it, which is described as ivory-like; and the more porous portion visible at the bottom of figure 3. Perhaps more than in previous cases, here the rendering of textures is especially effective. Clearly a great deal of thinking and skill was required to produce an image of this quality.[67]

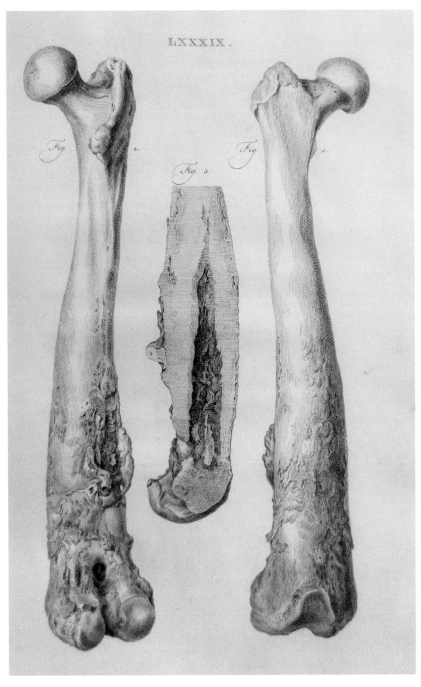

Illustration 2.8
Sandifort, *Museum*, 1793, volume 2, plate LXXXIX, right femur. Drawing by Abraham Delfos, engraving by Robert Muys/Pieter de Mare.

The decades between Cheselden and Sandifort saw the establishment of a database with scores of plates of diseased bones. The very fact that these specimens were collected in the first place, even before being illustrated, testifies to their significance in the eyes of contemporary medical men. The nature and meaning of these collections and of the illustrations changed over time, from "monstrous" or "extraordinary" cases, to use Méry's and Cheselden's terms, to more taxonomic concerns; progressively the attention shifted from focusing mainly on curiosities and remarkable specimens to comparing and classifying specimens in a systematic fashion. The extensive cross-references among the works we have seen testify to their shifting meaning and use, as visual resources for understanding and classifying disease. During the eighteenth century bone pathology slowly emerged as a more systematic subject of study, Cheselden being a key figure in this transition.

Among all the body parts, bones are those that require the least care and can be most easily preserved; they formed the basis of a number of collections, from Cheselden and his fellow London surgeons to a number of Paris figures, from Ludwig, Weidmann and Soemmerring in Germany to a few individual collections by Leiden professors that came together in the university museum. In London, Leiden, Paris, and Amsterdam collections were already being assembled during the early decades of the century. The practice seems to have been especially prominent in the Netherlands: for Rau, Albinus, van Doeveren, and Sandifort in Leiden, as well as Bonn, Hovius, and his associates in Amsterdam, diseased bones had become collectible items for the purposes of classifying disease, studying its effects, and providing better cures, as well as a source of civic pride and competition. Hospitals and related centers played a key role in the creation of private and public collections and museums and in favoring the interactions among surgeons and physicians.[68]

Whereas a scholarly tradition has emphasized a shift in the notion of disease from patients' narratives to physical examinations and postmortems around 1800, the study of illustrated bone pathology problematizes views of postmortems and lesions. Surgeons and medical men with surgical and anatomical interests played a key role in this process; after all, setting bones and removing growths were surgical operations. A notable feature common to the six figures I have selected is that they all had a significant surgical and anatomical background: while Cheselden was the most renowned London surgeon of his time, all the other practitioners held medical degrees but were also active teaching and practicing anatomy and surgery. Trioen graduated with a thesis on childbirth and settled in surgical practice; Ludwig taught anatomy and surgery, published a manual on it, and worked in close contact with surgeons. Bonn taught anatomy and surgery at the Amsterdam Athenaeum and at the surgeons' guild and founded a society for the advancement of surgery; Weidmann taught and was an active practitioner of surgery and obstetrics; lastly,

Sandifort too taught anatomy and surgery. Surgery's growing status contributed to the rise of a more localized notion of disease and of illustrations of diseased states; conversely, illustrations contributed to a progressive shift of emphasis in the notion of disease from causes and theory to localization and classification of pathological forms.

Although some commentators highlighted that the Netherlands lagged behind other countries—notably France and Britain—in terms of the clinical training offered to medical students, most of the authors I discuss were Dutch. While Sylvius and Boerhaave at Leiden and Blasius in Amsterdam had relied on clinical training, the practice seems to have decreased in the eighteenth century, its lack in Amsterdam being one of Bonn's concerns. Despite this relative disadvantage with respect to the most advanced medical centers of the time, the great anatomical and pathological traditions of Leiden and Amsterdam embodied in their collections and museums came together with the Dutch publishing and artistic traditions in an especially fruitful fashion. Sandifort's extensive postmortems and reliance on the pathology collections of the Leiden Museum for his teaching highlights a widespread feature among our characters, namely the emphasis on visualization in the fruitful combination of dissecting, collecting, innovative pedagogy, and publishing.[69]

Our authors relied on different resources and discussed bone diseases in different ways: Cheselden expressed the hope to provide better cures; Trioen stressed the mechanical operations of the body; Weidmann spoke of vital forces; Ludwig worked on a variety of ailments; Bonn focused on the nature of callus; Sandifort wished to establish a museum on paper. All, however, shared emphasis on specific, individual cases and a concern for the importance of visual representation, going to great lengths to secure the best and most competent artists for the task.

Whether they relied on line engraving, etching, or a combination of the two, all the cases we have discussed involve remarkable plates that testify to the effort and skill devoted to their production. Bones are comparatively simpler to represent than other body parts because of their hardness and of the relatively less crucial role of color; shape and especially texture, however, required close attention and were rendered in a strikingly sensitive and effective fashion. Following Cheselden, most of the plates we have been discussing represented all the bones life-size or nearly so, and in folio, despite the expense of copper and paper involved. Effective visual representations of diseases involved a number of factors, such as showing the specimens from different perspectives or even in cross section, highlighting not only variations in shape but also the porous or smooth texture of the surface and interior of bones. In many instances the authors worried about spoiling the image with obtrusive lettering, as if they appreciated representations of tumors and scoliosis not only from a medical standpoint but also for their artistic value. The production of the illustrations

shows constant patterns and concerns: anatomical expertise on the part of draftsmen and engravers was crucial from the time of Gerard Vandergucht— through his father at the very least—and van der Spyk, Reichel, Houtman, Muys, Delfos, and Koeck all had experience and often rich portfolios in anatomy and even specifically pathology. Moreover, the rendering of drawings into engravings was also a concern: in some cases, the draftsmen were responsible for the engravings as well, as with Gerard Vandergucht, Shijnvoet, Stock, and Houtman; in other cases, such as Koeck and Coentgen, or Delfos and Muys, draftsman and engraver were regular collaborators. Technical expertise, both medical and artistic, was a valued skill in knowing what to represent and how best to do it, in order to capture the key features of individual specimens, with all their idiosyncrasies, rather than aiming at universal features of Albinus's "homo perfectus." Medical men and artists focused on individual specimens and their specific representations rather than seeking idealized or abstract forms.

While Sandifort's *Museum* unquestionably occupied a key position in the history of pathological iconography and especially bone diseases, it seems more accurate to characterize his work as marking not the beginning of an entirely new genre but rather a nodal point, the culmination of a tradition and the opening of another at the same time. As we are going to see in the next chapter, the availability of specimens that was so crucial to the study of bones played a key role in the representation of soft parts too.

THREE

PRESERVED SPECIMENS AND COMPREHENSIVE TREATISES

In the course of the eighteenth century a number of works involving the visual representation of disease appeared in different formats and in different countries; while bones were a key focus of attention, other parts too were examined in treatises, pamphlets, dissertations, and articles in learned periodicals. By the early decades of the nineteenth century anatomists and physicians showed growing awareness of the crucial role of pathological illustrations as an indispensable tool, a claim explicitly made by both Meckel in 1817 and Cruveilhier in 1829.[1]

In the *avant-propos* to *Anatomie pathologique* Cruveilhier provided a brief history of pathological illustrations. While acknowledging the role of many individuals and the fact that, from their inception in the seventeenth century, scientific and medical journals included plates of several remarkable cases, he named Sandifort as the "father of pathological illustrations." However, Cruveilhier's reconstruction and Sandifort's own claim that *Museum* marked the birth of illustrated pathological anatomy appear problematic because *Museum* dealt almost exclusively with bones, and even bone diseases were not examined in a comprehensive fashion—his work was completed by his son Gerard only in 1835, for example. In 1799 Matthew Baillie seemingly addressed related concerns in the opening of *A Series of Engravings*:[2]

No Work has been published in this, nor, I believe, in any other country, in which the principal Morbid Changes of Structure, affecting the most important parts of the Human Body, have, as far as they admit of it, been illustrated by a regular series of Engravings. Whatever has been hitherto done upon this

subject, has been without any regular plan, and scattered over various works, some of which are expensive, and others difficult to be procured.

The reference to lack of planning and scattered works suggests journal articles or occasional publications with a small number of illustrations on random subjects. Sandifort's *Museum* would certainly count among the expensive works—additionally limited to one domain. Thus Baillie could claim a major role in morbid anatomy as the author of the first comprehensive illustrated treatise.

Traditional historiography has identified Paris as the center of a novel approach where medicine and surgery came together, the clinic was established, and Bichat redefined the location of disease from organs to their constituent tissues; for many the rise of pathological anatomy went hand in hand with the reception of Bichat's views. Such claims have now come under scrutiny and can no longer be accepted in their original form: the erosion of the boundaries between surgeons and physicians was a longer and complex process; clinical medicine developed across Europe, especially in the second half of the eighteenth century; and the emphasis on tissues and membranes can be documented at earlier times and at many locations.[3]

Around the same period other closely related transformations occurred: they include a growing attention to the description and representation of the specific nature of the lesions, including attempts to distinguish and classify them. The move towards systematic visual representations occurred not in France but primarily in Britain, Germany, and the Netherlands, in the form of the extensive illustrated treatises in morbid anatomy and pathology. Besides Baillie's *Engravings*, others too, such as Johann Friedrich Meckel the Younger at Halle and Jan Bleuland at Utrecht, authored extensive illustrated treatises, *Tabulae anatomico-pathologicae* (Leipzig, 1817–26) and *Icones anatomico-pathologicae* (Utrecht, 1826–28), respectively.

These transformations relied on the growing collections and museums of diseased preparations. Thus pathological museums and collections were key resources with a research and pedagogical role in the first phase of the production of comprehensive illustrated pathology treatises. The works I discuss here relied overwhelmingly on preparations and their illustrations, whether line engravings, etching, or lithographs, were virtually without exception in black and white; the nature of the preparations depicted, where color was obliterated, contributed to shaping the forms of representation adopted.

THE AUTHORS AND THEIR PRACTICES

Matthew Baillie (1761–1823) was a Scottish physician and anatomist active in London. He studied at Balliol College, Oxford, where he took his BA in 1783 and MD in 1789; he also studied medicine in London at the school of his uncle

William Hunter, the celebrated anatomist, man-midwife, and collector, with whom he lodged, and his brother John, the renowned surgeon and collector of anatomical and pathological preparations. Following William's death in 1783, Baillie was left in control of the anatomy school in Great Windmill Street and was given the use for thirty years of William Hunter's museum, which included many pathological preparations. Baillie also had his own museum, which included over one thousand preparations, about half of them pathological. In 1787 he was appointed physician at St. George's Hospital, which had about 270 beds. In 1788 Baillie undertook a journey through France, Switzerland, Germany, Belgium, and the Netherlands, during which he visited hospitals and museums. He noted that the Hôtel-Dieu in Paris had over three thousand patients, while the preparations at the Leiden Museum were badly arranged and the jars not properly sealed, though the cabinet of Albinus contained two hundred impressive injected preparations.[4]

After publishing two memoirs in the *Philosophical Transactions*, one on a case of transposition of the abdominal viscera and one on a peculiar growth in a young girl's ovary, Baillie was elected Fellow of the Royal Society in 1790. It was Baillie who oversaw for publication William Hunter's *An Anatomical Description of the Human Gravid Uterus and its Contents* (1794), accompanying the celebrated 1774 treatise that included some of the most striking anatomical plates ever produced. Following the death of John Hunter in 1793, Baillie became joint executor of his will and had immediate access to his museum, which included between two and three thousand pathology preparations. Baillie taught at the Windmill school together with the anatomist and physician William Cruikshank until 1799, when he retired both from lecturing and from his hospital appointment to devote himself to private practice. Thus Baillie was an established anatomy lecturer, physician at St. George's Hospital, and also had an extensive private practice; these three activities put him in a privileged position to investigate diseased states. Moreover, no one in Britain, or anywhere else, would have had at his disposal as many pathological preparations as Baillie. When an interesting case presented itself at his school, he made sure to preserve the relevant body part.[5]

In 1793 he published a successful work on pathological anatomy, *The Morbid Anatomy of Some of the Most Important Parts of the Human Body*, which went through several editions and translations into German, French, Italian, and Russian. The German one is notable in that it was much expanded and extensively annotated by Soemmerring; Baillie relied on it for his own second edition of *Morbid Anatomy* in 1797. Both, however, lacked illustrations. Soon after the second edition appeared, Baillie started issuing an illustrated work as a companion to his treatise, *A Series of Engravings, Accompanied with Explanations, which are Intended to Illustrate the Morbid Anatomy of Some of the Most Important Parts of the Human Body* (London, 1799–1803). The engravings appeared initially in ten installments, which were then brought together as a

single volume in 1803 for which the first installment was reissued and with a new title page; they mark a major development in the history of pathological illustrations. The appearance of the first installment of *Engravings* coincided with Baillie's retirement from Great Windmill Street, thus he did not envisage his work to accompany his lectures; rather, he wished to produce a reference available "at any time" for studying and comparing morbid cases. Possibly also because he had given up his hospital position in 1799, his illustrations relied on preserved preparations. A second edition of Baillie's *Engravings* appeared in 1812. Unlike *Morbid Anatomy*, it remained untranslated, yet it had a wide circulation in Europe and beyond and was cited by Meckel, Bleuland, and Cruveilhier among others; in 1865 Charles Daremberg claimed that it was still of use.[6]

Johann Friedrich Meckel the Younger (1781–1833) was a comparative anatomist, embryologist, and pathologist. He studied with two of the leading German physiologists of the time, Johann Friedrich Blumenbach in Göttingen and Johann Christian Reil in Halle. Blumenbach and Reil operated within a broadly Kantian framework, seeking a new synthesis in the biological realm between teleology and mechanism. Meckel took his medical degree at Halle in 1802 with an illustrated dissertation on congenital cardiac malformations, *De cordis conditionibus abnormis.* As he stated in a later work, the family anatomical and pathological collection was especially rich in relevant preparations and he relied extensively on it in his dissertation. His grandfather, Johann Friedrich the Elder, one of Albrecht von Haller's prized students, was a renowned anatomist, while his father Philipp Friedrich was a surgeon who contributed to the *Handbuch der pathologischen anatomie*, which appeared posthumously, one year after his death (Halle, 1804). In 1803, aged twenty-two, Johann Friedrich inherited the imposing family collection.[7]

Soon thereafter Meckel was at the Paris Muséum d'Histoire Naturelle working at the huge comparative anatomy collection with leading French naturalists and comparative anatomists Étienne Geoffroy Saint-Hilaire and Georges Cuvier; he also published an annotated translation of Cuvier's *Leçons d'anatomie comparée.* Thus in both pathological and comparative anatomy museums proved key to his endeavors. In 1808 Meckel was appointed professor of anatomy, pathology, surgery, and obstetrics at Halle, where he remained for the rest of his career. In 1812 he translated, again with annotations, a work on embryology by leading physiologist Caspar Friedrich Wolff. Wolff was a defender of epigenesis, the doctrine of the successive formation and differentiation of the fetus that was the framework of Meckel's views on bridging embryology and pathology.[8]

Meckel's *Handbuch der pathologischen Anatomie* (Leipzig, 1812–18), in three volumes, presents a systematic treatment of diseases ordered nosologically in different sections and classes, but it contains no illustrations. In the year of Waterloo he published an illustrated work on a monstrous double birth, *De*

duplicitate monstrosa commentarius (Halle, 1815). These treatises offered a conceptual framework for a later illustrated work, *Tabulae anatomico-pathologicae*, issued in four installments between 1817 and 1826, which will be our main focus. Meckel was the editor of *Deutches Archiv für die Physiologie* and *Archiv für Anatomie und Physiologie* and published extensively in those journals. In 1827 he was offered the chair of surgery, anatomy, and physiology at the recently founded University College, London, but he declined. The position went to Robert Carswell, another distinguished pathologist whom we shall discuss in chapter 7.[9]

Jan Bleuland (1756–1838) was a younger contemporary of Baillie's; he graduated in 1780 from Leiden University, where he learned the art of injecting preparations and attended lectures by Sandifort, who supplemented his teaching of pathological osteology with the collection of the Leiden Museum. One of Bleuland's teachers was Wouter van Doeveren, whose collection of anatomical preparations went to the University Museum. Bleuland practiced medicine at Gouda and in 1791 started his academic career at the University of Harderwijk, teaching anatomy, physiology, surgery, and obstetrics. In 1795 he moved to Utrecht, where he taught human and comparative anatomy and physiology in Latin, as well as surgery and obstetrics in Dutch. Bleuland published a number of illustrated anatomical works printed in color, showing a special interest in the fine structure of healthy and diseased states of the organs and tunics of the digestive tract; among them is *Observationes anatomico-medicae de sana et morbosa oesophagi structura* (Leiden, 1785), with a plate engraved by Robert Muys.[10]

Bleuland assembled a collection of over two and a half thousand anatomical preparations of human and animal remains, both healthy and diseased; he relied on the assistance of Petrus Koning, whom he had trained as his attendant and as a surgeon from 1800, when the boy was thirteen. Bleuland was envious of the large number of preparations assembled by Johann Gottlieb Walter in Berlin, who had access to over eight thousand cadavers and whose huge collection was bought by the state. Bleuland's own collection, however, was not something anyone could assemble in a short time and was remarkable in its own right. In 1826 Bleuland began producing an inventory, *Descriptio musei anatomici* (Utrecht, 1826), starting from human blood and the heart; he then produced a more detailed illustrated catalogue of selected preparations, *Otium academicum* (Utrecht, 1826–28). His museum, including some of the illustrated preparations, still exists in Utrecht.[11]

There are significant common features among our authors: all shared expertise in medicine, anatomy, and surgery. Moreover, they all assembled and had access to large collections of pathological preparations. Besides his personal collection and those of his uncles, Baillie relied on preparations from other London collections. Meckel was a scion of a distinguished medical family who owned an extensive anatomical and pathological museum that sur-

vived the ravages of the Napoleonic wars because Napoleon himself made the Meckel residence his temporary headquarters. Following Johann Friedrich's death, his widow sold the collection to Halle University. An idea of the scale of the collection can be gained by a comment by German pathologist Hermann Lebert, who in 1857 compared the Halle Museum to that of Leiden University.[12] Lastly, Bleuland's extensive private collection was purchased by the king for the Utrecht University Museum. He relied on the "arte Ruischiana" of injections with colored fluids both to highlight the fine vascular structure of his preparations and to preserve them. Thus the combination of different techniques involving injections and immersion in spirit of wine enabled the establishment by individuals, universities, and learned societies of private collections and museums of human and animal body parts, as well as—crucially for us—rare and instructive pathological preparations. It is through such collections that preparations could be studied and compared, lesions could be differentiated and classified, and "anatome pathologica" became "picta."[13]

THE BOOKS AND THEIR ILLUSTRATORS

Publishing an extensive collection of illustrated pathological plates rather than a limited number of cases as they presented themselves posed many difficulties in terms of planning and execution. Producing a meaningful comprehensive work required extensive experience and the ability to compare and evaluate a wide range of items; moreover, encountering specific diseases may be a once-in-a-lifetime opportunity. Therefore it is not surprising that early attempts relied on wet, dry, and injected preparations preserved in museums or private collections. Moreover, those works could not have been produced without the technicians who helped prepare the specimens and the artists who drew and engraved them.

Baillie's treatise differed both from the at times detailed but random cases described in periodical publications and pamphlets and from Morgagni's huge and systematic work, whose descriptions of lesions were often cursory. Baillie focused on rare and common structural lesions and eschewed both case histories and symptoms, ignoring the characteristics of individual patients, such as their age, sex, profession, and temperament. While *Morbid Anatomy* was much leaner than *De sedibus*, both Morgagni and Baillie followed an anatomical order, organ-by-organ rather than disease-by-disease. Baillie's second edition in 1797 added at the end of each section a brief list of symptoms beside material from Soemmerring's 1794 expanded German translation. Baillie's focus on describing "more minutely" the diseased structures was a shift from Morgagni's clinical approach, which included brief characterizations of the patients' case histories and focused on establishing correlations between symptoms and lesions. In this regard Morgagni's indices are revealing; the first and fourth provide a list of the contents and a subject index; the second was

devoted to symptoms, enabling physicians to determine the corresponding internal lesion; the third was devoted to postmortem findings, enabling anatomists to determine the symptom corresponding to internal lesions.[14]

Baillie relied on the collections of surgeons and anatomists John Heaviside, Henry Cline, Alexander Monro *secundus*, and William Cruikshank, as well as physicians Charles Combe and Robert Hooper. By giving ample credit to the owners of the preparations, Baillie was also enticing them to lend him significant items for his work, which in this way also served as an advertisement to the owners and their collections, some of which were noteworthy in their own right. Five years after Cruikshank's death in 1800, his collection was purchased by the czar and was placed in the Medico-Chirurgical Academy in St. Petersburg; preparations had a commercial value and were often auctioned in London. Occasionally, Baillie reproduced some items from other publications; for example, he relied on Robert Hooper's *Observations on the Structure of the Intestinal Worms in Humans* (1799). Hooper's original plates were striking productions relying on drawings based on microscopic observations. In his turn, Hooper had access to William Hunter's museum, then run by Baillie, in which he found preserved intestinal worms relevant to his work.[15] In Edinburgh Monro *secundus* had an extensive collection, which was then augmented by his son Alexander Monro *tertius*, so as to provide an extensive documentation of diseases and their progress. With the exception of Monro's preparation, which was drawn by the Edinburgh dissector and anatomist Andrew Fyfe, all the items reproduced in Baillie's work were in London, which housed a veritable treasure trove of pathological preparations, which had been assembled, traded, auctioned, inherited, and expanded throughout the eighteenth century, notably in the circle of William Hunter and his disciples. Baillie's reliance on London collections enabled him to present his series of engravings following an order and a plan, as he was keen to stress.[16]

Preservation techniques available at the time presented different problems: injected items could involve color, but this depended on the matter that was injected and could lead to their appearing rather artificial. Preservation in spirit of wine presented problems too because it obliterated color. Further, the preparations had to be carefully sealed because spirit of wine is very volatile. It was probably because unsealing the jars was a cumbersome, expensive, and time-consuming procedure that risked damaging the delicate contents that early representations showed the preparations in the jars, as we have seen in the case of Ruysch; some of Trioen's plates too showed items that way, though this format became progressively less acceptable and Baillie avoided it. While his choice would have been problematic for handling the preparations, it also opened the door to more extensive and systematic visual representations and was adopted by Meckel and Bleuland.[17]

A Series of Engravings relies on watercolors of wet and dry preparations by William Clift; as curator of John Hunter's museum and anatomical illustra-

tor, Clift would have been especially qualified to handle and draw the preparations. The plates were engraved by James Basire (probably II), who like his father was engraver to the Royal Society, his student William Skelton, and James Heath.[18] While Clift was paid one guinea for each drawing, the engravers received five guineas per plate. Among Clift's still surviving watercolors some are black and white, some tawny, and one employs a blue wash. As Baillie pointed out in the advertisement to his work, in order to attain "distinctness and fidelity of representation," he sought out artists and engravers not only adept at their work but also with specific anatomical expertise: Skelton was well known to the anatomical public as the illustrator of John Hunter's *A Treatise on the Blood, Inflammation, and Gun-Shot Wounds* (London, 1794), a seminal work on surgery and tissue pathology; he had also provided the color engravings for Edward Jenner, *An Inquiry into the Causes and Effects of the Variolae Vaccinae* (London, 1789), the celebrated treatise on cowpox vaccination. Heath had engraved the illustrations for Busick Harwood, *A System of Comparative Anatomy and Physiology* (Cambridge, 1796).[19]

Baillie's illustrations consist of seventy-three black-and-white engravings. Much like Ruysch's work, but unlike later publications such as Cruveilhier's *Anatomie pathologique*, Baillie had most of the material he needed at his disposal from the start: the main reason to publish in installments was practical and financial, to test the waters and see whether the public was interested in his novel enterprise, and to make it easier to purchase as well. Conceptual issues went alongside technical challenges in the visualization of disease: the shift from healthy to diseased parts meant that a new language of visual representation had to be invented to suit the requirements of the new field. Engravings of diseased bones highlighted what could be represented with regard to textures and smooth versus corroded surfaces; now the challenge was the pathological changes of textures of soft parts, from the brain and the lungs to the liver and spleen. In the case of anatomy remarkable engravings could render the different textures of bones, muscles, and membranes, as for the celebrated plates in William Hunter, *Anatomy of the Human Gravid Uterus*, for example; pathology plates had to render the same surfaces as in anatomy and in addition all the variations due to disease as well.[20]

A feel for the financial side of Baillie's publication endeavors can be gained by comparing the prices of his books: his 1793 *Morbid Anatomy*, over three hundred octavo pages without illustrations, went for 6*s*; in the early 1800s the second expanded edition, nearly five hundred octavo pages still without illustrations, was marked at 7*s*. Baillie's *Series of Engravings* was in quarto: the first installment in 1799, with six plates, went for 12*s*; the last in 1803, with eight plates, went for 18*s*. Hence the complete *Series of Engravings*, with over seventy plates, would have gone for over 7*l*, more than twenty times the cost of any edition of *Morbid Anatomy*. For wealthy physicians such as Baillie, who in the

early 1800s was making 10,000*l* annually, this would have been no problem; matters, however, would have been very different for impecunious medical students who in those years paid a few guineas—3 to 5—for a course of lectures on anatomy with Charles Bell. For comparison's sake, in 1800 Clift was appointed conservator of the Hunterian Museum at an annual salary of 80*l*, which was a marked improvement on his previous situation; yet, the cost of *Series of Engravings* exceeded his monthly salary.[21]

Baillie's work, including his *Engravings*, which was not translated, exerted a considerable impact not only in Britain but on the Continent too. At Halle in *De duplicitate monstrosa commentarius* (Halle-Berlin, 1815) Meckel announced his ambition, following the regained freedom, to produce an illustrated pathology treatise as a German response to those by Sandifort and Baillie; he plausibly saw his treatise as giving his museum a status comparable to the London and Leiden ones. Taking the lead from eight plates left by his grandfather on a monstrous birth and engraved by Christian Benjamin Glassbach, who had engraved plates for Ludwig, Meckel's plan was to represent most exactly and systematically all aberrations from the normal state in external and internal form, or textures. His project took shape in the form of four folio installments—though presumably more were intended—of *Tabulae anatomico-pathologicae* with thirty-three plates published between 1817 and 1826. Meckel was responsible for many of the drawings, which were subsequently engraved by different artists, including A. G. Eberhard, Carl Frosch, and Johann Carl Bock; they had engraved anatomical and pathological plates previously, though Bock was also as a botanical illustrator.[22]

Meckel provides useful reflections on the organization of his *Tabulae*. While Baillie had followed an anatomical order, Meckel preferred a nosological structure, and indeed he adopted it in other works on pathology, such as his *Handbuch*. In the *Tabulae*, however, because of the emphasis on images, he followed an anatomical structure; he also claimed that since the material was organized around plates, readers could easily read the work with the plates in a different order. Similarly to the first edition of Baillie's *Morbid Anatomy*, Meckel avoided not only case histories but also symptoms, given that his emphasis was more on classification than on relating symptoms to lesions. Unlike Baillie, however, Meckel discussed the relevant pathology literature, with special emphasis on visual representations of lesions; thus his work is a rich and useful guide to previous studies. His four installments were devoted to the heart, vessels, the digestive system, and lastly hernias and intussusceptions—whereby a portion of the intestine passes within another portion. His reason for starting from the heart was that he had an especially good collection of diseased preparations and many distinguished physicians had studied it.[23]

Bleuland's *Otium* consists of three parts dealing with anatomy and physiology, comparative anatomy, and pathological anatomy, respectively; they

appeared in twelve installments between 1826 and 1828. The illustrations of the first two parts include thirty-six copper engravings printed in color and finished by hand; those of the third part consist of thirty-five black-and-white lithographs and one color engraving; the exceptional pathological plate in color will be discussed below. The separation between physiological and pathological sections, with his distinction between color engravings versus black-and-white lithographs, is quite striking; all his plates, though, relied on preparations.

Only the first plate is signed by the Utrecht landscape and town scene artist Jan Hendrik Verheyen (1778–1846) as draftsman and H. De Bruyn (whose details are unknown) as engraver. While striking for the preparation and printing techniques, the overall impression of Bleuland's colored plates is affected by the artificial look of the images: although Bleuland often rejoiced at the beauty of his colored injections, his colors look like implausible renderings of what an anatomist may find in the morgue, though they were possibly true to his preparations. The scope of his physiological and comparative sections, as in previous publications, was to highlight the physiological significance of his structural findings; in this respect, by highlighting the fine vascular structure, or what he called the *anatomia subtiliore*, in the tunics and membranes of his preparations, his presentation was perfectly suitable. Despite his criticism of the plate of the intestinal vessels in Albinus's work, due to Jan L'Admiral, there was a noticeable resemblance in their enterprises for the emphasis on the vascularity of tissues, the usage of multiple plates for each image, and the color printing. L'Admiral relied on mezzotint, however, whereas De Bruyn used other intaglio techniques.[24]

Lithography was the preferred medium for pathology presumably for reasons of cost, because most preparations were not colored through injections, and because the versatility of lithography enabled the artist effectively to capture the key features, such as changes in structure and especially texture. A notable feature of Bleuland's work is that he often tells us how his preparations were made, which vessels he injected, which colors he used, how slowly he injected them, and at times which substance he used, such as mercury.[25]

All three characters used large plates, quarto for Baillie and Bleuland, folio for Meckel, though they did not make it a rule to show specimens life-size; they all issued their works in installments. Baillie and Meckel relied mostly on recognized artists with a background in anatomy, whereas Bleuland's pathology plates were unsigned. Despite the attention and care to the quality of the illustrations, none of the authors we have considered worried about the appearance of letters on the plates; the concern we have encountered with Cheselden, Bonn, and Sandifort was superseded. The illustrations document the transition from more traditional engravings of Baillie's and Meckel's works to the newer methods that were becoming more prominent at the beginning of the nineteenth century, such as color printing and lithography, employed in

Bleuland's *Icones*. Although artists relying on traditional methods had developed remarkable skills, the new techniques could represent textures without cross-hatching and slowly gained greater popularity.

DISEASES AND THEIR REPRESENTATIONS

The structure of Baillie's *Series of Engravings* mirrors that of his *Morbid Anatomy*; both move from pericardium, heart, and lungs to the urinary system, the organs of reproduction, and the brain, rather than relying on diseases. It is easy to establish a correlation between the twenty-four chapters of Baillie's 1793 work and the ten installments of the *Engravings*. As with his *Morbid Anatomy*, the *Engravings* too eschews case histories to focus instead on the diseased organs themselves; at times, however, Baillie provides an account of the typical history and progress of the lesion, with valuable clinical signs. In one instance, for example, he describes the slow effect of kidney stones on the kidney, arguing that its substance becomes similar to a thin membrane; in another instance he anticipates the likely course of the lesion if the person had lived a few weeks longer, namely that the layer of lymph covering the capsule of the liver would have turned into a transparent membrane. By focusing on structural lesions, Baillie moved away from traditions privileging causes and symptoms, laying new foundations for pathology. In one instance he identified a "living principle" responsible for the formation of blood vessels in extravasated matter, though such concerns take the back seat in his work.[26]

Examining the work of his predecessor, Baillie identified a problem in Morgagni's lack of focus, whereby minor details obscured the main character of the condition under examination. Indeed *De sedibus* offered a plethora of details; at one point, for example, Morgagni reported the opinion that children born from an Italian mother and an Armenian father are often affected by complaints involving blood spitting. He often sought to correlate the sides of symptoms and lesions—left or right, as in diseases affecting the lungs or in apoplexy, for example, where the lesion is on the opposite side of the paralysis.[27] In *De sedibus* one occasionally finds rather vivid descriptions, even involving color. In two separate passages, for example, Morgagni states that a liver was externally "in colour, like a reddish marble, variegated with white"; in the second it was "variegated like marble, and having not only small white spots, but also spots of the color I spoke of just now," namely the color of tobacco.[28]

While it seems plausible that in some instances Morgagni may have welcomed the inclusion of images, matters were conceptually more complex. In one instance a woman of forty, of a yellowish complexion, whose right side of the abdomen felt hard to the touch, complained of pain in the stomach after eating. After she died, the stomach was found to be narrow in the middle, almost as if it was double. Her condition, however, was due to the liver, which was so enlarged as to protrude towards the stomach; its right lobe was hard-

ened and contained several whitish bodies, the largest of which were the size of hazelnuts. Although here Morgagni describes the location, size, and color of anomalous formations, his main focus was on the identification of the seat of diseases and the real organ affected. Despite the woman's complaint of pain in the stomach, her yellowish complexion and the hardness on her right side—felt through physical examination—pointed to the liver, a suspicion confirmed by the postmortem. In this instance Morgagni, like a clever detective, identifies the real culprit from his astute visual and physical examination rather than from the patient's own account.[29]

The sources Morgagni had at his disposal from his teacher Valsalva and those he contributed himself were almost exclusively in the form of the well-established genre of case histories. In order to focus more closely on changes of morbid structures, however, Baillie could rely on a huge number of pathological preparations, especially William and later John Hunter's, besides those he collected himself, which he could systematically compare "at any time" to cases he was encountering in his hospital experience; this constant availability of thousands of specimens, almost a three-dimensional reference library, was key to Baillie's project. Thus both Morgagni and Baillie continued their teachers' tradition, collecting case histories and preparations, respectively, and both relied on those collections only at a later stage. While Morgagni had almost exclusively written reports, with preparations making cameo appearances, Baillie could go back to preparations and systematically compare them to the cases under examination; this practice enabled him to go beyond mere localization and develop a new pathological visual dictionary based on detailed structural descriptions of lesions.[30]

In the preface to his expanded translation, Soemmerring highlighted the key role of preserved specimens and compared Baillie's descriptions to those in his own collection and those he had seen in museums from Edinburgh to Vienna; actually, Soemmerring had sold a portion of his collection of diseased bones to the Vienna Museum, where it was used for instructing surgeons. According to imperial surgeon Giovanni Alessandro Brambilla, the Vienna collection of diseased bones was larger than that at the Leiden or the Hovius museums. Since Baillie had not provided references to the literature, Soemmerring added an imposing apparatus of notes, over five hundred, systematically referring to the relevant pathological literature. Further, and crucially from our perspective, Soemmerring stated that he valued visual representations and provided extensive references to illustrations in print, from Ruysch's *Observationes* to Sandifort's *Museum*, and a host more. Since *Museum* appeared in 1793, the same year as Baillie's work, and Soemmerring's preface is dated December 1793, one can only wonder at his speed and the value he attached to Baillie's treatise. His extensive notes document how he studied Baillie's work and at the same time provided a powerful tool to contemporary readers, at least those equipped with a large library.[31]

Crucial as they were, museums did not lead automatically either to more accurate descriptions or to representations in the specific form adopted by Baillie. For example, Leiden too had an extensive museum, though Sandifort worked in a more established field, providing detailed textual and visual documentation mainly of bone conditions, an area that had already been largely mapped. By contrast, Baillie's work had a stronger investigative component: it sought to identify and to compare different types of lesions that previously had not been distinguished from each other, certainly not on such a scale and with the same level of accuracy and attention to detail, or to group together analogous ones in different organs. Further, eschewing case histories enabled him to focus on comparing structural lesions in different subjects rather than studying their diachronic connection with symptoms. In a significant difference from the nosological tradition, Baillie was uninterested in naming conditions; his focus was on accurate descriptions of morbid appearances.

Baillie explains that he was interested in what he called the "real changes of structure which are produced by disease" and therefore focused not simply on the general external appearance of morbid parts but also on their cross sections. His declared aim was practical: to distinguish more carefully different diseases and to find their exact location in large and small body parts. With his emphasis on the accuracy of visual representations, Baillie was also aware of the limitations of the traditional medium of engravings; he pointed out that some changes are "of so little consequence" as to be not worth representing; others can be better described in words; others still involve changes that cannot be represented by engravings—as examples he later refers to the initial stages of the inflammation of the lungs or the contents of a peculiar cyst. The textures of soft parts, as opposed to shapes, were difficult to render. Color was an issue too: since color is lost in preparations and would have had to be supplied relying on memory and thus imperfectly, he decided to leave the engravings not colored. It seems plausible that Baillie would have found Willan's work on cutaneous diseases, whose first installment had appeared in 1798, just one year before his own first installment, an inspiring and daunting exemplar, given that Willan's artists had relied on color illustrations. Willan's work, however, stemmed from the nosology tradition, as we are going to see in chapter 5. Despite its exclusion from the images, several comments in Baillie's text refer to color. The first illustration in the first fascicle, for example, shows a diseased heart covered with a porous layer of lymph due to violent inflammation of the pericardium. Baillie describes the general appearance of the lymph when fresh—thus relying on memory—as very light yellow or of a buff color. Implicit in his statements and descriptions was the admission that color was relevant and would have been a desideratum from his perspective.[32]

In a celebrated passage Baillie identified a disease *sui generis* in the liver and argued that the "tubercles" found in that organ are "commonly produced by a long habit of drinking spirituous liquors"; the clinical reference in this case

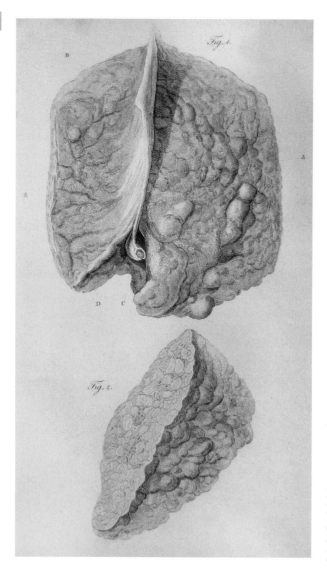

Illustration 3.1
Baillie, *Engravings*,
1800, fascicle 5, plate
II, external surface
(top) and cross
section (bottom) of
livers studded with
tubercles. Water-
color by William
Clift, engraving by
James Basire.

is exceptional. Based on the color and texture of the affected organ Baillie dis-
tinguished the present condition, which was only improperly called scirrhous,
from others, which were represented on different plates. He used the term
"tubercle" frequently for a number of formations; at times he stated that they
were scrofulous, thus specifying the condition. He argued that the affection
he identified presented the most common type of tubercles found in the liver.
The two figures (illustration 3.1) show portions of the surface and cross section
of the liver, highlighting that the tubercles are found both on the surface and
through its substance. Baillie added to the first figure, from a preparation in
Heaviside's museum, one from his own collection, in which he sectioned the
liver to show its internal structure. Neither Baillie nor Soemmerring referred to
Browne's 1685 essay in the *Philosophical Transactions*. The differences between
Browne and Baillie are significant: following Malpighi, the former was inter-

ested in the condition for what it revealed about the healthy liver (illustration 1.11), whereas the latter focused on its specific pathological characteristics— and in this case on a feature of its typical case history—to distinguish it from other morbid conditions affecting the liver.[33]

One of the most challenging plates shows a case of cancer of the stomach at the top and the effects of gastric juices at the bottom (illustration 3.2). A close examination of figure 1 at the top highlights the complexity of the challenge faced by Clift and Heath: AAA and B show portions of the stomach and of the duodenum, respectively, sound in structure; CC highlights that at the edges of the stomach near the pylorus the texture is of a "gristly hardness" and the muscular coats and the cellular membrane between them are considerably thickened; D shows an irregular fold in the inner membrane of the stomach, hard and thickened by the disease; E shows a hard excrescence growing from the inner membrane of the stomach; FF are two large ulcers; and finally GG are two masses supported upon a broad stalk growing from the inner surface of the stomach. The two white excrescences that immediately attract our attention are mentioned only at the end of a long list of normal and pathological features, all different among themselves in thickness, texture, and general appearance. Notice the attempt to render not only thickened and abnormal structures but also textures, several of them, highlighted by sinuous continuous lines; broken, bent, and straight ones; and cross-hatching, producing a huge variety in an especially striking print. Also worth noticing is the sectioning of the specimen, which offers to the viewer its key features.[34]

The figure below (illustration 3.2, figure 2) shows the effect of gastric juice on the stomach after death, thus it is not a representation of a diseased state; here the stomach has been "inverted", to highlight the effect on its inner membrane. Baillie states that the stomach looks as if it had been steeped in acid for some time and it appears very different from any effect due to disease. In addition to the effective rendering of transparency, this figure is of interest for its emphasis on the difference between genuine diseased states and conditions arising after death, a topic that had been raised by John Hunter and that troubled several pathologists.[35]

Given the frequency of phthisis at the time, the plate of pulmonary tubercles is especially noteworthy; Baillie established an unequivocal link between the lesions he depicted and "pulmonary consumption." The two preparations come from his own collection and show portions of the lungs studded with tubercles varying in size and shape, more advanced in figure 3 than in 2 (illustration 3.3). Baillie points out that in advanced cases tubercles appear in different stages in the same preparation, some having reached suppuration, where pus is discharged. The last decades of the eighteenth century had seen a growing awareness of the relation between tubercles and phthisis, one that was not especially explicit in the entry on "Phtisie" in the *Encyclopédie* or in Morgagni's *De sedibus*, for example. Baillie's description helps establish a three-fold cor-

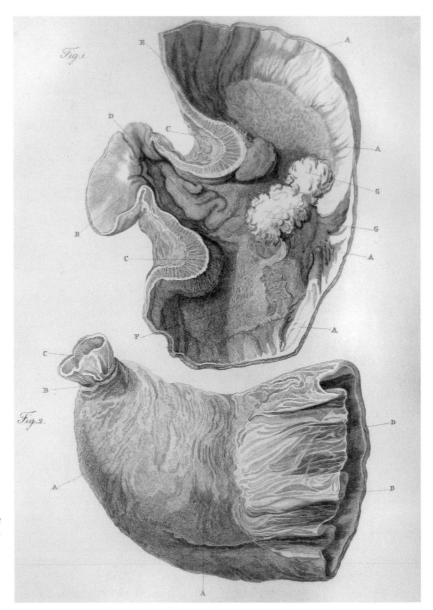

Illustration 3.2
Baillie, *Engravings*,
1800, fascicle 3, plate
VII. Figure 1: cancer
of the stomach; figure
2: postmortem effects
of gastric juice on the
stomach. Watercolor
by William Clift,
engraving by James
Heath.

relation among symptoms, verbal descriptions of the postmortem lesions, and
their visual representations. In two especially interesting cases of scrofulous
tubercles in the spleen and kidneys, he unequivocally stated that they were
structurally identical. Those in the spleen were less common than in the lungs
but "they are *precisely* of the same nature in both" (my emphasis). Similarly, in
the case of scrofulous tubercles in the kidneys, he stated that they "are *exactly*
of the same kind with the scrofulous tubercles of the lungs" (my emphasis),
though they too occur more rarely. Relying on the structural identity among
postmortem lesions, he established a connection among scrofulous tubercles

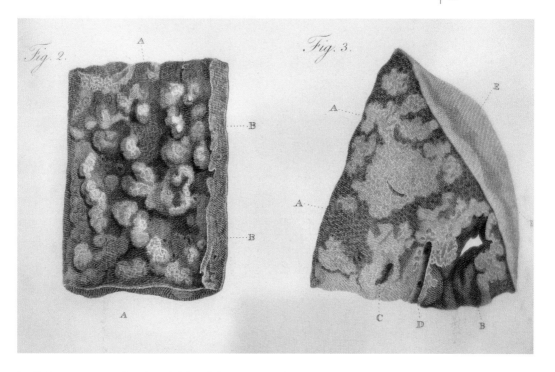

in different organs, thus implicitly raising the question of their common origin and possibly treatment despite their different locations. In the first edition of *Morbid Anatomy* Baillie recognized the identity between scrofulous tubercles in the lungs and spleen, though only in the second edition did he recognize that between lungs and kidneys.[36]

In three other instances Baillie identified strong structural parallels between scrofulous "absorbent glands," or lymph nodes, and the scrofulous tubercles of the jejunum, liver, and testicle. For the "scrofulous masses" in the jejunum Baillie stated that they "*resemble* in their texture a scrofulous absorbent gland"; those in the liver "*resemble exactly* in their texture a scrofulous absorbent gland" (my emphases). Baillie adds that at times they convert to scrofulous pus, though not so frequently as in the lungs, thus he established a link with pulmonary tubercles. Also scrofulous testicles "resemble exactly" in structure scrofulous absorbent glands. In all these cases morbid anatomy enabled him to establish structural links among scrofulous tubercles in different organs across the entire body. In his 1825 introduction to Baillie's *Works*, surgeon James Wardrop argued that Baillie had shown that scrofulous tubercles can affect many organs, had described their development, and had distinguished them from other conditions. He also added: "One disease sometimes appears to excite another; and hence small-pox, measles, and syphilis, are often the immediate cause of scrofulous affections." Unfortunately here Wardrop does not tell us how a disease excites another and through what process so many different conditions are the "immediate cause of scrofulous

Illustration 3.3
Baillie, *Engravings*, 1799, fascicle 2, plate IV, figures 2 and 3, lung tubercles associated with phthisis. Watercolor by William Clift, engraving by James Basire.

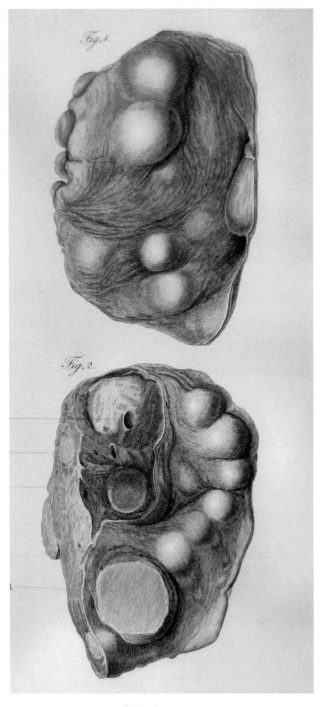

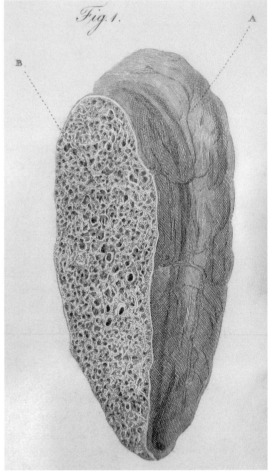

Illustration 3.4
Baillie, *Engravings*, 1799, fascicle 2, plate
V, different types of tubercles in the lungs.
Watercolor by William Clift, engraving by
James Basire.

Illustration 3.5
Baillie, *Engravings*, 1799, fascicle 2, plate
VI, figure 1, lung with enlarged air cells.
Watercolor by William Clift, engraving by
William Skelton.

affections," namely whether these are merely clinical correlations he established or in fact he is suggesting a deeper link. He also affirmed that scrofula is hereditary and denied that it is contagious.[37]

Baillie described other types of "tubercles" in the lungs, which are light brown in color, of a uniform texture, and very uncommon. He stated that it was not known whether these different tubercles ran into suppuration—this being a characteristic feature of scrofulous ones (illustration 3.4).[38]

Another plate (illustration 3.5) shows a rare condition, exhibiting the outer surface and cross section of a portion of a lung from his own collection. Baillie claimed that the air cells are so enlarged as to resemble those of amphibious animals; he had already identified and described this condition in *Morbid Anatomy*, though here the image adds a level of immediacy and helps identify it and distinguish it from others. In all these instances Baillie's concern was no longer merely the location of the lesion but also its precise structural identification and characterization.[39]

The fact that Baillie routinely identified the provenance of his specimens suggests that his illustrations portray individual cases, warts and all, rather than idealized cases or typical forms of this or that lesion. Baillie frequently pointed out that many lesions were very uncommon, thus making it even more unlikely that the illustrations would represent an idealized or typical case. But we also have direct evidence about the nature of his illustrations. For example, in one instance he regretted that the preparation was less than ideal, yet he made no attempt to modify it for didactic purposes; in some instances, such as when he discussed a case of pancreatic calculi or of a polyp in the bladder, Baillie stated that the cases he was discussing were unique in his experience. Other instances point even more directly to the individual nature of his illustrations: in a figure showing bony formations on the aorta, he stated that the artery from which the figure was taken was dry, since in "a wet preparation of this kind, the spots of bone are hardly observable"; similar comments apply to a case of prolapsed uterus. Finally, in the legend for a figure depicting an obstruction of the jejunum, Baillie added the following footnote: "The preparation from which this drawing was taken, is preserved dry, and hence in the engraving, as well as in the drawing, there is some appearance of transparency."[40]

While Baillie's views on morbid anatomy can be characterized as empirical and tentative, Meckel's approach was conceptually more complex, deeply shaped as it was by the scientific and philosophical concerns of his mentors and colleagues, such as Reil, Blumenbach, Cuvier, and Geoffroy Saint-Hilaire. Meckel's study and classification of disease in particular was interwoven with reflections on morphology, embryology, and taxonomy. Meckel argued that even if one put together everything Sandifort and Baillie had done, one would still lack a complete collection of the aberrations of human nature. His emphasis was not on freshness, as with later commentators, but on completeness, a concern that may seem overambitious to us and that stands in stark contrast

to Baillie's caution: while the Scot claimed that he was making the first steps in a new and difficult field and was painfully aware of the complexity of the task ahead, the German anatomist implied that a comprehensive taxonomy of diseases was within his grasp. Clearly, their understanding of their respective enterprises differed: Meckel had for pathological states of the adult human the same ambition he had shown for fetal abnormalities, namely to seek an empirically based largely morphological taxonomy.

One can gain a sense of his project from his dissertation, *De cordis*, in which he provided a taxonomy of heart abnormalities based on four notions: position, number, shape, and texture. In an 1805 article Meckel again took the lead from the heart to advocate a unified approach bringing together pathological anatomy and congenital malformations due to *Bildungsfehler*, or errors in the formation process. He saw malformations as opportunities to investigate that formation process and the relations among different organs and systems. Meckel argued that congenital malformations belonged to pathology because variations from the normal conditions of an organism or organ should be treated together regardless of whether they occur before or after birth. He identified a broad correlation between malformations and comparative embryonic development, because an imperfectly developed organ would resemble developmental stages of different species. To a large extent his pathology hinged on malformations and morphology, and to this end he also included animal preparations, such as a heart from a calf, and compared diseased organs to organs from different species, such as the stomachs of a dolphin or a seal. His ambition was to lead scholars from singular cases to general laws.[41]

In *Handbuch der pathologischen Anatomie* (Leipzig, 1812–18) Meckel presented a more elaborate taxonomy of diseases: the primary structure was nosological, followed by anatomical subsections on specific body parts. The main partition was between aberrations of form, treated in the first book, and aberrations of texture and composition, treated in the second. After this straightforward dichotomy, readers encounter a plethora of sections and subsections, a veritable maze that underpins Meckel's ambition to provide a complete taxonomy of diseases; the *Tabulae* rely on classes introduced in the *Handbuch*.[42]

Much like Baillie, Meckel too emphasized the difficulty in rendering textures and colors as opposed to external form. However, he also had a preference for external form over other changes and criticized Baillie for having neglected it in favor of a close analysis of changes in degrees of cohesion and texture, which are harder to represent visually and which he believed mostly pertained to the same species, whereas structural changes are more varied. Such comments highlight Meckel's predilection for morphological analyses and classifications.[43]

Illustration 3.6, unfortunately without attribution, is one of the most technically challenging and elaborate in the *Tabulae*, a veritable tour de force in

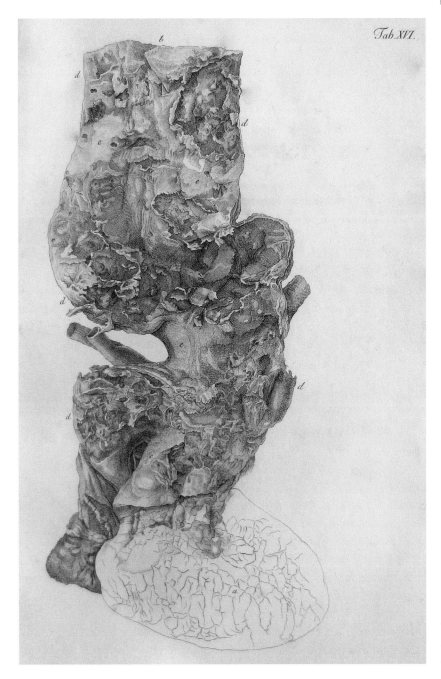

Illustration 3.6
Meckel, *Tabulae*,
1820, plate XVI,
diseased aorta.

rendering different textures: it shows at the bottom in outline the heart *a*; at the center of the plate is a diseased aorta *b* with the portion between the serous and fibrous tunics covered by small gelatinous or cartilaginous plates, while many portions *ddd* show extensive ulceration.[44]

It may not come as a surprise that Meckel had a special interest in diverticula, which present precisely those structural alterations he was so eager to

Illustration 3.7
Meckel, *Tabulae*, 1822, plate XXI, figure 9, diverticula.

Illustration 3.8
Bleuland, *Icones anatomico-pathologicae*, 1828, plate III, pleural inflammation. Lithograph; no attribution.

classify. Illustration 3.7 shows a particularly interesting case, involving several small and large ones in the jejunum. The lighting gives a three-dimensional effect, almost like a defective air chamber in a bicycle tire. Meckel singled out this example of diverticulum as representative of different types.[45]

Bleuland started producing his pathological plates in the wake of Meckel's *Tabulae*, though he did not mention Meckel in his six pathological sections. Bleuland followed an anatomical rather than a nosological order and proceeded roughly from the heart, pericardium, and lungs to the organs of digestion and generation. While providing a description of the specimens and their significance, the text seeks to include case histories when possible, complete with details about the therapies. Despite this difference with Baillie's approach, the

Scot's work was taken as an exemplar and praised. In some instances Bleuland even highlighted the similarities between his own and Baillie's specimens, thus establishing parallels among their collections.[46]

Illustration 3.8 shows a large portion of the right lung of an adult man who died of peripneumonia; *aaa* shows the internal portion of the lung, which was healthy; *bbb* is its exterior membrane, affected by inflammation and covered by pseudomembranes formed by the fibrous portion of blood and exhibiting vascularization; *ccc* at the bottom are the edges of those pseudomembranes. Although Bleuland lacked a case history, he deemed the specimen sufficiently important to include it for the light it shed on the "vis reproductiva" of nature on those fibrous portions of blood; he also compared his case to one Baillie had discussed in *Engravings*.[47]

Bleuland's only pathology plate in color addresses similar philosophical concerns, notably the ability of extravasated blood to form blood vessels. Bleuland saw a case of pneumonia as significant to physiology as well as to

Illustration 3.9
Bleuland, *Icones anatomico-pathologicae*, 1828, plate XXXVI, diseased ovary. Lithograph; no attribution.

pathology: he prepared it with injections to highlight nature's processes and reproduced it using a color intaglio as if it were one of his physiology plates; it shows that, even in a diseased state, nature acts through a reproductive force repairing the damaged parts, so that even if one cannot revert to the organ's original form, nature produces a new organic apparatus. Specifically, Bleuland argued that all the portions of the lungs affected by inflammation were covered by a membrane formed by the exudation of lymph; that membrane showed a vascularization highlighting that even in disease nature acts through a plastic formative force.[48]

Bleuland's last pathological plate (illustration 3.9) shows the right ovary of a woman who died in 1825. Her body was dissected following her wishes by Koning and Bleuland. Besides being much enlarged, the ovary presents ossified potions at *eee*; *bbb* is the ligament to the uterus; g is an opening of the membranous portion intended to show the internal portion at *k*. Figure 2 at bottom right shows a mass of long hairs mixed with a fatty and waxy substance found inside the ovary. As in Baillie's stomach cancer (illustration 3.3) and Meckel's ossified aorta (illustration 3.6), here too the artist faced the task of rendering exceedingly varied textures, this time succeeding through lithography rather than intaglio techniques.[49]

The works by Baillie, Meckel, and Bleuland open a new chapter in the history of pathological illustrations: as the first treatises seeking to offer extensive, and to some extent systematic, visual representations of morbid affections of the soft parts, they would have provided contemporary readers with an opportunity to study scores of morbid alterations they may have never seen directly. But all readers would have encountered for the first time numerous plates, nearly one hundred and fifty in the three volumes together, attempting to offer extensive representations of postmortem findings. In 1799 Baillie started publishing the first installments of his *Engravings* as an experiment, suggesting that he may stop if they did not sell; unlike Cheselden's *Osteographia*, which had no sequel, Baillie not only completed his project, but *Engravings* went also through a second edition in 1812. Within three decades of Baillie's initial move, Meckel and Cruveilhier could state that visual representations of diseased states were not simply desirable but indispensable.

While Morgagni had relied on case histories and written accounts of postmortems, all three works discussed here were based on specimens from museums and collections—on the example of what had earlier happened for bone diseases. Baillie was able to identify empirically by close examination differences and patterns with specific textural and structural similarities among those morbid affections: for example, tubercles in the liver form distinct groups depending on their color and texture, with a specific type being associated with abuse of alcoholic beverages; tubercles in the lungs are precisely of

the same nature as scrofulous formations in other parts of the body, implicitly raising the issue of their common origin. More broadly, Baillie's structural findings raised the issue of the individual nature of disease and of its relation with the corresponding specific lesions found at postmortems, thus pointing to a new order in the complex world of diseases and lesions in which careful study of, and differentiation among, lesions was at least as crucial as localization. While his approach resonates with later views in pathological anatomy, at the time it did not have a privileged status compared to Meckel's morphological concerns and Bleuland's emphasis on therapies and vitalism. Further, Wardrop's comments in the 1825 edition of Baillie's *Works* highlight that although many affections were clearly distinguished from scrofulous tubercles on structural grounds, diseases such as smallpox, measles, and syphilis were seen in some way as their "immediate cause."

The three scholars we have investigated shared broadly similar philosophical concerns in addition to an emphasis on visualization. In a brief passage from *Morbid Anatomy*, Baillie pointed out that in cases of inflammation of the pericardium there is an extravasated pulpy matter on its inner side; the fact that blood vessels run through this matter is proof of the existence of a living principle in blood, as John Hunter had argued. Such vitalistic views, however, took a comparatively minor role in his *Engravings*, where the focus was less on philosophical matters than on a close description of the visual data. Philosophical concerns feature more prominently in the other works we have reviewed. Meckel referred to aberrations arising from a defect in the "nisus formativus," or formative endeavor, for example; his teachers Blumenbach and Reil were among his philosophical sources here. Bleuland too acknowledged his debt to Blumenbach; his attempt to present an integrated approach including physiology and pathology together is revealing in this regard.[50]

London, Halle, and Utrecht were the centers in which the collections were assembled and relevant works produced: London and Halle had developed during the eighteenth century as notable medical centers with large specimen collections from extensive anatomical practices and the presence of medical schools and a university, respectively. Bleuland's collection stems from preservation practices originating at Leiden and Amsterdam in the late seventeenth and eighteenth centuries. Despite their common origin from museums, however, the works discussed here present also significant differences. While Meckel and Bleuland relied exclusively on their own museums, Baillie relied on many. In fact, his agenda went beyond not only his collection but also those of William and John Hunter: he wished to provide instructive examples almost regardless of their origin, well aware that his work was merely a beginning. Surprisingly, however, Baillie provided scant references to the literature. By contrast, Meckel's *Tabulae* provided a rich panorama of earlier pathological publications; he privileged structural changes and systematic classifications over the fine-grained textural descriptions and images one finds in Baillie.

Meckel sought a comprehensive morphological study of disease and to this end he included animal lesions as well. Bleuland's *Otium* follows in the wake of his museum catalogue; his selection included case histories and therapies, highlighted the role of nature's plastic forces acting even in disease, and referred quite extensively to Baillie and the literature more broadly, while eschewing Meckel's ambitious morphological project.

There are intrinsic limitations to what visual representations can show, as Baillie pointed out in his *Engravings*. A disease is a complex entity that may not be localizable: fevers may stem from specific local lesions, but these could also be lacking; mental disorders too may originate from lesions in the nervous system, though these may also be hard to see or lacking altogether. Problems of representation arose even for those diseases associated with localized lesions in specific organs; a dichotomy often found in the literature is that between, on the one hand, structure and, on the other, texture, cohesion, and color. While structure lent itself to visual representation, the other features did not do so as easily. Implicit in this dichotomy was the assumption that the illustrations would be printed with black ink—an assumption that was becoming problematic after 1800. But even against this background, different notions and concepts of disease played a role in the visualization of pathology. Overall, Baillie and Bleuland seemed more concerned with texture and inflammation, Meckel with structure or morphology.

The issue of color emerges in different forms with different authors and even specimens; on the one hand, the lesion or malformation one intends to represent may be eminently structural, so that it seems legitimate to eschew color altogether. In other instances, however, one can identify different epistemologies of color, just as there were different epistemological stances to the usage of illustrations; overall, color seemed to matter more to Baillie that to Meckel, with his morphological focus. Color played an important role for Bleuland both in preparing the physiological specimens following techniques derived from Ruysch and in representing them in print by means of relatively innovative methods, at least with respect to mainstream anatomical printing; this extended to one pathological case. It would not be long before many of these early attempts in the representation of pathological preparations would be seen as unsatisfactory because the preservation methods employed altered their general appearance and especially color, which was all but obliterated.

FOUR

INTERMEZZO

Identifying Disease in Its Inception

Comprehensive treatises represent only a small portion of the literature including pathological illustrations. Far more common were less ambitious works addressing a limited number of cases dealing with a disease, an organ, or a system, such as the urinary apparatus, for example, or even related to some investigative procedures. Illustrated pathology treatises became more frequent in the aftermath of Baillie's work; one could fill a small volume of bibliographic information on relevant works published between the second half of the eighteenth century and especially the first decades of the nineteenth, and therefore no analytic study could pretend to cover this field exhaustively. Here I discuss three works published at different locations that present intriguing features either conceptually or visually and that enrich our understanding of the problems and challenges of illustrating pathology. Notably, whereas most works we have seen so far show the final stages of a condition, those discussed here rely on different strategies to detect and represent early stages.

Observations on Fungus Hæmatodes (Edinburgh, 1809), by Scottish surgeon James Wardrop, examines a growth with peculiar characteristics that captured his interest relatively early on in his long career; the name refers to the Greek for blood and points to the heavy vascularization of the growth. Wardrop examined a few instances firsthand and investigated thoroughly both the relevant literature and a number of cases communicated to him by colleagues and friends. In one instance, when the condition was bilateral, affecting both eyes at slightly different times, it became possible to determine the specific body part whence the growth originated when the eye was involved.

The prostate presents peculiar features offering rare opportunities to the pathologist. Everard Home, John Hunter's brother-in-law, dealt with this

organ in *Practical Observations on the Treatment of the Diseases of the Prostate Gland* (London, 1811–18). Home realized that in older men the prostate is often enlarged, and this enabled him to provide an unusual series of illustrations documenting this process; whereas for most other internal organs all the pathologist could normally see was the final stage of the disease, in the case of the prostate Home showed the process of growth from the first tiny enlargements of its middle lobe, on which he had recently published an essay, to a number of fatal complaints.

The last work I examine is the iconic treatise by René-Théophile-Hyacinthe Laennec, *De l'auscultation médiate* (Paris, 1819), which introduced the stethoscope. The focus of his work was to tie sounds detected in live patients by the method of auscultation to lesions observed postmortem, especially in the lungs. Whereas virtually without exception all the illustrations we have encountered thus far depict individual cases, at times giving the name of the patient or the identification number in the museum, Laennec's treatise shows idealized didactic representations of tubercular lesions resulting from many observations on different patients. Laennec's plates give in one single image the entire range of lesions that may not necessarily occur in precisely that form in the patient—though to be sure tubercular lesions can be found at different stages of development at the same time.

These works are based on different organizing principles and range from relatively obscure ones, such as Wardrop on fungus hæmatodes, to classics, such as Laennec's *De l'auscultation*. Although they belong to different subgenres with regard to both contents and pathological iconography, they all include detailed accounts of diseases, whether recently identified, as with fungus hæmatodes, or better understood thanks to new anatomical findings, as with the middle lobe of the prostate, or studied through the stethoscope. The careful study of postmortem lesions provided crucial elements for the identification of the specific condition, while visual representations captured its specificity.

WARDROP AND FUNGUS HÆMATODES

James Wardrop (1782–1869) studied in Edinburgh and in 1797 became apprenticed as a surgeon to his uncle, physician Andrew Wardrop. Aged nineteen he was appointed house surgeon at the Edinburgh Royal Infirmary, but soon, in 1801, he left for London, where he attended lectures by the leading surgeons of the time, including John Abernethy, Henry Cline, and Astley Cooper, and witnessed work at St Thomas's, Guy's, and St George's Hospitals. In 1803 he moved to Paris, just before the outbreak of hostilities between France and Britain; as a British subject, he was treated as a prisoner of war, but he managed to escape to Germany and then Vienna. He probably visited Halle, since two passages in his work mention preparations showing eye lesions from Meckel's

museum. In Vienna he studied with leading eye surgeon Georg Josef Beer. Probably because eyes are external organs and have a well-defined nosology, there had been earlier attempts to represent their diseases in a systematic way even with color plates, as in *Nosographia opththalmica* (London, 1766), by the learned itinerant ophthalmologist (and Cheselden's student) John Taylor, and by Beer; both included plates with dozens of small color figures. Beer, for example, included figures he had painted himself of each disease as it appears in its most common form; he claimed that the occasional small variations should not prevent one from recognizing immediately its nature, "ihre Natur." Thus he advocated color representations, and, though aware of the variations of diseases from their most common form, he was not overly concerned with it.[1]

On his return to Scotland Wardrop was admitted Fellow of the Edinburgh Royal College of Surgeons in 1804 and practiced in the Scottish capital. Wardrop became an assistant to surgery professor John Thomson, working as curator of the museum of the College of Surgeons, until in 1808 he moved again to London, where he remained for the rest of his life.[2]

In 1814 Wardrop was admitted as a member to the Royal College of Surgeons of England without having to pass an exam, since its president Everard Home was aware of the quality of his publications. Wardrop practiced among the poor and was also involved in establishing the West London Hospital of Surgery in 1826, which he supported financially, though the hospital had to close after ten years. He lectured on surgery at the Aldersgate Street School and then at the Great Windmill Street School. In London Wardrop enjoyed a considerable success, becoming surgeon-in-ordinary to King George IV in 1828, but he was subsequently caught in a web of medical intrigue that damaged his career. In 1834 Wardrop received an honorary MD from the University of St Andrews, and in 1843 he became a fellow of the RCS.

Before his final move to London Wardrop started working on an illustrated treatise on eye diseases, *Essays on the Morbid Anatomy of the Human Eye*, which appeared in two parts (Edinburgh and London, 1808 and 1818). Wardrop's *Essays* provided a comprehensive account of eye diseases; it included several color plates painted by Patrick Syme, an Edinburgh flower and nature painter that Wardrop claimed was competent in anatomy as well. As a flower painter, Syme was especially skillful with colors, and he personally "retouched" the plates, a task normally accomplished by assistants copying the original drawing, to be confident of their accuracy. In 1814 Syme produced a revised edition of the color nomenclature by the German geologist Abraham Gottlob Werner, claiming its utility to a range of disciplines such as zoology, botany, and morbid anatomy. It was only in the second part of his *Essays* that Wardrop mentioned fungus hæmatodes, in the section on diseases of the retina and optic nerve, referring to his own treatise *Observations on Fungus Hæmatodes or Soft Cancer, in Several of the Most Important Organs of the Human Body* (Edinburgh,

1809); thus the two works were closely related, because the *Observations* give
fungus hæmatodes of the eye pride of place and the longest treatment, since
this is whence many cases originate. *Observations* went for 12*s*, while the two
volumes of the more ambitious *Essays* went for 2*l* 10*s*.[3]

Wardrop's treatises highlight the fluidity of the organizing principles of
pathological works: he started publishing a comprehensive treatise on dis-
eases of the eye in 1808, then in 1809 he shifted to fungus hæmatodes, a par-
ticular disease especially common in the eye but also found in other parts of
the body; thus he shifted from an organ-based treatise to a disease-based one.
He then went back to complete the second part of his work on the diseases of
the eye in 1818.

Few dedications could be more poignant in a pathology treatise of the early
nineteenth century than the one Wardrop made to Baillie in *Observations on
Fungus Hæmatodes*. Wardrop's *Observations*, however, included case histories,
which Baillie had avoided. Further, following Baillie's death in 1823, Wardrop
edited his works and authored a biography of his fellow Scot; he also provided
in an introduction an update of recent developments in the field of morbid
anatomy.[4]

Originally Wardrop presented a paper on the topic at the Chirurgical Soci-
ety of Edinburgh; his contribution generated a number of conversations and
led many colleagues to pass on cases they had encountered in their practice,
which were then incorporated in the treatise. Moreover, Wardrop made an
extensive study of the literature going back to cases of eye tumors discussed
by Fabricius Hildanus over two centuries before, as well as Heister, though
the latter was all too brief to draw any conclusions.[5] Wardrop was not the first
to study or indeed name the affection, which had already been described in
detail by the renowned Glasgow surgeon John Burns and Leeds surgeon Wil-
liam Hey, who also named it. Indeed, Burns provided reports of several cases
and even sent Wardrop preserved specimens for study. Wardrop faced the
problem of naming and classification, in that several previous scholars had
discussed a similar condition under a different name and some had used the
same name for different conditions.[6]

Observations consists of two parts: the first is devoted to cases of fungus
hæmatodes of the eye, which formed a meaningful subgroup with common
characteristics; the second examines similar types of growths in other parts of
the body. Wardrop was painfully aware of the high mortality associated with
the condition; his work was not an advertisement of his skills through a series
of successful cures, as many medical men had done before him, since the great
majority of the patients he discusses died. Rather, Wardrop sought to identify
a common pattern among several cases with a view toward establishing a well-
defined condition and a suitable therapy—prompt removal of the growth as
soon as its nature was ascertained, to prevent the fungus from affecting the
optic nerve and other parts of the body. According to Wardrop, fungus hæma-

todes differed from common scirrhus or cancer—which he took to be different stages of the same morbid affection—and involved the rapid growth of a substance resembling a medullary or brain-like matter that bled profusely when injured, hence the names "encephaloid tumor" or the French "carcinome sanglante."[7] In many instances Wardrop found that a growth seemingly originating in one part of the body, such as the eye, led to similar ones elsewhere, such as the pituitary gland or liver.[8]

The first part relies on seventeen cases that shared striking similarities. Wardrop noticed that the disease was especially common among young children: out of twenty-four cases surveyed, twenty were of children younger than twelve. At times the condition could be bilateral, as in a case reported in the *London Medical Observations and Inquiries* for 1767. Thus, at least with regard to the eye, Wardrop relied not only on the external characteristics of individual lesions but also on the age of the patients and growth patterns as diagnostic signs. Not all conditions were identical: no. 16, for example, involved a black tumor. In a later work Wardrop compared fungus hæmatodes to what Laennec had called "melanosis."[9] Moreover, one finds several references to chemical tests, microscopy, and maceration in water and other fluids for the purpose of studying the composition of the fungus.[10]

An especially significant case was communicated by John Cunningham Saunders, who had founded the London Ophthalmic Hospital. Initially only the left eye of a small child of eight or nine months was affected; shortly before the child succumbed, the right eye became affected too. The different stages of development of the disease in the two eyes enabled Saunders and Astley Cooper, who performed the dissection, to investigate the early stage of the disease affecting the right eye, which was preserved in Astley Cooper's collection. Thus a bilateral condition found at different stages of development enabled to locate the origin of the lesion. A rather simple yet remarkable plate relies on a drawing sent by Astley Cooper and shows in some detail a diseased eye, highlighting that the retina is the first organ to be affected: *a* is the optic nerve, *bb* the sclerotic coat or the outer membrane, *cc* the choroid coat just inside, and *dd* the shapeless mass into which the retina has degenerated, occupying the inside of the eye (illustration 4.1). In 1811 Saunders included the case history anew with a better engraving by John Stewart, a major pathology artist whom we shall encounter again in the sequel.[11]

Illustration 4.1
Wardrop, *Fungus*, page 193, affection of the retina.

Illustration 4.2
Wardrop, *Fungus*,
page 121, affection of
the arm.

Moving to the second part of the treatise, Wardrop examined cases of fungus hæmatodes in different parts of the body, starting from the extremities or limbs and proceeding to the testicles, the liver and other internal organs, and the female breast. Unlike the cases affecting the eye, fungus hæmatodes in other body parts did not concern predominantly young children and did not necessarily develop as fast, though it shared some external characteristics. A case beginning in the arm and then attacking the breast was recorded by surgeon George Bell; Wardrop reported Bell's account and also included a plate based on a drawing he had taken from a cast of the amputated diseased arm. Thus Bell not only composed and provided a written account of the diseases but also recorded its exact appearance in the form of a cast, which provided an effective way to represent external lesions.[12]

A small plate showing three separate cases marking successive stages of a diseased shoulder joint is of considerable interest for its provenance (illustration 4.2): Wardrop tells us that he took an outline from three drawings in the collection at the École de Médecine in Paris; in all probability they were due to the draftsman of the École, Anicet-Charles Lemonnier. The cases go from right to left, the third one at far left showing a vascularization of the growth. Thus in 1803 Wardrop was already so interested in the matter as to risk arrest by moving around the French capital surreptitiously when Britain was at war with France, copying pathology drawings. Such visual representations proved crucial to him in the identification of the disease since he relied expressly on the Paris drawing and a plate published by surgeon William Hey, which he compared to a case under the cure of Cooper he observed in London probably between 1801 and 1803.[13]

A case affecting the testicles provides several elements of interest. Wardrop claimed that the condition was often mistaken for hydrocele, thus leading to

inappropriate therapies. He identified a similar case described and illustrated in Baillie's *Engravings*. About a century earlier Ruysch had discussed a case of a diseased testicle he had arranged with a fetal arm, engraving them together, largely to highlight its size (illustration 1.13); a century later size still mattered, but it was not the main focus of such theatrical displays. Rather, the chief aim was to provide visual evidence for the purpose of comparing and identifying diseases. In addition, Wardrop referred to two related specimens in the collections of Alexander Monro *secundus* in Edinburgh and James Jeffray in Glasgow, once again showing how those collections were used for research purposes.[14]

Thus for his plates Wardrop relied on different sources ranging from live patients to preparations and casts. He was responsible for some of the drawings, while others were due to fellow surgeon James Russell; several are by Syme. Throughout texture and color play an important role, since the identification of the fungus relied on its medullary appearance and color, often ranging from brown and yellow to red and even purple. Overall, the plates are not very successful at offering a sense of the lesion; this is true even for those occasional plates showing a timid attempt at reproducing color. Most plates are etched by E. Mitchell, probably Edward, who was responsible for other surgical works.[15]

HOME AND THE PROSTATE

Whereas fungus hæmatodes of the eye affects primarily young children, so much so that age is a significant diagnostic sign, enlargement of the prostate is predominantly a disease of older men, age too being a revealing diagnostic sign in such cases. Younger men, according to Home, often suffer from strictures of the urethra; distinguishing the two complaints was one of the concerns of his treatise.[16]

Everard Home (1756–1832), the son of a former army surgeon, turned down a scholarship at Trinity College, Cambridge, in order to become an apprentice to his brother-in-law John Hunter, who had married his sister Anne. Home qualified as a surgeon in 1778. After a few years in Jamaica working for the army, he returned to London to become teaching assistant to Hunter at St George's Hospital, where Hunter was chief surgeon. In 1787 Home was elected Fellow of the Royal Society and became assistant surgeon at St George's Hospital. He lodged with Hunter at his large house in Leicester Square and progressively took over his anatomy lecturing. On Hunter's death in 1793, Home and Baillie were joint executors of his will and Home took over as chief surgeon at St George's Hospital. In 1799 the government purchased Hunter's large anatomical and pathological collection and donated it to the College of Surgeons, which moved to Lincoln's Inn Fields; Home was chief curator and Clift, who had been Hunter's assistant in the last few months of his life, was retained as its conservator. Later in life Home attained several honors: in 1808

he became sergeant-surgeon to George III, five years later he was made a baronet, and in 1821 he became surgeon at the Royal Chelsea Hospital, where he died. His reputation has been greatly tarnished by his plagiarism of Hunter's research and destruction of a large portion of his papers in 1823.[17]

Home published a considerable number of papers and treatises on surgery and comparative anatomy, seeking to emulate John Hunter and to take over his role. After coediting Hunter's *On the Blood, Inflammation, and Gun-shot Wounds* with Baillie (London, 1794), Home published treatises on *Practical Observations on the Treatment of Ulcers on the Legs* (London, 1797), *Lectures on Comparative Anatomy* (1814), and delivered a number of lectures and orations at the Royal Society.

His two volumes of *Practical Observations on the Treatment of the Diseases of the Prostate Gland* (London, 1811–18) follow in the tradition of previous illustrated works on the male urinary and reproductive system, such as *A Treatise on the Venereal Disease* (London, 1786) by John Hunter and *Engravings from Specimens of Morbid Parts, Preserved in the Author's Collection, now in Windmill Street* (London, 1813) by Charles Bell, dealing with diseases of the urethra, bladder, kidneys, and so forth. The peculiar features of the prostate, however, led to an unusual iconographic treatment including a "tolerably complete" visual documentation of its growth, even in cases that did not lead to the death of the patient. Whereas in most other works we have encountered the plates show the final stages of internal lesions, here they start from the prostate's middle lobe in its healthy state and then show progressive stages of the disease. In this regard Home's plates recall the investigation of the generation of the chick in the egg, in that they give the impression of a continuous process in the same individual, whilst of course each plate represents a different patient; implicit in this choice was the assumption that the mode of growth of the prostate would share broadly common features in different individuals. The presence of 23 plates pushed the price of Home's two volumes to 1*l* 6*s*. [18]

The reviewer in the *British Critic* confessed having opened Home's work "with reluctance," anticipating a plethora of tragic details. In fact, he found it quite comforting not only for the increase of knowledge it offered but also for its practical use in relieving the sick. Whereas in Wardrop's treatise a fatal outcome seemed inevitable, Home occasionally included some successful interventions and overall had a more optimistic tone. Still, having gone through two volumes of impaired urination, bougies, and catheters, frequently leading to increasingly greater evils and death, this reader does not recommend it for your next vacation.[19]

Home's research takes the lead from an essay he had published in the *Philosophical Transactions* and which he reproduced at the outset, in which he announced the discovery of a middle lobe in the prostate; the finding was not a purely anatomical one, in that it was the protrusion of that lobe into the cavity of the bladder that was the frequent cause of many of the affections he had

encountered.[20] The second volume offers some helpful reflections on the purpose of his enterprise: Home argued that young practitioners are liable to be mistaken in their confidence and optimism by lack of experience; older ones have their confidence shaken and are rendered insecure by their experience, by the surprises they encountered and the mistakes made. Thus his treatise would help the former temper their optimism and the latter gain a deeper understanding based on postmortem examinations, which alone allow one to ascertain the conditions of the prostate. As in Wardrop's case, the pathology treatise is at the service of knowledge and sound therapy.[21]

Much like many of his predecessors, Home showed concerns for the quality of the illustrations and stated not only that the drawings were made by such an accomplished artist as Clift, who was both an anatomical draftsman and an anatomist, but also that they had been executed under his own eye; in one case he went to the length of having Clift draw and engrave the same specimen shown by Baillie, though from a different perspective. Moreover, the preparations whence the plates for both the first and second volumes were taken were to be found at the Museum of the Royal College of Surgeons; thus London surgeons could access the preparations whence the engravings were taken, together with other related ones. The entire portfolio of Clift's watercolors for both of Home's volumes has survived at the Library of the Royal College of Surgeons. Home had Clift engrave the plates for the first volume, while in the second Basire accomplished the task with a surer hand: whilst Clift often uses short broken lines and his hatching appears tentative, Basire relies on more confident cross-hatching. Clift was a better watercolorist than an engraver, thus Basire does better justice to the quality of Clift's originals.[22]

From the first volume Home singled out plate V, for which the original drawing was made when its parts were still fresh, before immersion in spirit, "which coagulates them, and takes off all distinction in the appearance between this fold, and the lobe itself; this is so much the case that no examination of preparations in spirits can give an adequate idea of what the appearances really were in the living body." Clearly, despite the availability of the preparations to accompany the plate, a fresh specimen was to be preferred.[23] The plate I have selected (illustration 4.3) is remarkable in another respect: besides showing the largest middle lobe of the prostate Home had ever encountered, in the center, it also illustrates the case history in the form of five dark marks produced by the catheter in the attempt to draw urine, visible four on the left side, one on the right. They document both the fruitless therapeutic attempts and Home's concern to tie postmortems to case histories. Notice also the richly textured structure of the bladder, or trabeculation.[24]

The second volume discusses at greater length the causes of the enlargement of the prostate. Home believed it to be due to extravasated blood or lymph, a complaint often due to excessive horse riding or eating; hence in his view the increase in volume could be contained by avoiding activities likely to

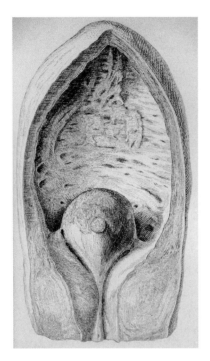

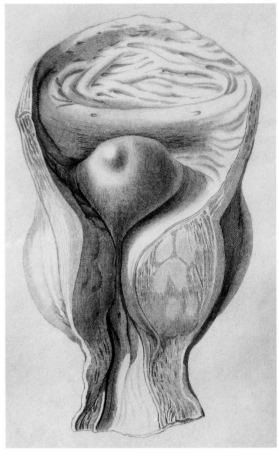

Illustration 4.3
Home, *Prostate*, 1811, plate I.9. Drawn and engraved by Clift.

Illustration 4.4
Home, *Prostate*, 1818, plate II.1. Drawn by Clift, engraved by Basire.

lead to such extravasations. The plate (illustration 4.4) is especially significant in this regard: it shows a much-enlarged forward-projecting middle lobe. When the specimen was fresh, a drop of blood at the orifice of a ruptured vein on that projection was clearly visible, suggesting to Home that the enlargement of the prostate was due to deposits of coagulated blood in the form of nodules; a section of the gland on the right clearly suggests the presence of nodules. Alas, the specimen had been preserved in spirit for some time and had hardened, preventing Home from carrying out a more thorough examination. However, he could confirm from the configuration of the growths of the lobes of the prostate why a complete stoppage of the flow of urine had not occurred.[25]

Thus once again, despite the availability not only of the engravings but also of a range of preparations documenting the entire process of growth of the middle lobe of the prostate, at least to surgeons in a position to visit Hunter's museum, Home attributed a privileged status to fresh specimens.

Crossing the Channel to post-Napoleonic Paris we move to Laennec, whose work has been studied and often celebrated ever since its publication nearly two centuries ago. The iconic status attained by Laennec makes it easier and at the same time harder to offer a pointed biographical sketch; even more so than in previous cases, I shall focus on those aspects relevant to my concerns while relying on the wonderful biography by Jacalyn Duffin.

Laennec (1781–1826) was a Breton who moved to Paris to study medicine in 1801. Following the celebrated reform of the medical curriculum in revolutionary France, Laennec studied a range of subjects, including surgery and chemistry, and gained clinical experience with Jean-Nicolas Corvisart at the Charité Hospital, then known as the Hospice de l'Unité. Besides being physician to Napoleon, Corvisart was deeply interested in clinical examination and was working on a treatise on heart disease that appeared shortly thereafter and a translation with commentary of Leopold Auenbrugger's celebrated work on chest percussion. In 1803 Laennec won first prize in the surgery examination and shared the first prize in medicine. He proceeded to take his degree in 1804 with a thesis on Hippocrates.[26]

Besides Corvisart, there were other figures that played an important role in his formation, such as the renowned anatomist and surgeon Guillame Dupuytren; Philippe Pinel, who was one of the examiners of his thesis; and Gaspard-Laurent Bayle, a fellow student and member of a religious royalist conservative group, la Congregation. Dupuytren was a strong advocate of pathological anatomy who founded an Anatomical Society, later led by Laennec; relations between the two anatomists soon soured over priority. Pinel is best known for his support for a more humane treatment for the insane; he was professor of medical pathology from 1795 until his death in 1826 and author of a treatise on the classification of diseases, *Nosographie philosophique* (Paris, 1797–98), which went through many editions and translations. While following in the tradition of Sauvages and Cullen, Pinel also tried to bring pathological anatomy into nosology; a notable example is his reliance on the work by physicians Johann Georg Roederer and Karl Gottlieb Wagler, whose 1762 illustrated study based on postmortems of the Göttingen epidemic of "mucous fevers" revealed inflammation of the digestive tract. Pinel's interest seemingly stimulated two French translations of their treatise, which included three pathology plates—though Pinel did not use illustrations in his work.[27]

From the seventeenth century the classification of diseases relied on symptoms and was hostile to anatomy, which Sydenham deemed redundant. In the course of the eighteenth century there was a rapprochement between nosology and morbid anatomy, though Sauvages too expressed skepticism as to whether "la méthode du siège de la maladie"—a clear reference to Morgagni—could establish the character of diseases. In a lecture published posthumously

by Edinburgh professor John Thomson, Cullen argued that while Sauvages had rejected in words "the employment of the internal seats of diseases as a means of distinguishing them," in fact he had relied on it "in an hundred instances." Cullen's views as presented by Thomson seem ambivalent: Cullen stated that it was generally agreed "that the dissection of morbid bodies is one of the best means of improving us in the distinction of diseases." He also warned against relying on theories, hypotheses, and causes in establishing the characters of diseases, since such factors are often contentious. Further, he questioned whether contemporary writers on nosology were "right in so universally rejecting the distinction of diseases by their internal seat." However, he also argued that although the "internal seat" is known "so well from dissections" and therefore it should be added to the history of the disease, "it is better not taken into the specific character [of the disease], as it never is directly evident," seemingly implying that the "internal seats" become evident only a posteriori.[28]

At the turn of the century Bayle proposed a new system of classification of disease based on organic or anatomical lesions rather than causes or symptoms. In his unpublished treatise on pathological anatomy of about 1805–6 Bayle's friend Laennec advocated similar views, which were becoming widespread in the early decades of the nineteenth century; as the English translator of Laennec's *De l'auscultation médiate* put it, "It is only by the progress of pathological knowledge that we can hope for a true nosology." Laennec, however, rejected the zoological and botanical model for nosology, since diseases are not beings but mere modifications of the texture of the organs. Classifying pulmonary lesions was problematic; since tubercular lesions can take quite different forms (illustration 4.5), Bayle grouped them together also based on the symptoms in the living patient; further, he added under the name of phthisis a few other types of lesions, such as melanosis and cancerous affections of the lungs, that Laennec considered to be of a different nature. Moreover, very similar lesions to those seen in the lungs could be found elsewhere, as Baillie and others had noticed, making the notion of localization problematic. Thus at the very best, a new system based on postmortem lesions was not an obvious and straightforward matter.[29]

While still a student and soon thereafter Laennec published a number of essays on themes that proved quite influential at the time and resonate with some of the material we have discussed; additional topics were treated in an unpublished treatise on pathological anatomy. For example, in 1802 he published an extensive essay in two parts on the inflammation of peritoneum or, as he named it, peritonitis; this work highlights the shifting focus from organs to tissues as the seat of diseases, a shift with long eighteenth-century roots that had crystallized in France in the work of Xavier Bichat, whose *Traité d'anatomie descriptive* (Paris, 1801–3) Laennec reviewed. In 1806 he presented a paper on "melanosis," or a tumor with a black pigmentation, that was soon

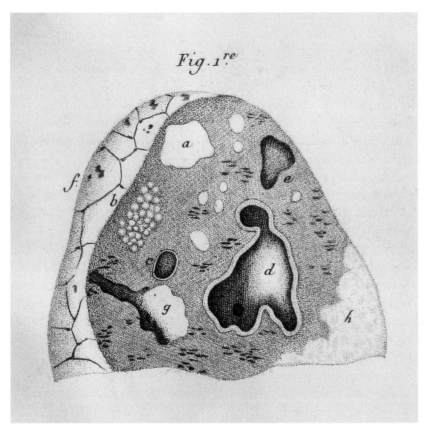

Illustration 4.5
Laennec, *Auscultation*,
1819, plate II, lung
tubercules.

excerpted in the *Bulletin de l'École de Médecine de Paris*. Laennec's work on
what he called "encephaloid" or "cerebriform" cancer was published in 1815 in
the *Dictionnaire des sciences médicales*; references can also be found in *De l'aus-
cultation médiate*, prompting the English translator John Forbes to complain
that Laennec had ignored several British writers such as Burns, Hey, and espe-
cially Wardrop, with his treatise on fungus hæmatodes. Laennec also coined
the term "cirrhosis" to describe a condition of the liver that he believed to
have been the first to identify; in this case too he ignored a few British authors,
from Browne to Baillie, who had identified and even included engravings of
cirrhotic livers *avant la lettre* (illustrations 1.11 and 3.1). Setting aside priority
claims, the parallel works of British and French medical men testifies to the
existence of far-reaching shared views and approaches to the study and classi-
fication of disease.[30]

An especially important notion in Laennec's pathological views was that
of lesion; although this time he did not coin the term, he certainly contrib-
uted to giving it prominence. Laennec's notion was threefold: organic lesions,
anchored to anatomy; liquid lesions, related to chemistry; and, when the first
two seemed to be lacking, vital lesions, due to sadness and nostalgia. Both
Laennec and Bayle shared such views, according to which deep and prolonged

sad passions weakened the vital force, inducing vital lesions that then became embodied in organic and liquid form. Bayle, for example, while in Paris suffered from nostalgia for his birthplace, Le Vernet, a village in the Southern Alps, and trips there apparently healed him—though he later died of phthisis. More generally, Laennec attributed the better mortality data from phthisis in the countryside than in urban areas to the depressing and tense conditions of the city.[31]

After about a decade of research supported by work as physician and author, in 1816 Laennec took over a position at the Necker Hospital, a sizeable institution that admitted about one thousand patients each year and provided ample opportunities for examining patients and performing postmortems. It was there that he carried out his epoch-making investigations leading to the publication of his two-volume treatise on mediated auscultation, marking a key stage in the study of pathology through lesions and symptoms. Significantly from our perspective, Laennec sent a dedication copy to Baillie, whose pathology work he admired.[32] After a short spell away from Paris, in 1822 Laennec was elected to the chair of practical medicine at the Collège de France; he resigned his position at the Necker and took over Corvisart's position, teaching clinical medicine at the Charité hospital, where he presided over the *clinique interne*, consisting of a unit of forty beds.[33]

We have seen that one tradition of pathological anatomy sought to establish a link between symptoms observed in the patients and lesions found in the cadaver; one of the problems of this approach was that symptoms may have been equivocal and subjective and could be confirmed only too late with a postmortem. Laennec sought to detect in the live patient unequivocal signs of different diseases both in the lungs and heart, thus providing a triangulation among general symptoms, sounds detected in the live patient, and lesions found in the cadaver. Moreover, Laennec became convinced that although tubercles appeared different and could be found at different locations in the body, they indicated the same disease: tubercles looked different because they grew going through different stages.[34]

Others in the past had employed analogous strategies relying on the senses to detect diseases and lesions: palpation, at times even internal, whether vaginal or anal, helped detect a number of complaints; chemical analysis too was used in different forms, including tasting, such as Galen with the sweat of patients or Thomas Willis, who detected a sweet taste in the urine of diabetic patients, or with the tests performed on the blood of patients suspected of leprosy; auscultation too was employed in antiquity, as testified by the Hippocratic corpus, and was revived in the eighteenth century by Leopold Auenbrugger, who relied on percussion of the chest to study its complaints, including consumption; his treatise had been translated by Laennec's teacher Corvisart. Building on Auenbrugger's work, Laennec devised a simple instrument consisting of a tube of paper or wood to enhance sounds from the chest,

such as the patient's voice, seeking to determine the nature and location of cavities in the lungs and other lesions. Laennec also investigated the sounds produced by the heart, which led to more problematic results.[35]

The iconic plates in his treatise focused exclusively on pulmonary lesions, possibly because he could not establish the univocal correlation between cardiac sounds and lesions that he hoped to find. Compared to some of the pathological plates we have discussed, Laennec's appear rather unassuming and less than outstanding in execution. Nonetheless, he devoted considerable efforts to them: some of the drawings were due to his student Adolphe Toulmouche, others probably to Laennec himself. It is not easy to characterize his plates in that they appear as a rather heterogeneous collection involving specimens from recent postmortems, preparations of inflated lung lobules, schematic diagrams, and also representations of the outside of a body cured of chronic pleurisy, showing a marked lack of symmetry with a retraction of the chest. The tension inside-outside was central to Laennec's interests and extended to his iconography as well at several levels: some of his plates show the inside and outside of a lung, highlighting its depression in correspondence to an internal lesion, as if he wanted to anticipate what a pathologist would see at different dissection stages. One plate (illustration 4.5) is unusual with respect to the pathology tradition in that it offers an idealized image combining a number of cases: here each letter marks a different stage of the tubercles, incipient or fully formed, with cavities lined by membranes or without, reduced to a cartilaginous cyst or evacuated. Although different stages of pulmonary lesions can coexist in the same individual at the same time, Laennec's figure was constructed for didactic purposes and differs considerably in conception and execution from Baillie's corresponding one (illustration 3.3): they are instructive exemplars of the role of pathological anatomy, localization, and visualization.[36]

The plate on emphysema must have been a source of frustration, since in a note Laennec explains that he was so unhappy with the drawings, presumably both Toulmouche's and his own, that he brought the original pathological preparations to the engraver, but even he could do no better. Although the name was not new, Laennec claimed to have described the particularity of the lesion and identified it as a specific entity, consisting in the loss of the fine structure of the lungs and the consequent enlargement of the alveoli. Laennec discussed previous authors who had described similar cases, notably Ruysch, who had also provided two figures of enlarged pulmonary cells, Valsalva as reported by Morgagni, and Baillie, who had strikingly compared the enlarged cells of the lungs affected by this disease to those of amphibious animals and had represented them (illustration 3.5). According to Laennec, however, Baillie would have failed to see the relation among three features of the same affection, namely expanded lungs, larger alveoli, and air vesicles attached to the side of the lungs. Figures 5 and 6 in the middle show two sectioned portions of

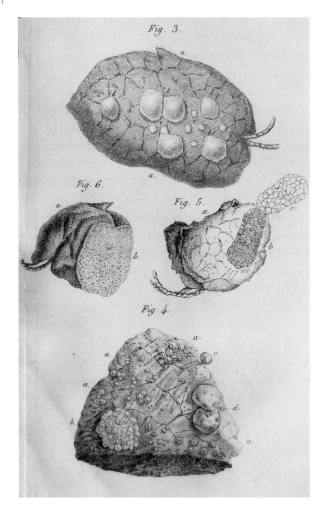

Illustration 4.6
Laennec, *Ausculta-tion*, 1819, plate III, emphysema.

lungs, 6 on the left healthy, 5 on the right affected by emphysema and with a portion of the lobule raised to show the internal structure: that of the healthy portion of the lung at 5 is much finer than that at 6 (illustration 4.6). In figures 3, 5, and 6 the sectioned lungs are inflated and then tied with threads clearly visible on the right, bottom, and left of the figures, so air cannot escape. In this state they can be preserved for some time, and in all probability this is what was given to the engraver: one can only imagine how delighted he must have been to have portions of diseased lungs delivered to his shop.[37]

The two plates from Laennec's work serve different purposes: that of emphysema seeks to identify what Laennec saw as a new nosological entity; that of tubercular lesions seeks to portray known and frequent lesions in order to identify them as related and to tie them to specific sounds detected through the stethoscope. Although color is not of central importance to the description of tubercles, Laennec did describe it in words in a few cases and even added comments on the transparency or semi-transparency of his specimens.

Thus in this regard he shared a concern with Baillie. However, Laennec differed from Baillie in another crucial respect: Laennec argued that scrofulous tubercles affecting the entire body pointed to consumption, though he did not include any illustration of internal organs besides those of the lungs.[38]

The authors we have discussed could be found at Edinburgh, London, and Paris. They shared surgical and medical backgrounds, were able dissectors, were attached to hospitals and infirmaries, and were also lecturers or holders of prestigious chairs. They all shared a concern for studying diseases and their lesions in a variety of ways from their earliest stages.

The sources of their cases varied: Wardrop identified a relatively rare affection and relied on a wide range of sources, including patients he had encountered, older literature, and several cases communicated to him by colleagues. The condition Home investigated was rather common; the vast majority of cases he reported were his private patients, who often moved between London and the countryside. By contrast, although Laennec relied on the literature and especially the work by Bayle, the great majority of cases he examined and reported were from hospital patients, testifying to their key role in early-nineteenth-century Paris. The conditions he examined, especially phthisis, were the scourge of the time.

The works we have discussed adopted different investigative and expository strategies: Wardrop examined specific lesions affecting many organs, Home studied different affections of the prostate due to a range of causes, and Laennec focused on lesions of the lungs and heart that could be investigated through the stethoscope, though he provided illustrations only for the former. Yet they also share several features: unlike Baillie, all routinely reported case histories and tried to establish links between lesions and symptoms, though in Wardrop's case, since eye lesions were external, symptoms were less crucial. They were concerned with identifying growth stages of organic lesions, such as the early affection of the retina in fungus hæmatodes, the initial growth of the middle lobe of the prostate, and the early stages of pulmonary lesions. They also sought the specific features of the disease.

They all relied on images: Wardrop and Laennec presented rather crude and schematic illustrations, while Home went to some length to provide high quality engravings by known artists with an established anatomical and pathological background. The images provided by Wardrop and Home showed individual cases; by contrast, Laennec included idealized images unrelated to a specific individual but rather illustrating a condition. Together, these works testify to the growing focus on histories of specific diseases, including detailed visual representations.

All the works we have discussed had a European circulation and went through several translations, Wardrop's into Dutch and German, Home's into

German, French, and Italian, and Laennec's into English, German, and Italian, going through many editions. Seen together, they document a growing interest in the close study of disease, including symptoms and lesions, and its visual representations and a growing—though by no means linear—shift from preserved to fresh specimens, at least as a desideratum.

FIVE

THE NOSOLOGY OF CUTANEOUS DISEASES

We now temporarily leave pathological anatomy in a strict sense to focus on a related area, the study and visual representation of cutaneous diseases. Although the study of skin diseases in live patients and the anatomical study of lesions in cadavers were perceived to belong to somewhat different genres,[1] it is not possible or helpful to draw too sharp a distinction between them: diseases could affect different body parts; they could migrate inwards from the skin to the interior, as with "melanosis," or outwards, as with syphilis, for example. Further, the study and classification of cutaneous diseases posed conceptual problems in nosology and artistic challenges intersecting contemporary practices in pathological anatomy.

The visual representation of cutaneous diseases relied on color and played a key role in the emergence of color representations in pathological anatomy, since cognitive concerns and techniques of representation were closely related. Often the same pathologists, such as Pierre Rayer, wrote on cutaneous and internal diseases, while some artists too, such as engraver John Stewart, represented internal and external lesions alike—despite some differences in iconographic conventions that we are going to explore in greater detail below. Whereas draftsmen in the previous chapters dealt with body parts preserved in museums and collections or examined them in the morgue, those discussed here dealt with live patients. At least in principle, therefore, physicians and draftsmen would have had access to the entire course of the disease, or at least from when they first saw the patient, rather than merely the final stage; while Home relied on a series of cadavers to study the growth of the prostate, dermatologists could follow the course of skin diseases on individual patients. Some

represented exclusively the actual skin eruption; others provided an image of entire body parts, at times including the face and the garments worn.

I focus on five especially prominent characters active in Britain, Germany, and France: Robert Willan and his successor Robert Bateman between Edinburgh and London; Wilhelm Gottlieb Tilesius at Leipzig; Jean-Louis-Marc Alibert and his antagonist Pierre Rayer in Paris.

THE NOSOLOGY AND ICONOGRAPHY OF WILLAN AND BATEMAN

Robert Willan (1757–1812) was a student at the Sedbergh Grammar School in Yorkshire, where he became an accomplished classicist, his knowledge of Greek being especially noteworthy; this skill proved useful in his later medical investigations. In 1777 Willan enrolled at Edinburgh University, where he graduated MD in 1780 with a dissertation on the inflammation of the liver. At Edinburgh Willan studied with William Cullen, who held the chair of the practice of medicine and who was one of the most prominent nosologists of the time, whose *Synopsis nosologiae methodica* (Edinburgh, 1769) went through many editions. Willan shared a concern with the classification of diseases.[2]

After taking his degree, Willan moved to London, where he became acquainted with the influential fellow Quaker physician John Fothergill, another Sedbergh alumnus, and won his support; Fothergill's death at the end of December 1780 deprived him of an influential patron, but friendship with Fothergill's sister proved helpful. In 1783 Willan was appointed physician at the newly established Public Dispensary in Carey Street; later he was appointed physician at the Finsbury Dispensary and the Fever Hospital and also established a private practice as the leading London expert on skin diseases. Dispensaries were often associated with Dissenting physicians and provided medical care to the sick poor either in loco or at the patients' home, since, unlike hospitals, they lacked beds. While relatively undistinguished as a lecturer, Willan proved more successful as a clinical teacher and trained more than forty young physicians at the Public Dispensary; he became a licentiate of the Royal College of Physicians in 1785 and was elected a Fellow of the Society of Antiquarians in 1791. In 1800 Willan was disowned as a Quaker because of his marriage by non-Quaker rites.[3]

According to his follower and biographer Thomas Bateman, who had access to his manuscripts, Willan started working on cutaneous diseases in the mid-1780s, attracted to the topic by the inadequate state of the field, both conceptually and terminologically, and by the frequency with which such diseases occurred at the Public Dispensary. In 1790 Willan was awarded the Fothergill Medal by the Medical Society of London for his dissertation on cutaneous diseases based on a careful study of their external characteristics, which constitutes the basis for his magnum opus, published in four installments between 1798 and 1808, *Description and Treatment of Cutaneous Diseases*, with thirty-

four colored plates. In 1808 the first three installments were reissued and joined with the fourth in a single volume with significant variants as *On Cutaneous Diseases*—the original title being an accurate rendering of its contents. Thus there are two versions with similar title pages, one assembled from the separate installments and the other including the expanded material. There are slight variations in the sources about the cost of Willan's work, though the four installments together would have been in the order of 4*l*. This was high, in excess of two shillings per plate, though considering that all thirty-four plates were in color, Willan kept it within reason.[4]

Willan's work stands out as the first attempt to provide a classification of skin diseases accompanied by impressive systematic illustrations in color; he was equally attentive to the recent literature, ancient sources, and visible lesions. In addition, Willan included a thorough historical and philological analysis of the field; he even relied on the help of the surgeon and physician Robert Jackson, who had studied Arabic in Paris, to have relevant sections from Avicenna's *Canon* translated.[5]

Willan also published a number of other medical works dealing with typical concerns of the time, on the sulfurous waters of Croft and the ventilation of rooms. His work *On Vaccine Inoculation* (London, 1806), dedicated to Chancellor of the Exchequer Henry Petty, was part of his work on cutaneous diseases, specifically the study of vesicles, and was illustrated with two color plates. In 1809 Willan was elected Fellow of the Royal Society. Suffering from consumption, in 1811 he settled in Madeira, where he died.

William Bateman (1778–1821), from Whitby, Yorkshire, studied there with a Dissenting minister; the son of a surgeon, he attended a local apothecary's shop to learn pharmacy and also studied mineralogy with a local medical practitioner. In 1797 he moved to London, where he studied medicine at the Great Windmill Street School of Matthew Baillie; around the same time he also attended Baillie's practice at St George's Hospital. In 1798 he moved to Edinburgh, where he took his MD in 1801 with a dissertation on blood extravasation. Back in London in the same year, he became first a clinical pupil and then an assistant to Willan at the Public Dispensary; thus Bateman was close to the two key British figures in pathological illustrations at the time. In 1804 Bateman was made a physician to the dispensary and was also appointed to the Fever Hospital at St. Pancras. In 1805 he became a licentiate at the Royal College of Physicians. Together with Henry Reeve, another pupil of Willan's at the Public Dispensary, Bateman helped to found the *Edinburgh Medical and Surgical Journal* in 1805. Following Willan's retirement due to ill health in 1811, Bateman became the leading authority on skin diseases in London. Upon Willan's death, Bateman published *A Practical Synopsis of Cutaneous Diseases According to the Arrangement of Dr. Willan* (London, 1813), which went through many editions. He also acquired the rights for the plates and drawings left by his mentor and in 1817 published *Delineations of Cutaneous Diseases*, incor-

porating the first four orders of diseases as described by Willan and adding the other four, following Willan's scheme and relying on his manuscripts and drawings, thus completing Willan's project. Bateman also wrote most of the medical—though not historical—articles in Abraham Rees's *Cyclopædia* from the letter C onwards. He became ill in the year his *Delineations* was published and progressively had to relinquish all his medical appointments, dying in his native Whitby.

In order to appreciate Willan's and Bateman's works, we have to take a step back. In 1776 Austrian surgeon, medical administrator, and botanist Joseph Jacob Plenck published *Doctrina de morbis cutaneis*, providing an influential taxonomy of cutaneous diseases consisting of 115 genera arranged in fourteen classes. Taxonomies of cutaneous diseases had been produced before; in *Pathologia methodica* (Amsterdam, 1752), for example, Sauvages identified six types of superficial affections or skin lesions, which he listed adding at times the briefest of descriptions or a reference to a previous author. Plenck complained about the lack of precision and consistency in the terminology used to describe skin diseases, leading to uncertainly in diagnoses and cures; as a remedy, he sought to provide brief, precise, and consistent descriptions of the skin affections, including size, color, location within the skin layers, whether the lesions are isolated or form a cluster, whether they are hard or soft, and so on. Instead of assuming that the affections were known and merely had to be listed, Plenck focused heavily on the external appearances of cutaneous lesions; the causes of the lesions and the patient's sensations were less prominent. Nor did he order the diseases depending on their location in the body, from the head and scalp to the toes, for example. One may argue that precisely the sort of nosology provided by Plenck constituted a key epistemological basis for visualization; yet, his work had no illustrations. Possibly the fact that Plenck was not in Vienna at the time but was professor of surgery and obstetrics at the University of Tyrnau (today Trnava in western Slovakia) may explain why. By contrast, his later work on plants, *Icones plantarum medicinalium* (1788–1812), composed when he was in Vienna, included several hundred plates. While remarkable artistic illustrations of medicinal plants date at least from Hans Weiditz's woodblocks in the 1530s, skin diseases lacked a comparable iconographic tradition; thus Plenck also followed the tradition of an established literary genre.[6]

Plenck's work is widely considered as having established a new canon for the description of cutaneous diseases; many followed him in focusing on the external characteristics, though they may have differed on the number of classes and genera. For example, while acknowledging Plenck's leading role, Rayer challenged the Austrian nosologist because he did not focus on primitive alterations: Plenck's sixth class, *crustae*, was not primitive but a later stage of other alterations, thus it did not qualify as a class. According to Bateman and Rayer, if one followed Plenck, the same lesion would be counted twice, following the stages of its development.[7] It is therefore clear that external

characteristics alone were not sufficient to classify skin diseases; those characteristics had to be evaluated in relation to other factors, such as the development and specific stage of the disease.

Willan mentioned Plenck in his work and Bateman convincingly argued that the Austrian surgeon was most probably his mentor's inspiration because of the similarity in their classification and terminology. Willan too wished to establish a secure foundation avoiding the confusion of vague and general terms, determine the number of orders of diseases relying largely on their external characteristics, and specify the best treatment for each disease. Whereas originally Willan had envisioned seven orders of disease, in the course of his work he added an eighth.[8]

A striking feature of Willan's and Bateman's works are the extensive color illustrations involving novel techniques of representation and posing new challenges to pathologists and artists alike. While previously black-and-white engraving and hatching were predominant, Willan had different needs: the minute features of pustules, rashes, and vesicles were best rendered through new techniques, notably stipple engraving colored *à la poupée*, enabling the artist to capture the appearance of the lesions by varying the size and density of the dots forming the image. Following Willan's lead, later works on skin diseases relied extensively on the same technique. The description of color too was subjected to precise calibration and careful terminological analysis as that of other features. An especially interesting case went beyond mere verbal accounts: in his treatise on skin diseases, the Berlin physician Friedrich Jacob Behrend added a chart consisting of fifteen hand-colored rectangles naming or defining each color in German and Latin.[9]

Willan was not the first to publish color illustrations of skin diseases: in 1790, for example, Halle physician Christian Friedrich Daniel (1753–1798) started publishing an edition of Sauvages, *Nosologia methodica* (Leipzig, 1790–97), with several illustrations, some of which showed surgical procedures while others were copied from previous works, such as those from the circle of Christian Gottlieb Ludwig. Daniel also included three illustrations in color of common skin diseases, one showing skin conditions arranged in tiny compartments on a large folded plate, the others showing examples in greater detail, such as that of scarlet fever. Daniel focused on an individual macula and had the plate colored by hand (illustration 5.1). Despite the poor quality of the images, his edition testifies to the growing interest in visualization in nosology and to a shift from exceptional to representative cases.[10]

As Willan pointed out in the introduction to *Description and Treatment of Cutaneous Diseases*, "This Publication has been delayed much beyond the Author's Intention, in consequence of the Difficulties experienced on a Subject entirely new, by the different Artists employed in completing it."[11] Hence Willan perceived both the novelty of the enterprise and the problem of producing systematic illustrations of cutaneous diseases, something with no real

Illustration 5.1
Sauvages, *Nosolo-
gia*, volume 2, 1791,
edited by Daniel,
plate XIV, figure 3,
scarlatina.

precedent and for which there was no obvious expertise to rely on. The task involved producing color drawings, likely executed directly from the patients at the Carey Street Dispensary, which then had to be engraved. Bateman also adds a precious detail: while a nosology crystallized in his mind, Willan provided more detailed descriptions "of the forms, magnitude, and progress" of the eruptions, "accompanied by slight sketches with the pen." Thus classification and visualization went hand in hand from the beginning. Despite these early attempts, Willan did not trust his artistic abilities and only once did he sign a plate with his initials, "R.W.," generally preferring professional artists instead. An essay of 1789 by physician Thomas Christie praised the role of figures to illustrate cutaneous diseases and stated that Willan's plans on that score were quite advanced. The first printed plates are dated October 1, 1796, suggesting quite a slow process.[12]

Willan wished to represent each genus with a colored engraving, claiming to be the first to do so. Despite his reliance on illustrations, he did not rely uncritically on them: he stated that they presented both advantages and disadvantages. Among the latter, he expressed concern for the degree of opacity and clearness in pustules, which could not be effectively rendered visually; likewise, the amount of matter discharged from ulcerations, for example, could not be captured in images; lastly, since the illustrations were drawn at some precise time, they could not capture the entire course of the disease. As we are going to see, authors tried to adopt different strategies to tackle this problem. Although cutaneous diseases were accessible to the gaze of physicians or surgeons throughout their evolution, early representations rarely included multiple figures, probably because of the cost involved. Thus Willan argued that the drawings had to be complemented by verbal descriptions, highlighting the role of his text alongside that of the images.[13]

Some plates provide incomplete or no information on either the draftsman or the engraver. Yet the information we have is of considerable interest. Willan relied on regular collaborators and names that occur only sporadically. Among the regular draftsmen the name of Sydenham Teast Edwards occurs most frequently (ten plates); Edwards was a botanical artist who contributed

extensively to William Curtis's *Flora Londinensis* and other botanical publications; his memorial states "As a faithful delineator of nature, few equalled, none excelled," a claim we now know extended from plants to skin eruptions.[14] Just behind Edwards, with seven plates, was William Thomas Strutt, a miniature painter specializing in flowers, birds, and still lifes. Lastly, four plates were signed by William Darton, a publisher, artist, and fellow Quaker. The earliest watercolor I traced among Willan's manuscripts is dated 21 August 1788, thus before Daniel's edition of Sauvages; it is signed by William Darton and shows ecthyma, a condition involving the eruption of large pustules. The watercolor is unusual in having a black background. Eventually Bateman included four specimens of ecthyma, none of which was based on Darton's work; two were due to J. W. Strutt and two to Bateman himself.[15]

The plates were etched by a number of artists relying without exception on tonal printing, mostly stipple engraving. Several plates were due to "Perry," possibly John, a stipple engraver active in London between the 1790s and 1820s at times associated with William Blake. Others were due to L. and J. Sailliar, in all probability relatives of the distinguished stipple engraver of French origin Louis Sailliar, who died in London about 1795.[16]

Bateman's first publication on skin diseases, *A Practical Synopsis*, contained only one plate drawn by himself and engraved by John Stewart, an artist from Edinburgh who had done work for Charles Bell and who was emerging as the main pathology engraver at the time.[17] This initial modest foray was followed by the imposing *Delineations of Cutaneous Diseases* with seventy-two colored plates: at 12*l* 12*s*, the cost of Bateman's work was at the very high end of illustrated medical books. Those who already had Willan's book, whose reworked plates were incorporated in the *Delineations*, could complete the set by purchasing the new plates separately for 7*l*, still a very substantial sum. To soften the financial blow, Bateman grouped them in twelve fascicles with six plates each, published in close succession. True to his title, Bateman focused on delineations accompanied by brief descriptions, whereas Willan had also produced an extensive analytical and historical work on skin diseases, including case histories and a thorough review of the literature.[18]

For the new illustrations Bateman relied extensively either on drawings left by Willan or on his own drawings, seventeen in all. As to the engravings, Bateman had John Stewart either retouch the plates from *On Cutaneous Diseases* or engrave most of the new ones, relying overwhelmingly on stipple engraving colored *à la poupée* and finishing by hand. Stewart was responsible for about forty plates. Valuable information about the coloring comes from the first professor of materia medica and therapeutics at the recently established London University, Anthony Todd Thomson, who states that the painter John Stewart Junior, the engraver's son, collaborated with his father in the engraving and coloring of Bateman's work; such family arrangements were not unusual at the time. Although the task of hand-coloring prints was rather

menial, John Stewart Junior went on to have a distinguished career as a painter in his own right and collaborated with his father on other works on pathology, as we are going to see in the next chapters.[19]

Given that Bateman was an assistant to Willan, that he wished to complete his mentor's work, and that he even purchased the rights for Willan's plates and drawings, it is not surprising to find a stylistic continuity between them. It was Bateman who included in his first dermatological publication a plate with a synoptic view of his mentor's eight orders: pimples, scales, rashes, bullae, pustules, vesicles, tubercles, and spots. While a detailed analysis of Willan's nosology and its evolution lies beyond our scope here, I wish to recall that his first order of *papulae*, or pimples, includes three genuses, the third being *prurigo*, "which is characterized by nearly colorless *papulae*, with intense itching," as Bateman put it. Therefore even for Willan and Bateman external characteristics were supplemented by other factors.[20]

Works by Willan and Bateman attracted considerable attention on the Continent and especially in Germany: Willan's work was promptly translated into German by the Breslau physician Friedrich Gotthilf Friesen; Bateman's work too, with all its plates, appeared in German translation at Weimer.[21]

Moving to the discussion of the illustrations, we may start from some common element among our authors. Color was epistemologically crucial to the description of cutaneous diseases and at the same time more easily accessible and less problematic than in postmortems: death led to the rapid decay of body parts and to swift color changes, providing a narrow window during which to observe a corpse. By contrast, since skin diseases were accessible during their entire course, color was more easily investigated; all the authors discussed here and treatises of cutaneous diseases more broadly relied on color illustrations, and stipple engraving was overwhelmingly the favorite technique.

Willan's plates usually depict a limb, face, or recognizable body part and include no more than a couple of figures on the same page; the first plate, however, differs stylistically and conceptually from the later ones since it presents in small neat compartments resembling postage stamps the technical terms employed in his work, such as scurf, scales, and rashes. The quality of his illustrations is remarkable for their rendering of textures and colors; no selection or reproduction can do justice to the richness and quality of the originals. Illustration 5.2, showing the rash of scarlet fever, is typical in some respects, but it is also unusual in its attempt to capture the development of the disease: figure 2 at top left shows an early stage, with innumerable isolated red points that on the following day coalesce, as shown in figure 1, cutting diagonally across the page. Figure 3 on the left highlights the speckled appearance, which Willan says has sometimes been mistaken as entailing vesicles. It would have been nearly impossible to capture the appearance of such lesions with line engraving and hatching, while the dots of stipple engraving printed directly in color seem especially suited to rendering skin conditions quite convincingly. It is

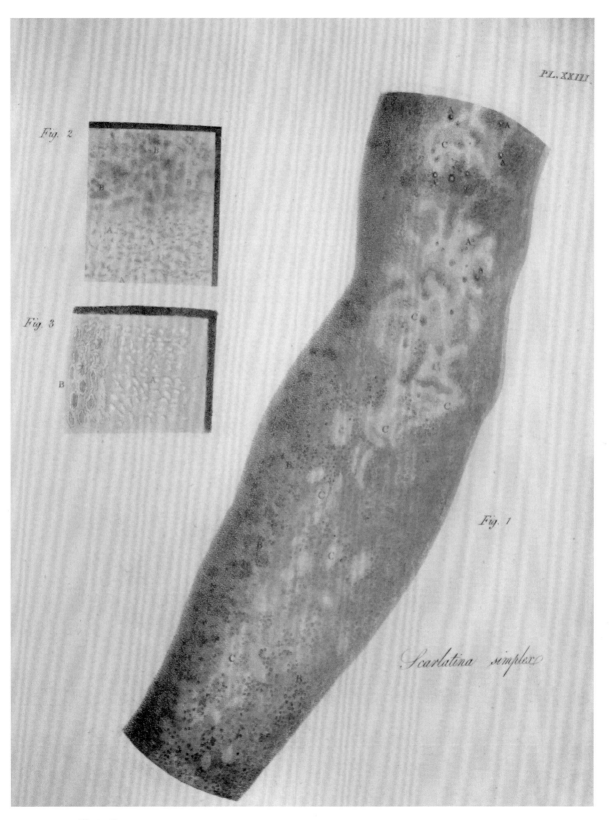

Illustration 5.2
Willan, *On Cutaneous Diseases*, 1808, plate XXIII, "*Scarlatina simplex*." Drawn by Strutt, color stipple engraving by Sailliar.

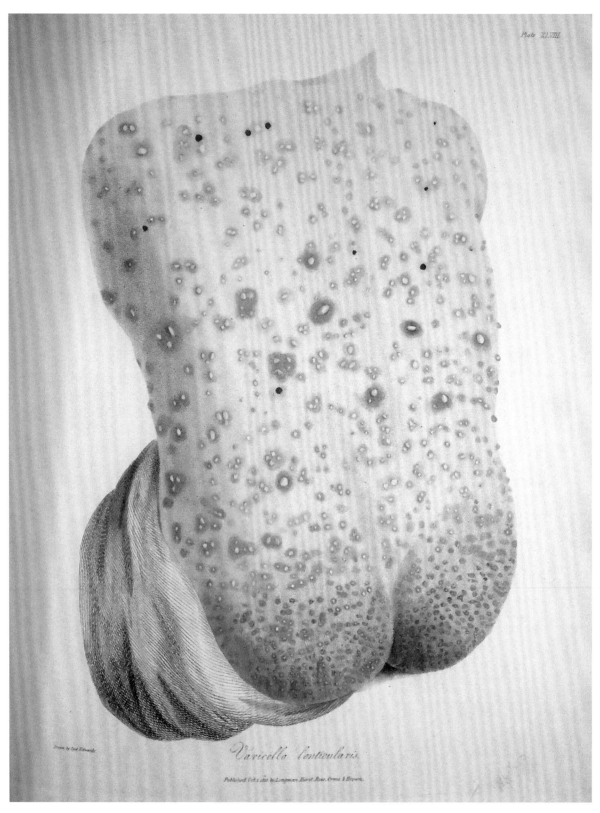

Varicella lenticularis.

Published Oct. 1 1816 by Longman, Hurst, Rees, Orme & Brown.

Illustration 5.3
Bateman, *Delineations*, 1817, plate XLVIII, "Varicella lenticularis." Drawn
by Sydenham Edwards, color stipple engraving by John Stewart.

instructive to compare Daniel's plate (illustration 5.1) to Willan's, to grasp the gulf in conception and execution between them.[22]

The plate of "varicella lenticularis" in Bateman's work relies on a drawing made by Sydenham Edwards for Willan. Here the artist has shown brown scabs alongside pustules and vesicles, some with a halo; this presence of different stages is characteristic of the condition (illustration 5.3). The plate is especially effective in rendering the different stages, including the raised vesicles at the edge of the figure; in this case it is easy to see the importance of color. Another example showing the different stages of a skin eruption can be found in Bateman's *Delineations*, but it was not due to him; rather, the drawing was due to and sent by Robert Calvert, physician to the British forces stationed in Malta. Calvert wrote an "Account" of the plague that Bateman communicated to the *Medico-Chirurgical Transactions*. The plate shows four successive stages of a plague carbuncle, from unassuming vesicle resembling the cow pock to a "fiery ulcer." Such representations, however, were uncommon; as Rayer pointed out, while the works by Willan, Bateman, and Alibert unquestionably contained the most beautiful illustrations, focusing on one stage only of the disease was misleading, in that different diseases at some point go through a common stage. Others adopted different strategies to tackle this problem, at times juxtaposing the entire course of the disease and producing images of diseases no pathologist would ever see in that form.[23]

As with the previous one, the following plates too rely on drawings made for Willan subsequently engraved by John Stewart for Bateman. That for "Molluscum pendulum" (illustration 5.4) shows only a section of the original

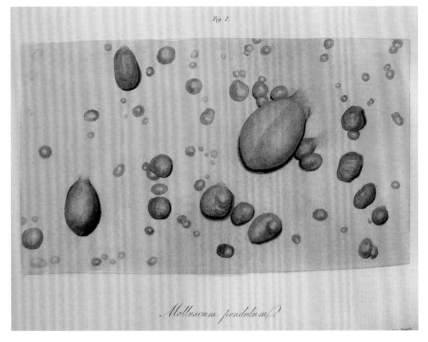

Illustration 5.4
Bateman, *Delineations*, 1817, plate LX, "Molluscum pendulum." Color
stipple engraving by John Stewart.

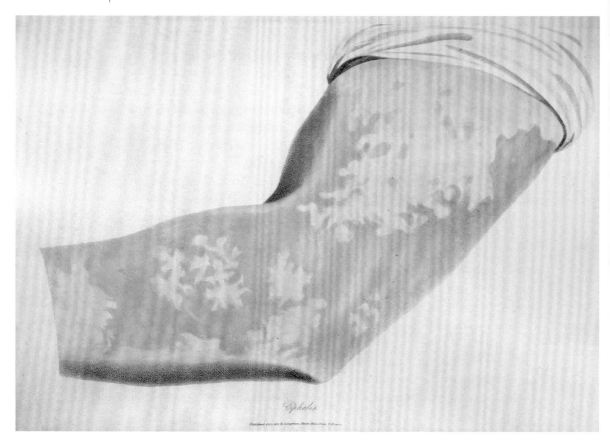

Illustration 5.5
Bateman, *Delineations*, 1817, plate LXIX, "Ephelis." Aquatint.

drawing; Bateman selected a characteristic portion with an especially large excrescence but seems to have deliberately avoided a slightly unusual excrescence that can be seen in the original manuscript drawing. The plate is especially effective in rendering the protruding "tubercles." Bateman reported that the same condition had been discussed by Tilesius in a work we are going to mention below.[24]

The next plate (illustration 5.5) shows a case of "Ephelis," whose patches "differ from freckles only in their extent, and in occurring also on parts of the skin not exposed to the direct influence of the sun." This plate had already been engraved for Willan, though it had not been printed. It is executed in a different technique from the previous ones, since it relies on aquatint; the resulting grained texture, resembling a fine mesh or lace, captures effectively the appearance of the skin. We witness here an interesting correlation between the skin affection and the printing technique employed. It is colored *à la poupée*, color being once again a characteristic mark of the condition that would have been hard to recognize with a black-and-white print.[25]

Unlike Willan and Bateman, Wilhelm Gottlieb Tilesius (1769-1857) was attracted to remarkable cases of skin affections. Tilesius matriculated at Leipzig University in 1790 and also studied art with Goethe's art teacher Adam Friedrich Oeser. While still a student, Tilesius published an illustrated work on a skin disease, *Historia pathologica singularis cutis turpitudinis* (Leipzig, 1793), with a preface by his teacher Christian Friedrich Ludwig, who, we have seen, had a special interest in the visual representation of disease; this is the work on "molluscum pendulum" Bateman referred to. After a trip to Portugal in 1795-96 as part of a naturalistic expedition, Tilesius gained his medical degree in 1801 with the pioneering dissertation *De pathologia artis pictoriae plasticesque auxilio illustranda* (Leipzig, 1801), a critical analysis of the usage of painting and the plastic arts in pathology. Tilesius published other illustrated works, such as one on a rare condition affecting two brothers of the Lambert family who were an attraction at the Leipzig fair, *Ausfürliche Beschreibung und Abbildung* of the so-called *Porcupine-Man* (Altenburg, 1802). At Leipzig he established a friendship with the physician Franz Heinrich Martens (1780-1805); both had private patients and worked at the Leipzig hospitals. Between 1803 and 1806 Tilesius took part in the first Russian circumnavigation of the globe, for which he was awarded a pension. While he was away, Martens published a work on the symptoms of venereal disease with plates partly drawn by Tilesius and partly by himself, while Martens engraved all the plates. His collaborative work with Martens was not devoted to cutaneous diseases in a strict sense, but on the symptoms of venereal disease, thus not on pathological anatomy but on external lesions on live patients. It can be a disturbing work with plates mostly showing diseased genitalia. Tilesius and Martens joined medical and artistic training and were also unusual because they were not only draftsmen but also engravers. In 1814 Tilesius returned to his birthplace, Mühlhausen in Thuringia, where he continued to publish on medical and naturalistic topics. He never obtained a university post, while Martens taught briefly at Jena.[26]

Tilesius had a collection of drawings and case histories of skin diseases, some dating from his trip to Portugal. He drew and engraved the illustrations of *Historia pathologica singularis* and *Ausfürliche Beschreibung*, since he did not trust unknown engravers, but the hand coloring of the latter was done at an illumination school; for his drawings he also relied on casts of clay and gypsum taken from the two Lambert brothers when they were in Leipzig. In the preface he discussed the merits of different printing techniques, arguing that he would have liked to use the le Prince method—that is, aquatint—which is especially demanding for printing, despite the fact that it is easier to print in color; however, the small number of prints this method allows and the fact that the magnified portions would have been unsuitable for aquatint led him to use a different technique that I am going to describe below.[27]

It is clear from the material we have discussed that pathological illustrations pose a series of conceptual problems related to both medicine and art. It is therefore especially helpful to rely on the contemporary doctoral dissertation by Tilesius, *De pathologia*, discussing the problems of representation of diseased states through both images and reliefs or sculptures, which he called the plastic arts. Tilesius's dissertation on the merits and problems of pictorial versus plastic renderings of pathological specimens echoes the Renaissance *paragone* between sculpture and painting and is a remarkable document on the state of the field at the time.[28]

Tilesius started by questioning nosology, which relied on the analogy between plants and diseases: however, plants and animals, argued Tilesius, have perpetual and stable forms proper to their genus; by contrast, diseases are mutations of the state of living bodies occurring in time and therefore can be known through a historical description rather than from a simple definition. Diseases mutate from benign to malignant and have different characters depending on the age, strength, sex, location, and habits of the patient. Nonetheless, Tilesius added, it could not be denied that nosology could be useful.[29]

In line with his notion of disease as developing in time, Tilesius advocated a continuous observation in order to capture its mutations through a series of illustrations; in the course of about a decade he assembled an extensive collection of pathological drawings. Moreover, these would have to be accompanied by case histories and a chemical and microscopic analysis of the fluids and solids.[30] Against the criticism by the Hannover physician Johann Ernst Wichmann, who had argued that features such as the hardness or elasticity of a tumor, for example, could not be rendered through images, Tilesius replied that images alone are insufficient, while at the same time verbal descriptions are insufficient without images.[31]

Tilesius provided a brief critical history of pathological illustrations, singling out those medical men who were also artists, such as Heister, Camper, and Reichel; few of the dozen he mentioned made delineations of diseases on a living body, while several questioned whether exanthemata or other skin lesions could be represented with a paintbrush or a burin. Tilesius was aware of at least the first installment of Willan's work and praised it for the quality of its illustrations. He then mentioned three illustrated nosological works by Taylor and Beer on the eyes, and by Daniel, condescendingly praising them more for their effort than for their artistry; he singled out Daniel's figure of scarlatina, or scarlet fever, as particularly unsuccessful (illustration 5.1). While Daniel had claimed that scarlatina is difficult to represent, Tilesius argued that it is not, provided one does not focus on individual maculae; rather, the character of the diseases is given by the position of the rash on the body, which has to be shown in its entirety.[32]

Much as he had done with printed images, Tilesius provided an invaluable historical review of the plastic arts, which do not simulate but represent form. He discussed the merits of wax and plaster: while there are celebrated sculptures of the healthy body in wax, only very few are devoted to the representations of diseases. Moreover, medically trained men do not excel at this art. Plaster can be used effectively to capture the form and position of muscles, once the skin has been removed, though Tilesius claimed no one beside himself had used it to represent diseased states, as far as he knew. Plaster effectively takes any form, then it hardens and does not break easily; further, because of its whiteness, it takes any color.[33]

Tilesius went on to report on the Marseille physician and man-midwife Jean-François Bertrand, who pioneered pathological ceroplastic in 1775, when he reproduced the lung of a young man who had died of phthisis. He continued making pathological specimens in wax, with the assistance of his wife. In 1791 he moved to Paris; having lost most of his collection through the turmoil of the Revolution, he started again with the support of celebrated Pierre-Joseph Desault, who put at his disposal relevant cases from the Hôtel-Dieu, where he was chief surgeon. Bertrand even set up a museum in three rooms with five hundred items, including several pathological ones; the museum was initially located in Rue Hautefeuille, later at the Palais-Royal, and charged an entrance fee. From what we now know, Bertrand had at least partly a moral focus, as highlighted by the display of bodies before and after the onset of venereal disease; he seemed especially concerned with the pernicious effects of masturbation. These remarkable details provide us with a vivid picture of one of the first collections of its kind; some of Bertrand's wax models belonging to Desault were acquired for the École de Santé—later Médecine—in 1795.[34]

Tilesius then proceeded to discuss the relative advantages of painting and the plastic arts and which diseases are best represented with each method. He argued that diseases involving an excrescence or cavity, or with a smooth, shiny, or rough skin, for example, can be rendered in wax; eye diseases cannot be rendered in plaster—it is hard to make a cast of the eye!—but can be rendered in wax. Tilesius further argued that while paintings can be reproduced through engravings, plastic images too could be reproduced by making casts. At one point we hear the rare voice of dissenting patients: Tilesius reports that many refuse to have casts taken of their lesions, because of the annoyance and pain involved.[35]

In conclusion, on the one hand Tilesius cautioned readers about relying exclusively on visual representations, because diseases can change and different stages can be confusing; therefore it is necessary to combine images with case histories. On the other hand, he argued that few have the opportunity through private practice and hospitals to see all skin diseases; a visual database has the advantage of being always available for study and compar-

ison, and indeed it is hard to see in what other way medical students could be instructed. In his illustrated book on venereal diseases, Tilesius's colleague and friend Martens states that in his lectures he used colored wax models, of which he had more than thirty.[36]

While Tilesius's dissertation contained no illustrations, his other works did. His treatise on the Lambert brothers, or *Porcupine-Man*, ambitiously dedicated to President of the Royal Society Joseph Banks and to Blumenbach, provided a historical and literary account of the case with two striking plates; virtually their entire bodies were covered with dark scales, though apart from that they suffered no ill health. Similar affections of their ancestors had been recorded at the Royal Society with illustrated reports published in the *Philosophical Transactions*. Tilesius discussed the relevant literature and provided a chemical analysis of the scales. For his plates, which he drew and engraved, he devised an ad hoc technique specifically suited to his subjects, whereby the image is formed neither by lines nor by dots but by the tiny scales of the skin of the brothers (illustration 5.6). Some figures in the lower portion of the plate show the details of the scales.[37]

THE RIVAL NOSOLOGICAL SYSTEMS OF ALIBERT AND RAYER

The early French scholar of cutaneous disease and Tilesius's contemporary was Jean-Marie-Marc Alibert (1768–1837). Alibert studied in his native Villefranche-de-Rouergue at the College of the Fathers of the Christian Doctrine, a teaching order that Alibert wished to join but that was suppressed with the Revolution. He was later trained in Paris first at the École Normale and then at the École de Santé, where he studied with the liberal philosopher and physician Pierre Jean Georges Cabanis, as well as with Bichat, Corvisart, and Pinel. Having obtained his MD in 1799 with a dissertation of fevers, in 1801 Alibert was appointed physician at the Saint-Louis Hospital, one of the largest in Europe, where in 1807 he became chief physician and where he taught clinical medicine. Alibert liked to lecture in the open air under the lime trees in the hospital courtyards, displaying colored images of skin diseases. The hospital, situated at the north periphery of Paris, was created for plague patients under Henri IV in a style reminiscent of the contemporary Place des Vosges, but with Alibert it became a center for the study of skin diseases; around the turn of the century it housed about six to seven hundred patients. The Saint-Louis Hospital was central to his activities and featured prominently in all publications discussed here, even in their titles; Alibert often emphasized its key role and its size. In a rather unfortunate but revealing passage, he compared it to a sewer collecting the rejects from the entire world, including rare diseases seldom seen in France, thus giving Alibert access to a huge range of cases.[38]

Alibert published a number of works, among which his contributions on skin diseases stand out for their size and illustrations. Between 1806 and 1814

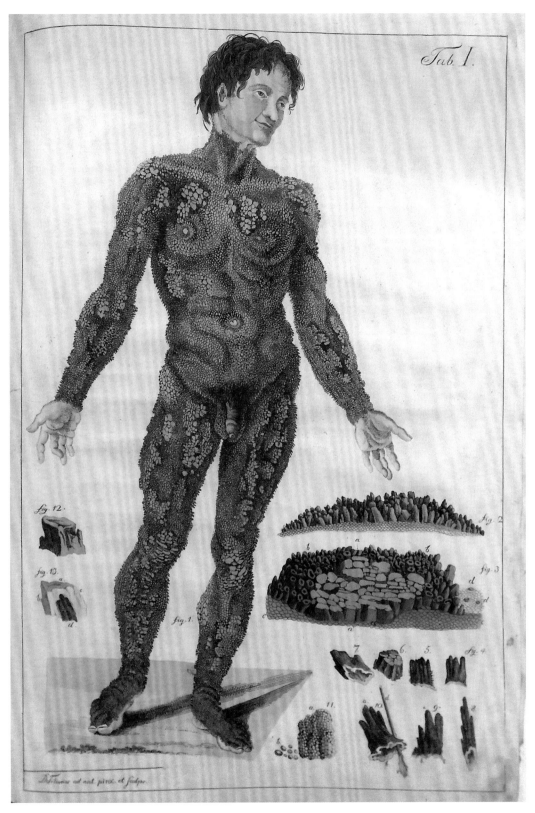

Illustration 5.6
Tilesius, *Beschreibung*, 1802, Richard Lambert's condition.
Drawn and engraved by Tilesius.

appeared the twelve fascicles of *Description des maladies de la peau*, an imposing folio treatise with dozens of colored engravings; since the book was so expensive as to be outside the range of students, he also published an octavo version without illustrations, which went through many editions.[39] He adopted creative solutions to the problem of financing: having married the daughter of his publisher, he could reinvest the substantial dowry of 100,000 francs in the family business to have his *Description* published in a format and quality without equal in pathology. Even so, the entire volume sold at the huge sum of 600 francs, fifty francs per installment. Alibert was aware of Willan's work by the time his *Description* started appearing: a brief preliminary prospectus of Alibert's work stated that Willan had begun an interesting work on cutaneous diseases, but his figures were too small to offer an exact delineation of the physical characters of the diseases. Alibert's introduction to *Description* challenged those who refer to ancient Greek, Arab, and Latin commentators, arguing that such display of erudition was of no advantage to science, since all that was needed was to observe nature. This was likely a criticism of Willan's erudite survey of ancient sources. Thus Alibert's work was seemingly inspired by Willan and was a French response to the English physician.[40]

For the engravings Alibert relied on Salvatore Tresca, a Sicilian artist who had produced a number of works in Paris. Even after Tresca's death in 1815, most of the plates in Alibert's works were signed by him; presumably Alibert owned a collection of engraved plates to be printed as the occasion arose. Alibert paid tribute to his accomplishments, arguing that his work was "nature herself, freed from her disgusting features and horrible stenches." The reference to stench was not gratuitous: apparently on one occasion the artist was so "offusqué" by the fetid lesions that Alibert had to sit with him for days and provide vinegar to help. Unfortunately, details on the draftsman responsible for most of the illustrations, Moreau Valvile—at times spelt with a hyphen—are missing. One of the reviews, however, provides a striking simile, comparing the pleasure and interest aroused by the plates to that aroused by the flowers drawn by Gerard van Spaendonck and Pierre-Joseph Redouté, the most celebrated botanical painters of the day. Both botanical and pathological illustrations required careful attention to detail, including textures and colors; moreover, in both areas the privileged printing technique was stipple engraving, one that had been brought to a striking level of accomplishment at the time by the very artists mentioned in the review.[41]

Following the demise of Napoleon and the Restoration in 1815, Alibert became personal physician to Louis XVIII and then in 1824 to his reactionary brother Charles X, who made him a baron in 1828. While official duties kept him away from the hospital, his student Laurent Théodore Biett stepped in. In 1817, the same year of Bateman's *Delineations*, Alibert published *Nosologie naturelle*, another imposing volume largely devoted to skin diseases, broadly conceived. Around the time this treatise was going to press, Biett went to

England, visited Bateman at the Carey Street Dispensary, and became convinced of the superiority of Willan's and Bateman's classification, which he proceeded to teach at the Saint-Louis Hospital, to Alibert's chagrin. Nor were matters limited to the hospital: in 1828 Biett's students Pierre Cazenave and Henry Schedel published an *Abrégé pratique des maladies de la peau* dedicated to Biett and based on Willan's system. *Abrégé* included only one plate, displaying a number of skin conditions artificially superimposed on the same individual, reminiscent of the Renaissance wound-man woodcut, in which an impossibly large number of wounds are shown for didactic purposes. Louis Godefroy Jadin, a landscape and animals painter, signed the image "dessiné d'après nature," a curious way of characterizing such a composite image.[42]

Alibert presented *Nosologie naturelle* as the extract of his clinical teaching. The book was intended to be the first of three volumes devoted to the diseases of the functions of assimilation, of sensation, and of reproduction, but the later ones never appeared. It too discussed extensively skin diseases and was ostensibly organized on the example of botanical works, grouping the diseases depending on their seat; it included an extensive historical introduction on the progress of medicine, ending with a praise of his mentor Cabanis. In this work Alibert also performed experiments to show that cancer is not contagious.[43]

In 1832 a former student of Alibert's turned publisher, Dr. Daynac, issued a work by his former teacher, *Monographie des dermatoses*, a quarto volume with a few engravings and lithographs. Lastly, in 1833 Alibert published *Clinique de l'Hôpital Saint-Louis, ou, Traité complet des maladies de la peau*. It was partly in response to Biett's challenge that Alibert sought to develop a better classification of skin diseases in these works. *Clinique de l'Hôpital Saint-Louis* was an imposing folio and included sixty-three color plates, reshuffling those from *Description* and adding some new ones. It appeared in twelve installments; the entire work cost 420 francs. The relatively less outrageous price may have been due to the fact that many of the plates were reissues of previous ones, often with the diseases renamed due to the new nosology. There were also seven new plates due to Choubard, a stipple engraver who had produced several natural history, botanical, and travel plates and also some medical illustrations.[44] Despite the stunning quality of his illustrations, his prominent position, and his attempt to revamp his classification, Alibert's work was challenged even in France.

One of his critics was Pierre François Olive Rayer (1793–1867), from Saint-Sylvain, in the Calvados department in Normandy. After a brief spell studying medicine at Caen, in 1810 Rayer moved to Paris to continue his studies, winning prizes in anatomy and chemistry, which he considered fundamental to medicine. He took his MD in 1818 with a historical dissertation, *Sommaire d'une histoire abrégée de l'anatomie pathologique* (Paris, 1818), dedicated to the memory of Cabanis. Thus within one year both Alibert and Rayer, though holding different political views, praised Cabanis's role in French medicine.

Soon after taking his degree Rayer started establishing a flourishing practice in Paris, which included wealthy patients ranging from the world of politics and finance to the Pesaro composer Gioacchino Rossini. In 1822 Rayer published a treatise on an epidemic of sweating sickness, a work that led to his election as adjunct resident member of the Académie de Médecine. In 1827 Rayer became physician to the Charité Hospital and the following year adjunct physician to the Saint-Antoine Hospice; in these two institutions he was to make many of his observations on the diseases of the skin and kidneys, though neither institution became a dermatology or nephrology center.[45] In 1848 he founded and was elected president of the Societé de Biologie, which included Claude Bernard among its members; during the second empire Rayer gained considerable power and was close to Napoleon III.[46]

Rayer's publications are too extensive to be listed, let alone discussed, here; therefore I shall focus on some aspects central to pathological illustrations. In 1826–27 and 1835–36 Rayer published two editions of a treatise on skin diseases, *Traité théoretique et pratique des maladies de la peau*. Both included a separate *Atlas*. Soon after the second edition, he published a magnum opus on the diseases of the kidneys, *Traité des maladies des reins* (Paris, 1837–41), consisting of three volumes and a large folio atlas with sixty colored engraved plates. Both works on the skin and kidneys contained historical chapters, a sign that his MD dissertation had also become a way to carry out research. Rayer's work on glanders, a disease affecting horses and other animals that can be transmitted to humans, appeared in the *Mémoirs de l'Académie Royale de Medecine* in 1837 and also as a separate volume in the same year; Rayer also worked extensively on epidemics and infectious diseases throughout his life, from an early work on sweat rush to a later major work on anthrax, in which he identified the bacillus under the microscope.[47]

The two editions of Rayer's treatise on skin diseases differed widely. For the second edition of his work, Rayer radically transformed his *Atlas* and had all the plates redesigned. The first edition included ten plates in small format: the illustrations were drawn by Jean Gabriel Prêtre, a student of van Spaendonck and a noted artist specializing in natural history, especially ornithology and botany. Much like Willan, Rayer relied on the expertise from natural history painters, trusting that artists with a keen eye for observing and depicting the shapes and colors of birds and plants would be equally adept at faithfully rendering skin lesions. His engraver, Charles Aimé Forestier, had a background in natural history and anatomy.[48]

The second edition had twenty-six plates in large quarto; often each plate included one to two dozen figures, for a total of about four hundred. Although in the first edition too each plate had several figures, the compositions differed: in 1826 most of them were framed within a rectangular box, as in a stamp collection, whereas in the second the figures had very different shapes and were arranged on the plate trying to maximize space, leading to a very

crowded field. Space was not the only reason for his new arrangement: Rayer argued that he wanted to group together on the same plate eruptions of the same order so as to make it easier to detect the distinguishing features of the genera and species. The *Atlas* of the 1835 edition sold for 70 francs, 88 francs together with the three volumes of text—which was also available separately for 23 francs.[49] This time Rayer relied on the British artist and medical student James Young of Paisley, who joined a medical gaze with an artist's hand. The plates—stipple engravings printed in color and finished by hand—were signed by Ambroise Tardieu; this may have been either one of the most active stipple engravers in Paris, or his namesake son, who was an engraver too and a medical student under Rayer. Tardieu's son later became estranged from Rayer and attained a very prominent role as a forensic physician in Paris.[50] It seems plausible that Rayer would have relied on an engraver who could join artistic skills with medical expertise, as he had done for his draftsman.

The preface to the second edition of the *Atlas* outlines the intended audience of his work: practitioners may need to be reminded of what they have seen, while students may acquire the diagnostic art. As Rayer put it, even in Paris, with so many hospitals devoted to skin diseases, it is easy to make mistakes; besides the Saint-Louis, he listed the Hôpital de la Pitié for eruptive fevers in adults; the Hôpital des Enfans Malades for a number of chronic skin diseases in infants; the Bureau Central des Hôpitaux for the treatment of the scalp; and the Hospice des Vénériens for syphilis and other venereal diseases, plus other hospitals for the relation between skin diseases and other organs.[51]

Moving a few years ahead in time, we find interesting terms of comparison with Rayer's work on kidney diseases, *Traité des maladies des reins* (Paris: Baillière, 1837–41); the first portion to appear was the 1837 *Atlas* with the plates executed in color stipple engraving and finished by hand; it consisted of twelve installments, each containing five plates and costing 16 francs, for a total of 192 francs, plus three volumes of text, which went for 24 francs together. At a time when lithography was becoming more and more common, Rayer persisted with very high-quality engravings based on drawings by James Young of Paisley and Jacquart; in all likelihood this was Alexis Jacquart, a medical student who completed his MD in 1839.[52] Thus it seems as if Rayer had a preference for medical interns with artistic skills over professional draftsmen. The engravers were Ambroise Tardieu and Oudet. The former, presumably the same who did the engravings for the *Traité des maladies de la peau*, whether father or son, signed nine plates. The latter, a noted stipple engraver active in Paris, worked especially on ornithology, botany, and anatomy and was responsible for fifty-one plates.[53] Once again, we find a pathologist relying on the expertise of a natural history engraver.

Of all the illustrations discussed in this chapter, those in Alibert's works have attracted the most scholarly attention: the color engravings in folio showing individual patients are memorable and arresting, though not necessarily prac-

tical for a dermatology treatise. Alibert highlighted that one of the advantages of a great hospital was that it enabled the study of diseases in all their stages. However, he did not include illustrations of those stages; rather, he claimed that he sought to represent skin affections when they have reached the "perfect" stage, just before they decrease. He explicitly compared himself to a botanist representing the flower fully open, when all the fructification parts are perfectly formed. One may wonder how appropriate Alibert's post-Linnaean attention to the reproductive parts was for studying skin lesions; after all, they are not flowers to be classified and a pathologist may well benefit from an illustration showing the early emergence of a lesion, in order to identify its nature swiftly, rather than at full maturity. Although both Willan and Alibert sought to represent as many species of diseases as possible, their strategies differed: the former focused on recognizable forms of elementary lesions, while the latter often selected very unusual cases depicted in a mature stage, giving his images a dis-

Illustration 5.7
Alibert, *Nosologie*, 1817, plate B of the sixth family (facing page 336), "Hématoncie fungoïde." Drawn by Valvile, color stipple engraving by Salvatore Tresca.

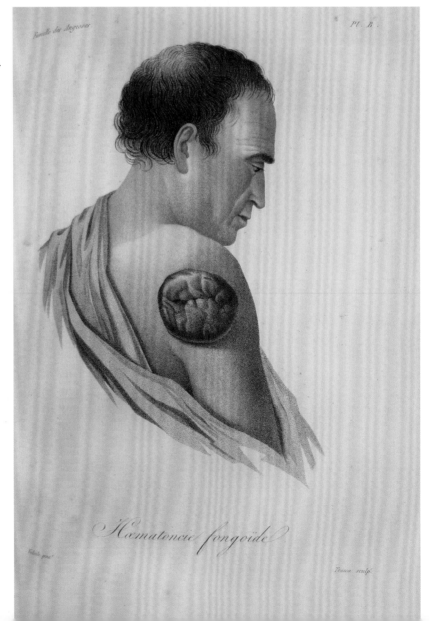

quieting look. In the "Avertissement" of *Nosologie naturelle*, Alibert stressed his taste for the rare and extraordinary. Whereas Willan's illustrations appear systematic and didactic, Alibert had a taste for the bizarre.[54]

The figures of *Description* showed both limbs or body parts and busts. The later *Nosologie naturelle* followed a different convention. The dedication to King Louis XVIII has a moral and religious tone in reminding the sovereign of human suffering through disease. Alibert stressed that his hospital was named after Saint Louis, the most pious and venerated among French kings. Possibly it is for this reason that all the plates, twenty-four in total, invariably present the face of the patient, regardless of the location of the lesion, and most show the entire body. As Leon Jacyna has convincingly argued, at times texts and images in Alibert's work have conservative religious and political overtones. By looking at the patient as a suffering human being rather than just a representative of a disease, Alibert could reinforce the moral message associated with his work. The plate for "hématoncie fungoïde" (illustration 5.7) is a case in point, since here the face of the patient is irrelevant. Alibert explained that his "hématoncie" is a bloody tumor corresponding to "fongus hématide," or fungus hæmatodes.[55]

Illustration 5.8 is instructive in several respects. Clearly we are dealing with a case that Alibert himself characterized as "très bizarre et très singulaire": the

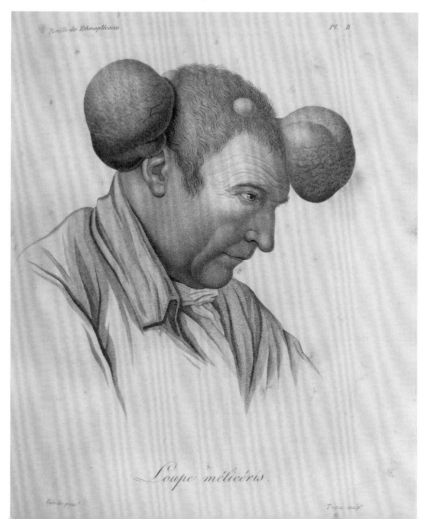

Illustration 5.8
Alibert, *Nosologie*, 1817, plate B of the ninth family (facing page 512), "Loupe méliceris." Drawn by Valvile, color stipple engraving by Salvatore Tresca .

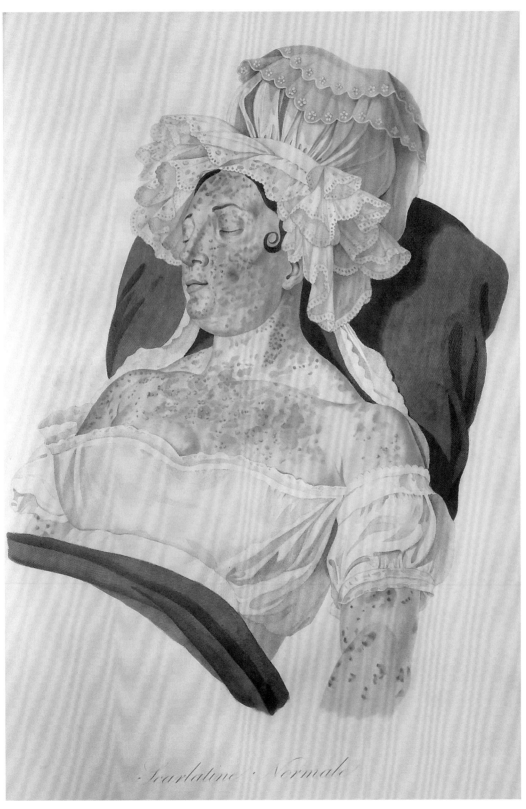

Scarlatine Normale

Illustration 5.9
Alibert, *Clinique*, 1833, "scarlatine," facing page 108,
color stipple engraving by Choubard.

sixty-two year-old patient, Pierre Huot, presented a number of growths on his head, two of which were remarkably large. As Susanne Dahm has pointed out, Alibert's text described the patient as showing no appearance of hair for the entire extension of the skull, whereas the plate clearly shows the patient with dark hair: although it is unclear whether plate and text date from slightly different times, the reader is alerted to take the plates with a degree of suspicion as to a number of factors, ranging from physiognomy to dress. Dahm astutely noticed that Alibert's patients do not look especially sick; they appear quite normal with the exception of the skin lesion, which is superadded as if it were makeup.[56]

The stunning plate of scarlet fever (illustration 5.9) can be compared to the plates in Daniel's edition of Sauvages and in Willan's work (illustrations 5.1, 5.3): Daniel's focused on an individual macula; Willan's tried to present both a detailed portrait of small skin portions and an overall impression of the arm. Alibert's is the most ambitious and shows the upper bust and arm of the patient. Although the rash does indeed affect the face, the elaborate bonnet, the curl of brown hair, and the blue pillow creating an effective color contrast are irrelevant to pathology. The three plates highlight the conceptual and technical problems involved and different priorities in the visual representation of diseased states.

Alibert routinely performed chemical analyses on the patients who had died as a result of their skin diseases, including their secretions and hair, and dissected their corpses in order to investigate internal lesions. Although pathological anatomy was central to his investigations, he never included an image of the internal body parts, which were only described verbally; the plates were exclusively devoted to external lesions. In one particularly disturbing case he included the illustration of the corpse of a patient who had died of "melanosis," as named by Laennec; although strictly speaking this was a postmortem, the body was shown whole.[57]

Much like Willan, Alibert followed a nosological tradition, in line with the teaching of his mentor Pinel. Alibert, however, was an admirer of Bernard de Jussieu's so-called natural system of plant taxonomy, which was based on a large number of characters rather than a privileged one; the title of his 1817 *Nosologie naturelle* is explicit in this regard. Alibert's early and late works are equally devoted to nosology; in *Nosologie*, for example, he stated that he was grouping diseases based on the organ where they have their special seat, starting from the head and hair. Rayer's classifications differ profoundly from Alibert's and were explicitly inspired by Willan's work; indeed, Rayer grouped Alibert with Renaissance physician Gerolamo Mercuriale for his usage of terms and a nosology based on the location of the lesions, such as tinea for affection of the scalp.[58] It was not until the *Clinique de l'Hôpital Saint-Louis* (Paris, 1833) that Alibert attempted a more elaborate nosology based on twelve groups of *dermatoses*.

Even the new nosology, however, was problematic. Rayer pointed out that Alibert's system lacked unity: eczematous dermatoses are defined on the basis of inflammation; exanthematous dermatoses on the basis of fevers; tinea (*dermatoses teigneuses*) on the basis of their location in the scalp; dyschromatous dermatoses on the basis of color; and scabies (*dermatoses scabieuses*) on the basis on the itching felt by the patient. It is hard to imagine a more heterogeneous assemblage. Given that this was Alibert's revised and improved nosology, it is no wonder that his favorite pupil Biett returned from London converted to Willan's system. In his later works Alibert included a nosological representation of cutaneous diseases in the form of a tree, where twelve branches correspond to as many groups of dermatoses; despite its visual appeal, its system was generally rejected and even ridiculed. Alibert was a more successful clinician and lecturer than a nosologist; even his students admitted that they would go to his open-air lectures in the courtyards of the Saint-Louis Hospital to amuse themselves and to Biett's lectures to be instructed. In *Monographie des dermatoses*, Alibert challenged Willan's system of elementary lesions. In an especially interesting passage he argued that since Willan practiced at a dispensary—which had no beds—he could not follow the entire course of a disease and had therefore an insufficient knowledge of long-term processes. The implication was that Alibert, as head of one of the major Paris hospitals, was in a position to follow diseases even over years. According to Alibert, Willan's system would separate what should be united and unite what should be separated. Alas, soon after Alibert's death his nosology was ignored and his work was talked about more in the context of art history.[59]

Unlike Alibert at the Saint-Louis Hospital, Rayer did not establish a dermatological center or school. Moreover, whereas Alibert was credited even by his critics with having first described and represented a number of diseases, such as "pian fongoïde" and "kéloïde," and to have correctly claimed that scabies, or "gale," was due to an animalcule, Rayer did not describe new conditions or have some named after him. Nonetheless, his treatise was highly regarded by contemporaries and immediate successors for its thoroughness, precise descriptions and systematic analysis of skin diseases and the link between them and internal pathology.[60]

Rayer devoted a few remarks to iconography. His plates looked dramatically less impressive than those in works by Willan, Bateman, Tilesius, and Alibert. However, he argued that such display of elegance was quite unnecessary. Also unnecessary was to use life-size figures showing the head, limbs, and large portions of the body with hundreds of pustules and dozens of tubercles, since a small portion of the skin with the representative lesions served the same purpose as effectively; the character of diseases could be shown without representing all the regions of the body where they occur, with much smaller figures chosen "avec soin." But there are other significant features in Rayer's images: unlike most previous cases we have considered, he did not claim that

his figures were taken from nature but stated that they were also taken from the best engravings published to that point. Whereas for the most part Willan and Bateman provided portraits of actual cases, at times providing the names of the patients, and Alibert often provided actual portraits including the face and the entire body even when this was unnecessary from a pathological standpoint, Rayer gives the impression that he was taking some liberties and was edging towards the illustration of an idealized representative case rather than an individual portrait.[61]

Rayer's plates too show a striking departure from Alibert's even at a first sight: almost without exception, Rayer included many figures on one plate, focusing on the diseased portions of the skin rather the whole body or limb. Illustration 5.10 is a typical example from Rayer's 1835 second edition of his *Traité*, displaying a collection of twenty-four figures of pustules appearing crowded even by Rayer's standards. Here we find cowpox on a cow nipple (figure 18, top left), a striking image of purulent layers with a brown crust at the entrance of the nostril (figure 5, top right), a series of images showing the development and drying of smallpox pustules (figure 7, center), and a number of pustules in profile, highlighting their height and structure (figure 8, center).

Many of the treatises we have discussed included detailed evaluations of treatment as well; although this aspect will remain largely outside the scope of my research, a few remarks are of more general interest. Willan, for example, attributed the high occurrence of skin diseases in London to the lack of cleanliness of the lower classes and argued that public baths should be more accessible to people; he also advocated bathing in sea water. In commenting approvingly on these matters, Rayer expressed astonishment at the "prodigious" number of free baths offered to people in Paris; 127,752 were given at the Saint-Louis Hospital alone in 1822.[62]

Plenck's *Doctrina de morbis cutaneis* emerges as a major work in the last quarter of the eighteenth century. Previously a plethora of factors entered the study and taxonomy of skin diseases; features that could be visually represented were only a fraction of those factors. By producing a taxonomy largely based on the external appearances, Plenck provided a key epistemological framework and justification for their visual representation, despite the fact that he did not produce one himself.

About two decades later Willan and the artists working with him established an illustrated taxonomy of cutaneous diseases and developed a pictorial language that effectively captured their subtle appearances and that was soon to be extended to other areas. The identification of the key characters of a new nosology, however, was a complex matter: Willan moved from seven to eight classes while publishing his work; Tilesius acknowledged that nosology could be useful, though he saw it as an artificial and problematic construction;

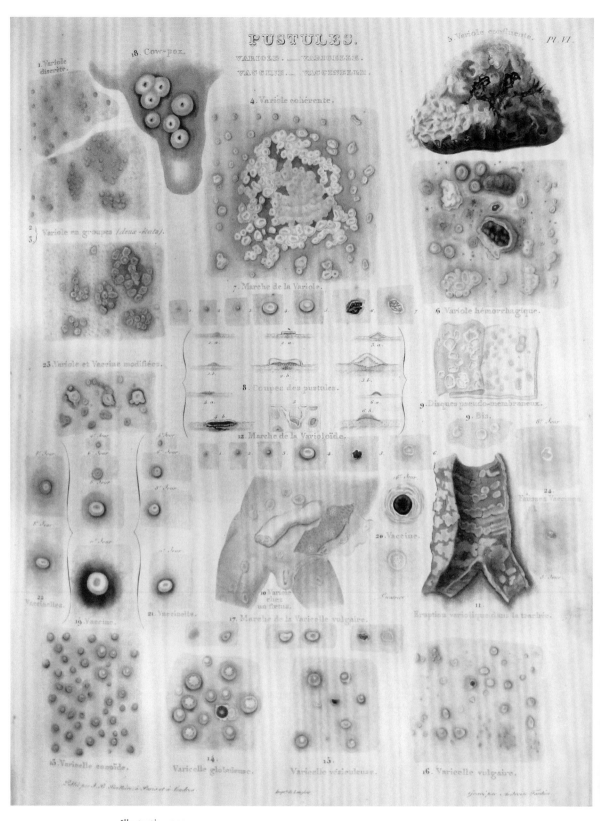

Illustration 5.10
Rayer, *Traité des maladies de la peau*, 1835, plate VI,
"Pustules." Drawn by James Young of Paisley, color
stipple engraving by Ambroise Tardieu.

Alibert struggled to identify the key characters of his system; and Rayer cautioned against relying uncritically on external characteristics. Although Willan's system won the day, a great deal of practical experience and thinking was required to develop a consensus.

The brief biographical sketches of arguably the key authors of illustrated treatises on skin diseases in the early decades of the nineteenth century present a common feature: all the authors were physicians at large dispensaries and hospitals, suggesting that such institutions were key to providing a critical mass of patients to study a wide range of diseases. For skin diseases hospitals and dispensaries were as crucial as museums were to morbid anatomy. Alibert, however, argued that Willan's work at a dispensary, which had no beds, prevented him from studying the entire course of a disease, something he could routinely do at his large hospital. Arguably, however, Willan's patients visited his dispensary more than once.

The iconography of cutaneous diseases presents a wide spectrum of forms of representation: the "postage stamp" collection of tiny portions of skin; images of limbs or body parts, including the face, that are strictly relevant to the diseases to be represented; and images of large portions of the patient, often including the face, the bust, or the entire body, even if this is irrelevant to the representation of diseases. Medical men and artists had access not only to the final stages but to the entire course of the disease, enabling them to choose among a wide spectrum of options for visual representations: to capture one significant moment, to present successive snapshots, or to artificially superimpose different stages in the same figure. Other differences we have encountered concern the representation of standard forms of the disease, versus a focus on the remarkable, exceptional, or even bizarre.

Regardless of the form of representation adopted, color was a key concern in the study and identification of skin diseases and was routinely used in the printed works; whereas black-and-white prints were adequate for rendering the shape and texture of corroded portions and growths of diseased bones, physicians believed that skin lesions needed to be shown in color if the plates had to serve as a guide for identification. Stipple engraving printed *à la poupée* and finished by hand was the most common technique employed. Natural history painters and engravers expert at color printing proved crucial to the first illustrated treatises on the subject: the elaborate and expensive plates included in the works we have encountered could not have been produced without their skills and the subtlety of the new tonal printing technique that was becoming more widespread in the late eighteenth century. As we are going to see in the next chapter, in the first decades of the nineteenth century a new tradition of pathological anatomy in color emerged from the synthesis of the pathological anatomy of museum preparations represented in black and white and the techniques and concerns of the nosology of cutaneous diseases.

SIX

MORBID ANATOMY
IN COLOR

DROPSY OF THE OVARIUM.

London Published by Dr Hooper 1830

In the early decades of the nineteenth century morbid anatomy was a grow-
ing science. The decades around 1800 witnessed the publication of several
pathology treatises of differing scope with black and white illustrations. By
the second quarter of the nineteenth century, however, these works appeared
unsatisfactory in that generally they relied on preserved specimens, which dif-
fered in texture and especially color from fresh ones; even when they relied
on fresh specimens, the omission of color proved problematic for pedagogical
and research purposes. Admittedly, bones did not have to be still warm to be
studied, but for soft parts key features could be compromised or even lost in
dry or wet preparations. Publications on cutaneous diseases highlighted the
need for a different approach to illustrations and the potential of color. In the
second quarter of the new century the tide shifted and several treatises relied
on fresh specimens illustrated in color.[1]

The claim that in the late 1820s the new genre of the colored pathology
treatise became established requires qualification: works relevant to pathology
with some colored illustrations had appeared in the past. Bleuland's *Observa-
tiones* on the esophagus (Leiden, 1785) had tiny monochromatic plates smaller
than a postage stamp; some plates in Daniel's edition of Sauvages (Leipzig,
1790–97) were in color; *Observations on Aneurism* (Birmingham, 1807), by sur-
geon George Freer, included a handful of colored plates; the treatise on vene-
real disease by Martens and Tilesius (Leipzig, 1804) was exceptional in having
extensive color illustrations. In the late 1820s, however, several extensively
illustrated works in color were produced: many were ambitious treatises often
intended as initial installments of larger projects, and seen together, they doc-
ument a new phase in pathological illustrations.[2]

The appearance of pathology treatises in color raises a number of questions, from the perspective of the production and circulation of books to that of more strictly medical and surgical issues. The British natural history tradition was flourishing at the time in areas as diverse as mineralogy, botany, and ornithology. Unlike gorgeous flowers, fancy gems, or colorful birds, which may appeal to the genteel audience of wealthy collectors, diseased states are generally unappealing and often repulsive: it is hard to imagine a less suitable after-dinner display to guests while serving claret and cigars. On the other hand, such lavish works fell squarely at the high end of the market.[3] Publication in installments made them more affordable to the intended audience of medical practitioners, but publishers needed good reasons to include expensive colored illustrations in the first place. One of those reasons was cognitive, in that many lesions were identified through color and were valuable not only to wealthy medical practitioners but also to institutions: illustrated pathology works often stem from the libraries of hospitals and infirmaries.

Unlike rocks or stuffed birds, body parts do not last long; they show up at random times and some of them rarely. Producing images from recent postmortems, as opposed to preserved specimens or live patients, posed different constraints to the artist, who had to be available at very short notice in order to fix on paper the appearances of the diseased parts before they decayed. When an interesting case appeared, an artist would be called to the autopsy room or a nearby space to produce an illustration—most frequently a watercolor—of the specimen at hand; alternatively, the relevant body part may have been delivered to the artist's studio. Both options were viable: at times the draftsman was a medical man or an artist resident at the hospital. As with preserved specimens, fresh specimens too would have to be prepared by the anatomist, sectioned, and arranged in a suitable way to be depicted, these being tasks requiring specialized skills.

Producing a pathological treatise with color illustrations was a major logistic, artistic, financial, and intellectual endeavor. All the works I discuss below were published in London, which offered a fertile intersection among artistic, printing, and medical communities with large hospitals and numerous medical schools; except for Armstrong's work, all were due to the same publisher, Longman and associates. The illustrated works I discuss here were produced at a time of flux in terms of printing and coloring: a broad range of techniques was employed, including stipple engraving, mezzotint, aquatint, and lithography, with plates colored by hand, *à la poupée*, and using multiple plates.

Some historians have singled out France as the center of key transformations in the professional structure and training of surgeons and physicians, for example, and the emergence of tissue pathology with Bichat. More recent scholarship, however, has broadened the geographical horizon, showing that in Britain too the boundaries between surgeons and physicians were reshaped. Similarly, Bichat's views had significant precedents in Britain and elsewhere.

Moreover, the works discussed here focused on distinguishing and comparing key visual features of lesions rather than primarily on localization. The first decades of the nineteenth century proved crucial, with the creation of new societies and journals bringing the two domains together and testifying to increased dialogue and cooperation. This new situation is reflected in the careers and professional affiliations of my authors.[4]

I have selected key authors whose works testify to shifting concerns in the visual representation of morbid anatomy: John Richard Farre and Robert Hooper advocated the merger of nosology and morbid anatomy; Thomas Fawdington at Manchester focused on an individual case of melanosis; works by Richard Bright and Astley Cooper document research carried out at Guy's Hospital; lastly, James Annesley's tomes on diseases of the digestive tract in India and John Armstrong's study of diseases of the stomach and intestine document colonial and London perspectives. Except for the work by Farre, who is an especially interesting figure and whose illustrations are of exceptional quality, all date from after 1825.

JOHN RICHARD FARRE AND ROBERT HOOPER: NOSOLOGY AND MORBID ANATOMY

John Richard Farre (1775–1862), born in the Barbados, moved to England in 1792 and became a member of the Company of Surgeons in the following year; he studied at Edinburgh University but gained his MD from Glasgow in 1802 and later became a licentiate of the London Royal College of Physicians. In the same year Farre helped found the Ophthalmic Hospital, where he worked for half a century. We have seen in chapter 4 that eye diseases had long been studied with color illustrations in the tradition of nosology; moreover, as Farre pointed out, eye diseases are observable throughout their course. In the preface to an 1811 treatise by John Cunningham Saunders, Farre stated that since only a few cases of "malignant fungi" can fall under the observation of one individual, it is especially worthwhile to record and illustrate them by means of engravings, this being the "only method" of communicating correct notions of disease. Historian Russell Maulitz has identified Farre as a pivotal figure in promoting British pathology with special emphasis on visual representation and a clinical approach. Farre's contribution to the area was *The Morbid Anatomy of the Liver* (London, 1812–15), a work he presented as a synthesis between Morgagni's focus on case histories and Baillie's careful descriptions of morbid structures and alterations of textures, which he had carefully illustrated; moreover, Farre saw his work as a contribution to a form of nosology that relied overwhelmingly on lesions rather than symptoms or causes. Later he published *Apology for British Anatomy, and an Incitement to the Study of Morbid Anatomy* (London, 1827), and edited the single issue of the *Journal of Morbid Anatomy, Ophthalmic Medicine, and Pharmaceutical Analysis* (1828), the first of

its kind. The *Apology* stressed the importance of studying the structure and especially texture of diseased parts, as opposed to their mere "relative situation"; this distinction characterizes the shift in the study of diseases of the soft parts occurring around the turn of the century, especially with Baillie.[5]

Although Farre advocated the study of drawing, painting, and modeling by medical men, in *The Morbid Anatomy of the Liver* the plates relied on drawings by Henry Thomson, a miniature painter whom Astley Cooper had encouraged to train in anatomy and anatomical drawing at St. Thomas's Hospital; he worked three days for Cooper and three for Farre and also made drawings for Bateman. The engraver was pathology artist John Stewart. Farre owned a collection of specimens, drawings, and also engraved plates on diseases of the liver. The work is incomplete, since Farre had envisaged four or six installments with twelve or thirteen color engravings total, though only two installments with two engravings each appeared. The considerable cost of 15*s* for each installment highlights the challenges met by such publications and the significance of the cluster of works considered here. The plates in Farre's work stand out for their quality. Illustration 6.1 shows a portion of a liver studded with light-colored growths, which he called *tubera circumscripta*—not to be confused with *tubera diffusa*, which presented different features in Farre's nosology of lesions. Farre's figure effectively renders the uneven surface of the liver, the presence of tubers on the surface as well as in the parenchyma, their overall spherical shape, unless some have coalesced, and their color, both with the respect to the parenchyma of the liver and internally. A contemporary review praised the work and especially the quality of the plates, while lamenting the therapeutic limitations of morbid anatomy.[6]

Baillie had tentatively taken *tubera circumscripta*, which he called "large white tubercle," to be scrofulous, at least in some instances. Although at times Farre had observed them together with scrofulous signs, on the basis of a careful visual inspection he respectfully challenged Baillie, arguing that they belong to "fungous" diseases. Thus although in this instance Baillie's analysis was challenged within a dozen years of its appearance, Farre's methodology closely resembled that of his predecessor, except for his reliance on case histories and a closer attention to providing specific names, as in the nosological tradition; Farre cited Linnaeus, Cullen, and Sauvages. Readers may want to compare the condition described, though not illustrated, by Morgagni, mentioned in chapter 3, in which the liver was found studded with whitish bodies, the largest of which was the size of hazelnuts. Although Morgagni described the lesion, the main focus of his analysis was its seat in the liver as opposed to the stomach.[7]

A close contemporary of Farre's, Robert Hooper (1773–1835) was born in London and attended medical lectures there. He was appointed apothecary to the Marylebone Infirmary, where he assembled an extensive collection of anatomical and pathological preparations. After studying at Pembroke College,

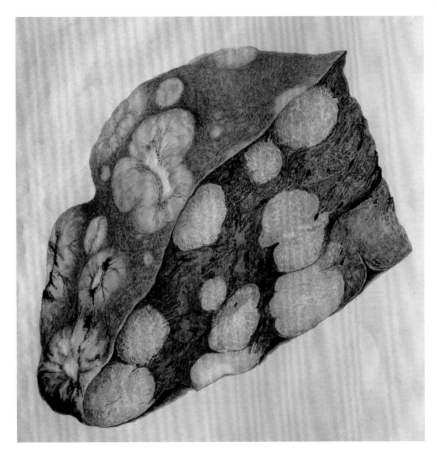

Illustration 6.1
Farre, *Liver*, 1812,
plate I, "Tubera
circumscripta."
Drawn by Henry
Thomson, stipple
engraving by John
Stewart.

Oxford, he obtained his MD from the University of St Andrews in 1805. Hooper became a physician to the Marylebone Infirmary and also had an extensive practice. He was a popular lecturer on the practice of medicine in London and a prolific medical writer, composing medical dictionaries and vade mecums that went through several editions in Britain and America, selling many thousands of copies. In 1798 he composed an essay on intestinal worms that received the silver medal from the Medical Society of London, of which he was secretary, and was published in the following year, *Observations on the Structure of the Intestinal Worms of the Human Body* ([London], 1799). His work contained striking aquatint illustrations based on microscopic observations. His *Anatomical Plates of the Bones and Muscles Reduced from Albinus, for the Use of Students in Anatomy, and Artists* (London, 1802) contains simple didactic plates. His *Morbid Anatomy of the Human Brain* (London, 1826), however, belongs to quite a different genre, in that it included fifteen far more sophisticated color illustrations for a more professionally advanced and affluent audience. Copies of the treatise on the brain—which appeared in a second enlarged edition in 1828—were for sale for *2l 12s 6d*, a considerable sum. Hooper retired from practice in 1829 and from his post at the Marylebone Infirmary in 1831. In

the following year he published a companion volume, *Morbid Anatomy of the Human Uterus and its Appendages* (London, 1832). Hooper was an art collector who left a fine collection of paintings at his death.[8]

Hooper's *Morbid Anatomy of the Human Brain* set out the ambitious project of representing "the most important morbid appearances to which the viscera of the human body are subject." In addition to the treatises on the brain and uterus, he had planned and partly completed four additional volumes with colored illustrations on the alimentary system, the respiratory system, the heart, and the urinary system; the manuscripts survive among his papers at the Olser Library at McGill, together with a wealth of preparatory materials for his treatises on the brain and uterus. Many watercolors date from 1802–3, testifying to the interest color representations of diseased states aroused already at the beginning of the century. Hooper conceived the color drawings as forming a paper museum "in some respects more useful than the preparations themselves." For good measure, he also preserved the specimens after they had been drawn.[9]

Hooper relied on a range of draftsmen, including the painter John Stewart Jr.—John Stewart Sr.'s son—and George Kirtland, who also worked for a number of other surgeons and anatomists such as Astley Cooper and produced publications on the anatomy of the horse as well as pathological studies of the appearance of smallpox and cowpox. One of his draftsmen was John Howship, a distinguished surgeon in his own right, who had published anatomical works with colored engravings based on his own drawings in the past. Hooper and Howship were closely associated: Howship dedicated to Hooper his *Practical Remarks on Indigestion* (London, 1825), in which he poignantly characterized him as having "trodden in the steps" of Matthew Baillie. Further, in *A Series of Engravings*, Baillie had relied on a preparation by Hooper; Howship was one of Baillie's last students at the Great Windmill Street School and he made a manuscript copy of Baillie's work on morbid anatomy, including the illustrations.[10] The employment of a surgeon such as Howship as an artist and their personal closeness testify to the value Hooper attached to technical expertise in the delineations of diseased body parts, to his commitment to the accuracy of the illustrations, and to the interplay among medicine, surgery, and art.[11]

The plates for the *Morbid Anatomy of the Human Brain* were engraved by J. Wedgwood (ten plates), who had previously engraved plates in Howship's surgical works, and John Stewart Sr. (five plates); they were stipple engravings colored by hand. In one instance, a portion of a plate printed in black and white and finished by hand in a copy of the 1826 version was colored *à la poupée* in a copy of the 1828 edition, highlighting the constant search for better solutions.[12]

An especially interesting plate from our perspective shows what Hooper calls a hæmatoma of the left hemisphere of the brain, arising from its medullary substance; the figure highlights the irregular shape and high vascularity

PLATE X.

161

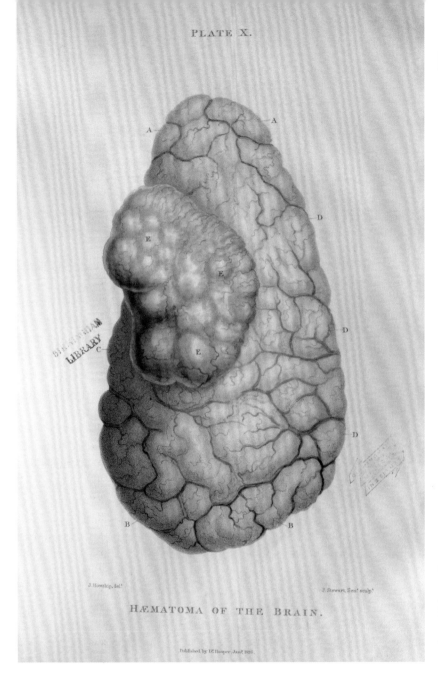

J. Howship, del.

J. Stewart, Sen.' sculp.'

HÆMATOMA OF THE BRAIN.

Published by D.' Hooper, Jan.' 1826.

Illustration 6.2
Hooper, *Brain*, 1826, plate X, hæmatoma. Drawn by John Howship, stipple engraving by John Stewart Senior.

(illustration 6.2). Hooper tells us that the growth is soft and somewhat elastic and that it is also called fungus hæmatodes—studied by Wardrop (illustrations 4.1 and 4.2). One can gauge the difference in size and execution from Wardrop's plates, which were much smaller, whereas Hooper's takes a whole imperial quarto page and is in color.[13]

At the back of his work on the uterus Hooper stated that his two works were in the same format; presumably he envisaged them to be bound together. Whether this is the case or not, the two works followed a similar structure. Hooper's chief aim was nosological, seeking a taxonomy of lesions: he argued that his work sought "to diffuse the knowledge of morbid structure, and enable

the pathologist to distinguish organic diseases from one another, and thereby dispose them in classes, orders, genera, species, and varieties." Once this is achieved, "nosology will assume a new and permanent arrangement, and the practice of physic arrive at its greatest perfection." While adopting a nosological approach, Hooper differed from Farre in omitting case histories.[14]

In the work on the brain Hooper identified five categories of disease, inflammation, tumors, diseased structures and unnatural appearances without tumefaction, morbid collections of fluids secreted between the membranes and in the cavities, and extravasated fluids. The plates are divided between diseases of the membranes and diseases of the substance of the brain. In his work on the uterus too he adopted a five-fold distinction, the first three corresponding closely to those of the brain, followed by ulcers and polyps.[15]

Diseased states are defined in relation to healthy ones. This way of seeing matters poses conceptual and practical problems, particularly in cases of highly variable organs, such as the uterus. In Hooper's treatise the first plate shows two images of a healthy uterus, one of a virgin in her twenty-second year, the other "under the catamenial functions." Hooper justified the inclusion of two figures by arguing that he did not recall having ever seen an illustration of the healthy uterus during the menstrual period.[16]

Despite his allegiance and closeness to Baillie, Hooper did not hesitate to criticize him when he saw fit, as Farre had done. A footnote to the plate describing tubercles in the brain praised Baillie's illustration but challenged his view that the lesion was of a scrofulous nature. This example captures his concerns, though in this case Hooper added in a footnote a comment going beyond exclusively taxonomic matters: he confirmed his opinion by a clinical observation, stating that none of the several bodies whose brains showed such tubercles displayed, either before death or after dissection, any other evidence of scrofula. Thus Hooper's nosological concerns led him beyond a narrow description of the specimen, because clinical signs were crucial to the identification of the nature of the disease.[17]

In the *Morbid Anatomy of the Human Uterus* Hooper relied on a broader set of artists and techniques, including stipple engraving, aquatint, and lithography. In addition to Howship, Kirkland, and John Stewart Jr., we encounter the distinguished watercolorist Thomas Heaphy. Besides engravings by Wedgewood and John Stewart Sr., we also find three were aquatints by Thomas and John Heaphy. Of twenty-one plates, ten were lithographs due to Thomas Heaphy and one by John Stewart Jr. The large number of print proofs in black and white and in color among Hooper's papers testifies to the care he devoted to his project.[18]

Illustration 6.3 shows a case of dropsy or hygroma of the ovary that was so large that it had to be scaled down, the original being about two spans. Hooper could extract from the hygromatous sac ten quarts of a thick albuminous fluid that he subjected to an elementary chemical analysis by placing it over a flame;

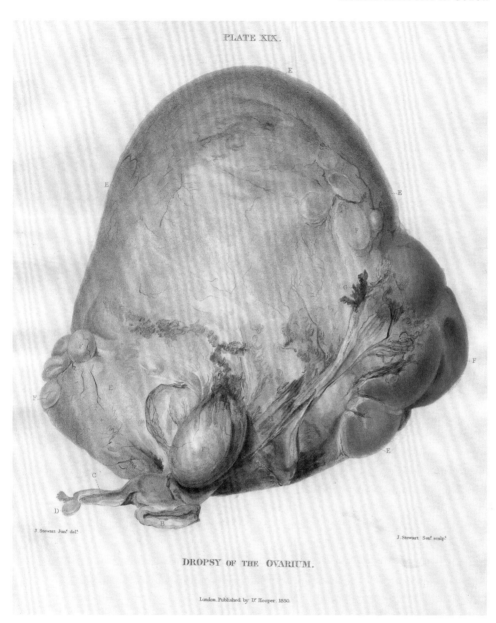

PLATE XIX.

DROPSY OF THE OVARIUM.

J. Stewart Jun.ʳ del.ᵗ

J. Stewart Sen.ʳ sculp.ᵗ

London, Published by Dʳ Hooper. 1830.

Illustration 6.3
Hooper, *Uterus*, 1832, plate XIX, "Dropsy of the Ovarium." Drawing by John Stewart Junior, stipple engraving by John Stewart Senior.

two thirds formed a solid mass and the last third remained serous. Although similar tests—and others too, as we have seen in the case of leprosy in illustration 1.1—had been common for centuries, they had become especially prominent at the time following Bright's work, as we are going to see shortly. The sac contained five tumors adhering to its inside surface. The plate was printed in red and is quite remarkable for its three-dimensional effect and its ability to convey not only the size—compare a portion of the vagina at B—but also the weight and tension of the specimen.[19]

THOMAS FAWDINGTON'S STUDY OF MELANOSIS

A generation younger than Farre and Hooper, Thomas Fawdington (1795–1843) qualified as a surgeon in 1817 and started working as a clerk at the Manchester Infirmary, where he was elected to the staff in 1837. After becoming a member of the Royal College of Surgeons in London, in 1826 he was appointed surgeon at the Manchester Lying-in Hospital, a charitable institution for women. Fawdington lectured on anatomy and pathology, devoting considerable efforts to a museum of morbid anatomy, on which he wrote *A Catalogue Chiefly of the Morbid Preparations Contained in the Museum of the Manchester Theater* (Manchester, 1833). He stated that for nearly all the preparations in the museum there were colored drawings made from the fresh specimen, thus highlighting the combined usage of preserved specimens and colored delineations. His other publication was *A Case of Melanosis* (London, 1826), with eight hand-colored lithographic plates.[20]

Fawdington's treatise on melanosis relies on a single case history on a disease affecting many organs. Initially he envisaged a report for one of the medical journals but then changed his mind at the suggestion of some of his "professional friends"; presumably the change of venue was related to the inclusion of the colored plates. He justified his move by "the inadequacy of mere verbal description to convey an accurate notion of morbid appearances, together with the interesting peculiarity of the disease which it is my object to illustrate." The plates were due to his pupil J. A. Smith and lithographed by "Mr. James," in all probability Henry Gould James, who was also a watercolorist and restorer of paintings. The coloring was produced under Fawdington's supervision, to his "complete satisfaction." The small book sold for the comparatively affordable sum of 7s 6d.[21]

Fawdington's case seemingly originated from the eye. In January 1824 Thomas Peckett consulted Mr. Wilson, a surgeon at the Manchester Eye Infirmary, for pain in his left eye; after standard therapies produced no effect, the eye was removed on April 19. In August, however, the patient returned to the surgeon, who noticed at several places on the skin tumors similar to the one in the eye. Peckett was sent to the Manchester Infirmary, where he died on November 3. The postmortem revealed widespread melanosis in many organs, leaving Fawdington to wonder at the "laws" governing its behavior. He also compared his findings to the preparations by George Langstaff, surgeon at the London Cripplegate Dispensary, who had assembled an impressive museum; once again, we see the crucial role of museums in pathological research. Chemical analysis of the black matter suggested that it was a secretion from the coloring portion of the blood.[22]

The plate (illustration 6.4) shows a section of the kidney, which was the most affected organ after the liver. Fawdington noticed that the black "tubercles" were largest on the outer surface; the cross section shows also a portion

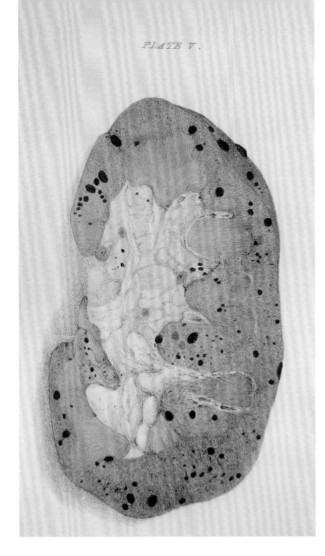

PLATE V.

Illustration 6.4
Fawdington,
Melanosis, 1826,
plate V, melano-
sis of the kidney.
Drawn by J. A.
Smith, lithograph
by Henry Gould
James.

of the surface at the top. Besides the plates from the postmortem, Fawdington included also one of the eyes before and after extirpation, which was provided by Mr. Wilson, the surgeon who had first visited the patient; he must have kept a visual record of at least some cases, highlighting the significance he attached to them.[23]

Fawdington questioned Wardrop's parallel between melanosis and fungus hæmatodes on structural grounds and displayed command of the recent French literature following the works by Bayle and Laennec. There is no explicit reference to the recent essay on the same topic by William Cullen, descendent of the eighteenth-century nosologist, and Robert Carswell, published in 1824, except for a possible allusion.[24] Although Carswell was an accomplished artist who had already produced pathological watercolors for teaching purposes, and was to become the author of one of the first comprehensive pathology treatises illustrated in color, his essay was not illustrated. In providing a Mancunian perspective, Fawdington documents the way pathology works, illustrated or not, were produced and used.

Richard Bright's extensive investigations were closely contemporary to Fawd-ington's more modest monograph and brought international fame and recognition to its author. In order to appreciate its background, it is helpful to consider some institutional developments instigated by Astley Cooper (1768–1841), a Norwich surgeon who had become arguably the leading London practitioner of his time. Trained at St. Thomas's and Guy's Hospital, Cooper later taught anatomy and surgery at St. Thomas's Hospital, where he also contributed to the establishment of an anatomical and pathological museum. He treated aristocracy and royalty and was made a baronet in 1821. In 1825 he moved to Guy's Hospital because of a patronage rift, leaving behind the museum. At Guy's he had to start afresh and did so with relentless energy, making of his new base a major center for teaching and pathological research. Cooper published extensively, notably *Outlines of Lectures on Surgery*, which went through ten editions between 1820 and 1839. He had a long-standing interest not only in specimens but also in their visual representations, and he established collaborations with several artists both for his private use and for numerous illustrated publications. His works on hernias (1804 and 1807, with an 1827 expanded edition) stand out for the number of size of their illustrations. He also published works with color illustrations on diseases of the testis and breast.[25]

At Guy's Hospital Cooper's career intersected that of Bright. Traditionally Bright has been grouped with two other great pathologists at Guy's, Thomas Hodgkin (1798–1866) and Thomas Addison (1793–1860). With regard to visual representations, however, Bright's work is in a class of its own. Here I focus on him and to a lesser extent Cooper's contemporary work.[26]

Bright (1789–1858) stemmed from Bristol. In 1808 he enrolled at Edinburgh University, where he studied, among others, with surgery professor John Thomson, who was to become one of Carswell's patrons in using pathological images in color. In 1810 Bright was part of an expedition to Iceland, where he focused on zoology, botany, and mineralogy, which was one of his passions; during this trip he made several sketches. Bright gained medical practice in London, where he attended lectures in medicine, chemistry, and surgery at Guy's and St. Thomas's Hospitals, including those by Cooper. In 1811, while still a student in Edinburgh but practicing at the London hospitals, he started making drawings of healthy and diseased body parts, including his first representation of a granular kidney; Bright referred to another drawing of a diseased kidney dating from around 1815.[27]

Bright gained his MD at Edinburgh in 1813 with a thesis on contagious erysipelas, a skin disease studied and represented by Willan. In January 1814 he started working at the Public Dispensary, Carey Street, where Willan and Bateman had been active. In 1814–15 and 1818 Bright embarked on two Continental tours and visited several centers, including Leiden, Vienna, and the

University Hospital at Pest. In Leiden he no doubt visited the anatomical museum described by Eduard Sandifort, who died in February 1814; in Vienna he visited the General Hospital, the remarkable collection of wax anatomical models imported from Florence, and the collection of injected body parts based on a secret method due to Georg Prochaska. In 1815 he found himself close to Waterloo, where he assisted the wounded together with several other British medical men, including Charles Bell. It was during his second Continental journey that he visited the Paris hospitals and met Laennec, who had just invented the stethoscope, though *De l'auscultation médiate* had not yet appeared, and Rayer.[28]

Bright had a deep interest in the visual arts and was an accomplished draftsman of landscapes and natural and medical specimens; during his European journeys he did not miss the works by the great masters, especially Dürer and Rembrandt; he also owned some of their prints, as part of an extensive collection that included what appears to be the mezzotint head of Christ on Veronica's veil printed by Jacob Christoph Le Blon, a pioneering work in the art of color printing. Bright also collected books on the history of print making.[29]

Back in London Bright worked at several medical institutions, including Bateman's Public Dispensary, the Fever Hospital, and the Lock Hospital for syphilitic patients; thus Bright was in close contact with Bateman around the time when he published the lavishly illustrated *Delineations of Cutaneous Diseases*. In 1816 Bright became a licentiate of the Royal College of Physicians and in 1820 was elected a Fellow of the Royal Society. In the same year he was appointed first assistant physician and then, in 1824, full physician at Guy's Hospital, where he also lectured on clinical medicine; thus he was perfectly placed to benefit from Guy's revival.[30]

While still a student he had already expressed his belief in the unity of medicine and surgery, which he believed depended on each other; such views were gaining wider acceptance at the time, though Bright was especially prominent in promoting their merging, delivering lectures at the Medico-Chirurgical Society and publishing in the *Medico-Chirurgical Transactions*, for example. Besides his major treatise, *Reports of Medical Cases Selected with a View of Illustrating the Symptoms and Cure of Diseases by a Reference to Morbid Anatomy* (London, 1827–31), Bright also published several papers in other journals, such as *Guy's Hospital Reports*. In 1832 he was elected Fellow of the Royal College of Physicians; he was physician to several members of the royal family and received many national and international honors and recognitions for his work on diseases of the kidneys.[31]

It was while at Guy's that Bright produced *Reports of Medical Cases*. The structure of his work presents some peculiar features: in the first volume he focused on individual diseases affecting several organs with plates showing the ulceration of the intestine in cases of phthisis of the lungs, for example. His move to the brain in volume two followed a similar plan—pathological rather

than anatomical—in that many of his kidney patients died of apoplexy. Since several diseases may affect many different organs, Bright had to provide an extensive index to allow readers to retrieve information about those organs. Unlike volume one, which was based on diseases, volume two was more rigidly based on one organ and related parts. It was Bright's colleague Cooper who had suggested to him that it would have been far more useful to readers to focus on diseases of one individual organ: hence volume two deals overwhelmingly with affections of the brain and nervous system, from inflammation to epilepsy, and all the plates except one are pertinent to the topic. Cooper's suggestion must have come at a rather late stage, since on two occasions Bright skipped plates (IV and VIII) that had already been drawn—though not yet engraved—intended to show diseases of the intestine and lungs related to those of the brain, justifying his decision by referring to Cooper's suggestion. The only exception is one plate showing a diseased uterus of a woman of seventy-four allegedly affected by nymphomania and other disorders, since these were considered pertinent to the nervous system.[32]

The case histories in the first volume of Bright's *Reports* date from October 1825 to April 1827. For the artwork Bright relied entirely on Frederick Richard Say and his father William; the former was a distinguished artist who also painted Bright's portrait, the latter a mezzotint engraver. The plates were colored *à la poupée* and finished by hand in quite a detailed fashion; as one reviewer put it, the main fault with the plates was their "excess of beauty," though those of the kidneys were deemed superior to those of the lungs. Frederick Richard studied at Benjamin Robert Haydon's art school, one that was unique in Britain at the time in promoting the study of anatomy and dissection for artists as a way to understand ancient sculpture. Haydon was a student of surgeon Charles Bell, thus underscoring the profound ties among art, anatomy, and now pathology in the 1820s.[33]

The extensive portfolio of watercolors for Bright's work from around 1825 and going far beyond what appeared in print has survived at the London Royal College of Physicians. In addition, we are especially fortunate that William Say's son donated to the British Museum virtually the entire portfolio of engravings produced by his father, over six hundred, thus enabling us to study in detail his artistic background and itinerary. William Say engraved mostly portraits and landscapes but had virtually no anatomical background prior to working for Bright, except for one plate from 1811 representing a heart in cross section based on Clift's watercolor. In the 1820s, however, thus immediately preceding his collaboration with Bright, Say produced several natural history plates in mezzotint and stipple engraving on steel, mainly of flowers but also of fruit, colored *à la poupée* and finished by hand, for the *Transactions of the Horticultural Society of London*. The journal also published prints by the student of Franz Bauer, William Hooker, future director of Kew Gardens. Thus Say moved from chrysanthemums, lilies, and pears to diseased kidneys, lungs, and intestines, his previous production offering experience in color prints of

natural history subjects. In the end William Say engraved thirty-two plates for Bright, sixteen for each volume.[34]

For the second volume Bright relied on a wider set of artists and techniques: of thirty-eight plates, thirty-one were engravings by William Say, William Frederick Fry, and Charles James Canton, while the remaining seven were lithographs mostly by the Bavarian-born artist and lithographer George Scharf, who also worked for zoological and geological journals; the lithographs were all in black and white. One lithograph was by Thomas and William Fairland, whom we are going to discuss below. From about the time when the Guy's Hospital School was established in 1825, Canton was permanently employed to make color drawings of the parts that entered the museum while still fresh, thus forming a collection on paper complementing the wet and dry preparations. Guy's also employed Joseph Towne to make wax models, thus highlighting the range of modes of representations employed. Canton's role paralleled that of the Moravian artist Franz (Francis) Bauer, who was employed at the end of the eighteenth century as the first botanical illustrator at Kew Gardens, a position he retained until his death in 1840. Bauer also replaced William Clift, with whom he was on excellent terms, for the anatomical, especially microscopic, drawings printed in an essay by Everard Home in the *Philosophical Transactions* and in the profusely illustrated *Lectures on Comparative Anatomy* (London, 1814-28). To close the circle, Clift was secretary of an anatomico-botanical society, and Bauer studied the diseases of plants, especially the blight of corn, on which he published essays with illustrations based on his drawings and experiments.[35]

Although most plates were printed in color, occasionally even more than two, they still had to be finished by hand. For the most part we do not know the names of the artist who colored the plates, though in Bright's second volume two plates are marked as colored by Canton. Canton had already illustrated surgical works by Astley Cooper and worked both in watercolor and engraving, including aquatint. It is unclear whether Canton colored just one plate as the exemplar to be copied by less skilled laborers or the entire set.[36] The quality of the hand coloring was remarkable: comparing two copies side by side it is hard to detect any differences.

Bright's volumes were not for the faint-hearted: volume one sold for 4*l* 4*s*, volume two for 7*l* 2*s*; not surprisingly, fewer than 250 complete copies were sold. The two pairs of volumes published by Hooper and Bright highlight changes in the printing techniques and the use of color. All the plates in Bright's first volume are mezzotints; the second volume, however, involved a broader set of artists and the use of lithography in some cases. After its invention at the end of the previous century, lithography was slowly making inroads in many areas.[37]

Bright's medical contribution can be seen—and indeed it was seen at the time, by Rayer, for example—as the synthesis of two traditions: one that had recognized a connection between edema and anomalous features in the kid-

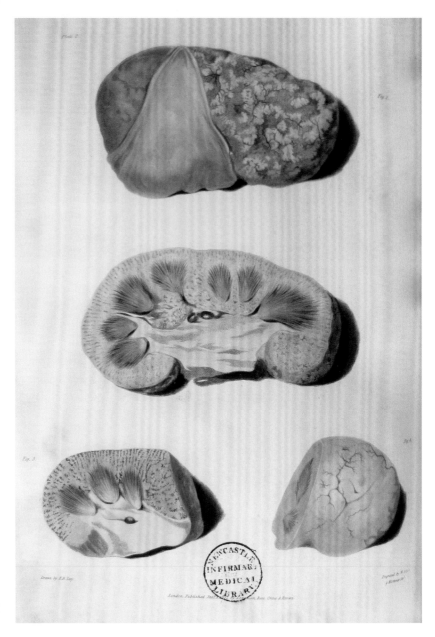

Illustration 6.5
Bright, *Reports*, 1827,
plate 1.II, Sallaway's
kidney. Drawn
by Frederick Say,
mezzotint engraving
by William Say.

neys found during postmortems; and one that had established a correlation
between edema and the presence of albumin in the urine, which produced
floccules at the application of heat. Bright brought these strands together by
combining clinical signs, postmortems, and chemical analysis and identify-
ing kidney lesions as a common cause of edema; he also had a ward at Guy's
Hospital specifically for kidney patients. The first part of his 1827 volume
deals with kidney diseases and identifies a condition involving all three ele-
ments; the chemical telltale was albuminous urine. Bright explained that he

was not concerned with presenting striking novelties—a possible jibe at the older literature on unusual or even monstrous cases. Much like Laennec with the stethoscope, Bright was able to detect in live patients, this time by means of a simple chemical test, possible signs of an internal lesion. Bright sought the collaboration of John Bostock, physician and chemical lecturer at Guy's Hospital, another Edinburgh MD, who had been trained by notable chemists

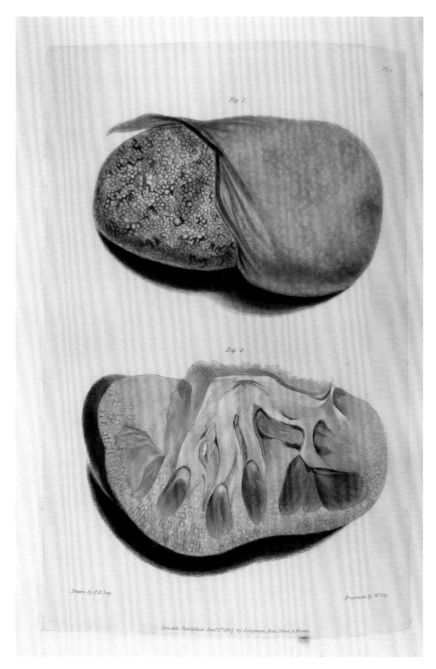

Illustration 6.6 Bright, *Reports*, 1827, plate 1.I, King's kidney. Drawn by Frederick Say, mezzotint engraving by William Say.

Joseph Priestley and Joseph Black. With Bostock's help Bright secured the chemical data that established his reputation. The condition Bright identified was named after him for over a century. Unfortunately signs were not always univocal, in that dropsy, albuminous urine, and kidney lesions did not invariably go together.[38]

The appearance of the kidneys in cases with broadly similar symptoms could vary greatly. Therefore Bright did not identify a unique lesion but rather a cluster of them with significantly different features: which ones were different stages of the same condition, and which were genuinely different, was not a straightforward matter since Bright could not establish the course of the lesion. In the case of phthisis too analogous symptoms and sounds detected through the stethoscope could be associated with different looking lesions,

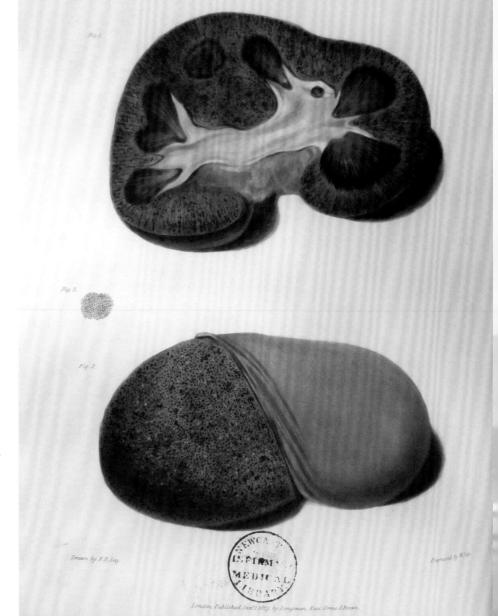

Illustration 6.7
Bright, *Reports*, 1827, plate 1.V, Evans's kidney. Drawn by Frederick Say, mezzotint engraving by William Say.

Drawn by F.R.Say.

Engraved by W.Say.

London, Published Jan.ʳ 1 1827, by Longman, Rees, Orme & Brown.

as Bright pointed out. In the end, he tentatively adopted a three-fold taxonomy. The plates had to render the different appearances in terms of color and texture; the following selection seeks to capture the complexity of the task encountered by Bright and the Says.[39]

The three main varieties of the disease are identified by the last name of the patient, whose case history is reported in the text. Illustration 6.5 shows a very advanced stage of what Bright tentatively identified as the first variety. Mary Sallaway suffered from dropsy and her urine was albuminous. Her kidney is shown whole (top) and in longitudinal section (center); a portion of the same kidney whose arteries were injected with a red dye (bottom left) highlights that a large section was nearly impermeable.[40]

In the second variety the cortical portion of the kidney is converted into a granulated texture that can exhibit strikingly different appearances depending on the stage of the disease and the amount of blood present. Bright expressed uncertainty about the classification of some cases. Although the kidneys of John King and Leonard Evans (illustrations 6.6 and 6.7) appear quite different, they are presented as variants of the same condition: the former involved albuminous urine, anasarca or widespread swelling, and hydrothorax; the latter slightly albuminous urine, anasarca, and blood in the urine. Both kidneys are shown whole and in longitudinal section. In addition, Bright included a tiny portion (illustration 6.7, center left) of Evans's kidney macerated for a few days, highlighting its granulated structure. Evans's kidney is described as "deep" or "dark chocolate," with dark and white specks, "like grains of sand."[41]

The third variety is represented by the case of Elizabeth Stewart, whose kidneys exhibit an especially rough and scabrous surface; their color, however, was lighter than in other cases, which were more purplish gray (illustration 6.8). Her case history involved albuminous urine and anasarca. This time Bright shows the external view of one kidney and the longitudinal section of the other.[42]

Bright included other plates showing kidneys tentatively seen as belonging to intermediate stages. From this brief analysis we can gain a sense of the complexity of his task and of the crucial role of color illustration. Despite their prominent role, Bright routinely viewed color illustrations in conjunction with other aspects, notably case histories, chemical analyses, and tests on the specimens, such as maceration.

 The art of representation deserves close scrutiny for the specific problems associated with disease, such as shape, texture, and color. Overall, authors were not necessarily explicit about the advantages of color illustrations, besides stating that they allowed a better recognition of the disease. Since their books were aimed at practitioners, the advantages of the new form of representation would have been self-evident and could therefore be taken for granted. Bright, however, was unusually attentive to and explicit about these matters: on some occasions he highlighted that exposure to the atmosphere

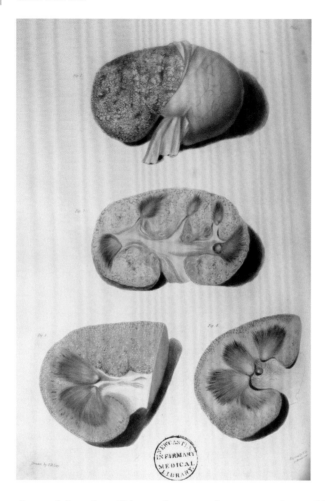

Illustration 6.8
Bright, *Reports*, 1827,
plate 1.III (figures
1 and 2), Stewart's
kidney. Drawn by
Frederick Say, mez-
zotint engraving by
William Say.

changed the color of his specimens, as in some portions of the lungs, for exam-
ple. He also provided a number of details on the condition of the specimens
and their arrangement. On one occasion, for example, we are told that a tumor
removed and placed on a table broke open due to its own weight.[43] In his cap-
tions he routinely addressed issues like how the specimen had been sectioned,
perspectival presentations, and preparation techniques involving maceration
and washing with water; at times he relied on preserved specimens,[44] injec-
tions with differently colored liquids,[45] and magnification.[46] Some plates show
the same organs under different conditions, such as in different stages of dis-
section or under increasing magnification; the same specimen can appear on
different plates. On two occasions Bright represented portions of the intestines
suspended against a light in order to highlight their fine vascular structure.[47]

Each printing technique presented distinct textural qualities, which made
it preferable for the representation of specific body parts. For example, in
illustration 6.9, the outside surface of the brain is rendered in powerful mez-
zotint, while the cerebral cortex in the cross section is rendered through the

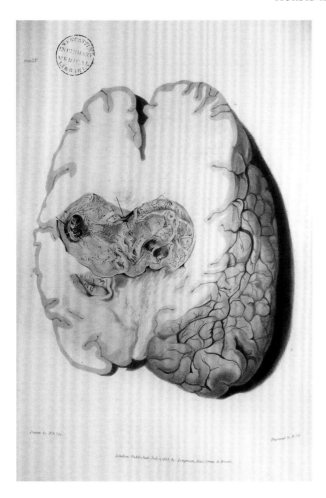

Illustration 6.9
Bright, *Reports*,
1831, plate 2.XXV,
Morely's brain cysts.
Drawn by Frederick
Richard Say, mixed
intaglio techniques
by William Say.

more delicate stipple engraving. The plate relates to the case of Thomas Morley, a "stout dark-coloured man" aged forty-four, who succumbed to this fatal disease associated with vascular cysts in the brain in forty-four days from the occurrence of the first symptoms, when he lost the use of the thumb and its two adjacent fingers.[48]

Right in between Bright's two volumes, his colleague Cooper published works with hand-colored lithographs on the diseases of the breast and testis, two surgical domains.[49] Here I discuss very briefly the latter, which consists of two parts, one anatomical, the other pathological. The provenance of the specimens is revealing of the institutional history of the hospitals: Cooper owned the anatomical material, but he had donated the pathological specimens to St. Thomas's Hospital, where they remained even after his rift with the administration and move to Guy's. Cooper had devised a way to inject the testis, enabling him to preserve it and dissect it better. One of the plates shows a preserved specimen predating Cooper's time at St. Thomas's, thus not after the 1780s. Another shows three stages of chimney-sweep cancer, the

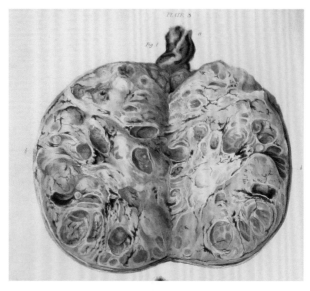

Illustration 6.10
Cooper, *Testis*,
1830, part 2, plate
III.1. Hand-colored
lithograph, drawn by
Thomas Fairland.

scrotal condition identified by Pott in 1775, superimposed on the same scrotum.[50] The plate I have selected (illustration 6.10) shows a case of "hydatid testis," "immediately after its removal from the living body" in May 1804. Cooper described the drawing as "most excellent" and the condition as "beautiful," highlighting his sense of aesthetic appreciation even for diseased states. Cooper gives the name of the patient as Charles Demby, who recovered from the surgery.[51]

JAMES ANNESLEY AND JOHN ARMSTRONG: COLONIAL AND LONDON PERSPECTIVES

Two notable contemporary works on the digestive apparatus by India surgeon Sir James Annesley and London surgeon and physician John Armstrong stand out for the number and quality of their color images.

John Armstrong (1784–1829) was born near Durham and studied at Edinburgh University, where he took his MD with a dissertation on dropsy in 1807. In the same year he qualified as a surgeon at an examination of the Edinburgh Royal College of Surgeons. Armstrong practiced in his birthplace and at the nearby Sunderland Infirmary, before moving to London in 1818, where in 1819, following Bateman's retirement, he became physician at the St Pancras Fever Hospital, where Bright also worked. His appointment was probably due to the high opinion that Quaker communities in the North of England and London had of him. The following year he became a licentiate at the Royal College of Physicians. He taught at several anatomy and medical schools in London and published many works, especially on typhus and fevers, and also *On the Morbid Anatomy of the Stomach, Bowels and Liver* (London, 1828–29), with hand-colored lithographic plates. Like many of his colleagues, he died of consump-

tion, which he detected through a "metallic tinkling" in the lungs as described by Laennec and confirmed at autopsy.[52]

Ten years older than Armstrong, Annesley (1774–1847) was educated at Trinity College, Dublin, and the Dublin College of Surgeons; he also studied with Matthew Baillie and William Cruikshank in London before moving to India, where he served the Honourable East India Company (HEIC) as a surgeon at various hospitals almost continuously from 1800 to 1824. By that point he stated that he had had a twenty-five-year practice in charge of rather large hospitals across India. Back in England he published two works: *Sketches of the Most Prevalent Diseases of India, Comprising a Treatise on Epidemic Cholera of the East* (London, 1825) and *Researches into the Causes, Nature, and Treatment of the More Prevalent Diseases of India, and of Warm Climates Generally* (London, 1828), the latter with forty colored engravings. He went back to India in 1829. On his return to England he was elected a Fellow of the Society of Antiquaries in 1840, with surgeon Thomas Pettigrew as the first signatory of his nomination, and was knighted in 1844. He died in Florence. Pettigrew included him in the Medical Portrait Gallery, a pantheon of medical and surgical authorities, alongside Hippocrates, Galen, many nineteenth-century practitioners, and Pettigrew himself, for his services in India and the thoroughness and scope of his case histories and postmortems of diseases of warm climates.[53]

In *Researches* Annesley sought to triangulate case histories and postmortem reports with an additional dimension: he provided an extensive account of the geography, soil, vegetation, and climate of India, and of the causes of diseases in warm climates more generally. He believed that the conformation and constitution of patients is best suited to the country or continent they inhabit; migrations to other regions engender disorders of various sorts, both for the differences of climate and diet or regimen. His *Researches* focused on the digestive system, including the stomach, liver, and intestine, with special chapters devoted to dysentery, cholera, and fevers. His treatise provided readers with a wide collection of diseases that would not have been encountered—at least in the same form—in different climates. Annesley claimed that in warm climates postmortems occur very soon after death and therefore, somewhat paradoxically, bodies are in better conditions when they are inspected; for all his cases he routinely provided the time elapsed from death, which ranged from one to nine hours, the latter being rather exceptional. He was also especially concerned with the state of the internal organs once the capillary circulation has ceased and blood has returned to the main veins. As in Bright's first volume of *Reports*, in Annesley's *Researches* the cases were identified by the patient's name and included detailed case histories.[54]

Unlike Annesley, Armstrong eschewed case histories; he provided a description of the diseases of the abdomen and added a section on symptoms, explicitly following the approach of the second edition (1797) of Baillie's *Morbid Anatomy*. Armstrong challenged the nosological technicalities and

metaphysical abstractions of scholastic education. For him morbid anatomy dealt only with observable lesions of the solid parts; broader considerations on disease, including the fluids, pertained to pathology more generally. Armstrong played close attention to the tissue localization of diseases, especially in serous and mucous membranes. Besides fresh specimens, Armstrong relied on preserved specimens collected by George Langstaff; his friendship with Thomas Hodgkin, curator at the Guy's museum, possibly gave him access to that collection too.[55]

During his time in India Annesley had easy access both to postmortems and to an unnamed artist who made up to 150 color drawings under his own eye. They were made for his own private records between 1811 and 1824 and were not intended for publication. It was only on his return to Britain in 1824 that he relied on them for publication, possibly inspired by contemporary works. This was a common pattern: Farre, Hooper, Fawdington, Bright, and Cooper also had portfolios of pathological watercolors.[56]

The engravings in Annesley's work were due to different artists, mostly John Stewart Sr., who signed thirty-three out of forty plates, as well as James Basire III and Neele, possibly James or Josiah, from a family of London engravers. Stewart Sr. had engraved the four plates of Farre's *The Morbid Anatomy of the Liver* and works by Bateman and Hooper. At times the exceptionally bright colors were criticized, but it was argued that the specific circumstances of India made the colors more vivid and Annesley claimed great accuracy for the plates. His treatise was extraordinarily ambitious in scope: its production was subsidized by the HEIC in the amount of several thousand pounds, which enabled it to appear in the form of two thick imperial quarto volumes with large colored engravings, sadly lacking in later editions. Despite the subsidy, its price at 14*l* 14*s* made it possibly the most expensive work of its kind not issued in installments. In all likelihood the HEIC subsidy came in the form of the purchase of a number of copies that were "attached (as a regimental record) to every regiment in India"; thus the work was part of the British medical and military colonial enterprise. Such was the size and weight of Annesley's tomes that, as a reviewer put it, a buffalo may have to be employed by each regiment "for the transportation of these volumes from station to station."[57]

The outrageous price of Annesley's treatise contrasts with Armstrong's, who wanted his work to be as affordable as possible, hence his reliance on lithography. Even so, each fascicle sold for 10*s* 6*d* in black and white and 1*l* 1*s*, or double that, colored, thus the whole treatise sold for 1*l* 11*s* 6*d* in black and white or 3*l* 3*s* colored; coloring added almost exactly 2*s* per plate. While the uncolored version was much more affordable, Armstrong's work was more expensive than Hooper's on the brain, with a comparable number of colored plates. In the other works discussed in this chapter the coloring was a cognitively integral and significant aspect of the plates. By contrast, in Armstrong's work the coloring enhanced the plates, though the black and white lithographs

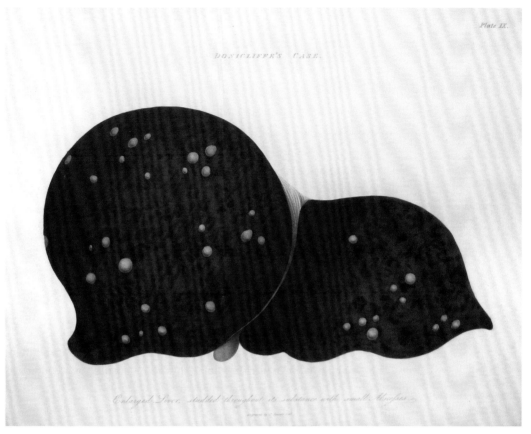

Illustration 6.11
Annesley, *Researches*,
1828, plate IX,
Donacliff's case,
small abscessed
on enlarged liver.
Stipple engraving by
John Stewart Senior.

were self-standing and of remarkable quality. As a reviewer put it, the plates are "too beautiful, the common and universal fault of all pathological representations"—a similar comment to one elicited by Bright's work. The reviewer found the color of Armstrong's plates excessive and preferred the uncolored ones for their greater faithfulness, highlighting an unresolved tension between artistic and pathological concerns. Most plates were drawn by the surgeon and naturalist William Pennington Cocks; all were lithographed by Thomas and William Fairland. Thomas, a student of the Swiss-born artist Henry Fuseli, was a well-known lithographer, while his younger brother had already produced lithographs with an anatomical subject.[58]

Many of Annesley's illustrations, such as those of the liver, for example, are very large and often included both the whole organ and its section on separate plates. At times they showed the internal organs in situ, with the surrounding abdomen sketched out around them. Possibly because of the extensive subsidy received from the HEIC, no expense was spared in the production of the illustrations. Occasionally John Stewart Senior made impressions with multiple plates in addition to coloring *à la poupée*, creating the most elaborate and ambitious productions of his pathological oeuvre. The case I wish to discuss is that of Thomas Donacliff, who arrived from England in June 1816, was admit-

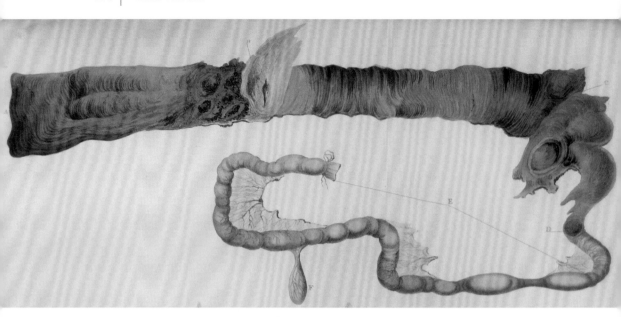

Illustration 6.12
Annesley, *Researches*, 1828, plate XXXIII, figure 1, Donacliff's case, colon laid open. Stipple engraving by John Stewart Senior.

ted into hospital on October 29, and died on November 13. The plate (illustration 6.11) shows a dark brick-colored liver, with very dark spots; moreover, the liver is covered by abscesses with purulent matter consisting of semifluid pus. Since its internal structure resembled the outer one, no cross section was included in this instance; in several other cases Annesley included a cross section as well. On another plate, however, he presented a portion of the intestine from the same patient (illustration 6.12); here at A on the left is the rectum, where the mucous coat has sloughed and was expelled by stool; B is a portion with a large ulcer; at C is the cecum laid open with the villous coat detached and gangrenous; at E is the ileum contracted in many places.[59]

Another plate (illustration 6.13) is quite striking in that it shows the liver in situ, with a large abscess in the right lobe and smaller ones throughout; Annesley chose this particular arrangement because he argued that similar cases may be amenable to surgical intervention in between the ribs, whose remains are shown in the upper half of the plate at the edge of the open oval. Annesley points out that the smaller abscesses resemble those of plate IX (illustration 6.11); thus the plate gives a closer impression of what the surgeon may find in his practice. Unlike the report on Donacliff, here Annesley provides a more extensive case history; thus we learn that twenty leeches were applied to James Lynch, aged twenty-seven, and that a decoction of cinchona and sulfuric acid had to be interrupted because it gave too much thirst and uneasiness.[60]

In India as much as in Britain, inflammation was thought to degenerate into many ailments and was therefore deemed as their cause; Armstrong listed tubercles, scirrhus, fungus, and melanosis as stemming from inflammation. Hence the so-called antiphlogistic treatment of bloodletting, which was thought to remove inflammation, appeared as a rational response, one

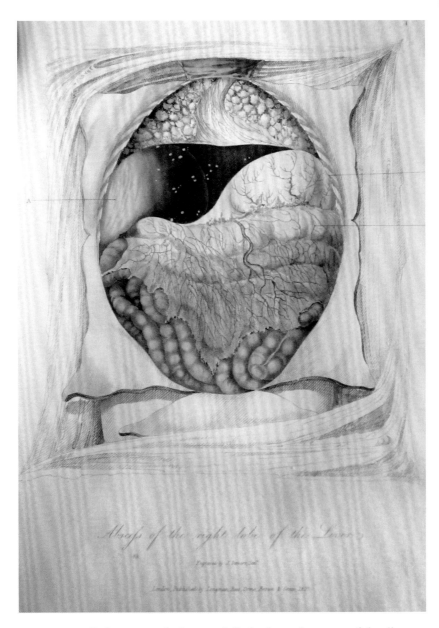

Illustration 6.13
Annesley, *Researches*,
1828, plate XII,
Lynch's case, liver
abscess. Stipple
engraving by John
Stewart Senior.

Armstrong relied on extensively especially in the early stages of the disease. In some instances, however, after careful investigation of their incipient stage, he doubted whether tubercles and melanosis were related to inflammation. Melanosis, for example, seemed to occur in "ill-conditioned patients," especially those addicted to alcoholic beverages—this being a common cause of many diseases. Moreover, he argued that scirrhus, or hard cancer, and fungus, or soft cancer, were not different stages of the same disease. Armstrong also indulged in therapeutic speculations, as when he predicted that with time diseases would be cured by remedies acting through blood.[61]

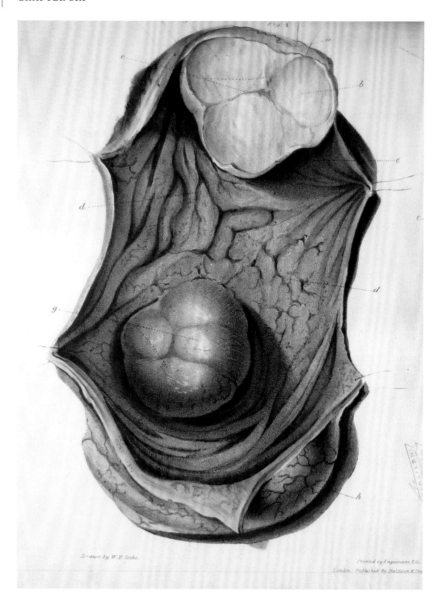

Illustration 6.14
Armstrong, *Morbid Anatomy*, 1828, plate IX, figure 1, encephaloid tumor of the stomach. Drawn by William Pennington Cocks, lithograph by William Fairland.

Illustration 6.14 shows fungus hæmatodes, here called encephaloid tumor, of the stomach; it shows both a cross section of the tumor at the top and a whole one at the bottom. The figure is especially successful in rendering the smooth and shiny surface of the tumor; the corrugated mucous membrane at *d* and the varicose serous membrane at *h* are rendered very effectively.

Armstrong's treatise was left incomplete due to his premature death, with the section on the liver missing. One reader bound Farre's *Morbid Anatomy of the Liver* together with Armstrong's fascicles, as a way to complete it with another pertinent illustrated pathology work; clearly he saw a link between the two works, despite differences between their authors' views.[62]

Producing extensively illustrated pathology treatises in color required a commitment over a relatively long time and an extensive medical practice, such as that offered by a large hospital or infirmary, providing a large and varied supply of cases. It is no accident that nearly all the authors discussed above were in this situation, whether in Manchester, London, or colonial outposts: Fawdington and Hooper worked at the Manchester and Marylebone Infirmary, respectively, Cooper and Bright at Guy's Hospital, Annesley at several Indian Hospitals, and Armstrong at the Fever Hospital. Indeed, Bright stated that his motivation for publishing *Reports of Medical Cases* was to render the experiences learnt at a large hospital more permanent, thus presenting his work as firmly tied to his tenure at Guy's.[63]

In addition, Fawdington relied on the Manchester Pathology Museum and Langstaff's museum in London, Hooper had his own collection of specimens, Cooper and Bright relied on Guy's Hospital museums, under Hodgkin's curatorship, and Armstrong praised Langstaff's museum and his friend Hodgkin. Far from replacing museums and preparations, illustrated works complemented them.[64]

Extensive collaborations with artists were a requirement; some artists specialized in pathology, from miniaturist Henry Thomson to engraver John Stewart. The British scene included many watercolorists and a widespread culture of colored books ranging across many disciplines, especially in areas of natural history such as botany, ornithology, and mineralogy; this world of artists, engravers, and printers provided valuable expertise in the representation of nature, capturing shapes, textures, and color shades, proving fertile soil for the growing and sophisticated world of colored pathological images. We witness a progressive shift from tonal printing—especially stipple engraving—often printed in color and finished by hand to hand-colored lithographs.[65]

Producing extensively illustrated pathology treatises in color was a challenging financial endeavor; Baillie already expressed concerns in issuing his black-and-white *Series of Engravings*. Morbid anatomy had a seemingly limited market and the price of books with extensive color illustrations was very high: authors' deaths and high prices meant that several works remained incomplete. Nonetheless, the works we have discussed here entailed well over one hundred color plates, many in large format. These works did circulate and have a significant impact, as testified by Bright's treatise on the kidneys. Moreover, copies I have perused of the works discussed here stem from British hospitals and infirmaries, suggesting that medical institutions were part of the intended market; although this is an area for a more extensive investigation, medical practitioners seemingly would have had access to them for reference in their workplace. In addition, entire works, such as Cooper's *Diseases of the Testis*, were translated into German, while Robert Froriep in Weimar and Johann Albers in Bonn reproduced many pathology plates in color from a number of works for their usefulness to physicians and surgeons.[66]

Concerns about printing techniques and cost were pressing, but significant epistemological issues were also at stake in that the use of color had implications on the way lesions were described and identified. By the second half of the 1820s color had become a crucial cognitive feature in the study, identification, and classification of lesions; almost invariably the lesions described by our characters relied on color as a major descriptive and distinguishing element, most famously in Bright's study of diseased kidneys. This is the reason why several surgeons and physicians, such as Farre, Hooper, Bright, Cooper, and Annesley, owned portfolios of pathological watercolors. These collections seemingly grew during the first quarter of the century and many led to publications in close succession in the late 1820s. Moreover, Hooper and Bright had a documented appreciation for art: Hooper had a collection of paintings, while Bright was a draftsman and collected prints.[67]

The problems of conceptualization and representation of lesions associated with diseases are exceedingly complex. From melanosis to the kidney conditions studied by Bright, visual representations of diseased states had a major cognitive role in distinguishing a number of conditions going beyond simple localization. Virtually without exception, images presented portraits of individual organs and body parts as they appear in a postmortem. Hooper and Armstrong provide images of the disease without case histories. Farre and Hooper sought a nosology based on postmortem lesions. At times the patients with their case histories are identified by name in the text, as in works by Farre, Fawdington, Bright, Cooper, and Annesley. At times there is a certain tension between the specific and individual portrait of a diseased state versus the general title of each section and some authors' taxonomic ambitions. This difference of presentation points to different ways of understanding pathology: those who included case histories wished to anchor it to clinical signs in the tradition of Morgagni; others focused on a careful description of lesions, what Maulitz has called pure pathology, and which some at the time called morbid anatomy; some sought a common ground eschewing case histories but adding a list of symptoms to the classification of the lesions.[68]

In the *avant-propos* to *Anatomie pathologique*, Cruveilhier provided a historical sketch of the field of pathological illustrations in color, singling out works by Hooper, Bright, and Annesley among the major contributions. He also lamented that the French, despite their leading role in pathology, had not paid much attention to illustrations, whether in color or not. Matters, however, were to change rapidly.

SEVEN
COMPREHENSIVE
TREATISES IN COLOR

In the aftermath of the London pathology publications in color, a number of French investigators undertook the task of producing something even more ambitious: a comprehensive illustrated treatise of pathological anatomy on the main diseases of the entire human body. In 1829 three such works were started: *Traité d'anatomie pathologique* (Paris, 1829–33) by Jean-Frédéric Lobstein of Strasbourg, holder of the first chair of pathological anatomy in France; *Iconographie pathologique* (Paris, 1829) by Jean-Baptiste Delestre, a renowned artist and a pupil of Antoine-Jean Gros, working in collaboration with a host of medical men; lastly, *Anatomie pathologique* (Paris, 1829–42) by Cruveilhier, the only work among the three to be brought to completion.[1]

Delestre's treatise was unusual not only because it was conceived by an artist but also because it envisaged the collaboration with dozens of medical men—forty-nine are listed on the title page, though only a fraction contributed. Delestre may have been rather naive in planning such a work, given the rivalries in the Parisian medical world; one wonders whether he would have included Laennec, if he had not died in 1826, alongside his arch rival François-Joseph-Victor Broussais, who communicated the first case. Perhaps it is not surprising that Delestre's enterprise did not go beyond the second installment out of thirty-six planned. One of the most active collaborators was Rayer, who contributed two reports. We have four letters by him to Delestre dating from 1829; in two of them Rayer requested his presence on the following day—in one case at the "Hôpital St Antoine"; the other may have been the same or the Charité—since he expected the postmortems to reveal remarkable heart and lung diseases that had not yet been described in words or with figures. In another letter Rayer asked for the proofs of the figures; although Delestre was

responsible for the publication, the accuracy of the illustrations was checked by the pathologist too.[2] It seems plausible that other forms of cooperation may have proceeded along similar lines, even when the author was the medical man rather than the artist.

Moving from treatises dealing with a specific body part to more ambitious works, the issue of cost became even more pressing. Works by Lobstein, Delestre, and Cruveilhier relied almost exclusively on lithography, which was the most affordable printing technique; the cost of having an artist make the original drawing, transferring it on copper, preparing the intaglio, and having it printed and finished in color by hand made such treatises laborious to prepare and expensive. By contrast, lithography cut production costs and had a more immediate relation to the drawing process. Two other comprehensive works published in London, though sharing French roots, relied on the same technique: James Hope, *Principles and Illustrations of Morbid Anatomy* (London, 1834) and Robert Carswell, *Pathological Anatomy: Illustrations of the Elementary Forms of Disease* (London, 1838) were completed before Cruveilhier's work. Here I shall focus on the three completed works.[3]

There is more tying these works together than the use of lithography. Cruveilhier's work was by far the most extensive pathology treatise yet published and also the first major one produced in France; in addition, both Hope and Carswell spent several years in France and relied on the facilities offered by French hospitals for the production of their treatises. Thus France—mostly Paris and to a lesser extent Lyon—plays a role in all three works. In the case of Cruveilhier, that role extends to the artistic production and printing of the images, whereas for Hope and Carswell it is more limited though still significant; the full title of Hope's work, for example, is *Principles and Illustrations of Morbid Anatomy: Adapted to the Elements of M. Andral, and to the Cyclopædia of Practical Medicine*. In terms of size and scope, the works by Cruveilhier, Hope, and Carswell stand out for their intellectual and artistic ambition; they share common features but also display striking and instructive differences in the organization of the text and illustrations. Together, they mark a key stage in the history of pathological illustrations.[4]

THE AUTHORS AND THEIR PRACTICES

Jean Cruveilhier (1791–1874), whose professional career bridges surgery, anatomy, medicine, and pathology, stemmed from Limoges. In his youth he wished to enter the priesthood, like Alibert, but was dissuaded by his father, who was a surgeon. Eventually he studied medicine in Paris under Dupuytren, who stemmed from the same region and owned an extensive collection of pathological specimens, taking his MD with an *Essai sur l'anatomie pathologique* (Paris, 1816). His thesis included historical and systematic sections but showed no interest in illustrations. While in Paris Cruveilhier

belonged to the Congregation, the conservative royalist group that also included Laennec. After a few years back in Limoges and, starting in 1823, a brief stint as *agrégé* in surgery at the University of Montpellier, Cruveilhier became professor of anatomy in Paris in 1825 and *médecin des hôpitaux* in the following year, working extensively across Paris hospitals. In 1826 he revived the Anatomical Society, which had been founded by Dupuytren but had become inactive just a few years later, and became its president, a position he held for forty years. In 1836 Cruveilhier was appointed to the first chair of pathological anatomy in Paris, endowed by his mentor Dupuytren, who also established a museum including pathological preparations, wax models, and drawings. Besides his *Anatomie pathologique*, he also published four volumes of *Anatomie descriptive* (Paris, 1834–36), which went through several editions and translations, and a five-volume *Traité d'anatomie pathologique générale* (Paris, 1849–64), which made him one of the leading pathologists of his time. Cruveilhier had a strong empirical bend, preference for factual knowledge, and suspicion of systems.[5]

The next two physicians we are going to consider share many biographical elements, though they never cited each other in the main works we will discuss. James Hope (1801–41) began his studies at Edinburgh University in 1820 and took his MD there in 1825 with a dissertation on aortal aneurisms, a topic that remained close to his interests for his professional career. He was a student when John Thomson and Alexander Monro *tertius* held appointments in military surgery and medicine, surgery, and anatomy, respectively. Hope had a fine ear and played the flute in his youth; this skill proved useful in his investigations of the sounds of respiration and heartbeat with the stethoscope, of which he was an early supporter. His wife and biographer Anne recounts how important musical expertise was in mediated auscultation for Laennec too. Hope was also an accomplished artist, who made copies in oil of great masters and assembled a collection of several hundred pathological color drawings. Anne states that he was inspired by Baillie's example to pursue the study of morbid anatomy, though he emphasized the ties between postmortem lesions and symptoms. Although Anne Hope was a scholar and a writer in her own right, the level of detail in the biography of her husband, even about rather technical medical matters, suggests that he had a hand at composing the text, which would thus be more like a posthumous autobiography. As an accomplished physician, James Hope would have known that he was dying of consumption and would have had time at the very least to assemble the material for the work.[6]

Immediately after completing his degree he worked at St Bartholomew's Hospital in London, which led to his diploma from the Royal College of Surgeons: thus Hope held both medical and surgical qualifications, much like Armstrong, underscoring the connections between the two fields. Following a tradition of the time, Hope traveled to Paris to benefit from the advanced

medical thinking and the easy availability of clinical instruction; he worked for a year at the Charité Hospital as a clerk of Auguste François Chomel, followed by a year-long medical tour of the Continent. On his return to London in 1828 he was attached to St. George's Hospital and set up a successful practice. Hope was one of the first to rely on Laennec's discoveries of mediated auscultation and to extend similar methods to the study of the heart, relying also on vivisection experiments in order to test his views. Around 1830 Hope published in the *London Medical Gazette* a series of important contributions to the diseases of the heart and major vessels, leading to his 1832 *Treatise on the Diseases of the Heart and Great Vessels*, arguably his major work, which relied on a thousand cases and whose later edition (1839) included black-and-white illustrations. In the same year he was elected Fellow of the Royal Society. In 1831, following Hooper's retirement, Hope took over the position as physician to the Marylebone Infirmary, where he was in charge of ninety beds; the infirmary had 350 beds, in addition to about one thousand paupers, and between three and four hundred children. From 1834 Hope was assistant physician at St. George's Hospital; in addition, he lectured in his home and from 1836 at the Aldersgate School of Medicine, a large school not attached to a hospital. In 1834 he completed a key treatise from our perspective, *Principles and Illustrations of Morbid Anatomy*, an extensive work with lithographic plates colored by hand based on his own drawings; thus, while occupying Hooper's post, he continued the tradition of pathological illustrations in color pursued by his predecessor.[7]

Robert Carswell's (1793–1857) career too led him to Edinburgh, Paris, and London. As a son of a printmaker in Paisley, near Glasgow, he was presumably exposed to artistic productions from an early age. Unfortunately little is known about his artistic training and background, but two plates from 1818 engraved after Carswell are included in a publication on Scottish history. Thus he was an accomplished artist before starting his medical studies, which led him to three Scottish universities: at Glasgow he studied with Professor of Anatomy and Physiology James Jeffray. In his dedication of *Pathological Anatomy* (London, 1838) to Jeffray, Carswell recalled Jeffray's approbation of his "coloured delineations" of "the healthy and diseased appearances of the human body"; thus presumably Jeffray relied on Carswell's color delineation for his lectures. He later collaborated with the Edinburgh Professor of Military Surgery John Thomson; previously Thomson had relied on military surgeon and watercolorist John Alexander Schetky, who seemed ideally suited in view of his double expertise. In the early 1820s Thomson sent his son William with Carswell to France to study, draw, and paint fresh pathological specimens in color. Carswell spent a large amount of time in France over several trips and worked at all the major teaching hospitals in Paris, including the Necker with Laennec, as well as the Hôtel-Dieu in Lyon. After taking his MD in 1826 at Marischal College, one of two universities in Aberdeen, Carswell returned to France, where he stayed for four more years.[8]

In 1828 he obtained the chair of pathological anatomy and the curatorship of the medical museum at the newly established London University, after Johann Friedrich Meckel had declined the offer. Carswell was allowed to stay in France two more years to complete his collections of colored delineations and pathological preparations preserved in alcohol, which were intended for research and teaching. He did not start lecturing until 1831, but his lectures were not a success, despite his innovative pedagogy; possibly his soft voice, melancholic countenance, and the fact that pathological anatomy was a new subject that was not required for the examinations of the London Royal College of Surgeons, or of the Society of Apothecaries, did not help. Carswell was both an anatomist and an accomplished artist; the extensive collection of watercolors that he had been preparing largely in France became the basis for his *Pathological Anatomy*, which came to fruition over a decade later. An imposing collection of over one thousand of his watercolors is still extant at University College, London. This, however, must be only a portion of his output, since in previous years he had sent many watercolors to his teachers in Scotland. Carswell was associated with the physician Charles Williams, who was in a dispute with Hope over the role of vivisection: although Hope and Carswell do not cite each other, both cite Cruveilhier, especially Hope. Carswell resigned his professorship in 1840 and, following his appointment to the King of the Belgians, moved to Belgium, where he died.[9]

THE BOOKS AND THEIR ILLUSTRATORS

Cruveilhier's *Anatomie pathologique*, with about 230 folio plates, was the most comprehensive work of its kind yet produced: its forty installments appeared over fourteen years, helping spreading its cost over time. He decided a priori the number of installments, since the work had no structure. There are other reasons why his treatise appeared in this form: Cruveilhier deemed images of preparations from museums and collections as inadequate because conservation methods altered their appearances, and memory was unreliable. Therefore he relied on recent cases of patients who had arrived and died at the Salpêtrière and other Paris hospitals. On at least one occasion, however, one of his figures showed the wax model of a brain. Each installment included several case histories, often totally unrelated to each other, and corresponding plates: there were five color plates per installment, more if some plates were not colored—when this was deemed unnecessary.[10]

In Cruveilhier's case we are lucky to have an extensive list of subscribers, giving us a feel for the social, intellectual, and geographical distribution of his readership on both sides of the Channel and of the Atlantic. Starting with Louis Philippe, King of France, we find twenty copies for the Ministry of Education, five for the War Ministry, and twelve for the navy. The single largest subscriber with twenty-six copies was the Paris branch of Treutel and Würtz,

booksellers and publishers—who had published Meckel's *Tabulae*. Almost
without exception, all subscribers were physicians, surgeons, hospitals, pro-
fessional bodies such as the Royal Society and the Hunterian collection in
London, and booksellers. There was only one lawyer, at Dijon. Copies in the
United States went not only to Philadelphia, Baltimore, Boston, and New York,
but also to Ohio, Georgia, New Hampshire, and South Carolina. The copies
for educational and medical institutions suggest that young practitioners and
students may have had access to such expensive books through institutional
libraries, though Cruveilhier stated that he had chosen the medium of lithog-
raphy also to render his work affordable to students. A slightly later catalog by
the iconic Paris medical publisher Ballière put the cost at 11 francs per install-
ment, plus one installment of indices, for a total of 451 francs. In London each
installment went for between 9s and 11s; therefore the entire work would have
cost approximately 20l. Remarkably, Cruveilhier's work appeared also in Ital-
ian translation with all its plates.[11]

For the overwhelmingly majority of his plates Cruveilhier relied on Antoine
Chazal, brother of Paul Gauguin's maternal grandfather. Chazal was a distin-
guished and versatile artist who worked in oil and watercolor and from 1822
until his death in 1854 exhibited at the Salon, the official exhibition of the
Académie des Beaux-Arts in Paris. His production ranged from portraits to
scenes for travel books and natural history subjects, especially flowers and
animals. In 1835 he was appointed *professeur d'iconographie des animaux* at the
Jardin des Plantes in Paris. Chazal trained with, among others, the renowned
flower painter Gerard van Spaendonck, who was best man at his wedding;
their exquisite flower pieces follow closely in the Dutch still-life tradition.
Chazal had already drawn obstetrical, anatomical, and also pathological
plates, joining expertise in anatomical and natural history drawing. Indeed,
Cruveilhier compared pathological anatomy to natural history and argued that
the introduction of illustrations in the former was having a comparable impact
to what it had had in the latter. It would seem that Chazal used watercolor for
his pathological work, as for natural history.[12]

In addition, Cruveilhier relied on Gaspar-Joseph Martin Saint-Ange, mem-
ber of the Anatomical Society and conservator of its museum, both for the
preparation of difficult specimens and for some drawings. This collabora-
tion seems especially significant in offering technical expertise triangulating
among fresh body parts, pathological preparations, and images.[13]

Cruveilhier relied on a number of Paris printers for the lithography, which
he considered a superior technique; I have found only a couple of engravings.
He paid special attention to color and stated that several trials were made
to check that the colors were true and natural. In all probability the process
resembled the one we have seen documented with Rayer and Delestre, with
Cruveilhier summoning Chazal every time an interesting case presented itself
over fourteen years, even during the 1832 cholera epidemic that claimed the

lives of 20,000 Parisians—overall hundreds of times, since most plates had several figures. No wonder that Cruveilhier deemed Antoine Chazal worthy of the praise of the "professeur de Leyde" for his skill and commitment, thus comparing his artist to Jan Wandelaar, or possibly his student Abraham Delfos, and, by association, himself to Bernhard Siegfried Albinus, or Eduard Sandifort, whom he had named "père de l'iconographie pathologique."[14]

Hope and Carswell were both distinguished artists in their own right, who produced watercolors of diseased body parts over several years, mostly in Paris in the late 1820s. Having extensive collections at their disposal, they could arrange the material as they pleased, giving a structure to their works that was lacking in Cruveilhier's *Anatomie pathologique*. Many of Hope's and Carswell's watercolors predate Cruveilhier's work; possibly the ease with which cadavers could be obtained in Paris deterred French scholars from producing illustrations, as Cruveilhier suggested, though they had a significant cognitive role even when cadavers were abundant, since many lesions were uncommon and generally images enabled comparing lesions without having to rely on memory. From 1795, however, the École de Santé employed draftsman Anicet-Charles Lemonnier and surgeon/wax modeler André-Pierre Pinson.[15]

Valuable information on the production of treatises in color comes from Anne Hope's biography of her husband. While a clerk to Chomel, one of the leading Paris clinicians at the time, James compelled himself to work five hours daily to complete three or four drawings per week, each one requiring two to eight hours, depending on its size and the attention it deserved; the drawings were completed within a few hours of the specimens being removed from the subject, though we are not told how long the patient had been dead. Hope's drawings were used together with the specimens in discussion sessions in Chomel's group. James used to say that preparing such drawings was far "from being a mere mechanical employment like copying; for in making original drawings, one paints with the head, not with the hand alone: every touch, every shade of colour is a thought, and thus the intellectual process is a severe one." As a result, he came to dislike drawings, though he retained his taste for art. The overwhelming majority of the figures in *Principles and Illustrations* were due to him, though some were copied from Cruveilhier and one was due to Patrick Syme in Edinburgh; none was drawn without the specimen, since representations from memory are inaccurate.[16]

Anne states that James had considered having a folio book but decided against artistic excellence in favor of making his work available to students and had the book published in octavo. Moreover, whereas in several instances Cruveilhier had devoted an entire folio plate to an individual specimen, reproducing them life-size, Hope packed 260 figures into forty-eight plates, giving them a rather crowded look. Hope's *Principles* appeared in twelve installments issued at close interval between 1833 and 1834, at the cost of 8s 6d each; thus

the whole book would cost 5*l* 2*s*, still a substantial amount. Anne Hope also argued that his collection of pathological drawings had the advantage of being due to someone who was a skillful artist and anatomist at the same time. The lithographic plates—though due to Alfred Ducote—were completed "under his roof," under his constant supervision, with the help of his explanations, and at times were completed by him. Hope colored the first plate as an exemplar, while the colorists finished the others; he still checked and corrected all the copies being produced. Moreover, Hope himself colored most, if not all, of the copies presented to the public libraries. Library copies no doubt made the book more widely available. Anne's wonderfully detailed account provides us with a vivid picture of the production process of his work.[17]

While for Carswell's work we lack such details, we are fortunate that a large portion of his remarkable watercolors have survived, enabling one to compare the originals to the printed color lithographs; Carswell's surviving works at University College date mostly from about 1828 to 1831, thus from about the same time when Chazal started working for Cruveilhier. Carswell too efficiently packed on the same plate a number of figures, at times reducing them in size and losing the spaciousness of the original watercolors and at times also cropping them, though overall the colored lithographs rendered them quite effectively. While some watercolors are portraits showing the face and dress of the patient, as in Alibert's work, the published works only include lesions of specific organs. In one case in which the lesion affects the neck and mouth Carswell cropped as much of the face as possible, as historian Heribert Reckert has shown. Like Hope and unlike Cruveilhier, Carswell never devoted a whole plate to a single specimen. Carswell's treatise appeared over six years in twelve large quarto installments with four plates each, for a total of forty-eight plates; his first installment appeared in 1833, just a few months after Hope started issuing his treatise, suggesting a degree of rivalry between them. Carswell's installments cost 12*s* each, for a total of 7*l* 4*s*.[18]

Carswell's role seems to have changed in the course of the production of the book. The first six installments in the volume are signed as drawn by Carswell; however, since in the introduction he states that the installments appeared in the reverse order in which they were bound, these would have been the last to appear. In the second half of the volume, from the section on "hemorrhage" to the end, the plates are signed "Drawn on stone by Dr. Carswell," suggesting that he initially transferred his drawings directly on the lithographic stone— thus cutting cost and ensuring the fidelity of reproduction. While the plates are generally printed in black and white and colored by hand, the first plate of the installment on inflammation—the first in the volume but the last one to appear—is printed in red, and others have portions colored *à la poupée*, suggesting an evolution in the printing technique.[19] The lithographers changed too: in the first six installments, up to and including that on hemorrhage, the plates are due to Belgian-born lithographer and watercolorist Louis Haghe and

to William Day; in later ones—and the first to appear—the plates are signed by Alfred Ducote, the same lithographer employed by Hope, suggesting that midway Carswell delegated the task of drawing on stone to Haghe.[20]

DISEASES AND LESIONS

In his teaching Cruveilhier adopted what he called a nosological order, namely an organization based on organic alterations, each affecting several body parts. However, he argued that a book with that structure would have been impractical, since he would have had to show all the organs affected by each alteration and therefore each organ would have had to be depicted many times. Thus he chose an anatomical order instead, arranging each section by the organ affected—lungs, brain, kidneys, and so on. Cruveilhier conceived his work as a paper museum, but it is clear that only a double set of indices provided the museum plan, or an order, enabling readers to find their way; they consisted of a methodic table structured according to the six systems—locomotive, digestive, respiratory, circulatory, sensory and nervous, and lastly generative and urinary—and an analytic table for both volumes, including a name and subject index. Since the latter was not produced until the work was complete, readers would have encountered problems in retrieving information during the fourteen years it took to be printed. Although Cruveilhier was thoroughly familiar with previous pathological illustrations, which he discussed in the *avant-propos*, he did not refer to historical images in the text as systematically as Soemmerring or Meckel had done before him; unusually rich references, however, can be found in the discussion of placental hydatides, including those to Tyson and Ruysch, and in a note on "acute follicular enteritis," mentioning Baillie and Bright. In both cases illustrations played a major epistemic role.[21]

To provide a brief characterization of Cruveilhier's pathological views is a challenging task. In the *avant-propos* to Anatomie pathologique he claimed that he wished to compare the morbid alterations and trace them to a small number of fundamental types. Moreover, he aimed to study them not in their perfect state but in their evolution, starting from their beginning at the embryonic stage, seeking to determine the organic element that is first and principally affected. These were ambitious and challenging objectives, since nineteenth-century pathologists had few chances of seeing the early stages of a lesion; therefore Cruveilhier had recourse to pathological experiments on animals, especially injections.[22]

Cruveilhier's position on Bichat, outlined in a later historical account, was ambivalent. On the one hand, he hailed his iconic predecessor as the founder of pathological anatomy and the first in Paris to teach a course on that science *ex professo*. On the other hand, Bichat showed contempt for illustrations, a position Cruveilhier deemed unacceptable. Also, Bichat "collected and coor-

dinated" information on tissues, founding on them his pathological anatomy. Bichat divided alterations into general, affecting all tissues, and special, proper to each specific tissue. The only general affections would be inflammation and scirrhus; all the others would each pertain to their individual tissues. Alas, says Cruveilhier, Bichat was mistaken, in that exactly the opposite is true: special alterations are very rare, whereas general ones are more frequent. Moreover, although in some respects Cruveilhier's treatise reflects the changes in the notion of disease due to the shift from organs to their constituent tissues, Bichat makes only cameo appearances.[23] One may argue in addition that Bichat's pathological system and rejection of illustrations went hand in hand, since identifying the affected tissue was key to identifying the alteration, rendering the role of illustrations less significant.

The material is usually organized around case histories, followed by a separate section of remarks with more abstract and theoretical reflections; occasionally Cruveilhier added some introductory comments or short essays on specific topics. However, at times he included figures of specimens he deemed important even if he did not have a case history, and correspondingly he did not illustrate all the cases he discussed. Cruveilhier formulated a general principle of his pathological thinking: he argued that all organic alterations of texture, without exception, such as productions, transformations, and degenerations, consist in the deposit of secreted matter in the mesh of cellular tissue, and that organic tissues are inalterable in themselves. His reference to cellular tissue is unrelated to the cellular theory that was about to be developed, the cellular being one of Bichat's twenty-one tissues; in fact, Cruveilhier made only limited use of the microscope. His attempt at identifying a single process as the basis of all forms of disease strikes us as peculiar more than it did contemporaries; Cruveilhier, however, accepted that processes of disease development would crystallize in specific forms. His plates fared better than his general principle, since they could be used with profit even if one questioned Cruveilhier's views.[24]

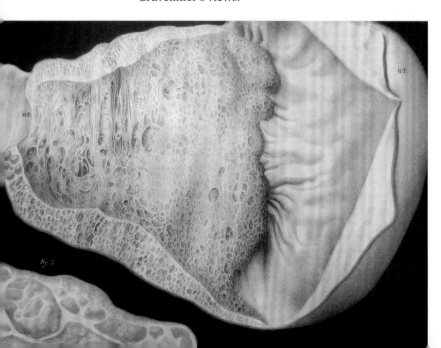

Illustration 7.1
Cruveilhier, *Anatomie pathologique*, 1829–35, X.4, stomach cancer. Drawn by Antoine Chazal, hand-colored lithograph.

Unlike Hope, Carswell, and the majority of the medical men I have discussed, Cruveilhier considered congenital malformations and monsters, such as "syrénie," also known as mermaid syndrome or the fusion of the lower limbs, as pathological phenomena relevant to his project and discussed them from the first to the last installment of his sprawling treatise.[25]

Cruveilhier must have been a demanding employer even for such a talented and versatile artist as Antoine Chazal. The arrangement of the specimens and their rendering highlight the individual attention that was devoted to each figure. For example, in illustration 7.1 the diseased stomach is set against a black background in order to highlight the variations in texture by contrast with the different shades of gray. Unfortunately Cruveilhier could not provide a case history. He states that the figure was drawn with special care, and indeed one can only admire Chazal's ability to render the texture of what Cruveilhier calls "aereolar," or full of interstices, "gelatinous cancer" on the left and the rugae in the stomach at the edge of the cancerous area, in the middle; Cruveilhier states that he could not find any vestiges of the mucous membrane in the cancerous portion. Figure 2 at bottom left shows a related case; however, he discussed extensively other related cases and provided an introductory essay on this type of cancer.[26]

An especially striking plate (illustration 7.2) shows a huge cyst lodged between the liver on the left and the spleen on the right, covered by a folded yellow membrane held by a hook. As in the previous case, Cruveilhier could not provide a case history, though this did not prevent him from giving a detailed description of the preparation. Here too Chazal showed the preparation against a black background to highlight the cyst's ivory and gray tones and, no doubt, to add to the dramatic effect; notice also the slit showing the inside of the cyst, and the liver with a distinct slate color. The bottom figure shows a life-size detail from the top left, including the liver and the yellow membrane held by three hooks, and highlights the structure of the cysts, which consists of interconnected openings.[27]

In 1832 cholera reached Paris and affected tens of thousands of people, who flocked to the local hospitals and generally died, naturalist Georges Cuvier among them. Cruveilhier produced a fifty-two-page installment with five plates entirely devoted to the disease, discussing many case histories as well as its nature and possible therapies; he expressed no doubt on the identity of European cholera with the Indian one that had struck Calcutta. Cruveilhier was tragically aware that the cause of cholera was unknown; therefore all he could do was try to counteract its effects. Nonetheless, through systematic postmortems he sought to investigate structural lesions of the parts seemingly affected, notably the digestive tract.[28]

The following plate shows the small intestine of J. Trimbalat, a cook aged thirty-eight who lived in Rue des Boucheries-Saint-Honoré; Cruveilhier often gave the name of his patients and, in the case of cholera, their address,

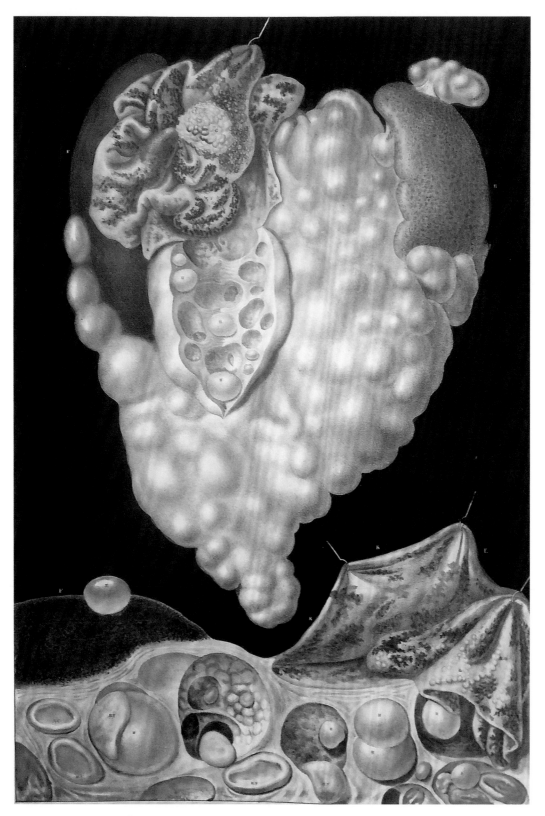

Illustration 7.2
Cruveilhier, *Anatomie pathologique*, 1829–35, XIX.1, "acephalocyst."
Drawn by Antoine Chazal, hand-colored lithograph.

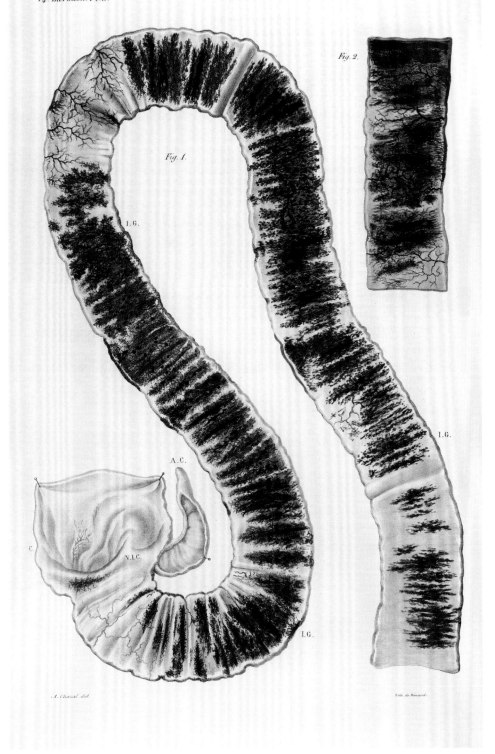

Illustration 7.3
Cruveilhier, *Anatomie pathologique*, 1829–35, XIV.3, intestine of
cholera victim. Drawn by Antoine Chazal, hand-colored lithograph.

showing a special interest in the topography of the disease. She arrived at the medical center on April 20 with two young children and was already in such a desperate state that she was oblivious to the death of her child at her side two hours later. The application of twenty leeches to her anus, presumably to remove inflammation of the intestine; alcohol fumigations every two hours; and other remedies had no effect and she died on April 22. After removing some mucous formations, white in the upper parts and bloody in the lower, the surface of her small intestine appeared extremely bloodshot and presented ecchymosis in the form of points and plaques, as shown in figure 1 (illustration 7.3). Figure 2 shows a partly dried portion of her intestine viewed against the light, a technique enabling Cruveilhier to observe a very delicate vascular ramification, which would have otherwise been hard to detect.[29]

The following case may serve to illustrate Cruveilhier's concern with the origin and development of morbid affections. It relates to a doctor in medicine aged fifty-six, known only through his initials M. G., who enjoyed good health, except for a chronic inflammation of the right eye, which had recurred three times. In 1830 he lost his job. In February and March 1835 his appetite diminished; on April 24 he felt his liver enlarged and in the following months it continued to grow. One of the consulting physicians noticed a black tumor the size of a large pea, resembling a blackberry, on the right arm; thereafter several similar tumors, which Cruveilhier identified as "mélaniques," were found on other parts of the body. Remedies ranging from leeches applied to the anus to injection of caustic potash sorted no effect and he died on July 5. When eighteen hours later the body was opened the liver was found two to three times its natural volume. The most striking feature was the large number of "tumeurs mélaniques" of all sizes, taking together about two thirds of its volume (illustration 7.4). Cross sections on the left and right reveal a huge number of tumors, which Cruveilhier compared to black truffles, which could be easily enucleated from the tissue of the liver; they vary in color from dark brown to gray, at times giving a marbled effect with gray and black streaks. The flatness of the surfaces of the cross sections and their difference in color with respect to the uncut parts enhance the three-dimensional effect. The liver is the only portion represented but the rest of the autopsy report is of interest too; the lungs showed tumors of the same nature but smaller and lighter in color. Cruveilhier wished to inspect the eye, which had given trouble to the patient; he found two "tumeurs mélaniques" the size of large peas, streaked black and white, one where the optic nerve joins the retina, the other on the outside. They seemed to grow at the expense of the choroid. In the "réflexions," Cruveilhier observed that such tumors are often found at different locations, such as the lungs and liver, though it is unclear whether they develop at the same time or whether they originate from the skin, as one found in this case. His theory according to which cancer is due to a juice originating from the venous capillary network and which can be obtained pressing the diseased

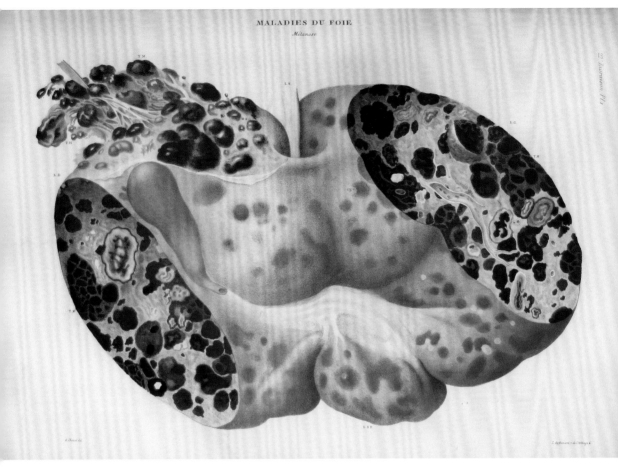

Illustration 7.4
Cruveilhier, *Anatomie pathologique*, 1835–42, XXII.1, "mélanose"
of the liver. Drawn by Antoine Chazal, hand-colored lithograph.

organ proved of no help in this circumstance. Elsewhere in his treatise Cruveilhier provided figures of "tumeurs mélaniques" affecting the skin and the eye.[30]

This case provides useful material for grasping Cruveilhier's balanced approach to case histories, reflections, and illustrations; he was striving to determine the site whence the disease originated and the main organs affected. We also see how the index, in this case under "mélanose," proves crucial in organizing the textual and visual material of the entire work, leading to related sections.

Towards the end of his enterprise Cruveilhier was struck by the "identité absolue d'aspect et de structure" between two cases of "exostosis" affecting the humerus and pelvis in two patients. The observation of that uncanny resemblance led him to conclude that the economy of living organisms follows perfectly regular laws both in physiology and in morbid states; therefore the

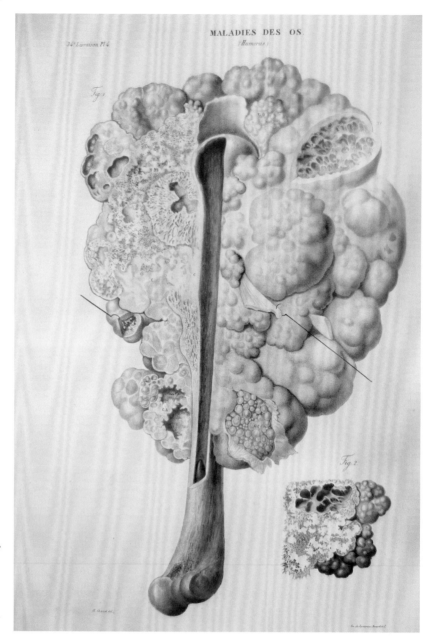

Illustration 7.5
Cruveilhier, *Anatomie pathologique*, 1835–42, XXXIV.4, "exostosis" of the humerus. Drawn by Antoine Chazal, hand-colored lithograph.

latter can be studied as easily as the former. At the time physiological research was a key aspect of medical research and physiology was very much a loaded term. Cruveilhier's views were part of a long historical process; his identification of the striking regularity of the morbid processes is especially significant from our standpoint in that it provides a rationale for relying on pathological illustrations. Although Cruveilhier saw disease as a process, the process was not a random one: lesions crystallize into remarkably regular, even identical, forms

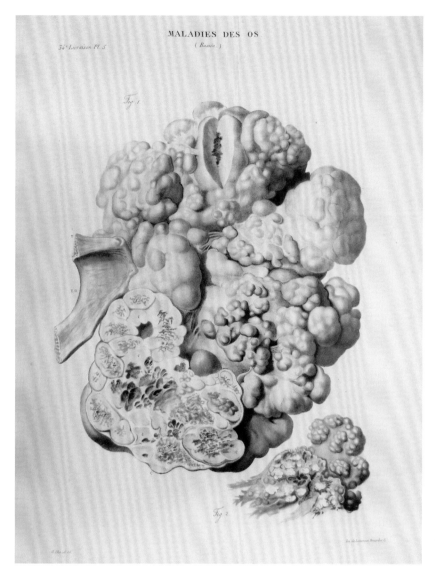

Illustration 7.6
Cruveilhier, *Anat-
omie pathologique*,
1835–42, XXXIV.5,
"exostosis" of the
pelvis. Drawn by
Antoine Chazal,
hand-colored
lithograph.

in different individuals. The full folio plates show the external appearance of
the huge growths, which Cruveilhier compared to a cauliflower, their internal
structure in sectioned portions, and small dry fragments (illustrations 7.5 and
7.6). Although the experiences gained at the bedside and in the morgue, and
described verbally, played a role, they attained a different visibility—in the real
sense of the word—only through images. It is for this reason that Cruveilhier
claimed that pathological anatomy could not be pursued without them.[31]

While Cruveilhier had drawings made and printed as the cases presented
themselves, Hope and Carswell patiently accumulated over many years the
watercolors that eventually became the bases for their works, which could
thus be given a structure. Let's examine them in turn.

Hope's *Principles* was based on organs, but "the lesions of each organ are considered in reference to the particular tissues which they occupy." Hope wished to present the elementary lesions, which, "like the primitive words of a language, is comparatively small." He broadly followed the framework devised by French pathologist Gabriel Andral, who had organized the first part of his *Précis d'anatomie pathologique* around lesions of circulation, nutrition, secretion, the blood, and innervation, whereas the second part of his treatise applied his framework organ by organ to the pathological anatomy of the digestive, circulatory, respiratory, secretory, generative, and innervation systems. Hope also relied on the *Cyclopædia of Practical Medicine* (London, 1832–35), a periodical publication to which he contributed.[32]

Anne Hope recounts that figure 46 of James's *Principles*, showing the ulceration of the fauces and adjacent parts due to an excess mercury employed in treating a syphilitic lesion (illustration 7.7), reproduces the first drawing from nature that he ever made and illustrates his skill and natural talent and that later sketches were not necessarily superior. The figure shows the fauces *aa* with the epiglottis *b* in the center.[33]

The reviewer of the first fascicle of Hope's work, on diseases of the lungs, singled out figure 9 (illustration 7.8) as especially successful in conveying to the students an image so characteristic that they would very easily recognize it in the morgue—a revealing comment on the intended readership and purpose of Hope's work. It shows "Lobular hepatization seen on the pleura," from a case of peripneumony after typhus at the Marylebone Infirmary; more precisely, one sees a series of hepatized red lobules within uninflamed (but emphysematous) pulmonary tissue. Red hepatization, as in this case, is the process whereby the lungs are engorged with blood and come to resemble the liver.[34]

As we have seen above, Hope was a distinguished cardiologist who sought to apply Laennec's stethoscope to the heart in order to disentangle its sounds in health and disease. The first edition of his *Treatise on the Diseases of the Heart and Great Vessels* (London, 1832) contained no illustrations, which appeared in the third edition (London, 1839); thus the illustrated section on heart disease in *Principles and Illustrations* was especially significant in that it presented for the first time images of cardiac lesions discussed in the text. It opens with a reference to Andral's system and argues that, like diseases of other body parts, they involve lesions of circulation, nutrition, secretion, and of the nervous function. In the discussion of diseases of the valves and orifices, and in the legends of the corresponding plates, Hope relies on his auscultation research and refers to the sounds related to the specific lesions. Hope was explicit about the nature of his sources: in the case of William Hedgley, a boy aged ten whose ventricular contraction produced a sawing murmur, for example, he pointed out that the specimen came from a preparation discolored by spirit.[35]

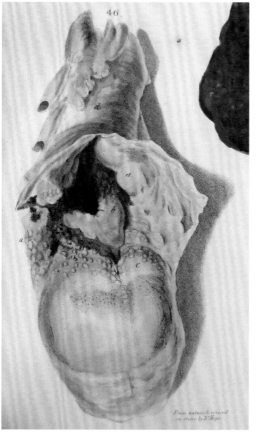

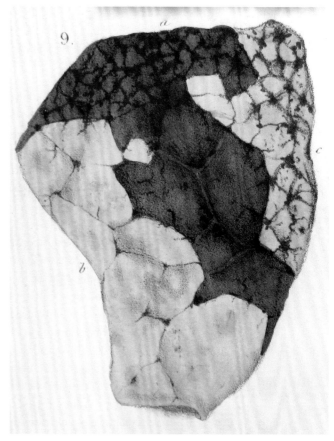

Illustration 7.7
Hope, *Principles*, 1833–34, figure 46. Ulcer-
ation of the fauces and epiglottis. Drawn
by Hope, hand-colored lithograph.

Illustration 7.8
Hope, *Principles*, 1833–34, figure 9. Lobular
hepatization of the lungs. Hand-colored litho-
graph based on a drawing by Hope.

We have seen that in Chomel's group in Paris Hope's drawings and the cor-
responding preparations were used to discuss the cases, thus joining research
and pedagogical roles. Analogous comments apply to Carswell's work: he put
his watercolors to use well before completing his treatise in 1838. In Thomas
Hodgkin's celebrated 1832 essay "On Some Morbid Appearances of the
Absorbent Glands and Spleen," based on a lecture delivered at the Medico-
Chirurgical Society of London and containing a description of the eponymous
disease, the author acknowledged the help he had received from Carswell,
who had returned to London in 1831:[36]

While examining the unrivalled collection of pathological drawings made by
my friend Dr. Carswell, I was struck with one representing a greatly enlarged
spleen, loaded with large tubercles of a rounded figure and light colour. I imme-

diately recognized it as a fine example of the affection I have been describing, and my suspicions were presently confirmed by the doctor shewing me another fine drawing of the greatly enlarged glands of the neck, axillae, and groins of the same subject.

Originally Carswell had identified the condition as fungus hæmatodes, though Hodgkin disputed this on the basis of his own study and Carswell's watercolors: thus those very images led to a reassessment of Carswell's own initial identification. Hodgkin's text highlights how visual representations of diseased states entered research practices and provided crucial evidence in the study and identification of disease. Visual representations were used for teaching too: in 1827 Hodgkin had inaugurated a series of lectures on morbid anatomy at Guy's relying on museum preparations and occasionally illustrations. In 1832, he did not reproduce Carswell's watercolors in his published essay, possibly because the journal in which it appeared did not include elaborate color images. In 1898, however, all four of Carswell's relevant watercolors of this case were deemed sufficiently important to be reproduced as a special installment of the extensive and heavily illustrated series *Atlas of Illustrations of Pathology*. By the end of the century printing techniques had changed; our plate (illustration 7.9) was produced in chromolithography, the standard technique of the time, whereby individual colors are printed separately from as many lithographic plates and superimposed. Although Carswell's plate appeared beyond the period covered in this study, I have included it here because the original watercolor stems from Carswell's stay in Paris—it is dated from the St. Louis Hospital, April 1828—and further documents key events of 1832.[37]

In what must count as one of the most dramatic plates in the history of pathological illustrations, Carswell built the image along a diagonal from the closed eye and open mouth at top right to the ribs at bottom left. He arranged the body sideways, in order best to show the "greatly enlarged glands of the neck, axillae, and groins," which stand out in their vivid colors against the ashen pallor of the cadaver. In this portrait of a deceased human being as much as of diseased body parts, we grasp not only the appearance of the growths but also their precise size and location with respect to the rest of the body. In 1832 Boston medical student James Jackson Jr., then residing in Paris, visited London; though disappointed by the access to patients compared to the French capital, as John Warner has shown, Jackson took advantage of the anatomical preparations at Guy's Hospital and at the Royal College of Surgeons. Not surprisingly, however, what he admired most were the pathological watercolors Carswell used as teaching tools at University College.[38]

Carswell's *Pathological Anatomy: Illustrations of the Elementary Forms of Disease* was an attempt to study pathology, including the physiology, nature, ori-

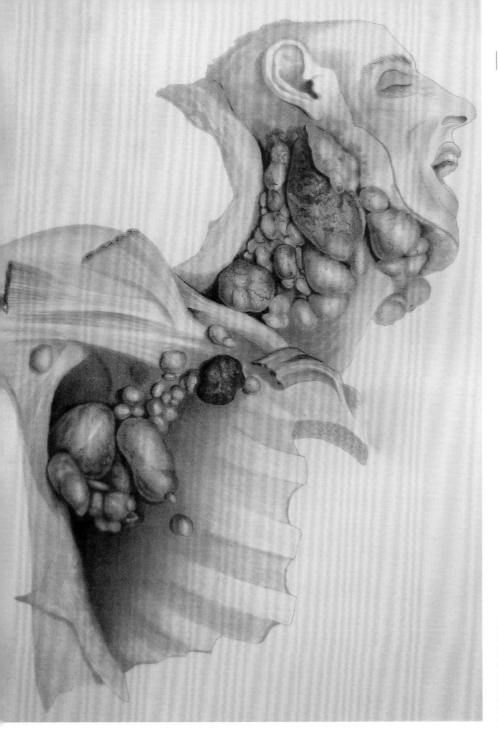

Illustration 7.9
New Sydenham
Society, *Atlas*, fascicle
12, 1898, plate 1,
Hodgkin's malady.
Chromolithograph
based on a drawing
by Carswell.

gins, and causes of the elementary forms of disease, as well as chemical anal-
yses of the relevant body parts; case histories, however, were not included.
The notion of "elementary forms of disease," almost a nosology of lesions,
highlights the systematic nature of the work tying visualization and concep-
tualization. Since he had virtually the entire portfolio of watercolors at his dis-

posal from the beginning, he could arrange the material in advance. Carswell's twelve installments deal with eleven elementary diseases: inflammation, analogous tissue, atrophy, hypertrophy, pus, mortification, hemorrhage, softening, melanoma, carcinoma, and tubercle. Because of its complexity and many forms, two installments and eight plates are devoted to carcinoma. In his discussion of carcinoma, Carswell challenged Cruveilhier's general principle of pathology, because the cellular tissue is not the only one where the deposition of morbid products occurs and also because other tissues too undergo pathological processes.[39]

Illustration 7.10 from the installment on tubercle shows a portion of a human lung with tubercles at different stages; this was the first figure of the first installment to appear in 1833. His installment included figures of tubercles in the lungs and also in other parts of the body, since Carswell's order was by elementary forms of disease. Carswell argues that the most common seats of the tuberculous matter are mucous membranes and highlights how it takes different shapes depending on its location, with ramifications and formations resembling a cauliflower. It is white and resembles cheese; tuberculous matter is scattered around the lung; in places tubercles are shown whole with the pulmonary tissue around them removed, to show that they consist of dilated and filled air cells; in the lower half we see two cavities. Carswell's elaborate specimen highlights the effort he had devoted not only to drawing but also to its preparation in order to elucidate complex matters. Many issues were controversial at the time, such as the mode of formation of tubercles, their nature, and their shape; it is probably not by accident that Carswell addressed the very same topic just covered by Hope, who had recently argued that tubercles are mostly roundish, for example. Compared to the corresponding plates by Baillie and Laennec (illustrations 3.4 and 4.6), one notices here not only the use of

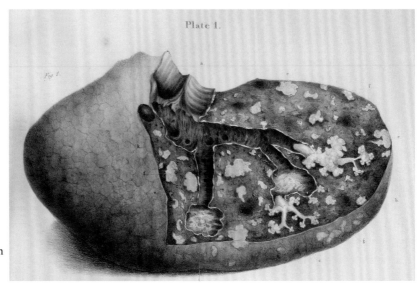

Illustration 7.10
Carswell, *Pathological Anatomy*, 1833–38, figure I.1 of tubercles, lobe of the lung. Drawn by Carswell, hand-colored lithograph.

Illustration 7.11
Carswell, *Pathological Anatomy*, 1833–38, "Melanoma," figures I.2 (lung), I.3 (horse skin), and I.4 (liver). Drawn by Carswell, hand-colored lithograph.

color but also the attempt to offer a three-dimensional view of the pulmonary lobe in the way the specimen has been sectioned.[40]

Since the time Laennec devoted a memoir to melanosis, several medical men discussed it and included visual representations, as we have seen above in the case of Cruveilhier. The lesion, however, was liable to misidentification in that many situations could lead to dark formations unrelated to Laennec's melanosis. Figure 4 at top left shows (illustration 7.11) what Carswell calls a compound melanotic tumor enclosed by a membrane. Carswell wished to distinguish true from spurious melanosis: figure 2 at top right shows an affected human lung where he arranged the specimen so as to display the surface of the lung at the top, its cross section on the left, a portion covered by the pleura in the middle, and a portion of the pleura costalis at the bottom, like a hanging veil. All are affected by true melanosis; in addition, the pleura costalis shows two areas at *e* with what he called "stratiform melanosis," which is not true melanosis but results from the stagnation of blood.[41]

One of the characteristic features of Carswell's treatise—like Meckel's—is that it is not devoted to humans exclusively but that in its systematic efforts to classify and represent diseases it includes animals too, such as cows, horses, monkeys, rabbits, and dogs; not surprisingly, some of his surviving original drawings too pertain to animals. Figure 3 at the bottom shows a portion of the skin of a gray horse affected by melanotic tumors, mostly black, but at *c* they are bistre or umber, which are shades of brown; Carswell pays close attention not only to visual representation but also to language in describing colors. The specimen has been partly folded, so as to display both sides; notice also the white and gray hairs, which appear like scratches on the lithographic stone, and the thickness of the specimen.[42]

The entire plate displays five cases and a range of representation techniques highlighting Carswell's attention to artistic as well as to pathological matters.

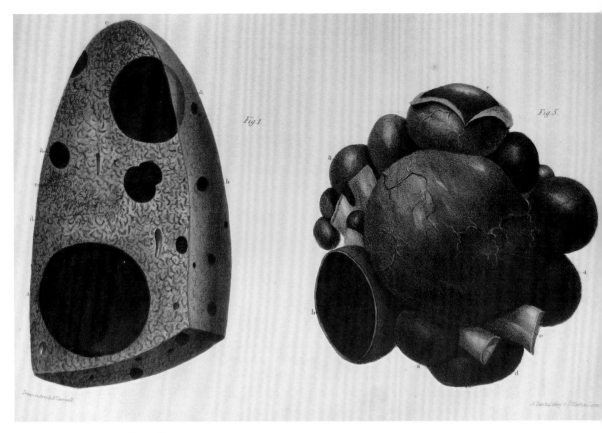

Illustration 7.12
Carswell, *Pathological Anatomy*, 1833–38, "Melanoma," figures I.1 (liver)
and I.5 (horse blood vessels). Drawn by Carswell, hand-colored lithograph.

Figure 1 (illustration 7.12, left) shows an affected liver; most tumors appear globular, but at the top it seems as if the liver had been dusted with "powdered charcoal," whereas on the left in the middle one sees a ramification along the veins, which Carswell calls "beautiful"—revealing the pathologist's aesthetic concerns. This figure highlights the striking difference with Cruveilhier's truffle-like formations (illustration 7.5); Carswell's lack the streaks and have a smooth surface. Lastly, figure 5 (illustration 7.12, right) shows a cluster of tumors around an artery and a vein of a horse running through them; a section on the left shows the pitchy inside, while at the top the membranous capsule has been partly removed, showing that the vessels do not pass into the melanotic matter. Carswell renders very effectively the spherical shapes and the different shades of color, including a bluish tinge at bottom left.[43]

There is nothing routine about the way the specimens are arranged and represented: each is carefully prepared and drawn, shown whole and sectioned, with portions removed in order to highlight points of interest, and surfaces are folded, all in order to render and highlight spatial arrangements and

colors. However, the printed images are often somewhat crowded, occasionally cropped, and generally do not withstand the comparison with the original watercolors, which are more faithfully rendered by illustration 7.9.

With the treatises by Cruveilhier, Hope, and Carswell anatomists had access for the first time to comprehensive color representations of the main lesions of all the organs of the body. Those three works stand out for their broad scope and ambition: together, they include over three hundred color plates with over one thousand figures presenting a remarkably rich set of issues both visually and intellectually. Inevitably, these works include the first visual representations of a number of conditions, which have attracted the attention of medical readers and historians in their respective subspecialties. My interest here, however, is more with their overall impact. Unlike previous comprehensive treatises by Baillie, Meckel, and Bleuland, the three works we have considered overwhelmingly eschewed preparations from museums and collections and relied on fresh specimens from hospitals and infirmaries—mostly in Paris.

Agreement on the importance of visual representation of fresh specimens did not carry over to all other matters: Carswell, for example, was critical of Cruveilhier and all but ignored Hope. The three pathologists held different views on a number of matters about the nature and meaning of specific lesions and on the organization of their works, which differed markedly: Cruveilhier referred extensively to case histories and relied on the indices, enabling readers to search and thereby organize the material depending on their interests, under an organ, for example, or a disease; Hope too referred to case histories and organized the material organ by organ, framing the diseases in each case following Andral's system; lastly, Carswell eschewed case histories and provided a highly theoretical taxonomy of diseases, seeking to represent the key elementary lesions within his categories.[44]

Despite their differences, visual representations were gaining a key role in pathology; while they were far from settling old debates and controversies—and in fact at times they generated new ones—they also brought investigations to a new level. Cruveilhier's bold assertion that illustrations are not just useful but in fact indispensable to the pathologist marks a new stage in the study of disease and justifies the considerable challenges and expense required to produce illustrated pathology treatises in color.

In publishing an illustrated work the author usually relies on a draftsman and an engraver or lithographer, as well as a printer and colorists, whose role for plates colored *à la poupée* could be quite complex: this division of labor created tensions that were addressed in different ways. Hope and Carswell did their own drawings, while Cruveilhier's long-standing collaboration with Antoine Chazal no doubt led to a mutual understanding about requirements and execution. All the works we have been discussing here relied overwhelm-

ingly, exclusively in the cases of Hope and Carswell, on lithographs colored by hand, which proved the privileged means in the emergence of comprehensive pathology treatises in color.

The publication of the pathology treatises we have discussed occurred at the same time as the establishment of pathological anatomy as an academic discipline: following Lobstein at Strasbourg, Carswell and Cruveilhier held chairs at University College London (1828) and Paris (1836), respectively, while John Thomson—who had commissioned Carswell's drawings in the 1820s—at Edinburgh was appointed to a chair of general pathology in 1832; Hodgkin, curator of the Guy's Hospital Museum, had been lecturer in morbid anatomy there since 1825. Even if some of these appointments were not especially successful in terms of enrollment, together they testify both to the growing status of the discipline and to the role of color delineations, alongside preserved specimens, for both research and teaching.

CONCLUDING REFLECTIONS

We may take it for granted that anatomy is a visual science and that anatomical works are illustrated, though matters were not always so: early sixteenth-century treatises contained no illustrations but dealt with issues like the recovery and translation of ancient texts, apparent contradictions among them, the relative merits of Greek and Arabic medicine, and related terminological matters, for example. The introduction of illustrations in the first half of the sixteenth century, most notably by Andreas Vesalius, reflected deep changes in the practice of anatomy and in its turn played a key role in shaping its course by focusing on the topography of the body and the connections among its parts, for example. By the seventeenth century anatomical illustrations had become standard, though they continued to present artistic and conceptual challenges that have accompanied them throughout their history.

As in anatomy, the extensive usage of illustrations in pathology reflected deep changes in the medical world and at the same time contributed to reshaping notions of disease. The slow emergence of pathological illustrations did not result simply from medical men and artists turning their gaze from healthy to diseased bodies but was a complex process involving new ways of looking at the body, the rise of museums and collections, and the emergence of new forms of representation.

The previous chapters have shown that pathological illustrations did not progress linearly toward greater accuracy; different areas, such as bone pathology or cutaneous diseases, for example, followed particular patterns. More generally, pathological illustrations were not neutral and unproblematic representations of reality; rather, they intersected a rich set of institutional, epistemic, professional, artistic, and broadly cultural themes, such as the growth

of museums and hospitals, changing notions of disease, the status of surgeons, the adoption of novel printing techniques, and even political and religious concerns, as we have seen with Alibert. Later nineteenth-century developments not discussed here, such as improvements in microscopy, the rise of cell pathology, of the germ theory of disease, of photography, and of chromolithography and other printing techniques, provided additional layers of complexity, though illustrated gross pathology retained a major place in the ensuing profound reconceptualizations of disease. Indeed, visualization continues to play a key role with the rapidly increasing number of recent medical technological devices and techniques at both the macroscopic and microscopic level.

Many developments in the history of the visual representation of disease were seemingly affected by a plurality of factors: Fabricius Hildanus wished to advertise his surgical skills and his museum as a teaching resource; Ruysch treated pathological and anatomical plates on a par because both showed preparations from his museum; Cheselden's life-sized diseased bones marked the rising status of surgery; Sandifort claimed to be the founder of "anatome pathologica picta" by comparing his work to Morgagni's, while asserting the primacy of Leiden over Amsterdam. Yet their works had also a broader historical significance going beyond self-advertisement and civic rivalries, leading to profound transformations in medicine as a whole.

It is helpful to review our investigation by focusing on some key aspects, from transformations in pathological anatomy to pathological iconography, and the relationships between images and disease.

CHANGING HORIZONS IN PATHOLOGICAL ANATOMY

Postmortems were performed with increasing frequency during the early modern period, while their reports were appearing with growing regularity in the literature, culminating with *De sedibus*. While Morgagni's magnum opus is so vast and complex as to defy simple categorizations, its building blocks are case histories and dissection reports cut, arranged, and enriched with comments and references to the literature. The ties Morgagni sought between symptoms and lesions involved a plethora of details but only rarely did they include precise descriptions of the affected part, never an illustration. Postmortems were part of a narrative tradition of case histories establishing correlations among symptoms identified by the patient, clinical signs detected by the physician during a physical exam, and the locations of diseases as found in the cadaver; they rarely provided precise structural descriptions of the lesions.[1]

Comments by two protagonists in the history of pathological anatomy such as Baillie and Cruveilhier provide valuable insights. In his 1846 historical account Cruveilhier states that at the end of the eighteenth century many facts had been collected but pathological anatomy as a science did not yet exist. Lesions were studied in relation to symptoms, the course of diseases, and

therapies; they were mentioned rather than described; they were neither studied in relation to each other nor classified and seen together. Cruveilhier was fully aware that postmortems were performed frequently in previous centuries. While hailing Bichat as the founder of pathological anatomy, Cruveilhier argued that Bichat was mistaken in dividing alterations into general, namely inflammation and scirrhus, affecting all tissues; and special, proper to each specific tissue, namely all the others, because special alterations are very rare, whereas general ones are more frequent. Thus the key task in pathological anatomy for Cruveilhier was the accurate identification of the lesion, not simply of the affected tissue, since each tissue could be affected by many lesions. He attributed a major role in this development to his mentor Dupuytren.[2]

Despite some differences in emphasis, Cruveilhier's account is in broad agreement with Baillie's views in 1793: the Scot's project to describe "more minutely" structural alterations in order to distinguish them with greater precision and highlight common patterns addresses precisely Cruveilhier's later concerns—though Baillie avoided case histories, while the Frenchman valued them highly. Only in 1797 did Baillie include symptoms and in 1799 illustrations.[3] The notion of "structural" or "organic lesion" implies something observable and that can be visually represented, at least in principle. Baillie's work established a new cognitive and visual dictionary pointing to a new grammar of disease whereby localization was no longer sufficient without a detailed structural and textural description; a systematic comparison with, and differentiation from, other conditions and lesions; and an accurate visual representation. We have seen that this novel approach shared features with the surgical tradition and with its emphasis on what I called its "double localism," namely the emphasis on the site of lesions and also on their precise conformation.[4] Thus Baillie and Cruveilhier point to a history of pathological anatomy differing from the one whose red thread is localization moving from organs, to tissues, to cells; from their perspective, localization by itself was insufficient in characterizing disease. The new fine-grained notion of lesion offered an epistemic justification for visual representations, which, in their turn, supported that notion.

A separate tradition stemming from nosology, or the classification of diseases, intersected developments in pathological anatomy. Sauvages classified diseases based on a range of features in which symptoms occupy center stage. Plenck provided a taxonomy of cutaneous diseases relying extensively on their external characteristics; his work opened the door to visual representations, though he did not make that step. In this regard his work resembles Baillie's *Morbid Anatomy*, which did not include illustrations: both laid the intellectual foundations for such a move. Willan inaugurated a new chapter in the history of pathological illustrations by seeking systematic visual representations in color based on his nosological system. For internal organs Baillie introduced black-and-white images in *A Series of Engravings*, possibly inspired by Sandifort

and Willan. In the decades around 1800 nosology progressively merged with morbid anatomy at Edinburgh with Cullen, at Paris with Pinel and Bayle, and at London with Farre and Hooper: lesions, which played only a minor role for Sauvages, became central to nosology, displacing causes.

Reviewing the development of pathological anatomy we have found it useful to look at the "objects" medical men relied on—material preparations as well as written records. New preservation methods developed at the end of the seventeenth century enabled the formation of museums and collections not only of bones, hard, and dry parts, as with the pioneering efforts of Fabricius Hildanus at Bern, but also of wet and injected preparations involving soft parts, leading to the creation of museums by Ruysch in Amsterdam, many medical men in Paris and at Leiden, the Meckel family at Halle, William and John Hunter in London, and many others. Much like in natural history, pathology museums and collections proved instrumental in the transition from random reports of "rare," "remarkable," and "monstrous" cases of the early modern period to the more systematic accounts of the eighteenth century. Anatomical and pathological museums and collections had been assembled from the early modern period to present instructive cases for study and teaching; they were key sites both reflecting and contributing to reshaping pathology. The time from Ruysch, possibly even Fabricius Hildanus, to the early 1800s was the age when pathological illustrations relied extensively on museums and collections.

Preparations were removed from the body, sectioned, preserved, and displayed—at times from different angles—in order to offer an informative view; often specialized technicians, from Petrus Koning to Gaspar-Joseph Martin Saint-Ange, working for Bleuland and Cruveilhier, respectively, played a significant role. Preparations had the advantage of being permanent, though preservation methods altered textures and obliterated color; images based on preparations were mostly in black and white. Following the example of cutaneous diseases, early nineteenth-century medical men progressively moved toward representing fresh specimens from recent postmortems, often in color. The major works with color illustrations, from Willan and Bateman to Bright and Cruveilhier, stem from large institutions. At times collections and museums were created at the hospitals, from the Manchester and Edinburgh Infirmaries to Guy's Hospital in London. We have seen how at the Manchester Infirmary and at Guy's Hospital, for example, colored delineations complemented preserved specimens; at times wax models or casts were used too, providing three-dimensional representations.[5]

The changing nature of the available resources played a key role in shaping the history of pathological anatomy and illustrations. Large hospitals and infirmaries took over as the main sites for the study of pathological anatomy. Large hospitals, especially, but not only, in Paris, enabled systematic clinical teaching and postmortems. The dynamic interaction among these factors

in the time from Fabricius Hildanus and Ruysch to Cruveilhier and Carswell led to an increasing number of illustrated works on bones and skin diseases, "wet" preparations, and fresh specimens, first focusing on specific domains, then on the entire body.

PATHOLOGICAL ICONOGRAPHY

Although there are some studies addressing pathological images, it seems fair to say that pathological iconography is still in its infancy. Here I offer some preliminary reflections and a tentative periodization based on my limited analysis.[6]

Some, like Bichat, were opposed to the use of illustrations, but generally even those medical men who used them were fully aware of their limitations in the study of disease: both Willan and Baillie, just to mention two key figures, were cautious about what an image could do and what it could not. Willan pointed out that the opacity or clearness of pustules could not be easily captured with images, not to mention the amount of matter discharged from an ulcer. Also the stage of the disease was a problem. Baillie pointed out that several diseases could not be rendered through images. Further, he was especially aware of the limitations imposed by preparations, whether wet or dry, with which he was working. Yet they also valued illustrations for what they could offer.[7]

The visual representation of diseased states poses specific problems not encountered in other areas, or that need to be addressed from a different angle. At times early modern representations of the human body involved playful, macabre, or allegorical motives generally lacking in pathological images. In some regards, however, it is helpful to review the history of anatomical representations: it is difficult to envisage the section on diseased bones in Cheselden's *Osteographia* without Bidloo's *Anatomia*, with its emphasis on the portrait of an individual as opposed to an idealized or composite body; similarly, some features of Sandifort's *Museum anatomicum*, from the rendering of bones to the multiple views, echo the works by Albinus and indeed Vesalius.[8]

In the early modern period pathological images, unlike anatomical ones, were part of neither the artistic nor the medical traditions, unless the case appeared extraordinary in nature, location, or size. Common occurrences were unworthy of being represented, as Blasius argued. Items that were represented included bladder, kidney, and other stones found inside the body, which exerted a special fascination; polyps found in the heart and elsewhere; growths and other affections visible from the outside in live patients; remarkable specimens from postmortems, often including kidneys and the uterus; and hard specimens such as ossifications, bone exostosis, and ankylosis. Unusual conditions continued to be represented, as they are even today. Start-

ing from the eighteenth century, however, visual representations were not restricted to exceptional cases but progressively sought to be more comprehensive. There were significant differences among them, however.

Early modern representations of diseased states varied in quality; some were produced in small format with few artistic pretensions, such as works by Tulp and especially Blasius. In the seventeenth and early eighteenth centuries Dutch authors and artists were especially prominent in pathological illustrations with extensive collections of *Observationes*, from Tulp to Ruysch and later Trioen.[9] Matters changed especially with Ruysch, who treated equally all the objects of his museum, whether healthy or diseased, in accomplished quarto engravings. Later Cheselden too devoted the same care to anatomy and pathology and showed diseased bones alongside healthy ones life-size, in spacious folio engravings; his move reflected and sought further to enhance the raising status of surgery. Arguably Ruysch and Cheselden opened a new chapter in the history of pathological iconography by giving comparable status to illustrations of healthy and diseased parts. Many pathological illustrations in the eighteenth century adopted a broadly comparable attention to detail and accomplished execution: unlike the early works by Ruysch and Cheselden, however, they were part of works focusing on disease, as with Trioen, Ludwig, Bonn, Weidmann, and Sandifort, and later Baillie, Meckel, and Bleuland. They relied overwhelmingly on preserved specimens, whether wet or dry, and black-and-white line engravings. Works by Bonn, Sandifort, Meckel, and Bleuland, were mostly based on one museum each, whereas Baillie relied on a wide range of London museums and collections.[10]

Besides bone diseases, eighteenth-century pathological illustrations often pertained to surgical domains with hernias, or involved eye diseases, which were represented in color already in the second half of the eighteenth century, as with Taylor and Beer. At the very end of the century Willan's visual representation of skin diseases in London proved geographically and artistically central to broader developments. His reliance on live patients and elaborate color plates raised both artistic and conceptual problems for which traditional black-and-white prints proved utterly inadequate. Thus Willan relied on artists—both draftsmen and engravers—with skills other than anatomical; they could capture colors and produce at short notice plates rendering the complex textures of skin lesions, relying on the relatively new methods of tonal printing, especially stipple engraving. It is not surprising that Willan and many of those who included color engravings relied on artists with a background in natural history, especially botany and to some extent ornithology. Moreover, unlike internal lesions, which became mostly accessible in their final stage, skin lesions can be observed in their entire course, posing the issue of which stage to represent. Some, like Willan, defended the role of verbal descriptions alongside images; Alibert tried to capture the lesion in its full maturity and, moreover, adopted a grander style often showing the suffering patient as much as the lesion.

In the early decades of the nineteenth century color representation started being produced from fresh cadavers; initially this process proceeded rather timidly, then after the mid-1820s more systematically, initially in Britain with Hooper, Cooper, Bright, Annesley, and Armstrong, then elsewhere. Works focused either on a disease affecting several organs or an organ affected by many diseases. Most illustrations portrayed specimens removed from the body, though occasionally they were shown in situ. Producing comprehensive treatises on the diseases of the entire human body proved a challenge at many levels. Cruveilhier published the illustrations from postmortems rather swiftly, without any order or structure, which could be added only through the index produced at the end of his fourteen-year-long project. Hope and Carswell assembled large collections of watercolors—together with case histories and at times preserved specimens—that became the basis of their later publications arranged according to body part or lesion, respectively.

Representing pathological specimens was a complex task at many levels requiring close exchanges between medical men and artists: since it would have been difficult for the artist to grasp what was at stake, expert medical guidance was likely indispensable. Also, transferring preliminary drawings and watercolors into prints could be problematic. We have seen different strategies at play to address these issues: Ruysch drew some of the images himself; Cheselden employed Gerard Vandergucht and Jacob Shijnvoet as both draftsmen and engravers, and in addition corrected some plates himself for greater accuracy; Ludwig relied on his medical student Reichel; Sandifort's draftsman, Abraham Delfos, was trained in anatomy and was also an engraver, thus he could grasp the issues involved and communicate effectively between Sandifort and his engraver Robert Muys; William Clift was a skillful watercolorist and the curator of John Hunter's museum; Tilesius was a physician, draftsman, and engraver who also took casts and discussed the relative merits of different forms of representation; Hope and Carswell were both artists and pathologists. While some artists produced occasional pathology works, others devoted a substantial portion of their output to this subgenre. This small community included Delfos, Clift, Henry Thomson, and Antoine Chazal among the draftsmen and Muys and John Stewart Sr. among the engravers.[11]

In a celebrated passage from 1794, Scottish surgeon John Bell highlighted the tension between artists seeking elegance versus anatomists striving for accuracy. Although the healthy human body had been part of the artistic canon since the Renaissance, whereas the diseased body was not, similar problems affected pathological illustrations. Even artists trained to observe nature closely, such as those working in anatomy and natural history, faced challenging problems in dealing with deformed and corroded bones, soft body parts fished out of liquids in glass jars, peculiar cutaneous formations on live patients, and rapidly decomposing internal organs corrupted by disease. It is worth revisiting the opinion of the reviewer of Bright's and Armstrong's works,

when he praised the plates as "beautiful," in fact too beautiful compared to what one would see in a cadaver—this being a common fault of pathological figures. It would seem as if artists were caught in the tension between fidelity to the object and emphasis on beauty, a tension that was especially strong with the seductive power of color. Cooper too found a diseased testicle "beautiful." Our reviewer preferred Armstrong's black-and-white lithographs to the twice more expensive hand-colored ones, where the overall effect had been altered—possibly by subtly adjusting contrast in the color scheme. Cruveilhier too expressed misgivings about some images' somewhat artificial coloring, thus confirming its especially problematic status, though he expressed confidence in the fidelity of those in his own work.[12]

THE COGNITIVE ROLE OF PATHOLOGICAL IMAGES

Debates and controversies across the medical world about the definition and nature of specific diseases date from antiquity: detailed visual representations of postmortem lesions enabled pathologists to focus on characteristic appearances in common among several cases. Visual representations helped redefine the notion of disease, from different types of "exostoses," or bone growths, to consumption and what was to become Bright's disease. At a time when disease was understood as an evolving process in which initial conditions, often starting from inflammation, could develop into dramatically different ones, images helped to identify clusters of specific and characteristic lesions shared by separate cases. While providing a new level of precision in some respects, however, visual representations proved problematic and ambiguous in others: Was a lesion the cause or the effect of the condition? Did the visual representation capture the key features of the lesion or preparation? Were seemingly analogous lesions variants or stages of the same underlying "elementary forms" of disease, to use Carswell's terms, or were they fundamentally different? We have seen Laennec with tubercles and Bright with kidney lesions facing similar problems.

Often analyses of images in anatomy and natural history have focused on the dichotomy between portraits of individual cases on the one hand versus idealized representations of a type on the other: such modes were already established in the Renaissance. An intermediate form of representation still involved individual types, though selected as representatives of a class. The overwhelming majority of pathological figures represented individual preparations or conditions, whether seen as unique or as representatives of a class, as indicated by the very name employed to characterize the disease, for example. My work sits rather awkwardly with the theses and periodization offered by Raine Daston and Peter Galison, who argued that before the early 1800s visual representations adopted in atlases of natural objects sought what they call "truth-to-nature." This could mean either images representing ideal

objects, composites of multiple individuals, showing ideal types or classes; or images of individual objects in the "counterfeyt" tradition, which were taken as representative of those types or classes. Most pathological images produced before 1800 portrayed individual specimens, however, which were not necessarily meant to stand for a class of similar objects; rather, many were what one may call "exploratory images," documenting an individual case as a starting point for further investigations. While at times the issue may be hard to assess, overall it seems difficult to argue that for "an eighteenth-century savant . . . judgments were universal, a realization of universal reason in interaction with universal nature" for all the cases we have seen. Often in pathology the focus was on the individual, while classes and types may have been the distant aim, not the precondition, of the investigation; as late as Cruveilhier and Carswell, universality was often lacking.[13]

Here I wish to examine matters from a different angle, or diachronically, in that the role of images was not fixed when they first appeared but changed over time depending on transformations in the field: initially a case may have been illustrated because it was deemed extraordinary, though in time it may have turned out to be analogous to other cases and thus less extraordinary—though not less interesting. Authors such as Sandifort, Hooper, Bright, and others emphasized the provisional status of pathological illustrations for studying and classifying diseases, thus expecting that status to change over time. In other words, authors often did not know how common a condition was, what its nature was, and how it related to other conditions but hoped that a collaborative effort over time would provide answers to these questions.[14] Baillie was especially aware of the provisional status of his claims and classifications and presented them tentatively. The extensive cross-references found in the literature, even to early works such as those by Ruysch and Cheselden, highlight how the growing number of pathological images and their subsequent usage proved crucial to the establishment and systematization of the field.

To argue that the rise of pathological illustrations was influenced by changes in the understanding of disease would be one-sided; visual representations of disease were an important factor in those transformations, in that it was also because diseased states were reproduced in print that medical men could identify patterns and similarities, attributing significance to lesions that may have passed unnoticed otherwise. A database of images, a paper museum, provided a permanent repository that fresh cadavers could not offer. By relying only on cadavers the pathologist had to have recourse to memory, which is fallacious; by contrast, images offered the possibility for study and comparison, much like the material preparations that often accompanied them, and while they lacked three-dimensionality, they could offer color and texture that were not altered by methods of preservation and circulated much more easily from town to town and across national borders, even in translation. At times pathologists studying a recently deceased cadaver could triangulate with

printed images, preparations, and even wax models.

Images of diseased states are seen differently by practitioners across time. Thus it is necessary to pay close attention to the changing understanding of disease without conflating views from different periods or projecting later perspectives onto the past. As pathologist and medical historian Edgar Goldschmid pointed out in 1925 with regard to Cruveilhier, for example, illustrations and the accompanying texts may age differently. By Goldschmid's time cancer was seen as an uncontrolled proliferation of cells and tuberculosis was understood as an infectious disease due to a microorganism; thus while Cruveilhier's general principle of pathology was superseded in a dramatic fashion, his images were still deemed useful. While illustrations may convey an aura of modernity, the corresponding texts often refer to obsolete views and to therapies based on bloodletting—with leeches applied to the anus, as Cruveilhier did for cholera and melanosis. Thus discussing the accompanying texts can be helpful in contextualizing images and avoiding what one may call "iconographic anachronism," or the misleading notion that an image familiar to us implies that those who produced it saw it with our same eyes and therefore held views akin to ours. Pathological images can be especially useful and dangerous at the same time.[15]

In several instances we have encountered an interplay between verbal descriptions and visual representations. Consumption was one of the leading causes of death in the decades around 1800 and an especially complex one to investigate through postmortems, in that pulmonary lesions could appear in different forms and stages in the same patient, while similar lesions could affect many other organs as well with scrofulous tubercles; pulmonary and other lesions had been described for a long period, but the analysis in Bayle's treatise, and especially the combined texts and images in Baillie's and Laennec's works, opened a new chapter in their study. Similarly, conditions identified and described in France by Bayle and Laennec as peritonitis, melanosis, cirrhosis, emphysema, and encephaloid tumor—known in Britain as fungus hæmatodes—were analyzed and represented visually by a number of British pathologists from Baillie and Wardrop to Carswell.[16]

Whether a disease was first identified through verbal descriptions or images, however, when images were available they often became a major and integral part of the investigation. The growth of pathological illustrations added a new dimension to the taxonomy of diseases: whereas previously a multitude of names could be applied to describe a lesion, images added a level of detail that would have been hard to find before and taught pathologists to look at it in a new way. Thus many illustrated pathology works circulated widely despite the high cost, as testified by the systematic references to illustrations found in Soemmerring's translation of Baillie's *Morbid Anatomy*, Meckel's *Tabulae*, or Bleuland's *Otium*, for example, or holdings by hospital and institutional libraries, as documented by Cruveilhier's list of subscribers.

Some works were translated into different languages—witness the German editions of works by Willan and Bateman, for example; Froriep and Albers included many plates of cutaneous and internal diseases in their German treatises. Astonishingly, Cruveilhier's *Anatomie pathologique* appeared in Italian translation with all 233 plates, mostly in color.[17]

Sandifort argued that his work *Museum anatomicum* would be especially welcome by those who did not have access to preparations. Hooper wished to provide to those who did not have the opportunity to inspect diseased parts "the means of becoming acquainted not only with their structure, but also with their appearances on examination, and of thus possessing a museum, in some respects more useful than the preparations themselves"; his paper museum would display the general appearance of diseased parts, notably color. In 1829 Cruveilhier too argued that his plates constituted a museum of pathological anatomy. In the same years, in his application to University College, Carswell presented his collection of watercolors of diseased states as the basis for a museum, one complemented by case histories and actual preparations. A collection of pathological illustrations, whether in a private portfolio or in print, forming a paper museum was a topos at the time. The theme of its utility, vaunted by Hooper and Bright, Armstrong and Cruveilhier, among others, was a companion topos, one serving as a self-advertisement too. The illustrated German works by Froriep and Albers, including extensive synopses of the current literature, emphasized their utility to surgeons and physicians.[18]

Medical men frequently relied on visual representations as helpful tools in order to identify specific conditions. Examples abound and include several cases of exostosis from Cheselden to Cruveilhier; many instances of skin disease; scrofulous tubercles in the whole body; and kidney conditions later known as "Bright's disease." Thomas Hodgkin used Robert Carswell's watercolors in his study of the eponymous disease and even showed them at the lecture where he presented his findings. As he put it, he "immediately recognized" the first image he saw as an "example of the affection I have been describing"; his initial identification was confirmed by additional watercolors from the same subject. Carswell's watercolors of "Hodgkin's malady" were deemed sufficiently important to be published some seventy years after they were first produced.[19] In the late 1830s the structural identity between two conditions affecting the pelvis and humerus in different patients led Cruveilhier to argue that living bodies follow regular laws in morbid affections as in physiology; disease may have been a process, but it was not a random one. He further claimed that, despite the apparently great variety of diseases, their species were limited and could be easily investigated; pathological illustrations played a crucial role in identifying those species of diseases.[20]

Cruveilhier argued that the French were left behind in the field of the visual representation of diseases because of the difficulties involved with artists and because cadavers for dissection were very abundant. France, however, did

not lack artists and printers skillful in anatomical representations: Felix Vicq-d'Azyr's 1786 treatise on the brain that outraged Bichat included remarkable color aquatints by Angélique and Alexandre Briceau. Also in terms of techniques the French were certainly not lagging behind, witness the quality of the plates in the works by Alibert, Rayer, and Cruveilhier. Certainly the easy availability of bodies in France, coupled with the collections of preparations, wax models, and drawings available in Paris, may have rendered the representation of lesions less pressing. Yet although Baillie's *Engravings* had no parallel in France, Willan's and Bateman's color representations of cutaneous diseases were soon followed by Alibert and Rayer, while extensive color representations of the internal organs emerged in Britain only in the late 1820s, immediately before Cruveilhier's magnum opus.[21]

These observations point to broadly parallel transformations between the two countries: although patients and fresh cadavers were more easily accessible in France than in Britain, the difference was less than some historians had thought. Although France took more radical measures to bridge the gap between surgeons and physicians, the same need was felt on both sides of the Channel. British medical men made up for the lack of the huge number of corpses available for dissection in Paris with museums and illustrations. While initially the British were more active in the field of visual representations of diseased states, by the 1830s major differences had vanished. Medical men, practices, and literature crossed borders; in the early decades of the nineteenth century notions of disease were not changing in substantially different ways in France and Britain. The emphasis on lesions of membranes and tissues, and careful distinction and comparison among lesions, was not found only in Paris but at other locations as well. We have now moved beyond an exclusively French, or even narrowly Parisian, horizon to a multicentric one including London and Edinburgh, Amsterdam and Leiden, Vienna and Berlin, Leipzig and Halle.[22]

Major transformations in the notion of disease from the early modern period to the nineteenth century resulted from a set of interacting factors, crucially including systematic illustrations. Much like, starting from the Renaissance, anatomical illustrations had reshaped anatomy, between the seventeenth and nineteenth centuries pathological illustrations played an increasingly larger role in reshaping notions of disease. The study of those illustrations opens a new field of inquiry into the history of pathology and medicine more broadly.

ACKNOWLEDGMENTS

During the time I have been engaged in this project I have incurred a number of debts with friends and colleagues. I am grateful for the comments and suggestions I received following my presentations of portions of my research at several venues. It is a pleasure to acknowledge the help I received from Keegan Adams; Ed Bernstein; Alexander, Rebecca, and Sofia Bertoloni Meli; Nan Brewer; Andrea Carlino; Ann Carmichael; Maria Pia Donato; Zach Downey; Martin Earl; Seth Fagan; Massimo Ghiringhelli, Sandy Gliboff; Anita Guerrini; Glenn Harcourt; Tim Huisman; Christoph Irmscher; Jerry Jesseph; Eric Jorink; Cindy Klestinec; Monique Kornell; Dan Lodge-Rigal; Rafael Mandressi; Dániel Margócsy; Edward McCarthy; Bill Newman; Gianna Pomata; Bret Rothstein; Arlene Shaner; Joel Silver; Ron Sims; Nancy Siraisi; Hubert Steinke; and Micaela Sullivan-Fowler. Special thanks to Anne Mylott and especially Allen Shotwell for their comments on earlier drafts of the manuscript. I claim sole responsibility for all remaining errors and inaccuracies.

I am extremely grateful to a number of libraries and archives for the help and assistance I have received while carrying out research for this project and for permission to reproduce images from their historical collections, notably: the Galter Library, Northwestern University, Chicago; the Regenstein Library and the Crerar Library at the University of Chicago; the Ebling Library, the University of Wisconsin, Madison; the Wellcome Library, the Library of the Royal College of Physicians, the Library of Royal College of Surgeons, the University College Library, and the Royal Academy Library in London; the BIUM in Paris; the University Library in Leiden; the Burgerbibliothek in Bern; the Olser Library at McGill University, Montreal; and of course the Lilly Library at Indiana University, Bloomington.

My home institution has been generous in supporting this project. I am grateful for a New Frontiers Award and a CAHI grant that enabled me to carry out extensive library and archival researches in the United States and Europe and for a Grant-in-Aid award that helped toward publication expenses.

ILLUSTRATION CREDITS

1.1 Gersdorff, *Feldbüch*, 1517, LXXII, leprosy. Lilly Library.

1.2 Fabricius Hildanus, *Opera*, 1646, page 2, eye tumor. Lilly Library.

1.3 Fabricius Hildanus, *Opera*, 1646, page 118, diseased spleen. Lilly Library.

1.4 Fabricius Hildanus, *Opera*, 1646, page 274, cancer of the penis. Lilly Library.

1.5 van Meek'ren, *Observationes*, 1682, title page. Lilly Library.

1.6 Bartholin, *Epistolae*, 1663, page 723, aortal ossification. Lilly Library.

1.7 Cleyer, "De Elephantia Javæ nova," *Miscellanea curiosa*, 1684, plate I, leprosy. Special Collections, Madison, Wisconsin.

1.8 Munnicks, *Bibliotheca anatomica*, 1699, volume 2, facing page 624, ovarian dropsy. Lilly Library.

1.9 Riva, "In paradoxico aneurismate aortico," *Miscellanea curiosa*, 1670, *Observatio* XVIII, aneurism. Regenstein Library.

1.10 Blasius, *Observationes*, 1677, plate IV, diseased liver. Regenstein Library.

1.11 Browne, *Acta eruditorum*, 1687, originally *Philosophical Transactions*, 1685, plate I, facing page 28, diseased liver. Lilly Library.

1.12 Méry, "Exostose," *Memoires de l'académie royale des sciences*, 1706, facing page 248, exostosis. Lilly Library.

1.13 Ruysch, *Thesaurus nonus*, 1714, plate III, enlarged testicle. Lilly Library.

2.1 Cheselden, *Osteographia*, 1733, plate LIII, exostosis. Lilly Library.

2.2 Trioen, *Observationes*, 1743, plate VII, "Spina Ventosa." Lilly Library.

2.3 Herrmann, *De osteosteatomate*, 1767, plate I, diseased pelvis; reprinted in Ludwig, *Tabulae sedecim*, 1798. BIUM.

2.4 Ludwig, "Tractatio," 1772, diseased and healed bones; reprinted in Ludwig, *Tabulae sedecim*, 1798. BIUM.

2.5 Weidmann, *De necrosi ossium*, plate XI, diseased knee. Lilly Library.

2.6 Bonn, *Tabulae*, plate X, 1785, fractured right femur. Wellcome Library.

2.7 Sandifort, *Museum*, 1793, vol. 2, plate LX, scoliosis and tumor. Galter Library.

2.8 Sandifort, *Museum*, 1793, vol. 2, plate LXXXIX, diseased right femur. Galter Library.

3.1 Baillie, *Engravings*, 1799–1803, fascicle 5, plate II, tubercles in the liver. Lilly Library.

3.2 Baillie, *Engravings*, 1799–1803, fascicle 3, plate VII, stomach cancer and postmortem appearance of stomach. Lilly Library.

3.3 Baillie, *Engravings*, 1799–1803, fascicle 2, plate IV, figures 2 and 3, lung tubercles. Lilly Library.

3.4 Baillie, *Engravings*, 1799–1803, fascicle 2, plate V, figure 2, different types of tubercles in the lungs. Lilly Library.

3.5 Baillie, *Engravings*, 1799–1803, fascicle 2, plate VI, figure 1, lung with enlarged air cells. Lilly Library.

3.6 Meckel, *Tabulae*, 1817–26, plate XVI, diseased aorta. Wellcome Library.

3.7 Meckel, *Tabulae*, 1817–26, plate XXI, figure 9, diverticula. Wellcome Library.

3.8 Bleuland, *Icones anatomico-pathologicae*, plate III, pleural inflammation. Lilly Library.

3.9 Bleuland, *Icones anatomico-pathologicae*, plate XXXVI, diseased ovary. Lilly Library.

4.1 Wardrop, *Fungus*, 1809, page 193, affection of the retina. Galter Library.

4.2 Wardrop, *Fungus*, 1809, page 121, affection of the shoulder. Galter Library.

4.3 Home, *Prostate*, 1811, plate 1.IX, 1811, diseased prostate. Galter Library.

4.4 Home, *Prostate*, 1818, plate 2.I, 1818, diseased prostate. Wellcome Library.

4.5 Laennec, *Auscultation*, 1819, plate II, lung tubercules. Lilly Library.

4.6 Laennec, *Auscultation*, 1819, plate III, emphysema. Lilly Library.

5.1 Sauvages, *Nosologia*, edited by Daniel, 1791, plate XIV, figure 3, scarlatina. Regenstein Library.

5.2 Willan, *On Cutaneous Diseases*, 1808, plate XXIII, "*Scarlatina simplex.*" Lilly Library.

5.3 Bateman, *Delineations*, 1817, plate XLVIII, "Varicella lenticularis." Lilly Library.

5.4 Bateman, *Delineations*, 1817, plate LX, "Molluscum pendulum." Lilly Library.

5.5 Bateman, *Delineations*, 1817, plate LXIX, "ephelis." Lilly Library.

5.6 Tilesius, *Beschreibung*, 1802, Richard Lambert's condition. Lilly Library.

5.7 Alibert, *Nosologie*, 1817, plate B (facing page 512), "Hématoncie fungoïde." Lilly Library.

5.8 Alibert, *Nosologie*, 1817, plate B (facing page 336), "Loupe mélicéris." Lilly Library.

5.9 Alibert, *Clinique*, 1833, "scarlatine" (facing page 108), scarlet fever. Lilly Library.

5.10 Rayer, *Traité*, 1835, plate VI, "Pustules." Lilly Library.

6.1 Farre, *Liver*, 1812, plate I, "Tubera circumscripta," diseased liver. Galter Library.

6.2 Hooper, *Brain*, 1826, plate X, hæmatoma. Galter Library.

6.3 Hooper, *Uterus*, 1832, plate XIX, "Dropsy of the Ovarium." Crerar Library, University of Chicago.

6.4 Fawdington, *Melanosis*, 1826, plate V, melanosis of the kidney. Ebling Library.

6.5 Bright, *Reports*, 1827, plate 1.II, Sallaway's kidney. Lilly Library.

6.6 Bright, *Reports*, 1827, plate 1.I, King's kidney. Lilly Library.

6.7 Bright, *Reports*, 1827, plate 1.V, Evans's kidney. Lilly Library.

6.8 Bright, *Reports*, 1827, plate 1.III (figures 1 and 2), Stewart's kidney. Lilly Library.

6.9 Bright, *Reports*, 1831, plate 2.XXV, Morely's brain cysts. Lilly Library.

6.10 Cooper, *Testis*, 1830, part 2, plate III.1, diseased kidney. Regenstein Library.

6.11 Annesley, *Researches*, 1828, plate IX, Donacliff's case. Galter Library.

6.12 Annesley, *Researches*, 1828, plate XXXIII, figure 1, Donacliff's case. Galter Library.

6.13 Annesley, *Researches*, 1828, plate XII, Lynch's case. Galter Library.

6.14 Armstrong, *Morbid Anatomy*, 1828, plate IX, figure 1, encephaloid tumor of the stomach. Lilly Library.

7.1 Cruveilhier, *Anatomie pathologique*, 1829–35, 10.IV, stomach cancer. Lilly Library.

7.2 Cruveilhier, *Anatomie pathologique*, 1829–35, 19.I, "acephalocyst." Lilly Library.

7.3 Cruveilhier, *Anatomie pathologique*, 1829–35, 14.III, intestine of cholera victim. Lilly Library.

7.4 Cruveilhier, *Anatomie pathologique*, 1835–42, 22.I, "mélanose" of the liver. Lilly Library.

7.5 Cruveilhier, *Anatomie pathologique*, 1835–42, 34.IV, "exostosis" of the humerus. Lilly Library.

7.6 Cruveilhier, *Anatomie pathologique*, 1835–42, 34.V, "exostosis" of the pelvis. Lilly Library.

7.7 Hope, *Principles*, 1834, figure 46, ulceration of the fauces and epiglottis. Galter Library.

7.8 Hope, *Principles*, 1834, figure 9, lobular hepatization of the lungs. Galter Library.

7.9 New Sydenham Society, *Atlas*, fascicle 12, 1898, plate 1, Hodgkin's malady. Lilly Library.

7.10 Carswell, *Pathological Anatomy*, 1838, figure I.1, tubercles, lobe of the lung. Lilly Library.

7.11 Carswell, *Pathological Anatomy*, 1838, "Melanoma," figures I.4 (liver), I.2 (lung), and I.3 (horse skin). Lilly Library.

7.12 Carswell, *Pathological Anatomy*, 1838, melanoma, figures I.1 (human liver) and I.5 (horse blood vessels). Lilly Library.

Front and back covers

Sandifort, *Museum*, 1793, Vol. 2, plates LIX and LX, scoliosis and tumor. Galter Library.

ABBREVIATIONS

AB	*Art Bulletin*
ANH	*Archives of Natural History*
AS	*Annals of Science*
BHM	*Bulletin of the History of Medicine*
BJHS	*British Journal of the History of Science*
DNB	*Oxford Dictionary of National Biography*
DSB	*Dictionary of Scientific Biography*
EMSJ	*Edinburgh Medical and Surgical Journal*
HLQ	*Huntington Library Quarterly*
HS	*History of Science*
HSM	*Histoire des sciences médicales*
JAMA	*Journal of the American Medical Association*
JHM	*Journal for the History of Medicine and Allied Sciences*
MARS	*Memoires de l'académie royale des sciences*
MCMP	*Miscellanea curiosa medico-physica*
MCR	*Medico-Chirurgical Review*
MCT	*Medico-Chirurgical Transactions*
MH	*Medical History*
MJ	*Medizinhistorisches Journal*
NRRS	*Notes and Records of the Royal Society*
PT	*Philosophical Transactions of the Royal Society*
RCP	Royal College of Physicians, London
SHPS	*Studies in History and Philosophy of Science*

NOTES

Preface

1 Sandifort, *Museum*, 1:v.

2 Choulant, *History*; Carlino, *Books*; Kemp, "Truth," "Temples," "Style"; Sappol, *Anatomy*; Kusukawa, *Picturing*; Roberts and Tomlinson, *Fabric*.

3 Goldschmid, *Entwicklung*; Duffin, "Imaging Disease"; Gilman, *Health, Disease*; Palfreyman, *Visualizing*; Boeckl, *Leprosy, Pestilence*; Porter, *Bodies*. Here I focus on images in a medical context.

4 Daston and Park, *Marvels*; Bates, *Monsters*; Hagner, *Der falsche Körper*; Fontes da Costa, "Monsters."

5 Cruveilhier, *Anatomie*, 1:iii; La Berge, "Dichotomy or Integration?" The treatise by London physician Richard Bright's colleague at Guy's Hospital, Thomas Addison, *On the Constitutional and Local Effects of Disease of the Supra-Renal Capsules* (London, 1855), for example, relies largely on methods discussed here; Addison's plates are lithographs colored by hand. For Bright's later works see Berry and Mackenzie, *Bright*, 160–61 and 164.

6 Here I do not discuss works on eye diseases; for which see Wardrop, *Human Eye*.

7 I provide dates for the main figures I discuss, though not for those who play only a minor role.

Introduction

1 Foucault, *Clinic*; Ackerknecht, *Paris*; Keel, "Politics"; Keel, *Avènement*, 70n112; Harley, "Post-Mortems." Bonet and Morgagni are discussed in later chapters.

2 Benivieni, *De abditis*; Bonet, *Sepulchretum*; Hess and Mendelsohn, "Case," 289; Morgagni, *De sedibus*, XII.11 and *Seats*, 1:260.

3 Bonet, *Sepulchretum*, preliminary unnumbered pages Weber, *Bellini* and *Sensata Veritas*.

4 Bonet excerpted the *Philosophical Transactions* of the Royal Society for England, the *Miscellanea curiosa* for Germany, and Thomas Bartholin's *Acta medica et philosophica hafniensia*, *Historiae anatomicae*, and *Epistolae* for Denmark. Evans, "Learned Societies," 135–39. In his preface Bonet provided a peculiar reconstruction of medicine excluding Southern authors; in fact, occasionally some did slip through the net, as with Francesco Redi's and Stefano Lorenzini's work on the torpedo fish. Bonet, *Medicina*, vol. 1, 152b–153b.

5 Donato, *Death*.

6 Hooper, *Brain*, 1828, preface, 7; Maulitz, *Appearances*, 136–54; Harrison, "Racial Pathologies"; Keel, *Avénement*, 21–74, 70n112.

7 Baillie, *Morbid Anatomy*, viii–ix and *Engrav-*

ings, 29n; Cruveilhier, *Anatomie pathologique*, 1:i, vi.

8 Bynum and Porter, *Hunter*, part 2; Lawrence, "Entrepreneurs"; Chaplin, "Hunter," chap. 6

9 Beretta, *Private*. On the development of preservation methods see Cook, "Time's Bodies" and *Exchange*, 268–88. Bleuland, *Descriptio*, xii; Alberti, "Owing"; Alberti and Hallam, *Medical Museums*; Walter and Walter, *Museum*; Keel, "Politics"; Bynum, *Science*, chap. 2; Ackerknecht, *Paris* and *History*, 146; Margócsy, *Visions*; Hendriksen, *Anatomy*; Knoeff, "Anatomy"; Knoeff and Zwijnenberg, *Fate*; Guerrini, "Material Turn."

10 Siraisi, "Vesalius," 320; Wilson, "Disease-Concepts"; Temkin, *Falling Sickness*; Rosenberg, "Framing Disease"; Maulitz, "Tradition"; Peitzman, "End-Stage"; Hess and Mendelsohn, "Case"; Tyson, "Observations," 1038; Bauhin, *Theatrum*, 1312–13; Blasius, *Exempla*, 104, 128–32. Horseshoe kidneys were first represented in Botallo, *De catarrho*. Bejamin and Schullian, "Observations"; Jacobaeus, "Monstrosi testes muliebres"; Méry, "Observation."

11 Bates, *Monsters*; Long, *Hermaphrodites*; Park and Daston, *Wonders*, esp. chap. 5; Hagner, *Körper* and "Monsters"; Cruveilhier, *Anatomie* (see the index under "Conformation," "Monstres," "Monstruosités," "Vices de conformation," and also "Foetus") and installment 1, plate 6, page 3; Geoffroy Saint-Hilaire, *Histoire*; Baillie, "Account"; Sandifort, *Museum*, vol. 2; Blasius, *Observationes* and *Exempla*; Liceti, *De monstris*.

12 Ehring, *Hautkrankheiten*. Eye lesions and hernias fall under the same category.

13 Foucault, *Birth*; Ackerknecht, *Medicine*; Brockliss, "Clinic"; Keel, "Pathology" and the recent *Avénement*. La Berge and Hannaway provide an excellent review in "Paris." See also Rey, "École."

14 Nicholson, "Morgagni"; Donato, *Death*; Weber, *Anatomia patologica*, *Aspetti poco noti*, and *Sensata veritas*; Canguilhelm, *Normal*; Vogt, *Bild*; Stolberg, "Uroscopy" and "Bedside"; Duffin, "Imaging Disease," especially 87, 85, 90. Morgagni's Latin editions include Naples, 1762; Padua, 1765; Louvain, 1766–67; Leiden, 1767; Yverdon (Switzerland), 1779. Fissell, "Disappearance."

15 La Berge and Hannaway, "Paris"; Keel, *Généalogie* and *Avènement*, especially 312–18, 412; Lindeboon, *Biography*, 200–202. Key figures include James Carmichael Smyth, Edward Johnstone, and Baillie. The entries on Carmichael Smyth and Johnstone in the *DNB* mention neither their contributions to histopathology nor the work by Keel. See also Maulitz, *Appearances*, 3, 114, 206–7.

16 Bichat, *Anatomie*, 1:l, xxxv–xcix; Haigh, *Bichat*, 120–22; Maulitz, *Appearances*, 27–31; Bertoloni Meli, "Rise."

17 A wonderful account of these developments is in Mukherjee, *Emperor*.

18 Pott, *Works*, 3:225–9, citation at 226, and *Farther Remarks*, plates. A relevant image was published by surgeons Wadd, *Cases*, and Cooper, *Testis*. Porter, "Eighteenth," 468; Temkin, "Surgery"; Keel, *Avènement*, 76; Gelfand, *Medicine*.

19 Keel, *Avènement*, 414, 427; Duchesneau, "Vitalism"; Morgagni, *Seats*, 1:57; Canguilhelm, *Normal*; [Johnston], review of Armstrong, 107; Wolfe, *Vitalism*.

20 Cruveilhier, *Anatomie pathologique*, *avant-propos*, 1:i. A useful bibliography of works relevant to pathology to 1804 is in Voigtel and P. F. Meckel, *Handbuch*, 1:7–64. Goldschmid, *Entwicklung*.

21 Hunter, "Digestion"; Carswell, *Pathological Anatomy*, under "softening," and "Inquiry".

22 Arrizabalaga, Henderson, and French, *Pox*; Bynum, *Blood*; Nicholson, "Theory."

23 Daniel, *Nosologia*; Risse, "Shift," 127–28, 131; Saunders, *Plants*; Willan, *Cutaneous Diseases*; De Lacy, "Nosology"; Bynum, "Nosology."

24 Arrizabalaga, Henderson, and French, *Pox*, 234–77; Bynum and Nutton, *Theories of Fevers*; Wilson, "Disease-Concepts"; Risse "Sintesi"; Rosenberg, "Framing Disease"; De Lacy, "Nosology"; Bynum, "Nosology."

25 Duffin, *Laennec*, especially 49, 202, 266.

26 Cruveilhier, *Anatomie*, 1:i; Weber, *Veritas* and *Aspetti*; Cunningham, *Anatomist*, 186–222; Morgagni, *Seats*, 1:101, 260. For surgical sources see Scultetus, *Armamentarium*; Bertoloni Meli, 'Representations." A recent

survey on the early modern period is Michael Hunter, "Introduction."

27 Cruveilhier, *Anatomie*, 1:i; Bichat, *Traité*, 1:xxviii–xxx; Chadarevian and Hopwood, *Models*; Lemire, *Artistes*, especially 234–44. On the Paris wax pathology museum see chapter 5. Rodari, *Anatomie*, 135; Vicq d'Azyr's plates were color aquatints by Angélique and Alexandre Briceau.

28 Kusukawa, *Book of Nature*, 184; Ekholm, "Representations."

29 On the huge field of visual representation see the "Focus" section on *Science and Visual Culture*, *Isis* 97 (2007): 75–220. Pang, "Representation"; Daston and Galison, *Objectivity*; Hentschel, *Visual Cultures*.

30 Parshall, "*Imago*"; Laennec, *Auscultation*, plate II, figure 1; Rayer, *Maladies de la peau*, 1826–27, *Atlas*, plate 1.

31 Some of these issues are discussed in Daston and Park, *Marvels*; Daston and Galison, *Objectivity*. Kemp, "Trust"; Bates, *Monsters*; Fontes da Costa, "Authentication," especially 270–76.

32 Jacyna, "Pathology"; Ehring, *Hautkrankheiten*; Dahm, *Krankenbildnisse*; Stafford, *Body*.

33 Knoeff, "Anatomy"; Hope, *Principles*, iii; Pang, "Visual Representation."

34 Jacyna, *Whigs*, 105–12, 122–23. On Bell see the entry in the *DNB* by Leon S. Jacyna. Secord, "Botany"; Dolan, "Pedagogy"; Berkowitz, "Beauty," "Anatomist," and *Bell*; Tansey and Mekie, *Museum*, 2–4; Carswell, *Pathological Anatomy*, dedication; Fend, "Skin"; Reckert, *Carswell*.

35 Schnalke, *Diseases*; Marker, *Model*; Lemire, *Artistes*, 234–44; Wells and Bettany, *Guy's Hospital*, 414–18. On Guy's Hospital see chapter 6, and on Carswell see chapter 7.

36 Kemp, "Style"; Bertoloni Meli, "Insects."

37 Among the most extensive manuscript collections are the drawings for Cheselden, *Osteographia* in London; the drawings for Sandifort, *Museum* at Leyden; William Clift's watercolors for Baillie's *Engravings* at the London College of Physicians; the watercolors for Hooper's treatises at the Osler Library in Montreal; the watercolors for Bright's *Re-*

port at the London College of Physicians; and Carswell's watercolors at University College, London. Théodoridès, *Rayer*, 40–41.

38 Rodari, *Anatomie*; Dolan, "Pedagogy," 282–93; Gascoigne, *Identify Prints* and *Milestones*; Kemp, "Style." Recent perspectives are in Stijnman and Savage, eds., *Printing Colour*.

39 Bertoloni Meli, "Visual Representations," 182–83; Berkowitz, "Beauty," 256.

40 I found Rodari, *Anatomie*, and Grasselli, *Impressions*, and in particular the essay by Walsch, "Ink," especially useful. Matters, however, could be exceedingly more complicated: see Harris, "Processes."

41 Maxime Préaud, "Du coloriage a l'impression en couleur," in Rodari, ed., *Anatomie de la couleur*, 18–49, at 46–48.

42 Rodari, *Anatomie*, 44, 94, 139.

43 Bright, *Reports*, vol. 2, plates XIII and XX. The captions to the illustrations in James John Audubon, *The Birds of America* (London, 1827–38) mention Robert Havell as having engraved and colored the plates, although in fact he colored the master copy only, while the rest of the coloring was done in his shop by low-paid, usually female employees. Hope too colored the master copy and copies donated to the libraries, though not all the copies (Anne Hope, *Memoir*, 34).

44 One of Le Blon's plates depicting a dissected penis was intended for a work on gonorrhea, though there is no reference to that in the equivalent plate by L'Admiral: Rodari, *Anatomie*, 70–71, 135–36. Roberts and Tomlinson, *Fabric*, 530–32 and plate 112; Grasselli, *Impressions*, 112 and plate 56; Bleuland, *Vasculorum*.

45 Rodari, *Anatomie*, 31, 132; Dolan, "Pedagogy through Print," 289; Grasselli, *Impressions*, 6–7.

46 Blunt and Stearn, *Art*, 147, 171, 204–5, 238; Saunders, *Plants*, plates 23, 38, 43, 45, 65, 67, 68, 74, 99. At times it can be difficult to determine the exact techniques used and the amount of hand coloring versus printing in color involved. Nissen, *Botanische, sub indice*.

47 Dobson, *Clift*, 20; Margócsy, *Commercial Visions*, chap. 6.

48 Hope, *Memoir*, 90–91.

49 Roberts and Tomlinson, *Fabric*, 534–51.

Chapter 1

1 Dackerman, *Prints*, 56–57; De Ketham, *Fasciculo*, 2. For an earlier image see MacKinney, *Illustrations*, figure 5. Stolberg, "Uroscopy."

2 Carmichael and Ratzan, *Medicine*, 115–16; Carlino, *Paper Bodies*; Sudhoff, *Graphische*, plate V; Dackerman, *Prints*, 80–81. Honemann et al., *Einblattdrücke*. For a later collection of medical broadsides (ca. 1660–1716) assembled by Hans Sloane see British Library, General Reference Collection C.112.f.9.

3 Moulin, *Surgery*; Temkin, "Surgery."

4 Demaitre, *Leprosy*, 203–7, 236; Boeckl, *Leprosy*, 57–59; Ehring, "Leprosy," 873–75; Flamm, "Pupil"; Dackerman, *Prints*, 60–64. I am grateful to Glenn Harcourt for his astute observation on the Jesus-like posture of the patient.

5 Goldschmid, *Entwicklung*, 39, 41, 51–52; Baker, "Surgery"; Klestinec, "Translating." On Guidi and Della Croce see the entries in *DBI* by Cesare Preti and Augusto De Ferrari.

6 Jones, "Hildanus," parts I and II, especially I:121; Meyer-Ahrens, *Fabry*. For a bibliography see Schneider-Hiltbrunner, *Fabry*, 21–64. Hess and Mendelsohn, "Case," 288–91. The sixth *centuria* appeared posthumously in the 1646 *Opera*. Bertoloni Meli, "*Ex museolo*."

7 Fabricius, *Opera*, 14a-b, Fabricius to Felix Platter, 6 September 1604; 62a-3a, Fabricius to Abel Roux, 13 August 1603; 76a-7b, Fabricius to Georgius & Franciscus von Lycke, 29 August 1609; 166b. Pomata, "Sharing Cases," "Observation," and "Word"; Daston and Lunbeck, *Histories*. Findlen, *Nature*; Park and Daston, *Wonders*, chap. 5; Ogilvie, *Science*, 41, 63–64; Bertoloni Meli, "*Ex museolo*."

8 Kooijmans, *Death*, 46; Fabricius, *Anatomiae praestantia et utilitas*, 203–4, 220–21, items 36 and 37.

9 Fabricius, *Praestantia*, 197-225, item 9 at 207, 200; Meyer-Ahrens, *Fabry*, 54; Fabricius, *Opera*, 76–77; Fabricius's *Monstro* was dedicated to Bauhin, on whom see Long, *Hermaphrodites*, chap. 2.

10 Fabricius, *Opera*, 249a: "Vasa hæc cum adhuc essent recentia, diligenter stupis suavibus infarci & exsiccavi, eaque in huuc usque diem 18 Maii 1630 quo hæc ad prælum describo, in Musæo meo ut rarum quid reservo: Et nunc per pictorem delineanda curavi." See also 330b: "Delineationem situs admirabilis fœtus in utero, quam in postremis meis ad te literis promisi, Vir amplissime ac doctissime, nunc a te mitto, ut possis ea, quae in descriptione sunt obscura, ex delineatione plenius cognoscere. Misissem eam maturius, nisi Lausannæ & alibi aliquandiu detentus fuissem, & pictorem diligentiorem habuissem." Fabricius, *Opera*, preface, 3r; Bern, Burgerbibliothek, Ms. 495, ff. 154r, 155v, 156r, three wash drawings signed by Plepp; Thieme, *Lexicon*.

11 Fabricius Hildanus, *Opera*, 1a–13a. The small particle in the middle of the table is probably a bone found in the tumor, discussed at 10a-b. From standard biographies it appears that Mayor lived two more years after Fabricius's operation. Goldschmid, *Abbildung*, plate 9. Other areas for surgical treatment were bladder and gallbladder stones, and bones.

12 Fabricius Hildanus, *Centuria secunda*, 188; Fabricius Hildanus, *Opera*, 123a–126b; Fabricius Hildanus, Basel, Universitätsbibliothek, Frey-Gryn Mscr II 5:Nr.29, letter to Jacob Zwinger, 13 February 1607 (the original color drawing is at http://dx.doi.org/10.7891/e-manuscripta-4386).

13 Fabricius Hildanus, *Opera*, 117b–118b; Fabricius Hildanus, *Centuria secunda*, 159. Interestingly, Laennec too referred to chalky matter; see *Auscultation*, 260, 280–81, 305; *Treatise*, 96, 118-9. Lebert, *Traité*, I.5.

14 Fabricius Hildanus, *Opera*, 125a, 273b, 274, 276b, 380a; Fabricius Hildanus, *Centuria tertia*, 388-98. There is a considerable difference between the woodcut in the third *centuria* and the posthumous one in *Opera*. Jones, "Fabricius," I:131. Goldschmid, *Entwicklung*, 44.

15 Meyer-Ahrens, *Fabry*, 16. Fabricius, *Opera*, contains frequent references to "tyrones": 2v, 81a, 171a, 197a, 202b, 216b, 261b, 339a, 397b, 406a, 462a, 471a, 493b, 509a, 778b, 801a, 820a, 855b. Bern, Burgerbibliothek, MSS 495 and 496 contain dozen of images

partly related to his published works. For the exchange of images see *Opera*, 104–5, 512. Bertoloni Meli, "*Ex museolo*," "Gerardus Blasius."

16 Winau, "Frügeschichte"; Bertoloni Meli, "Representations"; Conforti, "Pathologies."

17 On the huge topic of seventeenth-century Dutch art see the classic Alpers, *Art*. Olmi, *Inventario*, 119–61, at 121 challenges Alpers. Swan, "Natural History," "Collections," "Botanical Treatises," and "Realism."

18 Tulp, *Observationes*, 48, 52, 135, 168, 192, 325; the image on the orangutan is at 271 and on the title page.

19 Van Meek'ren, *Heel- en geneeskonstige aanmerkkingen*, translated as *Observationes medico-chirurgicae* (Amsterdam, 1682); Lindeboom, *Biography*, 1294–95; Kooijmans, *Death*, 61–64. Bertoloni Meli, "Blasius," discusses the Amsterdam *Observationes* and presents a more extensive bibliographic survey.

20 Van Roonhuyse, *Heel-konstige aanmerkkingen*; German translation, *Historischer Heil-Curen in zwey Theile verfassete Anmerckungen* (Nürnberg, 1674). It was also translated into English (London, 1676), where "aanmerk-kingen" is rendered as "observations." Van Roonhuyse, *Genees en heel-konstige aan-merkingen* (Amsterdam, 1672); Lindeboom, *Biography*, 1668–69.

21 See also *Spicilegium anatomicum, continens observationum anatomicarum rariorum centu-riam unam* (1670) by Amsterdam physician Theodor Kerckring; Lindeboom, *Biography*, 1030–32; Roberts and Tomlinson, *Fabric*, 300–305.

22 Lindeboom, *Biography*, 1295; Parapia and Jackson, "Ehlers-Danlos Syndrome"; Meek'ren, *Observationes*, 134–36, 177, 230–36, 255, 367; Schupbach, "Cabinets," 173.

23 Bartholin, *Epistolae*, 1:720–26, at 723. Today the condition is identified as atherosclerosis, or the deposition of plaques of fat and the "calcification" of arteries.

24 Belloni, "Aterosclerosi," 35–37; Malpighi, *Opera posthuma*, 69–70; Malpighi, *Opere*, 382–83, 436–37, 446–47; Bertoloni Meli, *Mechanism*, 21, 147, 300. Malpighi was familiar with Bartholin's correspondence

and probably this very case, because it also involved a heart polyp, the topic of one of his essays. Findlen, *Nature*.

25 Cleyer, "Elephantia," 8–9; Winau, "Mentzel"; Cook, *Exchange*, 307–9, 375; Lindeboom, *Biography*, 344–45; Conforti, "Pathologies."

26 Demaitre, *Leprosy*, chap. 7; Ehring, "Leprosy," 873–75; Cleyer, "Elephantia," citation at 8. The effect on hands and feet is due to the destruction of nervous tissue and the consequent lack of feeling.

27 Lindeboom, *Biography*, 1387–89; Le Clerc and Manget, *Bibliotheca*, 2:624–25.

28 Harvey, *Exercitatio anatomica de circulatione sanguinis* (Cambridge, 1649), in *Circulation*, 114; Cook, *Exchange*, 268–88, "Time's Bodies," "Naturalia," and "Representation"; Tompsett, *Techniques*; Lindeboom, *Biography*, 148–50.

29 On Cowper and Tyson see the *DNB* entries by Monique Cornell and Anita Guerrini. Bertoloni Meli, "Disease." On eighteenth-century developments see Schultka and Göbbel, "Präparationstechniken." Chaplin, "Hunter," 104.

30 Savio, "Riva"; Bonino, *Biografia medica piemontese*, vol. 1, 406–20; Donato, *Death*, 63; Elsner, "Paradoxico."

31 Jorink, "Noah's Ark." The Leiden museum is discussed in chapter 2.

32 Lindeboom, *Biography*, 156–58; Mooij, *Doctors*, 75; Kooijmans, *Death*, 69, 82. On Sylvius's Leiden teaching see Huisman, *Finger*, 145–54.

33 Blasius, *Observationes*, address to the reader: "Rarius occurrentia sola proponere voluimus"; see also 83 and tab. IX, figure 3. On early modern museums and cabinets of curiosities see Impey and MacGregor, *Origins*. Findlen, *Nature*; Park and Daston, *Wonders*.

34 Blasius, *Observationes*, 82, 84.

35 Ibid., 8, 17, 27.

36 Ibid., 1, 35, 42, 47, 61, 73; French, *Foligno*, 133–34.

37 Plate VII in Blasius, *Observationes*, shows several malformations of the urinary system.

38 Blasius, *Observationes*, 10–11 and plate II, 17–19 at 17; Lindeboom, *Biography*, 156–58. Blasius's son Abraham translated van Meek'ren's *Observationes* into Latin.

39 Blasius, *Observationes*, 19–24 and 24–25.

40 Ibid., 24–25; Blasius, *Miscellanea*, 307–8; Blasius, *Observata*, 119.

41 Buissière, "Triple Bladder," 752. His work appeared in Latin translation in the *Acta eruditorum*, 1702, 21:27–30.

42 Bertoloni Meli, "Representations."

43 Bertoloni Meli, *Mechanism*, 20–22 and chap. 12; Ragland, "Bodies"; Ehring, "Leprosy," 877–78.

44 Temkin, "Surgery"; Gelfand, *Medicine*; Keel, *Avénement*, 75–76; Bertoloni Meli, *Mechanism*, chap. 12.

45 Cook, "Physicians" and "Philosophy"; Hunter, *Society*. John Beaumont, for example, is referred to as "Somerset surgeon and naturalist" in Hunter, *Royal Society*, no. 424, though it is not known whether he actually was a surgeon (personal communication with Scott Mandelbrote, who wrote the *DNB* entry). Harley, "Post-Mortems."

46 See the entry by Robert L. Martensen in the *DNB*. Frank, *Harvey*, *ad indicem*; Hunter, *Society*, no. 22. London surgeon Charles Bernard was elected fellow of the Royal Society in 1696, though he did not contribute relevant publications. On Charles Bernard see the entry by Ian Lyle in the *DNB* and Hunter, *Royal Society*, no. 502. James Cuninghame (Cunningham) was an East India surgeon elected in 1699, though his main contributions were to Chinese flora; see Hunter, *Royal Society*, no. 543, and the *DNB* entry revised by D. J. Mabberley.

47 Brown(e), "Liver," also in *Acta eruditorum*, 1687, 6:26–9; Bertoloni Meli, "Royal Society"; Payne, "Address." On Brown(e) see the entry by Ian Lyle in the *DNB*. Malpighi, *Opere*, 415; Bertoloni Meli, *Mechanism*, 118.

48 Bertoloni Meli, "Visual Representations"; Bauhin, 1621; Tulp, 1641; Bartholin, *Histori-*

ae, III–IV, 39–44; Bartholin, *Epistolae*, 1:720–26, at 723; Belloni, "Aterosclerosis," 28–45.

49 Paul Buissière, "A Letter Concerning a Substance Cough'd up Resembling the Vessels of the Lungs," *PT* 1700–1701, 22:545–46. On Buissière see the entry in the *DNB*.

50 Sturdy, *Science*, 110, 115–18, 216–17; Gelfand, *Medicine*, 34–53; Guerrini, *Anatomists*, 49, 90–91, 227–38; Méry, "Exostose." Oliger Jacobaeus, Thomas Bartolin's son-in-law, in Bartholin's *Acta*, 3:87–88, also uses the adjective "monstrous" in reference to the size of an ovary in the title of essays with pathological illustrations.

51 Sturdy, *Science*, 189–92, 312–14, 401, 430; Louis, *Éloges*, iii, 1–19, 199–232; Portal, *Histoire*, 4:366–79, 4:560–63, 5:1–10; Gelfand, *Medicine*, esp. 181–83.

52 See the entries on Berengario, Massa, and Fabricius in the *DSB*. Palmer, "Massa."

53 Seiz, *Scultetus*.

54 Long, *Pathology*, 48–49; Golschmied, *Entwiclung*, 43–44.

55 Lindeboom, *Biography*, 135–39; Roberts and Tomlinson, *Fabric*, 309–19; Kooijmans, *Death*, 224–29; Hunter, *Royal Society*, no. 495. Sappol, *Dream*, 28, 34, attributed the engravings to Pieter Stevens van Gunst and Abraham Blooteling. Bidloo, *Exercitationum*.

56 Vater and Heister, *Museum anatomicum proprium* (Helmstadt, 1750); see also Vater, *Catalogus*. Kooijmans, *Death*, 405, 430; Helm, "Vater."

57 Lindeboom, *Biography*, 817–18; Kooijmans, *Death*, 416–17.

58 Lebert, *Traité*, I.6; I translate "iconographie pathologique" as "pathological illustration," since the term "iconography" has a more technical meaning in English. Margócsy, "Museum" and *Visions* highlights the commercial dimension of collections, including Ruysch's. Hendriksen, *Anatomy*, 75–76; Knoeff, "Anatomy."

59 Kooijmans, *Death*, chap. 1, at 59; Ruysch, *Dilucidatio*.

60 Mooij, *Doctors of Amsterdam*, 43; Kooijmans, *Death*, 78–79, 82, 88–89, 97.

61 Kooijmans, *Death*, 156; see 352 for the respective remunerations.

62 Ibid., 185. Quotation from *Epistola problematica duodecima*, 1699, at 21, "quotidiana enim cadaverum inspectio."

63 Kooijmans, *Death*, 164.

64 Ibid., 85.

65 Ibid., 269, 278, 283, 337, 344. The frontispiece of his *Centuria* shows an idealized view of his museum. Hansen, "Resurrecting Death"; Roemer "*Vanitas*"; Hendriksen, *Anatomy*, 87–101.

66 Kerckring, *Spicilegium*, 108, compared the "monstrous" kidney to a conglomerate gland. Belloni in Malpighi, *Opere*, 298–99, identified the condition as a polycystic kidney and reproduced the figure published by Littre, "Observation," of a similar condition in a nine-month fetus. Bertoloni Meli, *Mechanism*, 164, 142–47, 298–300; Kooijmans, *Death*, 393–99.

67 Ruysch, *Thesaurus primus*, address to the reader; Goldschmied, *Abbildung*, 54 and plate 13.

68 Ruysch, *Thesaurus nonus*, 12, "ex ligno indico"; such references are very common. Kooijmans, *Death*, 269–70.

69 Ruysch, *Thesaurus octavus*, 10–12, 50, item XCVIII, 62. The plate was based on his own drawing. *Catalogus*, 94.

70 In 1693 Rachel married painter Jurriaan Pool, but neither she nor her husband apparently contributed to Frederik's work; Kooijmans, *Death*, 169.

71 Lindeboom, *Biography*, 325; Kooijmans, *Death*, 397–400; Ruysch, *Catalogus*, figures 6–8 (facing page 94).

72 Ruysch, *Thesaurus nonus*, 69–70 and 37–39, item LI.

73 Ibid., 70; a possible related specimen is on 27, item 37.

74 Ibid., 70 and 61–62.

75 Lebert, *Traité*, I.6.

Chapter 2

1 Sandifort, *Museum*, 1:v; Rayer, *Sommaire*, 79, 84, 102–4; Cruveilhier, *Anatomie*, 1:iii; Meckel, *Tabulae*, iii.

2 Weber, *Aspetti*, 50; Cocchi's watercolors were due to Leonardo Frati. Morgagni, *Consultations*, 47–58 at 57–58. On Albinus and Soemmerring see below the reference to a *diseased* bone lent to Trioen and Weidmann. Daubenton, *Histoire*, 13–132. On Frati, who seemingly died in 1751, see Thieme, *Lexicon*. Guerrini, "Skeletons" and "Charnel House."

3 Sandifort, *Exercitationes*, preface; John Hunter, *Essays and Observations*, 394–95; Hendriksen, *Anatomy*, chap. 7, 185; Goldschmid, *Entwicklung*, 85.

4 Sandifort, *Museum*, vol. 2, preface, identifies the works mentioned here as the key illustrated treatises on bone pathology.

5 The two classics on the topic are Ackerchnecht, *Medicine*, and Foucault, *Birth*. An excellent reevaluation is La Berge and Hannaway, "Paris." Peltier, *Fractures* and *Ortopedics*, provides a survey from a medical perspective; see especially 101–2, 264–69. For a useful survey see Porter, "Eighteenth."

6 Smellie, *Sett*, plates III and XXVII; Massey, "Pregnancy," 77 and 79.

7 Cope, *Cheselden*, 2, 66. See also the *DNB* entry by John Kirkup.

8 Cope, *Cheselden*, 67–68.

9 Ibid., 66–71; Cheselden, *Osteographia*, address to the reader; *PT* paper by Cheselden on preparations; Kemp, "'Mark of Truth,'" 103–5; Bertoloni Meli, "Visual"; Cheselden, *Osteographia*, chap. 8.

10 Cheselden, *Osteographia*, address to the reader.

11 Cowper, "Kidney," "Polypus," "Ossification," and "Hydatides." Plates from the first two were signed by Vandergucht. Margócsy, *Visions*, chap. 5.

12 Cheselden, *Osteographia*, address to the reader; Clayton, *Print*, 58–59; Daston and Galison, *Objectivity*, 77–79; Kemp, "'Mark,'" 107–8. On Vandergucht (1696–1776) see the *DNB* entry by Timothy Clayton; on Schijn-

voet (1686–1733) see Le Fanu, "Schijnvoet." Cheselden singled out the acetabulum of the os innominatum in comparison to the heads and sockets of the other bones as the chief exemplar of this mixed technique; *Osteographia*, address to the reader, plate I, figure 9 and plate XVIII. We shall see other examples below.

13 Cheselden, *Osteographia*, plate XVII includes other variants as well.

14 Ibid., plate I, figure 5.

15 Ibid., plate XVII and plate VI, figures 2–3 and 4–5.

16 Ibid., chap. 7.

17 Ibid., plate XLVI, figure 1; Douglas, *Animadversions*, 38.

18 Cheselden, *Osteographia*, plate XLI, figure 1 and plate XLVIII; Bertoloni Meli, "Representations," 182–83.

19 Douglas, *Animadversions*, 22–23; Cheselden, *Osteographia*, table XLIX, figure 4.

20 Cheselden, *Osteographia*, chap. 7 and plate XLIX.3. On white swelling see Condie, *Diseases of Children*, 567–68.

21 Cheselden, *Osteographia*, plate XLII, figures 1–2.

22 Ibid., plate XLIX; Cope, *Cheselden*, 68.

23 The tibia and fibula shown in Cheselden, *Osteographia*, plate LIII can be found at the London Hunterian Museum, RCSPC/01422; after Cheselden they belonged to surgeon William Long. The original drawings are in London at the Royal Academy, 03–6801, 03–6802, 03–6798; they belong to a large cache of preliminary drawings for *Osteographia*. See also Cheselden, *Osteographia*, plate XLIV.

24 Houstet, "Exostoses," 131, 133; Daubenton, *Histoire*, 53–132 and plates I–IV; Louis, *Éloge*, 306–18; Stalnaker, "Life"; Loveland, "Daubenton"; Guerrini, *Anatomists*, 251–54.

25 Lindeboom, *Biography*, 2001–2; Moulin, *Surgery*, 128–29, 157–58, 162–64; Mooij, *Doctors*, 101–9.

26 Thieme, *Lexicon*; Albinus, *Academicarum annotationum libri*, and see Goldschmid,

Entwicklung, 63–64. In *Uteri humani gravidi anatome et historia* (Leiden, 1743), published in the same place and year as Trioen's *Observationes*, Willem Noortwjk described the findings of his wife's postmortem.

27 Trioen, *Observationes*, address to the reader, 24, 44, 55–58.

28 Ibid., 105–11, at 107.

29 Ibid., plates XI and XII.

30 Döring, "Ludwig"; Grosse, *Afrikaforscher*, 10–18; Nissen, *Botanische Buchillustration*, 1:247 and item 1252.

31 Goldschmid, *Entwicklung*, 85–87; Sandifort, *Museum*, 2:4.

32 Herrmann and Reichel, *Modo*; Herrmann, *Osteosteatoma*, 15; Reichel, *Epiphysium*, 26; C. F. Ludwig, *Tabulae*, 13; Ludwig, *Adversaria*, I:16. Among works not related to bones is Mummssen, *De corde*. Goldschmid, *Entwicklung*, 85–6.

33 Nissen, *Botanische*, index. Glassbach engraved the plates in Meckel, *Commentarius*. Ludwig, *Tabulae*, plate XIV, figures 2–3.

34 Herrmann, *Osteosteatoma*, 32, 33–35, 52.

35 Ibid., plate I; C. F. Ludwig, *De sedibus*, 13–15.

36 Herrmann translated books 2–4 of Morgagni, *Sitze*.

37 Ludwig, "Tractatio," 56–60.

38 Lindeboom, *Biography*, 200–202 and 921–22; Brockliss, *Clinic*; Keel, *Avénement*, 311–18; Sandifort, *Museum*, 3:4–6 and 311–29; Mooij, *Doctors*, 110–14 and 120; Moulin, *Surgery*, 175. Jacob Hovius (1710–1786) was still alive when Bonn published the first two fascicles of the *Tabulae*. Wenzel, *Krankheiten*, xiv and plate V, figure 5, dated 1779, plate VI, figures 3–4, and plate VII, figures 3–4; Bonn, *Tabulae anatomico-chirurgicae doctrinam herniarum illustrantes* (Leiden, 1828); Hendriksen, *Anatomy*, 103, 105.

39 Sandifort, *Museum*, 3:312; Karenberg, *Lernen*, 73–74; Hess and Mendelsohn, "Case," 292–93.

40 Weber, "Weidmann," 22. Pott, *Remarks*, in-

cludes six mezzotint plates by Robert Laurie. Sandifort, *Museum*, 1:vi.

41 Weber, "Weidmann," 40 and n332; Gruber, "Weidmann." Weidmann's work was followed by a short pamphlet on a related matter, *De abusu ferri candentis ad separandas partes ossium mortuas* (Mainz, 1797). Bone necrosis was a common subject of study at the time: Scottish surgeon John Russel, for example, wrote a treatise on bone necrosis soon after Weidmann, entitled *A Practical Essay on a Certain Disease of the Bones, Termed Necrosis* (Edinburgh, 1794).

42 Weber, *Weidmann*, 122n330; Geus, "Koeck." Koeck also engraved the work by the Frankfurt medicine professors Karl and Joseph Wenzel, who translated into German Weidmann's work *De abusu ferri candentis* with eight additional plates drawn by Franz Coengten.

43 Weidmann, *De necrosi*, 21.

44 Ibid., 5–6, 11, 29–31, 36; Randelli, "Troja."

45 Weidmann, *De necrosi*, 58–59, 57.

46 Moulin, *Surgery*, 195–96; Rooy, *Forces*, folding pages between 72 and 73; Mooij, *Doctors*, 49–56, 80, 149–54.

47 Bonn, *Descriptio*, preface, 116–17 (item CCCLXXXIX), and 117–20 (item CCCXCVI).

48 Bonn, *Tabulae*, preface; Camper, *Demonstrationes*; Albinus, *Tabulae sceleti* and *Tabulae ossium*.

49 Bonn, *Tabulae*, preface. On Houtman and Bakker see Thieme-Becker, *Lexicon*. Houtman engraved plates X–XII and XVII–XX.

50 Bonn, *Tabulae*, 199–200.

51 Ibid., plate X; Bonn, *Descriptio*, 71–72, item CCIX; Cheselden, *Osteographia*, plate LI.1, and see also plate LIV.

52 Bonn, *Tabulae*, conclusion following plate XXIII; De Moulin, *Surgery*, 205.

53 Lindeboom, *Biography*, 1718–21; Moulin, *Surgery*, 175; Sandifort, *Observationes anatomico-pathologicae*, preface, 1v–2v; Cunningham, *Anatomist*, 222; Elshout, *Kabinet*, 85–96. Two additional volumes to Sandifort's *Museum* were published by his son Gerard in 1827

and 1835 (Sandifort, *Icones* and *Anatome*). Van Doeveren's son, Antonie Jacob, also published a similar work, *Observationes pathologico-anatomicae* (Leiden, 1789).

54 Sandifort, *Observationes*, 3r.

55 Sandifort, *Museum*, 2:3. On Delfos (1731–1820), Muys (1742–1825), and Wandelaar (1690–1759) see the entries in Thieme, *Lexicon*.

56 Sandifort, *Museum*, dedication.

57 The copy I inspected is at the Galter Library at Northwestern University.

58 Rau also held a medical degree: Lindeboom, *Biography*, 1592–94. Kooijmans, *Death*, 390.

59 Sandifort, *Museum*, 1:v–vi,2:4; Choulant, *Anatomical Illustration*, 312–13; Bleuland, *Descriptio*, vii–viii; Anonymous, review of Hodgkin, *Catalogue*, at 394–96. On De Mare (1757–1796) see Thieme, *Lexicon*. Delfos's drawings are at the University Library Leiden, BPL 309, *Delinationes tabularum anatomicarum in usum musei anatomici Leidensis* (1780–1790); the drawings are arranged by the correspondent plate number. See especially those for plate LXXXIX (illustration 2.9), dated 1784 and 1786 for the cross section. I am grateful to Bret Rothstein for a helpful exchange on this point.

60 Kemp, "Truth," especially 107–12; Roberts and Tomlinson, *Fabric*, 320–39; Huisman, "Squares"; Daston and Galison, *Objectivity*, 55–57, 70, 72; Punt, *Albinus*, 13 and n99.

61 Sandifort, *Museum*, I:iii, II:4. On competition for students see Huisman, *Finger*, 128; Mooij, *Doctors*, 115–16.

62 See, e.g., Sandifort, *Museum*, 1:225, 232–34 and 234–42, with increasingly longer case histories. Hendriksen, *Anatomy*, 101–3, 197–200.

63 Stones were extensively represented in Johann Gottlieb Walter's collection in the Berlin Museum, for example, and were the subjects of all the illustrations in his 1796 catalogue, as if it was a collection of gems; Walter and Walter, *Museum*.

64 Sandifort, *Museum*, 2:3–4, 1:127–29 and plates I–IV; Belloni, "Spunti," 296; Kemp, "Truth," 108–12 and "Style," figure 4.

65 Sandifort, *Museum*, vol. 2, plates V, LXV.

66 Ibid., vol. 2, L–LIII, LIX–LX. The plates in
 between are on scoliosis.

67 Ibid., 1:211–12, item CCCXIX, and 6–7, item
 V, from Rau's collection.

68 Mooij, *Doctors*, 101, 122.

69 Ibid.,109, 114–15; Sandifort, *Museum*, 1:vii;
 Bleuland, *Descriptio*, ix.

Chapter 3

1 Cruveilhier, *Anatomie pathologique*, 1:i;
 Meckel, *Tabulae*, iv; Bichat, xxviii–xxix;
 Secord, "Botany."

2 Cruveilhier, *Anatomie*, 1:iii; Baillie, *Engrav-
 ings*, 3.

3 Ackerknecht, *Medicine*; Foucault, *Birth*; Mau-
 litz, *Appearances;* Duffin, "Imaging Disease."

4 See the *DNB* entry by John Jones. Cunning-
 ham, *Pathology*, 2; Plarr, "Travel"; Keel,
 Avénement, 34; Teacher, *Catalogue*.

5 Baillie, *Morbid Anatomy*, viii–ix, and "Trans-
 position," 352; Chaplin, "Nature," 143, and
 Hunter, 106. Susan Lawrence, "Senses,"
 highlights the common grounds between
 physicians and surgeons in London at the
 time.

6 Rodin, *Influence*; Crainz, "Editions," 449–50;
 Cunningham, *Anatomist*, 218–22; Darem-
 berg, *Médecine*, 302.

7 On Meckel see the *DSB* entry by Guenther
 Risse. Lenoir, *Strategy*, 17–37, 56–65; Meckel,
 De cordis, 6, which includes five plates. P. F.
 Meckel's coauthor was physician Friedrich
 Gotthilf Voigtel. For differences between
 Blumenbach and Kant see Richards, "Kant
 and Blumenbach."

8 Wolff, *De formatione intestinorvm praecipve,
 tvm et de amnio spvrio, aliisqve partibvs embry-
 onis gallinacei*; Meckel, *Tabulae*, 1:1; Hagner,
 "Naturalienkabinett."

9 Clark, "Contributions"; Lenoir, *Strategy*,
 esp. 56–61, and "Morphotypes," esp. 124–25;
 Opitz and others, "Meckel"; Rehbock, "Anat-
 omy"; Maulitz, *Appearances*, 215–16.

10 Sandifort, *Museum*, 1:vii. Other works by
 Bleuland are *Icon tunicae villosae intestini
 duodeni, juxta felicem vasculorum imple-
 tionem* (Utrecht, 1789), *Icon hepatis foetus
 octrimestris* (Utrecht, 1789), and *Vasculorum,
 in intestinorum tenuium tunicis, subtilioris
 anatomes opera detegendorum, descriptio*
 (Utrecht, 1797).

11 Lindeboom, *Biography*, 163–65, 459–61,
 1070–71; Bleuland, *Icones anatomico-
 pathologicae*, 141, 154; Bleuland, *Descriptio*,
 vii–ix and xi–xii; Keel, "Politics"; Walter,
 Anatomisches Museum. Rodari, *Anatomie*,
 136 reproduces and discusses the plates in
 *Vasculorum, in intestinorum tenuium tunicis,
 descriptio*. Bleuland's collection is divided
 between the University Museum and the
 medical center in Utrecht.

12 See the entry on Meckel in the *Dictionary of
 Scientific Biography*. Meckel, *Tabulae*, III–IV;
 Lebert, *Traité*, I.7–8. There is a remarkable
 parallel between the Meckel dynasty at Halle
 and the Monro dynasty at Edinburgh.

13 Ruysch, *Thesaurus*; Hansen, "Resurrecting
 Death"; Luyendijk-Elshout, "Death"; Alber-
 ti, "Owning."

14 Baillie, *Morbid Anatomy*, i, vii–ix; Morgagni,
 Seats, xxx, II:215 refers to differences among
 patients. Keel, "Politics," 228.

15 Chaplin, "Dissection"; Alberti, *Morbid Curi-
 osities*. Hooper, *Observations*, 6; the drawings
 were due to Henry de Bruyn and engraved
 in aquatint by Thomas Medland. Baillie,
 Engravings, fascicle 4, plate IX. See the entry
 on Cruikshank in the *DSB* by Jessie Dobson.

16 The specimen by Fyfe was fascicle 3, plate
 II, figure 2; see Baillie, *Engravings*, vii–viii,
 7. Fyfe was a distinguished artist in his
 own right. Göbbel, Schultka, and Olsson,
 "Collecting," 100–101; Monro *tertius*, *Gullet*,
 xvi–xvii; Chaplin, "Hunter," chap. 7.

17 A new technique based on formalin and
 retaining color was introduced at the end of
 the century by Carl Kaiserling; Dam, "Inter-
 actions," at 78.

18 On Clift see the entry in the *DNB* by Phillip
 R. Sloan; see also the entries on Basire
 (1769–1822), Skelton (1763–1848), and Heath
 (1757–1834). Attwood, "Specimens"; Baillie,
 Engravings (Melbourne, 1985), fascicle 5,
 plate V.

19 Dobson, *Clift*, 20. Jenner, *Inquiry*, includes four plates all engraved by Skelton. On Jenner see the entry in the *DNB* by Derrick Baxby and Newson Kerr, "Alteration." Some of the original watercolors for Willan's and Baillie's works can be directly compared because they are to be found at the library of the London College of Physicians. Willan's work is discussed in chapter 5.

20 Many plates in Hunter's work relied on *sanguigna* drawings by Jan van Rymsdyk and were engraved by a number of artists, including Robert Strange, who also made some drawings. Huffman, "Riemsdyk."

21 The cost of Baillie's work can be retrieved from contemporary periodicals, such as *A General Index of the Monthly Review* (London, 1818), 1:249; *The Annual Review and History of Literature* 1803, 1:x; *Monthly Magazine, or British Register* 1803, 14:539; *Monthly Epitome and Catalogue of New Publications* 1800, 3:73. For salary information see the *DNB* entries by John Jones (Baillie) and Phillip R. Sloan (Clift). Berkowitz, *Bell*, 22. There are 20 shillings in a pound, 21 shillings in a guinea, and 12 pence in a shilling.

22 On Bock (1757–after 1806) and Frosch (1771–after 1827) see Thieme, *Lexicon*. Nissen, *Botanische Buchillustration, sub indice*. Eberhard is documented as a pathology illustrator in Halle from about 1791; see Goldschmid, *Abbildung*, 248–49.

23 Meckel, *Tabulae*, iii–iv.

24 In all likelihood he also employed the microscope and stated as much in *Vasculorum in intestinorum tenuium tunicis, subtilioris anatomes opera detegendorum, descriptio* (Utrecht, 1797), 9. The color engravings of this earlier work were due to Johannes Baptista Kobell (1778–1814); Rodari, *Anatomie*, 124. Bleuland, *Icones anatomico-physiologicae* (published as part of *Otium academicum*), 53–55. L'Admiral's plate from Albinus, *Dissertatio de arteriis et venis intestinorum hominis* (Leiden, 1736) is reproduced and discussed in Rodari, *Anatomie de la couleur*, 84; L'Admiral followed the pioneering color printing techniques by Jacob Christoph Le Blon. Rodari, *Anatomie*, 70–71; Landwehr, *Studies*, 49–50.

25 Bleuland, *Icones anatomico-physiologicae*, 1.

26 Baillie, *Engravings*, 98, 131, and *Anatomy*, iii, 2–3.

27 Baillie, *Anatomy*, vii; Morgagni, *Seats*, 1:647. References to left-right correlations are very frequent; see for example 1:27 and 645–47. Nicholson, "Theory" and "Morgagni"; Rosenberg, "Framing."

28 Morgagni, *Seats*, 1:139, 724.

29 Ibid., 2:182–83.

30 Peyer, *Methodus*, 1–2; Baillie, *Morbid Anatomy*, preface, especially viii–ix; Rodin, *Influence*; Hunterian Museum, London, *Catalogue*; Moore, *Knife*, 239; Morgagni, *Seats*, 2:195, 197.

31 Baillie and Soemmerring, *Anatomie*, xii, xviii; for references to Soemmerring's own collection see 28, 52, 64, 135, 142, 155, 213, 227, 246, 261; for references to Ruysch and Sandifort see 57, 80, 170; for references to collections in Edinburgh and Vienna see 5, 11, 22, 68, 251. Maerker, *Model*, 157; Peintinger, "Appendice," 112–13, 182.

32 Baillie, *Morbid Anatomy*, iii–viii, and *Engravings*, 4–6, 9–10, 29, 37, 105, 109.

33 Baillie, *Engravings*, 101–2. The liver ailment was later referred to as liver cirrhosis by Laennec. Attwood, "Clift's Copy," 12; Bertoloni Meli, "Rise."

34 Baillie, *Engravings*, 63–64; Attwood, "Clift's Copy," 12.

35 Baillie, *Engraving*, 63–65; Attwood, "Clift's Copy," 12; Hunter, "Digestion."

36 Baillie, *Engravings*, 37–39, 123–24, 137–38, quotations at 37, 123, 137; Baillie, *Morbid Anatomy* (1793), 47–51, 171, 179–80, and (1797), 274. Although Baillie's statements were not as general and explicit as Laennec's, he went somewhat beyond what Helen Bynum stated in *Spitting Blood*, 53–56, at 56, where she denied that Baillie realized that "the scrofulous matter strewn throughout the body . . . was all the same." Rey, "Phtisie"; Diderot and d'Alembert, *Encyclopédie*, vol. 12, "Phtisie"; Duffin, *Laennec*, 96–101 and 155–63.

37 Baillie, *Engravings*, 68, 103, 177; Wardrop in Baillie, *Works*, 2:xxxii–xxxvi, at xxxv–xxxvi; Rey, "Diagnostic differential"; Bertoloni Meli, "Rise," 231–33.

38 Baillie, *Engravings*, 41; Attwood, "Clift's Copy," 10.

39 Baillie, *Engravings*, 43, and *Morbid Anatomy*, 51; Attwood, "Clift's Copy," 10–12.

40 Baillie, *Engravings*, 17, 20, 83, 115, 151, 195.

41 Meckel, *Tabulae*, 1:4–5, 2:1, 3:8; Meckel, "Bildungsfehler," 549–51; Meckel, *Commentarius*, v–vi; Meckel, *De cordis*, 3, 7, 9, 49; Clark, "Contributions"; Hagner, "Naturalienkabinett," 102–6; Gliboff, *Bronn*, 44–53.

42 Meckel, *Handbuch*; the indices provide the taxonomic structure. Meckel, *Tabulae*, 1:4, "in hac tabula exemplum vitii cordis a classe aberrationum nisus formativi congenitarum secunda, illarum sc., quae ex aucta eiusdem pendent energia et complura tertiae classis, nempe qualitativarum exhibui."

43 Meckel, *Tabulae*, iii–iv; Lenoir, *Strategy*, 60–65.

44 Meckel, *Tabulae*, 2:16.

45 Ibid., fascicle 3:8–12.

46 Bleuland, *Icones anatomico-pathologicae*, 6, 16, 41, 74–75, 130, 140.

47 Ibid., 15–19; Baillie, *Engravings*, page 34, fascicle 2, plate III, figure 3.

48 Bleuland, *Icones anatomico-pathologicae*, 20–24.

49 Ibid., 154.

50 Baillie, *Morbid Anatomy*, 2–3; Meckel, *Tabulae*, 1:4, 2:4–5, 2:9, 4:5. On Hunter and Blumenbach see Duchesneau, "Vitalism." Lenoir, *Strategy*, chap. 1.

Chapter 4

1 Millar, "Wardrop" and the *DNB* entry by Jean Loudon are not always in agreement. Wardrop, *Essays*, 2:40 and 49; Keel, *Avènement*, 136–41; Taylor, *Nosographia*; Beer, *Praktische Beobachtungen über Augenkrankheiten*, *Praktische Beobachtungen über den grauen Staar*, and *Lehre*, quotation at 1:xi. Studies and visual representations of eye diseases from the eighteenth century would deserve a more extensive investigation.

2 Tansey and Mekie, *Museum*, 2–4.

3 Wardrop, *Essays*, 1:xiv, 2:156 and 160; Syme, *Werner's Nomenclature*. On Syme see the *DNB* entry by Lucy Dixon. Hentschel, *Visual Cultures*, chap. 11. Based on Wardrop's descriptions of the eye growth and images, the age of the patients, and its bilateral nature at times, the condition has been identified as a cancerous growth of the retina known as retinoblastoma (Kivelä, "Success"). *The London Catalogue of Books* (1822), 214.

4 Baillie, *Works*, 2:xxi–lix.

5 Wardrop, *Fungus*, vii, 69–70, 88.

6 Ibid., 2, 167; Hey, *Practical Observations*, 233.

7 Wardrop, *Fungus*, 1, 121–22; Armstrong, *Morbid Anatomy*, 21.

8 Wardrop, *Fungus*, 61, 79, 105, 112, 134, 143, 150. Mukherjee, *Emperor*, 346–47, 366–69.

9 Ibid., 25, 55, 74–80; Wardrop, *Baillie*, 1:li–lvi.

10 Wardrop, *Fungus*, 18, 70, 76, 148, 163, 174.

11 Ibid., 47–49, 193–94; Saunders, *Diseases*, 120–23, 201.

12 Wardrop, *Fungus*, 112–15.

13 Ibid., 121–22; Lemire, *Artistes*, 236. Hey, *Practical Observations*, plate VII facing page 285; Hey's plate, as reproduced in the German translation of his work, *Chirurgische Beobachtungen* (Weimar, 1823), is singled out by Goldschmid, *Entwicklung*, 253.

14 Baillie, *Engravings*, fascicle 8, figure VII.3; Wardrop, *Fungus*, 124–26.

15 Wardrop, *Fungus*, 42–43, 200–201; for timid coloring see figure 2 on plate II. On Russell see the *DNB* entry by Leon Jacyna. On E. and Edward Mitchell see the Wellcome Library catalogue. Plate II was engraved by Meadeny. For color see, for example, *Fungus*, 12, 81, 140, 175, 187.

16 Home, *Prostate*, 1:3, 16, 23.

17 The *DNB* entry by N. G. Coley makes no mention of Home's treatise on the prostate.

18 Home, *Prostate*, 1:241–42; Berkowitz, *Bell*; Biagioli, *Instruments*, 135–43. *The London Catalogue of Books* (1822), 206.

19 *The British Critic*, 1812, 39:113–17.

20 Home, *Prostate*, 1:2–14. The original essay was published in 1806.

21 Ibid., 2:5.

22 Ibid., 1:257–9 and plate VII, 2:264–5; London, Royal College of Surgeons, William Clift Papers M50007/2/2; Baillie, *Engravings*, VIII.3.

23 Home, *Prostate*, 1:251.

24 Ibid., 2:5, 173, 265–66.

25 Ibid., 2:267–69; see also 27 and 38.

26 Duffin, *Laennec*, chap. 2; Keel, *Avènement*, 191–248.

27 Roederer and Wagler, *Morbo*; Pinel, *Nosographie*, 1:55–64 and 160; Keel, *Avénement*, 23; Duffin, *Laennec*, 28–9, 48–49, 63–65.

28 Cunningham, "Sydenham"; Martin, "Sauvages"; Grmek, "Morgagni," citation at 178; Duffin, *Laennec*, 44–46; Cullen, *Works*, 1:423, 435, 457–58; Bynum, *Science*, 30, and "Nosology"; Kendell, "Cullen," 221–22; Faber, *Nosography*, chaps. 1–2; DeLacy, "Nosology."

29 Duffin, *Laennec*, 37–40, 65–70; Risse, "Sintesi," 326–33; Forbes in Laennec, *Chest*, 423; Rey, "Phtisie," esp. 193, 195; Bright, *Reports*, 1:148. See also chapter 3 above. Keel, *Avénement*, 166–67n22.

30 Duffin, *Laennec*, 397–405 lists Laennec's publications; see also 36, 70–73. Laennec, *Auscultation*, 312–23; Forbes in Laennec, *Chest*, 425–26.

31 Duffin, *Laennec*, 98–101, 162–63, 180–83, 266–67.

32 Ibid., 108–34, 211.

33 Ibid., 243–47.

34 Ibid., part 2, esp. 129–30, 156–58.

35 Ibid., 32–33; but see also Keel, *Avènement*, 179–248.

36 Duffin, *Laennec*, 157–58; Jacyna, "Transformation," 42–43.

37 Laennec, *Auscultation*, xxxviii, 226–28, and *Explication des planches*; Duffin, *Laennec*,

143–44; Baillie, *Morbid Anatomy*, 1793, 51; Attwood, "Clift's Copy," 11.

38 Laennec, *Auscultation*, 22, 33–35, 206; Duffin, *Laennec*, 156–58.

Chapter 5

1 Cruveilhier, for example, did not mention illustrated works on cutaneous diseases in the historical survey of illustrated pathological anatomy in the *avant-propos* to *Anatomie*. The study of eye diseases, as in Wardrop, may be seen in connection to the themes in this chapter.

2 Booth, "Willan"; Willan has been voted as the "dermatologist of the millennium." [Bateman], "Memoir," 504.

3 See the *DNB* entry by Deborah Brunton. Kilpatrick, "Dispensaries," 257; Cunningham, *Pathology*, 14.

4 [Bateman], "Memoir," 511; *Monthly Epitome and Catalogue of New Publications* 2 (1798): 127; *Critical Review, or Annals of Literature* 7 (1807): 140–48; *Monthly Review, or Literary Journal* 59 (1809): 416–20. *The London Catalogue of Books* (1822), 214.

5 Ehring, *Hautkrankheiten*, 66–73; Willan, *Cutaneous Diseases*, 6. A posthumous addition to Willan's work on *Porrigo and Impetigo* was edited by Ashby Smith.

6 Plenck, *Doctrina*, 5–6, 14; Pusey, *Dermatology*, 56–58; Holubar and Frankl, "Plenck," 329; Ehring, *Hautkrankheiten*, 14–15.

7 Dann, "Abbildung," 33; Bateman, *Synopsis*, xi–xii; Rayer, *Traité* (1826), xi–xii; Tilles and Wallach, "Nosologie," 16.

8 Willan, *Cutaneous Diseases*, 15–16; Bateman, *Synopsis*, xi. Ehring, *Hautkrankheiten*, 66–73; his claim at 66 that Willan did not mention Plenck is inaccurate.

9 Behrend, *Hautkrankheiten*, 17, plate I; Ehring, *Hautkrankheiten*, 91–93 and figure 54.

10 Sauvages, *Nosologia*, edited by Daniel, includes sixteen plates; plates VIII, IX, and X are taken from plates in works by Herrmann, *De osteosteatomate*, and Knolle, *De carie*. Ehring, *Hautkrankheiten*, 64–65.

11 Beswick, *Willan*, 353.

12 [Bateman], "Memoir," 512; Christie, "Pemphigus," 367, cited in Dann, "Abbildung," 8.

13 Willan, *Cutaneous Diseases*, x.

14 On Edwards (1768–1819) see the entry in the *DNB* by Raymand B. Davies. Nissen, *Botanische Buchillustration*, vol. 1:120–21. Edwards also signed three plates in Bateman, *Delineations*; they were probably executed for Willan. Although at times he also engraved the plates, no plate in Willan's or Bateman's work is marked as having been engraved by him.

15 On Strutt and Darton see the *DNB* entries by Jennifer Harris and Gillian Avery. Both father (1755–1819) and son (1781–1854) were named William Darton. Willan's manuscript is among Bateman's papers, Royal College of Physicians, London, Ms 748, f. 106. Bateman, *Delineations*, plate XLIII, XLIV; both were engraved by John Stewart.

16 Thieme-Becker, *Lexicon*; Ehring, *Hautkrankheiten*, 73.

17 Ehring, *Hautkrankheiten*, 74–75; Bell, *System*, *Engravings*, *Essays*, and *Anatomy*.

18 Information on the cost of Bateman's work is from an October 1831 advertisement brochure by Longman, Rees, Orme, Brown & Green, where most illustrated books are in the range of a few pounds and do not even get close to ten. An edition of Saunders, *Treatise on Some Practical Points Relating to the Diseases of the Eye* (1816) went for 14 shillings plain and 1 pound 5 shillings with colored plates; colored plates roughly double the cost of the book. Anthony Todd Thomson, *Atlas of Delineations of Cutaneous Eruptions* (1829), illustrating Bateman's system, in royal octavo, with twenty-nine colored plates, went for 3 pounds 3 shillings; Wardrop's *Life and Works of Dr. Baillie's* (1825), 2 volumes in octavo, went for 1 pound 5 shillings.

19 Thomson, *Atlas*, v–vi. On John Stewart Jr. (1800–66) see Thieme, *Lexicon*.

20 Bateman, *Delineations*, plate VI; Beswick, "Willan," 363–65; Ehring, *Hautkrankheiten*, 74–75.

21 Bateman, *Abbildungen*.

22 Willan, *Cutaneous Diseases*, x, plates I and XXIII; Thieme, *Lexicon*.

23 Bateman, *Delineations*, plate XLVIII; Calvert, "Account"; Rayer, *Traité* (1826), xxiv. Thomson, *Atlas*, plate Y. His method closely resembles that of Renaissance botanical illustrations in Leonhard Fuchs, *Historia stirpium* (1542), which included images of plants a naturalist could never see in nature, since he juxtaposed different stages of growth that do not occur at the same time. On Thomson and his son see the *DNB* entry by P. W. J. Bartrip. Saunders, *Plants*, 22, 27.

24 Bateman, *Delineations*, plate LX; Bateman, RCP, Ms 159, f. 38.

25 Bateman, *Delineations*, plate LXIX.

26 Bersaques, "Tilesius." Martens claimed to be both "Artz und Künstler." Ehring, *Hautkrankheiten*, 110–15. In 1804 Martens obtained a position at Jena University and in 1805 was promoted to a medical chair, but he died only a few months later. Kästner and Hahn, "Freundschaft," 232–33, 233–38; Tilesius, *Pathologia*, 19.

27 Tilesius, *Pathologia*, 27. Tilesius, *Porcupineman*, iii–vi; at v he states that he relied on the "Geissler'schen Illuminierschule," and thus the claim by Ehring, *Hautkrankheiten*, 113, that Tilesius was responsible for the coloring is incorrect. Bersaques, "Tilesius," 566. Previously J. Machin and Henry Baker had published accounts and images of the father of the brothers seen by Tilesius in the *Philosophical Transactions* for 1731 and 1755.

28 Mendelsohn, *Paragoni*; Lichtenstein, *Spot*; Chadarevian and Hopwood, *Models*.

29 Tilesius, *Pathologia*, 1–3; Keel, *Avénement*, 136–41.

30 Tilesius, *Pathologia*, 3–4, 11.

31 Ibid., 14.

32 Ibid., 6, 11–14.

33 Ibid., 14–17.

34 Le Minor, "Bertrand," esp. 281–82. Bertrand-Rival, *Précis*, 222–381; Bertrand added his maternal last name to his paternal one. Tilesius, *Pathologia*, 22–25; Isenflamm and

Rosenmüller, *Zergliederungskunst*, 1:146–52; Lemire, *Artistes*, 232–33, 245.

35 Tilesius, *Pathologia*, 17–22.

36 Ibid., 25–28; Martens, *Icones*, preface.

37 Tilesius, *Beschreibung*; Ehring, *Hautkrankheiten*, 110–15.

38 Alibert, *Nosologie*, vol. 1, and *Description*, 1:ix, xlvii–xlviii; Jacyna, "Alibert," 190; Brodier, *Alibert*, 9–10; Dahm, *Krankenbildnisse*, 12.

39 Alibert, *Précis théorique et pratique sur les maladies de la peau* (Paris, 1810).

40 Brodier, *Alibert*, 1, 13, 62n2; Ehring, *Hautkrankheiten*, 24; Alibert, *Description*, 1:ix, xxvii; Williams, *Physical*, 122–34.

41 Alibert, *Nosologie*, ii–iii; Jacyna, "Alibert," 215n2; Blunt and Stearn, *Art*, chap. 14; Brodier, *Alibert*, 62–3; Dahm, *Krankenbildnisse*, 42.

42 Cazenave and Schedel, *Abrégé*, plate I; Ehring, *Hautkrankheiten*, 88–89; Thieme-Becker, *Lexicon*.

43 Alibert, *Nosologie*, dedication and 1:vii–lxxxiii, at lxxx; Brodier, *Alibert*, 93; Stolberg, "Cancer," 57, 68.

44 Brodier, *Alibert*, 2n1; Dahm, *Krankenbildnisse*, 54, 57; Niss, *Botanische Buchillustration*; Louis de Freycinet, *Voyage autour du monde* (Paris, 1824–44); *Journal général de la littérature de France* (Paris, 1832), 140.

45 Théodoridés, *Rayer*, 37–39, 79–81.

46 Ibid., 33, 43–73, 119–22; Berry, "Rayer."

47 Berry, "Rayer"; Théodoridés, *Rayer*, 117–54.

48 On Prêtre (1769–after 1826) and Forestier (1789–after 1831) see Nissen, *Botanische Buchillustration, Zoologische Buchillustration, Vogelbücher*. Prêtre drew plates for Louis Pierre Vieillot, *Histoire naturelle des plus beaux oiseaux chanteurs de la zone torride* (Paris, 1805) and François-Richard de Tussac, *Flore des Antilles* (Paris, 1808–27), which included also works by Redouté. In the preface to *Traité* (1826), 1:xliv, Rayer attributes the engravings to Forestier and Langlois, though all the plates are signed by the former and none by the latter.

49 Rayer, *Traité* (1835), *Atlas*, preliminary matter and 11.

50 Théodoridés, *Rayer*, 128, 176; on Rayer and Tardieu son (1818–1879) see 210–11. Rayer, *Traité* (1835), *Atlas*, 10–11. On Tardieu father (1788–1841) see Thieme, *Lexicon*.

51 Rayer, *Traité* (1835), *Atlas*, 9–10.

52 Alexis Jacquart, *Quelques aperçus pour servir à l'histoire de l'organe connu sous le nom d'appareil folliculaire intestinal* (Paris, 1839). Henri Jacquart was also a medical student who completed his MD in 1845; both collaborated as engravers of a *Traité de chirurgie plastique accompagné d'un atlas in-folio de 18 planches gravées et coloriées* (Paris, 1849). My attribution is based on the closeness of the dates. *Catalogue générale des livres qui se trouvent chez J. L. Ballière*, Paris, Ballière, January 1647, 41.

53 Nissen, *Vogelbücher*, sub indice. Oudet produced many ornithological engravings, such as those for René Primevère Lesson, *Les trochilidées ou les colibris et les oiseaux-mouches* (Paris, 1832–33), and later for George Cuvier, *Le règne animal* (Paris, 1836–49), for the stunning Laurent Berlese, *Iconographie du genre camellia* (Paris, 1841–43), and for François Leuret and Pierre Gratiolet, *Anatomie comparée du système nerveux* (Paris, 1839–57).

54 Alibert, *Nosologie*, iii; Dahm, *Krankenbildnisse*, 9–96, at 59; Jacyna, "Alibert"; Ehring, *Hautkrankheiten*, 97–109; Alibert, *Description*, xiv.

55 Alibert, *Nosologie*, dedication; 334 and plate B facing page 336; plates are identified by letters of the alphabet, starting from A in each section. Dahm, *Krankenbildnisse*, 64–65; Ehring, *Hautkrankheiten*, 104; Jacyna, "Alibert"; Ott, "Contagion."

56 Alibert, *Nosologie*, 511–12; Dahm, *Krankenbildnisse*, 26–27, 94.

57 Brodier, *Alibert*, 39, 72; Alibert, *Nosologie*, plate K facing page 554.

58 Alibert, *Nosologie*, avertissement, I, and *Description*, vi; Rayer, *Traité* (1826), xii; Tilles and Wallach, "Nosologie," 11.

59 Rayer, *Tratité* (1835), 1:xxxviii–xxxix; Brodier,

Alibert, 131, 136n1, 180–82; Stafford, *Body*, 300–305; Alibert, *Monographie*, xli and xliv–xlv.

60 Cazenave and Schedel, *Abrégé* (1828), 493; Brodier, *Alibert*, 25; Ehring, *Hautkrankheiten*, 99 and plate 60; Dahm, *Krankenbildnisse*, 44–45, 52 and note 27; Wallach and Tillès, "Rayer."

61 Rayer, *Traité* (1826), xxiv–xxv. Plate XVIII in Bateman, *Delineations*, showing "Ichthyosis facici," is explicitly modeled on Alibert.

62 Rayer, *Traité* (1826), 1:xxvi; Brodier, *Alibert*, 11n2.

Chapter 6

1 Cruveilhier, *Anatomie patholgique*, 1:vi–vii.

2 Long, *Pathology*; Gilman, *Disease*; Maulitz, *Morbid Appearances*.

3 Secord, "Botany"; Dolan, "Pedagogy"; Rudwick, "Emergence" and *Bursting*. Alibert, however, did not have a strictly medical audience in mind for his work on diseases of the skin (Jacyna, "Pious Pathology," 213).

4 Ackerknecht, *Medicine*; Foucaut, *Birth*; Maulitz, *Appearances*; Brockliss, "Clinic"; Keel, *Avènement*, 75–90.

5 Preface by Farre in Saunders, *Diseases of the Eye*, vi; Farre, *Liver*, 2–3; Farre, *Apology*, 5–6. Farre, *Journal*, xiin. Maulitz, *Appearances*, chap. 8, 189; Maulitz, 186n43, disagrees with the *DNB* entry revised by Hugh Series as to the place and date of Farre's MD, which Series gives as Aberdeen.

6 Farre, *Liver*, 4, 11–5; on *tubera diffusa* see 15–52. Farre, *Journal*, xiin; Maulitz, *Appearances*, 180. Information on its publication from an advertisement leaflet by Longman, dated May 1814; see also the review in the *Monthly Review*, 1815, 78:200–202. On Farre's draftsman, sometimes spelt "Thompson," who died about 1827, see Cooper, *Life*, 2:110–1; Farre, *Apology*, 5 and plate on chronic hydrocephalus; Bateman, *Delineations*, plate LX, figures 2–3. See also anonymous, review of Farre, *Morbid Anatomy*.

7 Farre, *Liver*, 4, 14. Goldschmid, *Entwicklung*, 101, identified the present lesion as metastatic cancer. Baillie, *Engravings*, 103–4;

Morgagni, *Seats*, 2:182–83; Bertoloni Meli, "Rise," 227–28 and plate 4.

8 The *DNB* entry revised by Michael Bevan makes no mention of Hooper's two chief works on the brain and uterus examined here and his award-winning treatise on intestinal worms; its plates were drawn by Henry de Bruyn and engraved by Thomas Medland. Courville, "Ancestry." Curiously, on the title page of *Intestinal Worms* and in other publications dating from before 1805, Hooper is referred to as MD, although it appears that he was not MD in 1799. Anne Hope, *Memoirs*, 64, 82. The claim in Kilpatrick, "Dispensaries," 278n49, that our Robert Hooper was a founding member of the Medical Society seems to be incorrect. See also *Memoirs of the Medical Society of London*, 1799, 5:ix. Hooper, *Uterus*, back cover.

9 Hooper's papers, Osler Library, McGill University, Ms 7574; Hooper, *Brain*, 9, 16; Hooper, *Uterus*, paper pasted on the back cover, preserved in the Osler Library copy.

10 The manuscripts by John Howship (1781–1841) can be found at the Royal College of Surgeons of England, MS0244—(FONDS), especially items 1 and 3. See for example Howship, "Experiments"; the quality of the hand-coloring in Howship's essays was inferior to that in Bright's work. Baillie, *Engravings*, tenth fascicle, plate VIII.1; Cooper, *Life*, 2:109–10. Some plates are signed J. Kirkland.

11 Charles Gold and George Kirtland, *Thirty Plates of the Small Pox and Cow Pox* (London: Kirtland, 1802); Kirtland, *Anatomical Plates of the Bones and Muscles of the Extremities of the Human Body* (London: Longman, Hurst, Rees, and Orme, 1807); *The Anatomy of the Horse* (London: S. Highley, 1815).

12 Compare plate II of the 1826 and 1828 versions at the Galter Medical Library, Northwestern University. Courville's claim in *The Ancestry of Neuropathology*, 155–56, that Hooper's 1826 plates were lithographs is inaccurate; in fact, the second 1828 edition with identical plates states that they were "coloured engravings" in the title. Probably J. Wedgwood was not John Taylor, who signed J. T. Wedgewood. The British Museum holds a painting by John Stewart (Jr.) and gives his dates as 1800–1866; Thieme, *Lexicon*, lists a landscape, genre, and portrait painter born in 1800 who exhibited in London 1828–65, consistent with our case. Thieme, *Lexicon*,

mentions an engraver John Stewart Sr. and a painter with the same name, marked Jr., who since 1812 and 1823, respectively, were members of the Society for the Management and Distribution of the Artists' Funds; they seem to coincide with our artists, and presumably they were father and son.

13 Hooper, *Brain* (1826), 27; Del Maestro, *History*, 20.

14 Hooper, *Brain* (1826), 9.

15 Hooper, *Uterus*, 1–38.

16 Ibid., preface and plate I.

17 Hooper, *Morbid Anatomy of the Human Brain*, 30; Baillie, *Engravings*, 223–25 and plate VII.

18 On Thomas Heaphy see Whitley, *Heaphy*, 30; the plates signed J. Heaphy were in all probability due to John, the brother or son of Thomas. See also the entries in the *DNB* and Theime, *Lexicon*. Hooper's paper, Osler Library, Ms 7574, boxes 1 and 2.

19 Hooper, *Uterus*, 65.

20 Fawdington, *Catalogue*, v; Alberti, *Morbid Curiosities*, 144, 164; Berkowitz, "Systems"; Duffin, *Laennec*, 62–63.

21 Fawdington, *Melanosis*, vi, and *Palatine Note-Book*, 3:53–56.

22 Fawdington, *Melanosis*, 27–29; for references to "laws" see 35, 40, 42; for Langstaff see 31–32 and Parr's lives of the Fellows of the Royal College of England Online, accessed July 15, 2013 (http://livesonline.rcseng.ac.uk/biogs/E000481b.htm); Alberti, *Morbid Curiosities*, 77, 133.

23 Fawdington, *Melanosis*, 45–46.

24 Ibid., 1–2, 40. The allusion to Carswell may be at 2: "Besides three or four cases recently published under its appropriate designation."

25 On Cooper see the *DNB* entry by William F. Bynum. Bransby Blake Cooper, *Life*; Wilks and Bettany, *Guy's*, 317–29. The second edition of Cooper, *Hernia*, sold for 5*l* 5*s*.

26 Peitzman, "Bright's Disease." Hodgkin is discussed briefly in the next chapter. Addison's work on the *Supra-Renal Capsules* appeared only after midcentury.

27 Berry and Mackenzie, *Bright*, 65–66, 112, 118, 150.

28 Ibid., 73–74, 77, 89–90, 101, 109; Schnalke, *Diseases*, 39–48; Bright, *Travels*, 84–88, 272–73.

29 Berry and Mackenzie, *Bright*, 3, 88, 228. Bright's collection was auctioned at Sotheby's in 1918 by his son the Reverend James Franck Bright, *Catalogue of Engravings by the Old Masters*; although the title is somewhat ambiguous, I suspect the additional sentence "And from the Collection of the Late Dr. Richard Bright, M.D." means that the collection was largely his. See especially lot 161 and Rodari, *Anatomie*, 66 and plate XXXXVI.

30 Berry and Mackenzie, *Bright*, 70, 104–5, 184–85.

31 See the entry in the *DNB* by Diana Berry.

32 Bright, *Reports*, vol. 1, plate XII; vol. 2:vii–viii and xi. Plate XXXVIII of vol. 2 shows "Mrs M.'s" uterus in a case of nymphomania; her case is described at 464–67. Berry and Mackenzie, *Bright*, 137, 141, 149; Young and Kark, "Bright."

33 Berkowitz, "Beauty," 265–66; Cummings, "Haydon," 379n; Berry and Mackenzie, *Bright*, 149; [Johnson], review of Bright, *Reports*, 91n. On William and Frederick Richard Say see the entry in the *DNB* by B. Hunnisett. Peitzman, *Bright's Disease*, 311–12.

34 Bright's papers, London, Royal College of Physicians, Ms 974, ff. 51, 56c, 59 are dated 1825. Blunt and Stearn, *Botanical Illustration*, 202. See for example British Museum, Prints and Drawings, registration numbers 1852, 1009.1236; 1852, 1009.1441; 1852, 1009.1426. Say printed several floral subjects; those prints are almost invariably accompanied by delineations printed in black ink and left uncolored. No such corresponding plates exist for the pathological illustrations. On Hooker see the *DNB* entry by Sylvia FitzGerald.

35 Hodgkin, *Catalogue*, vi–vii. Wilks and Bettany, *Guy's Hospital*, 414–19; Canton was succeeded by William Hurst. Blunt and Stearn, *Art*, 224–25; Meynell, "Bauer," 209, 214; Berkowitz, "Systems." On Towne and Scharf see the *DNB* entries by John Maynard and Peter Jackson.

36 Fine, "Specimens"; Bright, *Reports*, vol. 2, plates XIII, XX, and XXXVIII; Cooper, *Dislo-*

cations; Dolan, "Pedagogy," 300; Prideaux, *Aquatint*, 359; Blake Cooper, *Cooper*, 2:111-2, 316-8.

37 Peitzman, "Bright's Disease", 313. Bright, *Reports*, vol. 2, plate XXXII.

38 Peitzman, "Bright's Disease"; *Dropsy*, 24-40, 45-54; Bright, *Reports*, 1:viii and 1:70-4; Rayer, *Nephritis*.

39 Bright, *Reports*, 67-70, 148-52.

40 Ibid., 1:12-4 and plate II. Figure 4 (bottom right) is from a different patient with a similar condition.

41 Ibid., 1:5-10, 33-37, 68-69, and plates I and V.

42 Ibid., 1:20-22, 68-69.

43 Ibid., vol. 1, plates VIII (figure 1) and X, and vol. 2, plate VII (figure 2).

44 Ibid., vol. 1, plate IV (figure 3) and plate V (figure 3), and vol. 2, plate IX (figure 2). The preserved specimen is in plate VII, vol. 1.

45 Ibid., vol. 1, plate IV, figures 4 and 5.

46 Ibid., vol. 1, plate XV (figures 3 and 4), vol. 2, plate VI (figure 2), plate XIX (figure 1), and plate XXXVIII.

47 Ibid., vol. 1, plate XIII (figure 3) and plate XV (figures 3 and 4).

48 Ibid., 2:308-12, quotation at 308, and plate XXV.

49 Cooper, *Breast*, sold for 1*l* 11*s* 6*d*.

50 Cooper, *Testis*, 226-31, part 2, plates X.2 and XII.3.

51 Ibid., 79-90, at 82 and 87-8, and part 2, plate III.1.

52 Boott, *Armstrong*, especially 5, 89. See the *DNB* entry by Anita McConnell.

53 Biographical entry from the Royal College of Surgeons, accessed July 20, 2011, http://livesonline.rcseng.ac.uk/biogs/E000411b.htm; Adrian James, assistant librarian to the Society of Antiquaries, personal communication; Pettigrew, *Gallery*, 3:1-18. Annesley, *Sketches*, 393-97, included three illustrations showing that the effect of calomel on the intestine of dogs, which were used for therapeutic experimentation, was to decrease vascularity and therefore inflammation; the first two were lithographs by G. Scharf, while the third was engraved by John Stewart.

54 Annesley, *Researches*, ix, xi, xvi, plates XIV (nine hours) and XXIV (1 hour). In Bright's second volume of reports most cases are not identified by the patient's name, though often the name appears in the case history.

55 Armstrong, *Anatomy*, 1, 21, 23, 71; Rosenfeld, *Hodgkin*, 45-47, 67-71.

56 Hooper's papers, Osler Library, Ms 7574, box 4, Diseases of the Lungs, f. 5; presumably "Dr. Farr" was John Richard Farre. Among the many watercolors dated 1802, one due to J. Kirkland appeared as plate XXI in the *Uterus* volume. Cooper, *Life*, 2:110-1; Annesley, *Researches* (1855), 29n.

57 Annesley, *Researches*, vii-x. On the Neele family of engravers active in London see Thieme, *Allgemeines Lexicon*; Mackenzie, *British Prints*. On Basire (1796-1869) see entry by Lucy Pelts in the *DNB*. Information on the price of Annelsey's work is from a Longman's catalogue dated October 1831. Annesley, *Researches* (1841[2]), v, 29-31; Cruveilhier, *Anatomie*, 1:iv; [Johnson], review of James Annesley, *Researches*, 12:409, quotation at 13:337. On James Johnson see the *DNB* entry revised by Mark Harrison.

58 On the Fairland brothers see the *DNB* entry by Michael Twyman. Thieme, *Lexicon*. Compare the uncolored copy of Armstrong's work at the Regenstein Library at the University of Chicago. [Johnson], review of Armstrong, *Anatomy*, *MCR* 14:118, 123. For the respective prices see the *Edinburgh Review* 48 (1828): 536.

59 Annesley, *Researches*, 1:563-66.

60 Ibid., 1:544-46 and plate XII.

61 Armstrong, *Anatomy*, 5, 10, 21, 73-74.

62 Compare the copy at the Ebling Library, Madison, Wisconsin.

63 Bright, *Reports*, vii.

64 Hodgkin, *Catalogue*.

65 Dolan, "Pedagogy."

66 Froriep, *Klinische* and *Chirurgische*; Albers, *Atlas*. The Lilly Library copy of Bright, *Reports*, for example, stems from the Newcastle Infirmary Medical Library; the copy of Hooper's 1826 *Human Brain* at the Galter Library, Northwestern University, and that of Armstrong, *Bowels*, at the Lilly Library, stem both from the Birmingham Medical Institute; the copy of Farre's *Morbid Anatomy* at the Galter Library stems from the Manchester Infirmary, while that at the Lilly Library stems from the Royal College of Surgeons in Ireland.

67 See the *DNB* entry by Diana Berry.

68 Hooper, *Brain*, preface; Maulitz, *Appearances*, 135, 139; [Johnston], review of Armstrong, 107.

Chapter 7

1 Goldschmid, *Abbildung*, 131–32, 134–35, 146–47, 156.

2 Delestre, *Iconographie*, 2; Duffin, "Laennec and Broussais"; Théodoridès, *Rayer*, 39–41.

3 I do not discuss here the less ambitious Money, *Vade-mecum*, which nonetheless testifies to the growth of the field.

4 On several instances figures in these works have been identified as early or even the first representations of specific diseases. See for example Compston, *Sclerosis*, 7–12.

5 Delhoume, *Dupuytren*, 64; Lemire, *Artistes*, 325–34. See the entry in the *DSB* by Pierre Huard.

6 Anne Hope, *Memoirs*, 22–24, 30, 32–34. On Anne Hope see the entry in the *DNB*, revised by Rosemary Mitchell. Duffin, *Laennec*, 17, 80–81, 380n6.

7 See the *DNB* entry revised by Louis J. Acierno. Anne Hope, *Memoir*, 82–83; Hope, *Principles and Illustrations*, iv.

8 The *DNB* entry on Carswell by Andrew Hull is quite brief and does not cite Reckert, *Carswell*; on Carswell's early artistic training see p. 48. On Schetky see the *DNB* entry by Charlotte Yeldham. Carswell, *Pathological Anatomy*, dedication. Crawfurd and Robertson, *Renfrew*, includes two plates based on drawings by Carswell, facing 28 and 44.

9 Maulitz, *Appearances*, 146, 215–16, 252n37; Berkowitz, *Bell*, chap. 4.

10 Cruveilhier, *Anatomie pathologique*, 1:i, vi; book 2, plate VI, fig. 5.

11 Cruveilhier, *Anatomie pathologique*, list of subscribers and vii; Cruveilhier, *Anatomia patologica del corpo umano* (Florence, 1837–43), translated by Pietro Banchelli; *Catalogue générale des livres qui se trouvent chez J.L. Ballière* (Paris, Ballière, January 1647), 14; *Foreign Quarterly Review* 4 (1929): 699, 23 (1939): 233.

12 Galison and Daston, *Objectivity*, 82–83, 108, identify Cruveilhier's artist as André Chazal, Antoine's younger brother. André, however, was condemned to twenty years of forced labor in 1839, while *Anatomie pathologique* was being produced, for attempted uxoricide, his wife Flora Tristan being initially a colorist in his atelier (Puech, *Tristan*, 10-1, 98). Further, Cruveilhier states that Chazal had illustrated anatomical works, which corresponds to Antoine's biography: Jacques Pierre Maygrier, *Nouvelles démonstrations d'accouchemens* (Paris, 1822-27); Alfred Velpeau, *Traité d'anatomie chirurgicale* (Paris, 1825-26); Gilbert Beschet, *Considérations sur une altération organique appelée dégénérescence noire* (Paris, 1821). We now have an extensive biography of Antoine (1793-1854), listing his production year by year, including all his works for Cruveilhier: Nusbaumer, *Chazal*, 24-25, 25-27, 35-37, 623. Cruveilhier, "Histoire," 46, 75.

13 Cruveilhier, *Anatomie pathologique*, 1:vii.

14 Cruveilhier, *Anatomie*, installment III plate 6 and VII.1 are engravings based on Chazal's drawings—the latter was also engraved by him. Cruveilhier, *Anatomie pathologique*, 1:iii, vii. Goldschmid, *Abbildung*, 137-39, at 138, interprets the passage as referring to Albinus and Wandelaar, though it is possible that Cruveilhier was referring to Delfos and Sandifort.

15 Cruveilhier, *Anatomie pathologique*, 1:v; Lemire, *Artistes*, 233-44.

16 Anne Hope, *Memoirs*, 40-21; Jacyna, "Chomel," 425; Maulitz, "Clinic," 136. Hope, *Principles*, iii, figures 18, 115, 180, 240, 246, 247, and page 40; figures 30, 50, 81, and 103 relied on drawings by William Pulteney Alison, physician in Edinburgh. Hope's work had two American editions in color.

17 Anne Hope, *Memoirs*, 90–91; Hope, *Principles*, 58; [Johnson], review of Hope, *Principles*.

18 Reckert, *Carswell*, reproduces many portraits; see especially 44–47, at 45, and Reckert, *Carswell*, figure 47 and Carswell, *Pathological Anatomy*, analogous tissue, plate IV, figure 7. Fend, "Diseases."

19 [Johnston], review of Jean Cruveilhier, *Anatomie pathologique*, fascicles XV and XVI, and Robert Carswell, *Pathological Anatomy*, "Carcinoma," 137. See figure 1 in plate II of the section on inflammation.

20 See the *DNB* entry on Louis Haghe by Michael Twyman.

21 Cruveilhier, *Anatomie pathologique*, ii. The pagination of Cruveilhier's treatise is confusing; not only do different installments have separate pagination, but also their subsections associated with each plate are numbered separately. I refer to the installment and plate, followed by the page number: I, plates 1–2, pages 3–4; VII, plates 1–4, pages 15–16; see his *Table méthodique*. Pierre Louis called Cruveilhier's "acute follicular enteritis" "typhoid fever."

22 Cruveilhier, *Anatomie pathologique*, 1;v; installment XI, plates 1–3, pages 4–8; installment XXVII, plate 5, pages 3–4, for examples on phlebitis. Delhoume, *Dupuytren*, 178–84; Lesch, "Paris," 113–15.

23 Cruveilhier, "Histoire," 45, 76–77; on Bichat see the *Table analytique*. Maulitz, *Appearances*, 37, 137, 216. Keel has devoted extensive works to Bichat; see *Avènement* and his works cited therein.

24 Flamm, "Neurology"; Goldschmid, *Entwicklung*, 138. Cruveilhier's principle is referred to at I.4, page 3, and IV.1, pages 2–3. For references to magnification see I.5, p. 6; II.1, p. 3; IV.1, page 2.

25 Cruveilhier, *Anatomie pathologique*, I.6 and XL.6. See also the index under "Conformation," "Monstres," "Monstruosités," "Vices de conformation," and also under "Foetus," with several subentries, such as "Monstruosités" and "Vices de conformation."

26 Cruveilhier, *Anatomie pathologique*, X.3 and 4, pages 1–6, especially 6.

27 Ibid., XIX.1, pages 1–2.

28 Ibid., XIV, pages 1, 45; Hamlin, *Cholera*.

29 Cruveilhier, *Anatomie pathologique*, XIV, pages 27–28.

30 Ibid., XXII.1, pages 1–3. See also XXXII.3 and 4 and XXXIX.5, figures 4, 4", 4". Engelmann, "Bildpraxis." On Cruveilhier's cancer theory see IV.1, page 3; XXIII.6, pages 3–4; XXVII.2, page 2. Delhoume, *Dupuytren*, 177–78; Ménétrier, "Cruveilhier," 215.

31 Cruveilhier, *Anatomie pathologique*, XXXIV.4 and 5, pages 1–4, at 1; Hannaway and La Berge, *Paris, ad indicem*; Lesch, *Science*. Compare also illustration 2.4 above for a seemingly similar condition affecting the pelvis.

32 Hope, *Principles*, ii–iii, 1; Andral, *Précis*.

33 Anne Hope, *Memoirs*, 34; Hope, *Principles*, 58, xiv.

34 Hope, *Principles*, 8, and description of the plates, vi; [Johnson], review of Hope, *Principles*, 285.

35 Hope, *Principles*, description of the plates, xxi–xxii; *Treatise*, 564–65.

36 Hodgkin, "Appearances," 89–90; Maulitz, *Appearances*, 218. For another reference to drawings shown at a lecture see Hodgkin, *Lectures*, 211–12.

37 New Sydenham Society, *Atlas*, fascicle 12; Dawson, "Illustrations"; Rosenfeld, *Hodgkin*, 71–74; Hodgkin, *Lectures*, vii–ix, 385; UCL, Carswell papers, box 4, B 50.

38 Warner, "American Doctors," 354–35; Clarke, *Recollections*, 321–22.

39 Carswell, *Pathological Anatomy*, unnumbered pages; the relevant passage is on the last page of the first installment on carcinoma.

40 Carswell, *Pathological Anatomy*, tubercle, plate I, figure 1; the pages with the introductory matter are not numbered. Hope, *Principles*, 25; Reckert, *Carswell*, 40–44.

41 Carswell, *Pathological Anatomy*, "Melanoma," figure I.2.

42 Ibid., figure I.3.

43 Ibid., figures I.1 and I.5.

44 Carswell, "Inquiry"; *Pathological Anatomy*, [page 10], fascicle on carcinoma.

Concluding Remarks

1 Baillie, *Morbid Anatomy*, vii; Cruveilhier, "Histoire," 43; Peyer, *Methodus*, 1–2; Stolberg, "Bedside Teaching."

2 Cruveilhier, "Histoire," 45, 75–78; Bichat, *Anatomie générale*, 1:lxxxv–xcix; Haigh, *Bichat*, 120–22; Maulitz, *Appearances*, 27–31. For Keel on Bichat see *Avènement* and his works cited therein.

3 Baillie, *Morbid Anatomy*, i; Cruveilhier "Histoire," 44–45.

4 See chapter 1 in this volume and Bertoloni Meli, "Visual Representations," 174.

5 Berkowitz, "Systems"; Alberti, *Morbid Curiosities*.

6 Goldschmid, *Abbildung*; Boeckl, *Plague*; *Leprosy*; Jacyna, "Pious Pathology"; Ehring, *Skin Diseases*; Reckert, *Carswell*; Vogt, *Bild*; Palfreyman, *Disease*; Conforti, "Illustrating Pathologies."

7 Willan, *Cutaneous Diseases*, x; Baillie, *Engravings*, 4–5.

8 Sappol, *Dream*; Kemp, "Truth" and "Style."

9 Alpers, *Describing*; Bertoloni Meli, "Blasius."

10 Kemp, "Mark" and "Style."

11 Goldschmid, *Entwicklung* and Ehring, *Hautkrankheiten* provide indices of artists.

12 John Bell, *Engravings*, vi–vii; Berkowitz, *Bell*, 68; [Johnson], review of Bright, *Reports*, 91n, and of Armstrong, *Morbid Anatomy*, 118, 123; Cruveilhier, *Anatomie*, v; Cooper, *Testis*, 82; Hendriksen, *Anatomy*.

13 Parshall, "Imago"; Kemp, "Truth"; Kusukawa, *Book*; Daston and Galison, *Objectivity*, especially 82, 370–71 (quotation at 370).

14 Sandifort, *Museum*, 1:vi; Hooper, *Brain*, preface.

15 Goldschmid, *Entwicklung*, 138; Pang, "Representations"; Jordanova, "Representation"; Jardine, "Anachronism."

16 On peritonitis see Keel, *Avènement*, 290–92; Baillie, *Morbid Anatomy*, 77–80.

17 Froriep, *Klinische* and *Chirurgische*; his illustrations of cutaneous diseases are part of the *Chirurgische Kupfertafeln*.

18 Hooper, *Brain*, 9; Sandifort, *Museum*, v; Maulitz, *Morbid Appearances*, 216; Cruveilhier, *Anatomie pathologique*, 1:i–ii; Armstrong, *Morbid Anatomy*, 4; Froriep, *Klinische* and *Chirurgische*; Albers, *Atlas*.

19 Hodgkin, "Morbid Appearances," 89–90; New Sydenham Society, "Atlas."

20 Cruveilhier, *Anatomie pathologique*, XXXIV.4–5, pages 1 and 4.

21 Cruveilhier, *Anatomie pathologique*, 1:v. A few years later, Daremberg, *Médecine*, 302, praised Lebert above all others. Following Lebert, he mentioned Ruysch and Baillie but claimed that pathological illustration grew to maturity with Cruveilhier and Rayer. Dolan, "Pedagogy"; Roberts and Tomlinson, *Fabric*, 530–33 and plate 112.

22 Maulitz, *Appearances*; Warner, "American Doctors"; Berkowitz, *Bell*, chap. 4.

BIBLIOGRAPHY

MANUSCRIPT SOURCES

Baillie, Matthew. RCP, MS 103. Preparatory delineations by William Clift for *A Series of Engravings*.

Bateman, Thomas. RCP, MS 159; MS 748. Preparatory delineations by different artists of skin diseases, many of which were included in Willan, *Cutaneous Disease*, and Bateman, *Delineations*.

Bright, Richard. RCP, MS 974. Preparatory delineations by different artists of several diseased organs, many of which were included in *Reports*.

Carswell, Robert. London, University College, MS 304. Watercolors, mostly by Carswell, many of which were printed in *Pathological Anatomy*.

Cheselden, William. London, Royal Academy. Preliminary drawings for *Osteographia*.

Fabricius Hildanus, Guilhelmus. Basel, Universitätsbibliothek. Miscellaneous correspondence with Caspar Bauhin and Jacob Zwinger.

———. Bern, Burgerbibliothek, MS 669, MSS 495–97.

Home, Everard. London, Royal College of Surgeons, MS M50007/2/2. Preparatory delineations by William Clift for *Practical Observations*.

Hooper, Robert. Montreal, Osler Library, McGill University, MS 7574. Preliminary delineations and printing proofs of *The Morbid Anatomy of the Human Brain* and *The Morbid Anatomy of the Human Uterus*. Preliminary delineations pertaining to (3) The Alimentary System; (4) The Respiratory System; (5) The Heart; (6) The Urinary System & Miscellanea.

Howship, John. London, Royal College of Surgeons, MS 0244. Miscellaneous papers.

Sandifort, Eduard. Leiden, University Library. Preliminary drawings for *Museum anatomicum*, BPL 309.

Addison, Thomas. *On the Constitutional and Local Effects of Disease of the Supra-Renal Capsules.* London: Samuel Highley, 1855.

Albers, Johann F. H. *Atlas der pathologischen Anatomie für praktische Aerzte.* 4 vols. Bonn: Henry und Cohen, 1841–62.

Albinus, Bernhard Siegfried. *Academicarum annotationum libri.* 8 vols. Leiden: J. & H. Verbeek, 1754–68.

——. *Tabulae ossium humanorum.* Leiden: Johann & Hermann Verbeek, 1753.

——. *Tabulae sceleti et musculorum corporis humani.* Leiden: Johann & Hermann Verbeek, 1747.

Alibert, Jean-Louis-Marie. *Clinique de l'Hôpital Saint-Louis, ou, traité complet des maladies de la peau, contenant la description de ces maladies et leurs meilleurs modes de traitement.* Paris: B. Cormon et Blanc, 1833.

——. *Description des maladies de la peau, observée à l'Hôpital Saint-Louis.* 2 vols. Bruxelles: Wahlen, 1825².

——. *Monographie des dermatoses: ou, précis théorique et pratiques des maladies de la peau.* Paris: Daynac, 1832.

——. *Nosologie naturelle, ou les maladies du corps humain distribuée par familles.* Vol. 1 [no further volumes published]. Paris: Crapelet, 1817.

Andral, Gabriel. *Précis d'anatomie pathologique.* 2 vols. Paris: Gabon, 1829. English translation by Richard Townsend and William West, *A Treatise on Pathological Anatomy*, 2 vols, Dublin: Hodges and Smith, 1829–31.

Anonymous. *The Palatine Note-Book for 1883.* Manchester: J. E. Cornish, [1883].

——. Review of John Richard Farre, *The Morbid Anatomy of the Liver.* EMSJ 9 (1813): 97–105.

——. Review of Thomas Hodgkin, *A Catalogue of the Preparations in the Anatomical Museum at Guy's Hospital* (London: Highley, 1829), and *Descriptive Catalogue of the Anatomical Museum at the University of Edinburgh* (Edinburgh, 1829).*EMSJ* 33 (1830): 391–405.

Annesley, James. *Researches into the Causes, Nature and Treatment of the More Prevalent Diseases of India, and of Warm Climates Generally.* 2 vols. London: Longman, Rees, Orme, Brown, and Green, 1828. Later editions in reduced form without plates appeared in 1841 and 1855.

——. *Sketches of the Most Prevalent Diseases of India: Comprising a Treatise on the Epidemic Cholera of the East.* London: Underwood, 1825.

Armstrong, John. *The Morbid Anatomy of the Bowels, Liver, and Stomach.* London: Baldwin and Cradock, 1828–29.

Baker, Henry. "A Supplement to the Account of a Distempered Skin." *PT* 49 (1755): 21–24.

Baillie, Matthew. "An Account of a Particular Change of Structure in the Human Ovarium." *PT* 79 (1798): 71–78.

——. "An Account of a Remarkable Transposition in the Viscera." *PT*

78(1788): 450–63.

———. *Anatomie des krankhaften Baues von einigen der wichtigsten Theile im menschlischen Körper*. Translated by Samuel Thomas Soemmerring. Berlin: Voss, 1794.

———. *The Morbid Anatomy of Some of the Most Important Parts of the Human Body*. London: J. Johnson, and G. Nicol 1793. 2nd expanded ed., London: J. Johnson and G. Nicol, 1797.

———. *A Series of Engravings, Accompanied with Explanations, Which Are Intended to Illustrate the Morbid Anatomy of Some of the Most Important Parts of the Human Body*. 10 fascicles. London: Printed by W. Bulmer and Co., and sold by J. Johnson, 1799–1803.

———. *A Series of Engravings, Accompanied with Explanations, Which Are Intended to Illustrate the Morbid Anatomy of Some of the Most Important Parts of the Human Body*. With facsimile reproductions of William Clift's original watercolors and an introductory essay by Harold Attwood. [Carlton]: Melbourne University Press, 1985.

———. *Works, to Which is Prefixed an Account of His Life*. Edited by James Wardrop. 2 vols. London: Longman, Hurst, Rees, Orme, Brown and Green, 1825.

Bartholin, Thomas. *Acta philosophica et medica hafniensia*. 5 vols. Copenhagen: Haubold, 1673–80

———. *Epistolarum medicinalium centuriae I-IV*. 3 vols. Copenhagen: Haubold, 1663–67.

———. *Historiarum anatomicarum rariorum centuriae*. 3 vols. Copenhagen: Haubold, 1654, 1657, 1661.

Bartisch, Georg. *Ophthalmodouleia, das ist Augendienst*. [Dreszden: Stöckel], 1583. English translation by Donald Blanchard, *Ophthalmodouleia: That Is, the Service of the Eyes*, Ostend, Belgium: Wayenborgh, 1996.

Bateman, Thomas. *Abbildung der Hautkrankheiten*. Weimer: Landes-Industrie-Comptoir, 1829–30.

———. *Delineations of Cutaneous Diseases*. London: Longman, Hurst, Rees, Orme, and Brown, 1817.

———. *A Practical Synopsis of Cutaneous Diseases According to the Arrangement of Dr. Willan*. 8th ed. London: Longman, Rees, Orme, Brown, Green, & Longman, 1836 (originally published 1813).

[Bateman, Thomas.] "Biographical Memoir of the Late Dr Willan." *EMSJ* 8 (1812): 502–12.

Bauhin, Caspar. *Theatrum anatomicum*. Frankfurt/M: Matthaeus Becker, 1605.

Beer, Georg Josef. *Lehre der Augenkrankheiten*. 2 vols. Wien: Wappler, 1792.

———. *Praktische Beobachtungen über den grauen Staar und die Krankheiten der Hornhaut*. Wien: Wappler, 1791.

———. *Praktische Beobachtungen über verschiedene, vorzüglich aber über jene*

Augenkrankheiten. Wien: Kaiserer, 1791

Behrend, Friedrich Jacob. *Ikonographische Darstellung der nichr-syphilitischen Hautkrankheiten.* Leipzig: Brockhaus, 1839.

Bell, Charles. *The Anatomy of the Brain, Explained in a Series of Engravings.* London: Longman, Rees, Cadell, and Davies, 1802.

———. *Engravings from Specimens of Morbid Parts, Preserved in the Author's Collection, now in Windmill Street.* London: Longman, Hurst, Rees, Orme, and Brown, 1813.

———. *Essays on the Anatomy of Expression in Painting.* London: Longman, Hurst, Rees, and Orme, 1806.

———. *A System of Dissections, Explaining the Anatomy of the Human Body, the Manner of Displaying the Parts, and their Varieties in Disease.* 2 vols. Edinburgh: Mundell and Son, 1798–1803.

Bell, John. *Engravings, Explaining the Anatomy of the Bones, Muscles, and Joints.* Edinburgh: John Paterson, 1794.

Benivieni, Antonio. *De abditis nonnullis ac mirandis morborum et sanationum causis.* Florence, 1507. Edited and translated by Giorgio Weber, Firenze: Olschki, 1994.

Bertrand-Rival, Jean-François. *Précis historique, physiologique et moral, des principaux objects en cire préparée et coloriée d'apres nature, qui composent le muséum de J.-Fois Bertrand-Rival.* Paris: Richard, 1801.

Bichat, Xavier. *Anatomie générale: appliquée à la physiologie et à la médecine.* 4 vols. Paris: Brosson, 1801.

———. *Traité d'anatomie descriptive.* 5 vols. Paris: Brosson et Gabon, 1801–3.

Bidloo, Govert. *Anatomia corporis humani.* Amsterdam: Sumptibus viduae Joannis à Someren, haeredum Joannis à Dyk, Henrici & viduae Theodori Boom, 1685.

———. *Exercitationum anatomico-chirurgicarum decades duae.* Leiden: Apud Jordanum Luchtmans, 1708.

Blasius, Gerardus. *Miscellanea anatomica, hominis, brutorumque variorum, fabricam diversam magna parte exhibentia.* Amsterdam: Casper Commelijn, 1673.

———. *Observata anatomica.* Leiden: Gaasbeeck, 1674.

———. *Observationes medicae rariores: Accedit monstri triplicis historia.* Amsterdam: Abraham Wolfgang, 1677.

———. *Renum monstrosorum exempla, ex medicorum celebrium scriptis.* Appendix to Lorenzo Bellini, *Exercitatio anatomica de structura & usu renum,* Amsterdam: Andreas Frisius, 1665.

Bleuland, Jan. *Descriptio Musei Anatomici quod universii Belgii regis augustissimi Guilielmi I, munificentia Academiae Rheno Trajectinae concessit.* Utrecht: Joh. Altheer, 1826.

———. *Observationes anatomico-medicae de sana et morbosa oesophagi structura.* Leiden: Apud Abrahamum et Janum Homkoop, 1785.

———. *Otium academicum, continens descriptionem speciminum nonnullarum partium corporis humani et animalium subtilioris anatomiae ope in physiologicum usum praeparatarum, aliarumque, quibus morborum organicorum natura illustratur*, consisting of 3 parts: *Icones anatomico-physiologicae*; *Icones quae ad anatomiam animalium comparatam pertinent*; *Icones anatomico-pathologicae*. Utrecht: Joh. Altheer, 1826–28.

———. *Vasculorum in intestinorum tenuium tunicis, subtillioris anatomes opera detegendorum, descriptio*. Utrecht: B. Wild et J. Altheer, 1797.

Bonet, Théophile. *Medicina septentrionalis collatitia*. Geneva: Chouët, 1684–87.

———. *Sepulchretum; sive anatomia practica, ex cadaveribus morbo denatis*. Geneva: Chouët, 1679; 2nd ed., Lyon and Geneva: Cramer et Perachon, 1700.

Bonn, Andreas. *Commentatio de humero luxato*. Leiden: S. et J. Luchtmans, 1782.

———. *Descriptio thesauri ossium morbosorum Hoviani. Adnexa est dissertatio de callo*. Amsterdam: J. C. Sepp, 1783.

———. *Tabulae ossium morbosorum, praecipue thesauri Hoviani*. 3 fascicles. Amsterdam: J. C. Sepp, 1785–88.

Boott, Francis. *Memoir of the Life and Medical Opinion of John Armstrong*. 2 vols. London: Baldwin and Cradock, 1833.

Botallo, Leonardo. *De catarrho commentarius: Addita est in fine monstrosorum renum figura, nuper in cadavere repertorum*. Paris: Bernardus Turrisanus, 1564.

Bright, Richard. *Reports of Medical Cases: Selected with a View of Illustrating the Symptoms and Cure of Diseases by a Reference to Morbid Anatomy*. 2 vols. London: Longman, Rees, Orme, and Green, 1827–31.

———. *Travels from Vienna to Lower Hungary*. Edinburgh: Constable & Co., 1818.

Brown(e), John. "A Remarkable Account of a Liver, Appearing Glandulous to the Eye." *PT* 15 (1685): 1266–68.

Calvert, Robert. "An Account of the Origin and Progress of the Plague in Malta, in the Year 1813." *MCT* 6 (1815): 1–64.

Camper, Petrus. *Demonstrationes pathologico-anatomicae*. Amsterdam: Joann. Schreuder et Petrus Mortier Junior, 1760–62.

Carswell, Robert. "An Inquiry on the Chemical Solution or Digestion of the Coats of the Stomach after Death." *EMSJ* 34 (1830): 282–311.

———. *Pathological Anatomy: Illustrations of the Elementary Forms of Disease*. London: Longman, Orme, Brown, Green and Longman, 1838.

Cazenave, Pierre-Louis Alphée, and Henry Edouard Schedel. *Abrégé pratique des maladies de la peau*. Paris: Béchet jeune, 1828. Only later editions include plates; see 4th ed., Paris: Labé, 1847.

Christie, Thomas. "Observations on Pemphigus." *London Medical Journal* 10 (1789): 361–95.

Cheselden, William. *Osteographia, or the Anatomy of the Bones*. London, 1733.

Clarke, James Fernandez. *Autobiographical Recollections of the Medical Profession*. London: J. & A. Churchill, 1874.

Cleyer, Andreas. "De elephantia Javae nova." *MCMP* 12 (1683): 7–15.

Condie, Francis. *A Practical Treatise on the Diseases of Children*. Philadelphia: Lea & Blanchard, 1844.

Cooper, Astley. *The Anatomy and Surgical Treatment of Abdominal Hernia*. London: Longman, Rees, Orme, Brown, and Green, 1827.

———. *The Anatomy and Surgical Treatment of Inguinal and Congenital Hernia*. Part 1. London: T. Cox, 1804. *The Anatomy and Surgical Treatment of Crural and Umbilical Hernia*. Part 2. London: Longman, Hurst, Rees, and Orme and E. Cox, 1807.

———. *Die Bildung und Krankheiten des Hodens. Beobachtungen*. Weimer: Verlag des Landes-Industrie Comptoirs, 1832.

———. *Illustrations of the Diseases of the Breast*. London, Longman, Rees, Orme, Brown & Green, 1829.

———. *Observations on the Structure and Diseases of the Testis*. London: Longman, Rees, Orme, Brown & Green, 1830.

———. *A Treatise on Dislocations, and on Fractures of the Joints*. London: Longman, Hurst, Rees, Orme and Brown, 1822.

Cooper, Bransby Blake. *The Life of Sir Astley Cooper*. 2 vols. London: Parker, 1843.

Cowper, William. "An Account of a Polypus Taken Out of the Vena Pulmonalis, and of the Structure of That Vessel." *PT* 22 (1701): 797–8.

———. "An Account of a Very Large Diseased Kidney." *PT* 19 (1696): 301–9.

———. "Of Hydatides Inclosed With a Stony Crust in the Kidney of a Sheep." *PT* 25 (1706): 2304–5.

———. "Of Ossifications or Petrifactions in the Coats of Arteries, Particularly in the Valves of the Great Artery." *PT* 24 (1705): 1949–77.

Crawfurd, George, and George Robertson. *A General Description of the Shire of Renfrew*. Paisley: J. Neilson, 1818.

Cruveilhier, Jean. *Anatomie pathologique du corps humain, ou descriptions, avec figures lithographiées et coloriées, des diverses altérations morbides dont le corps humain est susceptible*. 2 vols. Paris: J. B. Baillière, 1829–42.

———. *Essai sur l'anatomie pathologique en générale*. Paris: Didot jeune, 1816

———. "Histoire de l'anatomie pathologique." *Annales de l'anatomie et de la physiologie pathologique*. Paris: Hildebrand, 1846: 9–18, 37–46, 75–88.

Cullen, William. *Works*. 2 vols. Edited by John Thomson. Edinburgh: Blackwood, 1827.

Cullen, William, and Robert Carswell. "On Melanosis." *Transactions of the Medico-Chirurgical Society of Edinburgh* 1 (1824): 264–84.

Daremberg, Charles. *Médecine: Histoire et doctrines*. 2nd ed. Paris: Didier, 1865.

Daubenton, Louis-Jean-Marie. *Histoire naturelle, générale et particuliére, avec la description du cabinet du roi*. Vol. 3. Paris: imprimerie royale, 1749.

Delestre, Jean-Baptiste. *Iconographie pathologique*. Paris: Compére, 1829.

Diderot, Denis, and Jean le Rond d'Alembert, eds. *Encyclopédie*. 17 vols. Paris: Briasson, 1751–65.

Douglas, John. *Animadversions on a Late Pompous Book Intituled Osteographia, or the Anatomy of the Bones, by William Cheselden*. London: printed by the Author, 1735.

Durston, William. "An Extract of a Letter Concerning a Very Sudden and Excessive Swelling of a Womans Breasts." *PT* 4 (1669): 1047–50.

Elsner, Joachim Georg. "Dn. Guglielmi Rivae de paradoxico aneurismate aortico." *MCMP* 1 (1670): 75–77.

Fabricius Hildanus, Guilhelmus. *Anatomiae praestantia et utilitas*. Bern: Jacob Stuber, 1624.

———. *De monstro Lausannæ Equestrium exciso*. Oppenheim: Hieronymus Gallerus, 1615

———. *Observationum et curationum cheirurgicarum centuria secunda*. Geneva: Petrus and Jacobus Chouët, 1611.

———. *Observationum et curationum cheirurgicarum centuria tertia*. Oppenheim: Hieronymus Gallerus, 1614.

———. *Observationum et curationum chirurgicarum centuriae*. Basel: Regis, 1606.

———. *Opera*. Frankfurt: Johann Beyer, 1646.

Farre, John Richard. *Journal of Morbid Anatomy, Ophthalmic Medicine, and Pharmaceutical Analysis*. Vol. 1. London: Longman, Rees, Orme, Brown and Green, 1828.

———. *The Morbid Anatomy of the Liver*. London: Longman, Hurst, Rees, Orme, and Brown, 1812–15.

Fawdington, Thomas. *A Case of Melanosis, with General Observations on the Pathology of this Interesting Disease*. London: Longman, Rees, Orme, Brown & Green, 1826.

———. *A Catalogue Descriptive Chiefly of the Morbid Preparations Contained in the Museum of the Manchester Theatre of Anatomy and Medicine, Marsden Street*. Manchester: Harrison and Crosfield, 1833.

Freer, George. *Observations on Aneurisms, and some Diseases of the Arterial System*. Birmingham: Knott & Lloyd, 1807.

Froriep, Robert. *Chirurgische Kupfertafeln: eine auserlesene Sammlung der nöthigsten Abbildungen von äusserlich sichtbaren Krankheitsformen, anatomischen Präparaten und Instrumenten und Bandagen, welche auf die Chirurgie Bezug haben; zum Gebrauch für praktische Chirurgen*. Weimar: Landes-Industrie-Comptoir, 1820–47.

———. *Klinische Kupfertafeln: Eine auserlesene Sammlung von Abbildungen in Bezug auf innere Krankheiten, vorzüglich auf deren Diagnostik und patholo-*

gische Anatomie für practische Ärzte. Weimar: Landes-Industrie-Comptoir, 1828–37.

Geoffroy Saint-Hilaire, Isidore. *Histoire générale et particulière des anomalies de l'organisation chez l'homme et les animaux . . . ou traité de tératologie.* 3 vols. and atlas. Paris: Ballière, 1832–37.

Gersdorff, Hans von. *Feldtbüch der Wundtartzney.* Strassburg: Schott, [1517].

Guidi, Guido. *Chirurgia è Græco in Latinum conuersa.* Paris: Petrus Galterius, 1544.

Harvey, William. *Exercitatio anatomica de motu cordis et sanguinis in animalibus.* Frankfurt: Wilhelm Fitzer, 1628. Translated by Kenneth J. Franklin, with an introduction by Andrew Wear, as *The Circulation of the Blood and Other Writings,* London: Everyman, 1993.

Herrmann, Ioannes Gotthelf. *De osteosteatomate.* Leipzig: ex officina Breitkopfia, 1767.

Herrmann, Ioannes Gotthelf, and Johann Daniel Reichel. *De modo cavendae corruptionis corporum naturalium in museis.* Leipzig: ex officina Breitkopfia, 1766.

Hey, William. *Practical Observations in Surgery, Illustrated with Cases.* London: Luke Hansard, 1803.

Hodgkin, Thomas. *A Catalogue of the Preparations in the Anatomical Museum at Guy's Hospital.* London: Highley, 1829.

———. *Lectures on the Morbid Anatomy of the Serous and Mucous Membranes.* 2 vols. London: Sherwood, Gilbert, and Piper, 1836–40.

———. "On Some Morbid Appearances of the Absorbent Glands and Spleen." *MCT* 17 (1832): 68–114.

Home, Everard. *Practical Observations on the Treatment of the Diseases of the Prostate Gland.* 2 vols. London: G. and W. Nicol, 1811–18.

Hooper, Robert. *The Morbid Anatomy of the Human Brain; Being Illustrations of the Most Frequent and Important Organic Diseases to Which That Viscus is Subject.* London: Longman, Rees, Orme, Brown, and Green, 1826. Reissued with additional material as *The Morbid Anatomy of the Human Brain; Illustrated by Coloured Engravings of the Most Frequent and Important Organic Diseases to Which That Viscus is Subject,* London: Longman, Rees, Orme, Brown, and Green, 1828.

———. *The Morbid Anatomy of the Human Uterus and its Appendages; With Illustrations of the Most Frequent and Important Organic Diseases to Which Those Viscera Are Subject.* London: Longman, Rees, Orme, Brown, and Green, 1832.

———. *Observations on the Structure of the Intestinal Worms in Humans.* [London], 1799. Also published in *Memoirs of the Medical Society of London* 5 (1799): 224–85.

Hope, Anne. *Memoir of the Late James Hope, M.D.* London: Hatchard, 1842.

Hope, James. *Principles and Illustrations of Morbid Anatomy, Adapted to the Elements of M. Andral, and to the Cyclopædia of Practical Medicine.* London: Whittaker, 1834. Cincinnati: Desilver & Burr, 1844; Desilver, 1852.

———. *A Treatise on the Diseases of the Heart and Great Vessels.* London: Kidd, 1832; 3rd ed., London: Churchill, 1839.

Houstet, François. "Mémoire sur l'exostoses des os cylindriques, dans lequel on établit une nouvelle espece d'Exostose." *Mémoires de l'académie royale de chirurgie* (quarto ed.) 3 (1757): 130–44.

Howship, John. "Experiments and Observations in Order to Ascertain the Means Employed by the Animal Economy, in the Formation of Bones." 6 (1815): 263–403.

Hunter, John. *Essays and Observations on Natural History, Anatomy, Physiology, Psychology, and Geology.* 2 vols. London: J. van Voorts, 1861.

———. "On the Digestion of the Stomach After Death." *PT* 62 (1772): 447–54.

Hunter, William. *Anatomia uteri humani gravidi tabulis illustrata.* [*The Anatomy of the Human Gravid Uterus Exhibited in Figures.*] Birmingham: John Baskerville, 1774.

Jacobaeus, Oliger. "Monstrosi testes muliebres: Hernia quadruplex. Vermis aureus." Letter to Thomas Bartholin, Leiden, 19 March 1675, in Thomas Bartholin, *Acta medica et philosophica hafniensia*, 3 (1677): 87–88.

Jenner, Edward. *An Inquiry into the Causes and Effects of the Variolae Vaccinae, a Disease Discovered in some of the Western Counties of England, Particularly Gloucestershire, and Known by the Name of the Cow Pox.* London: Sampson Low, 1798.

[Johnson, James]. Review of James Annesley, *Researches* (London, 1828). Vol. 1, *MCR* 12 (1828): 409–425; (1828) 13:337–47; 14 (1829): 309–21, 435–44. Vol. 2, *MCR* 16 (1829): 138–44, 570–72.

———. Review of John Armstrong, *Morbid Anatomy*, fascicles 1–3. *MCR* 13 (1829): 347–58; 14 (1829): 118–23; 15 (1829): 97–107.

———. Review of Richard Bright, *Reports of Medical Cases* (London, 1827). *MCR* 12 (1828): 90–103.

———. Review of Jean Cruveilhier, *Anatomie pathologique*, fascicles 15 and 16, and Robert Carswell, *Pathological Anatomy*, "Carcinoma." *MCR* 23 (1833): 137–44, 186–90.

———. Review of James Hope, *Principles*, fascicles 1 and 2, and Robert Carswell, *Pathological Anatomy*, fascicle 1. *MCR* 22 (1833): 284–85, 366–74.

Kerckring, Theodor. *Spicilegium anatomicum, continens observationum anatomicarum rariorum centuriam unam.* Amsterdam: Andreas Frisius, 1670.

Ketham, Johannes de. *Fasciculo de medicina.* Venice: Johannes and Gregorius de Gregoriis, 1494.

Knolle, Johann Friedrich. *De ossium carie venerea.* Leipzig: Langenheim, 1763.

Laennec, René T. H. *De l'auscultation médiate.* 2 vols. Paris: J.-A. Brosson et J.-S. Chaudé, 1819.

———. *A Treatise on the Diseases of the Chest.* Translated by John Forbes. London: T. and G. Underwood, 1821.

Lebert, Hermann. *Traité d'anatomie pathologique générale et speciale.* 4 vols. Paris: Ballière, 1857–61.

Le Clerc, Daniel, and Jean-Jacques Manget, eds. *Bibliotheca anatomica.* 2 vols. 2nd ed. Geneva: Johan. Anthon. Chouët & David Ritter, 1699.

Liceti, Fortunio. *De monstris, ex recensione Gerardi Blasii, qui monstra quædam nova & rariora ex recentiorum scriptis addidit.* Amsterdam: sumptibus Andreae Frisii, 1665.

Littre, Alexis. "Observation sur le reins d'un fœtus humain de neuf mois." *MARS* (1705): 111–18.

Louis, Antoine. *Éloges lus dans les séances publiques de l'Académie royale de chirurgie, de 1750 à 1792.* Paris: Baillière, 1859.

Ludwig, Christian Friedrich. *De quarundam aegritudinum humani corporis sedibus et causis tabulae sedecim.* Leipzig: Seidmann, 1798.

Ludwig, Christian Gottlieb, ed. *Adversaria medico practica.* 3 vols. Leipzig: apud haeredes Weidmanni et Reich, 1769–1774.

———. "Tractatio de diaphysibus ossium cylindricorum laesis exfoliatione separatis et callo subnato restitutis." *Adversaria medico practica* 3 (1772): 45–74.

Machin, John. "An Extract from the Minutes of the Royal Society, March 16, 1731, Containing an Uncommon Case of a Distempered Skin." *PT* 37 (1731): 299–301.

Malpighi, Marcello. *Opera posthuma.* Amsterdam: Georgius Gallet, 1700.

———. *Opere scelte.* Edited by Luigi Belloni. Torino: UTET, 1967.

Martens, Franciscus Henricus, and Wilhelm Gottlieb Tilesius von Tilenau. *Icones symptomatum venerei morbi.* Leipzig: Baumgärtner, 1804.

Meckel, Johann Friedrich [the Younger]. *De cordis conditionibus abnormis.* Halle: Bathe, 1802.

———. *De duplicitate monstrosa commentarius.* Halle: e Librariis Orphanotrophei, 1815.

———. *Tabulae anatomico-pathologicae, modos omnes quibus partium corporis humani omnium forma externa atque interna a norma recedit, exhibentes.* 4 parts. Leipzig: Gleditsch, 1817–26.

———. "Ueber die Bildungsfehler des Herzens." *Archiv für die Physiologie* 6 (1805): 549–610.

Meek'ren, Job van. *Observationes medico-chirurgicae.* Amsterdam: Ex officina Henrici & Viduae Theodori Boom, 1682.

Méry, Jean. "Description d'une exostose monstrueuse." *MARS* (1706): 245–48.

Money, William. *A Vade-mecum of Morbid Anatomy, Medical and Chirurgical.* 2nd ed. London: Burgess and Hill, 1831.

Monro, Alexander, III. *The Morbid Anatomy of the Human Gullet, Stomach, and Intestines.* Edinburgh: A. Constable & Co., 1811.

Morgagni, Giovanni Battista. *De sedibus, et causis morborum per anatomen ind-*

agatis. 2 vols. Venice: ex typographia Remondiana, 1761.

———. *The Seats and Causes of Diseases Investigated by Anatomy.* Translated by Benjamin Alexander. 3 vols. London: A. Millar and T. Cadell, 1769.

———. *Von dem Sitze and den Ursachen der Krankheiten, welche durch die Anatomie sind erforscht worden.* Translated by Georg Heinrich Königsdörfer and Johann Gotthelf Herrmann. 5 vols in 8 vols. Altenburg: Richterische Buchhandlung, 1771–76.

Mummssen, Dietrich. *De corde rupto.* Leipzig: Langenheim, 1764.

New Sydenham Society. *An Atlas of Illustrations of Pathology.* Fascicle 12, *Infective Diseases of the Lymphatic System: Lymph-Adenoma, or Hodgkin's Malady.* London: New Sydenham Society, 1898.

Payne, Joseph Frank. "An Address on the Morbid Anatomy and Pathology of Chronic Alcoholism." *British Medical Journal* (Dec. 8, 1888): 1275–77.

Pettigrew, Thomas Joseph. *Medical Portrait Gallery: Biographical Memoirs of the Most Celebrated Physicians, Surgeons, etc., etc., Who Have Contributed to the Advancement of Medical Science.* 4 vols. London: Fisher, Son, & Co.; Whittaker & Co., 1838–40.

Peyer, Johann Conrad. *Methodus historiarum anatomico-medicarum.* Paris: Roulland, 1678.

Pinel, Philippe. *Nosographie philosopphique.* 2 vols. Paris: Crapelet, [1797–98].

Plenck, Joseph Jacob. *Doctrina de morbis cutaneis: qua hi morbi in suas classes, genera & species rediguntur.* Vienna: Graeffer, 1776.

Portal, Antoine. *Histoire de l'anatomie et de la chirurgie.* 6 vols. Paris: P. Fr. Didot le jeune, 1770–73.

Pott, Percivall. *Farther Remarks on the Useless State of the Lower Limbs, in Consequence of a Curvature of the Spine.* London: J. Johnson, 1782.

———. *Chirurgical Works.* 3 vols. London: T. Lowndes et alii, 1779.

Rayer, Pierre François Olive. *De la morve et du farcin chez l'homme.* Paris: Ballière, 1837.

———. *Sommaire d'une histoire abrégée de l'anatomie pathologique.* Paris: Gabon et Méquignon-Marvis, 1818.

———. *Traité des maladies des reins.* 3 vols. and atlas. Paris: Baillière, 1837–41.

———. *Traité théorique et pratique des maladies de la peau.* 2 vols. and atlas. Paris: J.-B. Baillière, 1826–27.

———. *Traité théoretique et pratique des maladies de la peau.* 3 vols. and atlas. Paris: Baillière, 1835.

Reichel, Georg Christian. *De epiphysium ab ossium diaphysi diductione.* Leipzig: ex officina Breitkopfia, 1759.

Roederer, Johann Georg, and Karl Gottlieb Wagler. *De morbo mucoso liber singularis.* Göttingen: Victorinus Bossiegel, [1762].

Roonhyuse, Hendrik van. *Heel-konstige Aanmerkkingen.* 2nd ed. Amsterdam: By de Weduwe van Theunis Jacobsz. Lootsman, 1672.

Ruysch, Frederik. *Dilucidatio valvularum in vasis lymphaticis et lacteis.* The

Hague: Harman Gael, 1665. Facsimile edition with an introduction by Anoine M. Luydendijk-Elshout, Nieuwkoop: De Graaf, 1964.

———. *Observationum anatomico-chirurgicarum centuria: accedit catalogus rariorum, quae in Museo Ruyschiano asservantur*. Amsterdam: Apud Henricum & viduam Theodori Boom, 1691.

———. *Thesaurus anatomicus primus—[decimus]*. 10 vols. Amsterdam: Johann Wolters, 1701–16.

Sandifort, Eduard. *Anatome infanti cerebro destituti*. Leiden: Apud P.v.d. Eyk et D. Vygh, 1784.

———. *Exercitationes academicae*. 2 vols. Leiden: S. & J. Luchtmans, P. v. d. Eyk et D. Vygh, 1783–85.

———. *Icones herniae inguinalis congenitae*. Leiden: Apud P.v.d. Eyk et D. Vygh, 1781.

———. *Museum anatomicum Academiae Lugduno-Batavae*. 4 vols. (the last two published by his son Gerard). Leiden: Luchtmans, 1793–1835.

———. *Observationes anatomico-pathologicae*. 4 vols. Leiden: Apud P.v.d. Eyk et D. Vygh, 1777–81.

———. *Opuscula anatomica*. 3 vols. Leiden: Apud P.v.d. Eyk et D. Vygh, 1780–84.

———. *Oratio de circumspecto cadaverum examine optimo practicae medicinae adminiculo*. Leiden: Sam. et Joh. Luchtmans, 1772.

Saunders, John Cunningham. *A Treatise on Some Practical Points Relating to the Diseases of the Eye*. London: Longman, Hurst, 1811.

Sauvages, François Boissier de. *Nosologia methodica sistens morborum classes, genera et species, juxtà Sydenhami menten & botanicorum ordinem*. 3 vols. Amsterdam: Fratres de Tournes, 1763.

———. *Pathologia methodica, seu de cognoscendis morbis*. Amsterdam: Fratres de Tournes, 1752^2.

Sauvages, François Boissier de, and Christian Friedrich Daniel. *Nosologia methodica sistens aegritudines morbos passiones ordine artificiali ac naturali*. 5 vols. Leipzig: E. B. Schwickert, 1790–97.

Scultetus, Johannes. *Armamentarium chirurgicum*. Frankfurt: typis Joannis Gerlini, 1666.

Severino, Marco Aurelio. *De recondita abscessuum natura*. Naples: Ottavio Beltrani, 1632. 2nd expanded edition, Frankfurt/M: Beyer, 1643.

Sloane, Hans. Collection of medical broadsides, British Library, General Reference Collection C.112.f.9.

Smellie, William. *A Sett of Anatomical Tables, with Explanations, and an Abridgment, of the Practice of Midwifery*. London, 1754.

Syme, Patrick. *Werner's Nomenclature of Colours, with Additions, Arranged so as to Render it Highly Useful to the Arts and Sciences, Particularly Zoology, Botany, Chemistry, Mineralogy, and Morbid Anatomy*. Edinburgh: Ballantyne, 1814.

Thomson, Anthony Todd. *Atlas of Delineations of Cutaneous Eruptions*. London:

Longman, Rees, Orme, Brown, and Green, 1829.

Tilesius, Wilhelm Gottlieb. *Ausführliche Beschreibung und Abbildung der beiden sogenannten Stachelschweinmenschen aus der Bekannten engelischen Familie Lambert, oder, The porcupine man*. Altenburg: Im literarischen Comtoir, 1802.

———. *De pathologia artis pictoriae plasticeque auxilio illustranda*. Leipzig, 1801.

Tilesius, Wilhelm Gottlieb, and Christian Freidrich Ludwig. *Historia pathologica singularis cutis turpitudinis Io. Gotofredi Rheinhardi*. Leipzig: Crusius, 1793.

Trioen, Cornelis. *Observationum medico chirurgicarum fasciculus*. Leiden: Petrum van der Eyk et Jacobum van der Kluis, 1743.

Tulp, Nicolaas. *Observationes medicae*. 2nd ed. Amsterdam: Apud Ludovicum Elzevirium, 1652; first published in 1641.

Tyson, Edward. "Anatomical Observations." *PT* 12 (1678-79): 1035-39.

Vater, Abraham. *Musei anatomici augustei catalogus universalis*. Wittenberg: in officina Henningiana, 1736.

———. *Museum anatomicum proprium*. Helmstadt: Christian Frederic Weygand, 1750.

Voigtel, Friedrich Gotthilf, and Philipp Friedrich Meckel. *Handbuch der pathologischen Anatomie*. 2 vols. Halle: Hemmerde und Schwetschke, 1804.

Wadd, William. *Cases of Diseased Prepuce and Scrotum*. London: J. Callow, 1817.

Walter, Johann Gottlieb, and Friedrich August Walter. *Anatomisches Museum*. 2 vols. Collected by Johann Gottlieb and described by Friedrich August. Berlin: Belitz and Braun, 1796.

Wardrop, James. *Essays on the Morbid Anatomy of the Human Eye*. 2 vols. Edinburgh: G. Ramsay & Co., 1808; London: Archibald Constable & Co., 1818.

———. *Observations on Fungus Hæmatodes or Soft Cancer, in Several of the Most Important Organs of the Human Body*. Edinburgh: G. Ramsay & Co., 1809.

Weidmann, Johann Peter. *De necrosi ossium*. Frankfurt/M: Andreae, 1793.

———. *De necrosi ossium adnotatio*. Mainz: J. J. Alef, 1784.

Wenzel, Carl. *Über die Krankheiten am Rückgrathe*. Bamberg: W. L. Wesché, 1824.

Willan, Robert. *Description and Treatment of Cutaneous Diseases*. 3 fascicles. London: J. Johnson, 1798-1805. Reissued with a new title with variants and a fourth fascicle, *On Cutaneous Diseases*, London: J. Johnson, 1808.

———. *A Practical Treatise on Porrigo, or Scalled Head, and on Impetigo, the Humid, or Running Tetter*. London: E. Cox and Son, 1814.

———. *On Vaccine Inoculation*. London: Phillips, 1806.

SECONDARY SOURCES

Ackerknecht, Erwin H. *Medicine at the Paris Hospital, 1794-1848*. Baltimore: Johns Hopkins University Press, 1967.

——. *A Short History of Medicine*. Baltimore: Johns Hopkins University Press, 1982.

Alberti, Samuel J. M. M. *Morbid Curiosities: Medical Museums in Nineteenth-Century Britain*. Oxford: Oxford University Press, 2011.

——. "The Museum Affect: Visiting Collections of Anatomy and Natural History." In *Science in the Marketplace*, edited by Aileen Fyfe and Bernard Lightman, 371–403. Chicago: University of Chicago Press, 2007.

——. "Owning and Collecting Natural History Objects in Nineteenth-Century Britain." In *From Private to Public*, edited by Marco Beretta, 141–54. Sagamore Beach, MA: Science History Publications, 2005.

——. "The Status of Museums: Authority, Identity, and Material Culture." In *Geographies of Nineteenth-Century Science*, edited by David N. Livingstone and Charles W. J. Withers, 51–72. Chicago: University of Chicago Press, 2011.

Alberti, Samuel J. M. M., and Elizabeth Hallam, eds. *Medical Museums: Past, Present, Future*. London: Royal College of Physicians, 2013.

Alpers, Svetlana. *The Art of Describing: Dutch Art in the Seventeenth Century*. Chicago: University of Chicago Press, 1983.

Appleby, John H. "Human Curiosities at the Royal Society, 1699–1751." *NRRS* 50 (1996): 13–27.

Arrizabalaga, Jon, John Henderson, and Roger French. *The Great Pox: The French Disease in Renaissance Europe*. New Haven: Yale University Press, 1997.

Attwood, Harold Dallas. "Some Specimens from William Clift's Copy of Matthew's *The Morbid Anatomy of the Human Body* (1799–1802)." *Australian and New Zealand Journal of Surgery* 58 (1988): 665–70.

Baker, Tawrin. "Surgery and Sight: Anatomy, Visual Theory, and Surgical Practice in Some Sixteenth-Century Works on Surgery." *JHM* 72 (2017): 51–66.

Bates, Alan W. *Emblematic Monsters: Unnatural Conceptions and Deformed Births in Early Modern Europe*. Amsterdam: Rodopi, 2005.

Belloni, Luigi. "Introduzione storica alla patologia dell'aterosclerosi." In *Aterosclerosi umana e sperimentale*, edited by Società italiana di patologia, 25–66. Milan: Ambrosiana, 1956.

——. "Spunti di patologia osteo-articolare nel *De sedibus* di G.B. Morgagni." *Rivista di anatomia patologica e di oncologia* 21 (1962): 276–300.

Beneke, Rudolf. *Johann Friedrich Meckel der Jüngere*. Halle: Max Niemeyer, 1934.

Benjamin, John A., and Dorothy M. Schullian. "Observations on Fused Kidneys with Horseshoe Configuration: The Contribution of Leonardo Botallo (1564)." *JHM* 5 (1950): 315–26

Beretta, Marco, ed. *From Private to Public: Natural Collections and Museums*. Sagamore Beach, MA: Science History Publications, 2005.

Berkowitz, Carin. "The Beauty of Anatomy: Visual Displays and Surgical Education in Early Nineteenth-Century London." *BHM* 85 (2011): 248–78.

———. *Charles Bell and the Anatomy of Reform*. Chicago: University of Chicago Press, 2015.

———. "The Illustrious Anatomist: Authorship, Patronage, and Illustrative Style in Anatomy Folios, 1700–1840." *BHM* 2015 (2015): 171–208.

———. "Systems of Display: The Making of Anatomical Knowledge in Enlightenment Britain." *BJHS* 46 (2012): 359–87.

Berry, Diana. "Pierre-François Olive Rayer: Biography." *Medical History* supplement, no. 24 (2005): 7–13.

Berry, Diana, and Campbell Mackenzie. *Richard Bright, 1789–1858: Physician in an Age of Revolution and Reform*. London: Royal Society of Medicine, 1992.

Bersaques, Jean de. "Wilhelm Gottlieb Tilesius—A Forgotten Dermatologist." *Journal of the German Society of Dermatology* 9, no. 7 (2011): 563–70.

Bertoloni Meli, Domenico. "Early Modern Experimentation on Live Animals." *Journal of the History of Biology* 46 (2013): 199–226.

———. "*Ex Museolo nostro machaonico*: Collecting, Publishing, and Visualization in Fabricius Hildanus." JHM 72 (2017): 98–116.

———. "Gerardus Blasius and the Illustrated Amsterdam *Observationes* from Nicolaas Tulp to Frederik Ruysch." In *Festschrift for Nancy Siraisi*, edited by Cindy Klestinec and Gideon Manning. New York: Springer, 2016.

———. *Mechanism, Experiment, Disease: Marcello Malpighi, and Seventeenth-Century Anatomy*. Baltimore: Johns Hopkins University Press, 2011.

———. "The Representation of Insects in the Seventeenth Century: A Comparative Approach." *AS* 67 (2010): 405–29.

———. "The Rise of Pathological Illustrations: Baillie, Bleuland, and Their Collections." *MH* 89 (2015): 209–42.

———. "Visual Representations of Disease: The *Philosophical Transactions* and William Cheselden's *Osteographia*." *HLQ* 78 (2015): 157–86.

Beswick, T. S. L. "Robert Willan: The Solution of a Ninety-Year-Old Mystery." JHM 12 (1957): 349–65.

Biagioli, Mario. *Galileo's Instruments of Credit: Telescopes, Images, Secrecy*. Chicago: University of Chicago Press, 2006.

Blumberg, Baruch S., and Jean L. Blumberg. "Bernard Connor (1666–1698) and His Contribution to the Pathology of Ankylosing Spondylitis." *JHM* 13 (1958): 349–66.

Blunt, Wilfrid, and William T. Stearn. *The Art of Botanical Illustration*. 2nd ed. Woodbridge, UK: Antique Collectors' Club and Royal Botanic Gardens, Kew, 1994.

Boeckl, Christine M. *Images of Leprosy*. Kirksville, MO: Truman State University Press, 2011.

———. *Images of Plague and Pestilence*. Kirksville, MO: Truman State University Press, 2000.

Booth, Christopher C. "Robert Willan MD FRS (1757–1812): Dermatologist of the Millennium." *Journal of the Royal Society of Medicine* 92 (1999): 313–18.

Brockliss, Lawrence W. L. "Before the Clinic: French Medical Teaching in the Eighteenth Century." In *Constructing Paris Medicine*, edited by Caroline Hannaway and Ann La Berge, 71–115. Amsterdam: Rodopi, 1998.

Brodier, Léon. *J.-L. Alibert. Médecin de l'Hôpital Saint-Louis (1768–1837)*. Paris: A. Maloine & Fils, 1923.

Bynum, Helen. *Spitting Blood: The History of Tuberculosis*. Oxford: Oxford University Press, 2012.

Bynum, William F. "Nosology." In *Companion Encyclopedia of the History of Medicine*, edited by William F. Bynum and Roy Porter, 1:335–56. London: Routledge, 1993.

———. *Science and the Practice of Medicine in the Nineteenth Century*. Cambridge: Cambridge University Press, 1994.

Bynum, William F., and Vivian Nutton, eds. *Theories of Fevers from Antiquity to the Enlightenment* (*Medical History* supplement, no. 1). London: Wellcome Institute for the History of Medicine, 1981.

Bynum, William F., and Roy Porter, eds. *Companion Encyclopedia of the History of Medicine*. 2 vols. London: Routledge, 1993.

———. *Medicine and the Five Senses*. Cambridge: Cambridge University Press, 1993.

———. *William Hunter and the Eighteenth-Century Medical World*. Cambridge: Cambridge University Press, 1985.

Canguilhem, Georges. *On the Normal and the Pathological*. With an introduction by Michel Foucault. Dordrecht: Reidel, 1978.

Carlino, Andrea. *Books of the Body: Anatomical Ritual and Renaissance Learning*. Translated by John Tedeschi and Anne C. Tedeschi. Chicago: University of Chicago Press, 1999.

———. *Paper Bodies: A Catalogue of Anatomical Fugitive Sheets*. London: Wellcome Institute, 1999.

Carmichael, Ann G., and Richard M. Ratzan, eds. *Medicine: A Treasury of Art and Literature*. New York: Macmillan, 1991.

Chadarevian, Soraya de, and Nick Hopwood, eds. *Models: The Third Dimension of Science*. Stanford: Stanford University Press, 2004.

Chaplin, Simon D. J. "Dissection and Display in Eighteenth-Century London." In *Anatomical Dissection in Enlightenment England and Beyond: Autopsy, Pathology, and Display*, edited by Piers Mitchell, 95–114. Farnham, UK: Ashgate, 2012.

———. "John Hunter and the 'Museum Oeconomy,' 1750–1800." PhD diss., King's College, London, 2009.

———. "Nature Dissected, or Dissection Naturalized? The Case of John Hunter's Museum." *Museum and Society* 6 (2008): 135–51.

Choulant, Ludwig. *History and Bibliography of Anatomical Illustration*. Translated and edited by Frank Mortimer. Chicago: University of Chicago Press, 1920. Originally published in Leipzig, 1852.

Cimino, Guido, and François Duchesneau, eds. *Vitalism from Haller to the Cell Theory*. Florence: Olschki, 1997.

Clark, Owen E. "The Contributions of J. F. Meckel, the Younger, to Teratology." *JHM* 24 (1969): 310–22.

Clayton, Timothy. *The English Print, 1688–1802*. New Haven: Yale University Press, 1998.

Compston, Alistair, ed. *McAlpine's Multiple Sclerosis*. 4th ed. London: Churchill Livingstone Elsevier, 2005.

Conforti, Maria. "Illustrating Pathologies in the First Years of the *Miscellanea Curiosa*, 1670–1687." *Nuncius* 30 (2015): 570–609.

Cook, Harold J. *Matters of Exchange: Commerce, Medicine, and Science in the Dutch Golden Age*. New Haven: Yale University Press, 2007.

———. "The New Philosophy and Medicine in Seventeenth-Century England." In *Reappraisals of the Scientific Revolution*, edited by David C. Lindberg and Robert S. Westman, 397–436. Cambridge: Cambridge University Press.

———. "Physicians and Natural History." In *Cultures of Natural History*, edited by Nicholas Jardine, James Secord, and Emma Spary, 91–105. Cambridge: Cambridge University Press, 1996.

———. "The Preservation of Specimens and the Takeoff in Anatomical Knowledge in the Early Modern Period." In *Ways of Making and Knowing: The Material Culture of Empirical Knowledge*, edited by Pamela H. Smith, Amy R. W. Meyers, and Harold J. Cook, 302–29. Ann Arbor: University of Michigan Press, 2014.

———. "Time's Bodies: Crafting the Preparation and Preservation of Naturalia." In *Merchants and Marvels: Commerce, Science, and Art in Early Modern Europe*, edited by Pamela H. Smith and Paula Findlen, 223–47. New York: Routledge, 2002.

Cope, Zachary. *William Cheselden, 1688–1752*. Edinburgh: E. & S. Livingstone, 1953.

Courville, Cyril B. "The Ancestry of Neuropathology: Robert Hooper's *Morbid Anatomy of the Human Brain*." *Bulletin of the Los Angeles Neurological Society* 10 (1945): 155–73

Crainz, Franco. "The Editions and Translations of Dr. Matthew Baillie's *Morbid Anatomy*." *MH* 26 (1982): 443–52.

Cummings, Frederick. "B. R. Haydon and His School." *Journal of the Warburg and Courtauld Institutes* 26 (1963): 367–80.

Cunningham, Andrew. *The Anatomist Anatomis'd: An Experimental Discipline in Enlightenment Europe*. Farnham, UK: Ashgate, 2010.

———. "Thomas Sydenham: Epidemics, Experiment and the 'Good Old Cause.'" In *The Medical Revolution of the Seventeenth Century*, edited by Roger French and Andrew Wear, 161–90. Cambridge: Cambridge University Press, 1989.

Cunningham, Andrew, and Roger French, eds. *The Medical Enlightenment of*

the Eighteenth Century. Cambridge: Cambridge University Press, 1990.

Cunningham, Andrew, and Nicholas Jardine, eds. *Romanticism and the Sciences*. Cambridge: Cambridge University Press, 1990.

Cunningham, George J. *The History of British Pathology*. Bristol: White Tree Books, 1992.

Dackerman, Susan, ed. *Prints and the Pursuit of Knowledge in Early Modern Europe*. Cambridge, MA: Harvard Art Museum, 2011.

Dahm, Susanne. *Frühe Krankenbildnisse: Alibert Esquirol Baumgärtner*. Cologne: F. Hansen, 1981.

Dam, Andries J. van. "The Interactions of Preservative Fluid, Specimen Container, and Sealant in a Fluid Collection." *Collection Forum* 14 (2000): 78–92.

Dann, Walther. "Die Abbildung der Hautkrankheiten vom Beginn der modernen Dermatologie bis zum Ende des 19. Jahrhunderts." PhD diss., University of Kiel, 1969.

Daston, Lorraine, and Peter Galison. *Objectivity*. New York: Zone Books, 2007.

Daston, Lorraine, and Elizabeth Lunbeck, eds. *Histories of Scientific Observation*. Chicago: University of Chicago Press, 2011.

Daston, Lorraine, and Katharine Park. *Wonders and the Order of Nature, 1150–1750*. New York: Zone Books, 1998.

Dawson, Peter J. "The Original Illustrations of Hodgkin's Disease." *Archives of Internal Medicine* 121 (1968): 288–90.

DeLacy, Margareth. "Nosology, Mortality, and Disease Theory in the Eighteenth Century." *JHM* 54 (1999): 261–84.

Delhoume, Léon. *L'ecole de Dupuytren: Jean Cruveilhier*. Paris: Baillière & Fils, 1937.

Del Maestro, Rolando F. *A History of Neuro-Oncology*. [Montreal]: DW Medical Consulting Inc., [2006].

Demaitre, Luke. *Leprosy in Premodern Medicine: A Malady of the Whole Body*. Baltimore: Johns Hopkins University Press, 2007.

Dobson, Jessie. *William Clift*. London: Heinemann, 1954.

———. "William Clift, FRS: First Conservator of the Hunterian Museum." *Proceedings of the Royal Society of Medicine* 48, no. 323 (1955): 13–15.

Doherty, Meghan C. "Creating Standards of Accuracy: Faithorne's *The Art of Graveing* and the Royal Society." In *Science in Print: Essays on the History of Science and the Culture of Print*, edited by Rima D. Apple, Gregory J. Downey, and Stephen L. Vaughn, 15–36. Madison: University of Wisconsin Press, 2012.

———. "Discovering the 'True Form': Hooke's *Micrographia* and the Visual Vocabulary of Engraved Portraits." *NRRS* 66 (2012): 211–34.

Dolan, Brian. "Pedagogy Through Print: James Sowerby, John Mawe and the Problem of Color in Early Nineteenth-Century Natural History Illustrations." *BJHS* 31 (1998): 275–304.

Donato, Maria Pia. *Morti improvvise: Medicina e religione nel Settecento*. Roma:

Carocci, 2010.

———. *Sudden Death: Medicine and Religion in Eighteenth-Century Rome*. Farnham, UK: Ashgate, 2014. Revised translation by Valentina Mazzei of *Morti improvvise*, Rome: Carocci, 2010.

Döring, Detlef. "Der Nachlass von Christian Gottlieb Ludwig (1709–1773) in der Universitätsbibliothek Leipzig." *MJ* 27 (1992): 113–25.Duchesneau, François. "Territoires et frontières du vitalisme (1750–1850)." In *Vitalism from Haller to the Cell Theory*, edited by Guido Cimino and François Dechesneau, 297–349. Florence: Olschki, 1997.

———. "Vitalism in Late Eighteenth-Century Physiology: The Cases of Barthez, Blumenbach, and John Hunter." In *William Hunter and the Eighteenth-Century Medical World*, edited by William F. Bynum and Roy Porter, 259–95. Cambridge: Cambridge University Press, 1985.

Duffin, Jacalyn. "Imaging Disease: The Illustration and Non-Illustration of Medical Texts, 1650–1850." In *Muse and Reason: The Relation of Arts and Sciences, 1650–1850: A Royal Society Symposium*, edited by Boris Castel, James A. Leith, and A.W. Riley, 79–108. [Kingston, ON]: Queen's Quarterly for the Royal Society of Canada, 1994.

———. "Laennec and Broussais: The 'Sympathetic Duel.'" In *Constructing Paris Medicine*, edited by Caroline Hannaway and Ann La Berge, 251–74. Amsterdam: Rodopi, 1998.

———. *Lovers and Livers: Disease Concepts in History*. Toronto: University of Toronto Press, 2005.

———. *To See with a Better Eye: A Life of R. T. H. Laennec*. Princeton: Princeton University Press, 1998.

Ehring, Franz. *Hautkrankheiten, 5 Jahrhunderte wissenschaftlicher Illustration*. [*Skin Diseases: 5 Centuries of Scientific Illustration*.] Stuttgart: Gustav Fisher, 1989.

———. "Leprosy Illustration in Medical Literature." *International Journal of Dermatology* 33 (1994): 872–83.

Elshout, Antonie Maria. *Het Leidse kabinet der anatomie uit de achttiende eeuw*. Leiden: Universitaire pers Leiden, 1952.

Engelmann, Lukas. "Eine analytische Bildpraxis: Die pathologisch-anatomischen Zeichnungen Jean Cruveilhiers in ihrem Verhältnis zu klinischen Beobachtungen." *Berichte zur Wissenschaftsgeschichte* 35 (2012): 7–24.

Evans, R. J. W. "Learned Societies in Germany in the Seventeenth Century." *European Studies Review* 6 (1977): 129–51.

Faber, Knud. *Nosography: The Evolution of Clinical Medicine in Modern Times*. New York: Hoeber, 1930.

Fend, Mechthild. "Portraying Skin Diseases: Robert Carswell's Dermatological Watercolours." In *A Medical History of Skin: Scratching the Surface*, edited by Jonathan Reinarz and Kevin Siena, 147–64. London: Pickering & Chatto, 2013.

Findlen, Paula. *Possessing Nature*. Berkeley: University of California Press, 1994.

Fine, Leon G. "Pathological Specimens of the Kidney Examined by Richard Bright." *Kidney International* 29 (1986): 779–83.

Fissell, Mary. "The Disappearance of the Patient's Narrative and the Invention of Hospital Medicine." In *British Medicine in the Age of Reform*, edited by Roger French and Andrew Wear, 92–109. London: Routledge, 1991.

Flamm, Eugene S. "The Dilated Pupil and Head Trauma 1517–1867." *MH* 16 (1972): 194–99.

———. "The Neurology of Jean Cruveilhier." *MH* 17 (1973): 343–55.

Fontes da Costa, Palmira. "The Making of Extraordinary Facts: Authentication of Singularities of Nature at the Royal Society of London in the First Half of the Eighteenth Century." *SHPS* 33 (2002): 265–88.

———. "The Understanding of Monsters at the Royal Society in the First Half of the Eighteenth Century." *Endeavour* 24 (2000): 34–39.

Foucault, Michel. *The Birth of the Clinic: An Archeology of Medical Perception*. Translated by A. M. Sheridan. Bristol: Tavistock, 1976.

———. *The Order of Things: An Archeology of the Human Sciences*. New York: Parthenon Books, 1971.

French, Roger. *Canonical Medicine: Gentile da Foligno and Scholasticism*. Leiden: Brill, 2001.

French, Roger, and Andrew Wear, eds. *British Medicine in the Age of Reform*. London: Routledge, 1991.

Gascoigne, Bamber. *How to Identify Prints: A Complete Guide to Manual and Mechanical Processes from Woodcut to Inkjet*. 2nd ed. New York: Thames and Hudson, 2004.

———. *Milestones in Colour Printing 1457–1859, with a Bibliography of Nelson Prints*. Cambridge: Cambridge University Press, 1997.

Gelfand, Toby. *Professionalizing Modern Medicine: Paris Surgeons and Medical Science and Institutions in the 18th Century*. Westport, CT: Greenwood Press, 1980.

Geus, Armin. "Christian Koeck (1758–1818), der Illustrator Samuel Thomas Soemmerrings." In *Samuel Thomas Soemmerring und die Gelehrten der Goethezeit*, edited by Gunter Mann and Franz Dumont, 263–78. Stuttgart: Fischer, 1985.

Gilman, Sander L. *Disease and Representation: Images of Illness from Madness to AIDS*. Ithaca: Cornell University Press, 1988.

———. *Picturing Health and Illness: Images of Identity and Difference*. Baltimore: Johns Hopkins University Press, 1995.

Gliboff, Sander. *H. G. Bronn, Ernst Haeckel, and the Origins of German Darwinism*. Cambridge: MIT Press, 2008.

Göbbel, Luminita, Schultka Rüdiger, and Lennart Olsson. "Collecting and Dissecting Nature: Meckel's Zootomical Museum at the University of Halle,

Germany." *Annals of the History and Philosophy of Biology* 12 (2007): 97–114.

Goldschmid, Edgar. *Entwicklung und Bibliographie der pathologisch-anatomischen Abbildung.* Leipzig: Hiersemann, 1925.

Grasselli, Margaret Morgan, ed. *Colorful Impressions: The Print-Making Revolution in 18th-Century France.* Washington, DC: National Gallery of Art, 2003.

Grmek, Mirko D. "Morgagni e la scuola anatomo-clinica di Parigi." In *"De sedibus, et causis": Morgagni nel centenario,* edited by Vincenzo Cappelletti and Federico Di Trocchio, 173–84. Rome: Istituto della enciclopedia italiana, 1986.

Grosse, Martin. *Die beiden Afrikaforscher Johann Ernst Hebenstreit und Christian Gottlieb Ludwig, ihr Leben und ihre Reise.* Leipzig: Duncker & Humblot, 1902.

Gruber, G. B. "In Memory of Johann Peter Weidmann, July 27, 1751–June 23, 1819." *Medizinische Klinik* 52 (1957): 1152–54.

Guerrini, Anita. *The Courtiers' Anatomists: Animals and Humans in Louis XIV's Paris.* Chicago: University of Chicago Press, 2015.

———. "Duverney's Skeletons." *Isis* 94 (2003): 577–603.

———. "Inside the Charnel House: The Display of Skeletons in Europe, 1500–1800." in *The Fate of Anatomical Collections,* edited by Rita Knoeff and Robert Zwijnenberg, 93–109. Farnham, UK: Boydell, 2015.

———. "The Material Turn in the History of Life Science." *Literature Compass* 13 (2016): 469–80.

Hagner, Michael. "Enlightened Monsters." in *The Sciences in Enlightened Europe,* edited by William Clark, Jan Golinski, and Simon Schaffer, 175–217. Chicago: University of Chicago Press, 1999.

———. *Der falsche Körper: Beiträge zu einer Geschichte der Monstrositäten.* 2nd ed. Göttingen: Wallstein, 2005.

———. "Vom Naturalienkabinett sur Embryologie: Wandlungen des Monströsen und die Ordnung des Lebens." In *Der falsche Körper,* edited by Michael Hagner, 73–107. Göttingen: Wallstein, 2005.

Hahn, Susanne, Ingrid Kästner, and Rosemarie Fröber, "Franz Heinrich Martens (1780–1805) und Wilhelm Gottlieb Tilesius (1769–1857)—Ärzte und Künstler um 1800." In *Icones symptomatum venerei morbi,* Franz Heinrich Martens. Facsimile ed., 111–24. Dresden: Deutches Hygiene-Museum, 1996.

Haigh, Elizabeth. *Xavier Bichat and the Medical Theory of the Eighteenth Century (Medical History* supplement, no. 4). London: Wellcome Institute, 1984.

Hamlin, Christopher. *Cholera: The Biography.* Oxford: Oxford University Press, 2009.

Hannaway, Caroline, and Ann La Berge, eds. *Constructing Paris Medicine.* Amsterdam: Rodopi, 1998.

Hansen, Julie V. "Resurrecting Death: Anatomical Art in the Cabinet of Dr. Frederik Ruysch." *AB* 78 (1996): 663–79.

Harley, David. "Political Post-Mortems and Morbid Anatomy in Seventeenth-Century England." *Social History of Medicine* 7 (1994): 1–28.

Harris, Elizabeth M. "Experimental Graphic Processes in England: 1800–1859." *Journal of the Printing Historical Society* 4 (1968): 33–86; 5 (1969): 41–80; 6 (1970): 53–89.

Harrison, Mark. "Racial Pathologies: Morbid Anatomy in British India, 1770–1850." In *The Social History of Health and Medicine in Colonial India*, edited by Biswamoy Pati and Mark Harrison, 173–94. London: Routledge, 2009.

Helm, Jürgen. "Abraham Vater: Ein Anatom im 18. Jahrhundert." In *Anatomie*, edited by Jürgen Helm and Karin Stukenbrock, 13–27. Wiesbaden: Steiner, 2003.

Helm, Jürgen, and Karin Stukenbrock, eds. *Anatomie: Sektionen einer medizinischen Wissenschaft im 18. Jahrhundert*. Wiesbaden: Steiner, 2003.

Hendriksen, Marieke M. A. *Elegant Anatomy: The Eighteenth-Century Leiden Anatomical Collections*. Leiden: Brill, 2015.

Hentschel, Klaus. *Visual Cultures in Science and Technology*. Oxford: Oxford University Press, 2014.

Hess, Volker, and J. Andrew Mendelsohn. "Case and Series: Medical Knowledge and Paper Technology, 1600–1900." *HS* 48 (2010): 287–314.

Holubar, Karl, and Joseph Frankl, "Joseph Plenck (1735–1807): A Forerunner of Modern European Dermatology." *Journal of the American Academy of Dermatology* 10 (1984): 326–32.

Honemann, Volker, Sabine Giese, Falk Eisermann, and Marcus Ostermann, eds. *Einblattdrücke des 15. und frühen 16. Jahrhunderts*. Tübingen: Niemeyer, 2000.

Huffman, John W. "Jan van Riemsdyk: Medical Illustrator Extraordinary." *JAMA* 208 (1969): 121–24.

Huisman, Tim. *The Finger of God: Anatomical Practice in 17th-Century Leiden*. Leiden: Primavera, 2009.

———. "Squares and Diopters: The Drawing System of a Famous Anatomical Atlas." *Tractrix* 4 (1992): 1–11.

Hunter, Matthew C. *Wicked Intelligence: Visual Art and the Science of Experiment in Restoration London*. Chicago: University of Chicago Press, 2013.

Hunter, Michael C. Introduction to the special issue *Curiously Drawn: Early Modern Science as a Visual Pursuit*, *HLQ* 78 (2015): 141–55.

———. *The Royal Society and Its Fellows, 1660–1700: The Morphology of an Early Scientific Institution*. [Oxford]: British Society for the History of Science, 1994.

Hunterian Museum, London. *Descriptive Catalogue of the Pathological Series in the Hunterian Museum of the Royal College of Surgeons of England*. 2 vols. Edinburgh: E & S. Livingstone, 1966–72.

Impey, Oliver, and Arthur Macgregor, eds. *The Origins of Museums: The Cabinet of Curiosities in Sixteenth- and Seventeenth-Century Europe*. Oxford: Claren-

don Press, 1985.

Jacyna, Leon S. "Au lit des malades: A. F. Chomel's Clinic at the Charité, 1828–9." *MH* 33 (1989): 420–49.

———. "Medicine in Transformation: 1800-1849." In *The Western Medical Tradition: 1800-2000*, edited by William F. Bynum et al., 11–101. Cambridge: Cambridge University Press, 2006.

———. *Philosophic Whigs: Medicine, Science, and Citizenship in Edinburgh, 1789-1848*. London: Routledge, 1994.

———. "Pious Pathology: J.-L. Alibert's Iconography of Disease." In *Constructing Paris Medicine*, edited by Caroline Hannaway and Ann La Berge, 185–219. Amsterdam: Rodopi, 1998.

Jardine, Nicholas. "Uses and Abuses of Anachronism in the History of Science." *HS* 38 (2000): 251–70.

Jones, Ellis W. P. "The Life and Works of Guilhelmus Fabricius Hildanus (1560-1634)." *MH* 4 (1960): 112–34, 196–209.

Jordanova, Ludmilla. *Nature Displayed: Gender, Science and Medicine 1760-1820*. London: Lomgman, 1999.

———. "The Representation of the Human Body: Art and Medicine in the Work of Charles Bell." In *Toward a Modern Art World*, edited by Brian Allen, 79–94. New Haven: Yale University Press, 1995.

Jorink, Erik. "Noah's Ark Restored (and Wrecked): Dutch Collectors, Natural History and the Problem of Biblical Exegesis." In *Silent Messengers*, edited by Sven Dupré and Christoph Lüthy, 153–84. Berlin: Lit, 2011.

Kästner, Ingrid, and Susanne Hahn. "Franz Heinrich Martens (1780-1805) und Wilhelm Gottlieb Tilesius (1769-1857)—Eine Freundschaft im Zeichen von Medizin und Kunst." *Zeitschrift für Geschichte der Naturwissenschaften, Technik und Medizin* 7 (1999): 231–43.

Keel, Othmar. *L'avènement de la médicine clinique moderne en Europe, 1750-1815*. Montreal: Presses de l'Université de Montreal, 2001.

———. "La formation de la problématique de l'anatomie des systèmes selon Laennec." *Revue du Palais de la Découverte* 22 (August 1981): 189–207.

———. *La généalogie de l'histopathologie: une révision déchirante, Philippe Pinel, lecteur discret de J.-C. Smyth (1741-1821)*. Paris: Vrin, 1979.

———. "The Politics of Health and the Institutionalisation of Clinical Practices in Europe in the Second Half of the Eighteenth Century." In *William Hunter and the Eighteenth-Century Medical World*, edited by William F. Bynum and Roy Porter, 207–56. Cambridge: Cambridge University Press, 1985.

———. "Was Anatomical and Tissue Pathology a Product of the Paris Clinical School or Not?" In *Constructing Paris Medicine*, edited by Caroline Hannaway and Ann La Berge, 117–83. Amsterdam: Rodopi, 1998.

Kemp, Martin. "'The Mark of Truth': Looking and Learning in Some Anatomical Illustrations in the Renaissance and Eighteenth Century." In *Medicine and the Five Senses*, edited by William F. Bynum and Roy Porter, 85–121.

Cambridge: Cambridge University Press, 1993.

——. "Style and Non-Style in Anatomical Illustration: From Renaissance Humanism to Henry Gray." *Journal of Anatomy* 216 (2010): 192–208.

——. "Taking It on Trust: Form and Meaning in Naturalistic Representation." *ANH* 17 (1990): 127–88.

——. "Temples of the Body and Temples of the Cosmos: Vision and Visualization in the Vesalian and Copernican Revolutions." In *Picturing Knowledge*, edited by Brian S. Baigrie, 40–85. Toronto: University of Toronto Press, 1996.

——. "True to Their Natures: Sir Joshua Reynolds and Dr. William Hunter at the Royal Academy of Arts." *NRRS* 46 (1992): 77–88.

Kendell, Robert E. "William Cullen's *Synopsis nosologiae methodicae*." In *William Cullen and the Eighteenth Century Medical World*, edited by Andrew Doig et al., 216–33. Edinburgh: Edinburgh University Press, 1993.

Kilpatrick, Robert. "'Living in the Light: Dispensaries, Philanthropy, and Medical Reform in Late-Eighteenth-Century London." In *Medical Enlightenment*, edited by Andrew Cunningham and Roger French, 254–80. Cambridge: Cambridge University Press, 1990.

Kivelä, Tero. "200 Years of Success Initiated by James Wardrop's 1809 Monograph on Retinoblastoma." *Acta ophthalmologica* 87 (2009): 810–12

Klestinec, Cynthia. "Translating Learned Surgery." Forthcoming.

Knoeff, Rita. "Touching Anatomy: On the Handling of Preparations in the Anatomical Cabinets of Frederik Ruysch (1638–1731)." *SHPS C* 49 (2015): 32–44.

Knoeff, Rita, and Robert Zwijnenberg, eds. *The Fate of Anatomical Collections*. Farnham: Boydell, 2015.

Kooijmans, Luuc. *Death Defied: The Anatomy Lessons of Frederik Ruysch*. Leiden: Brill, 2010.

Kornell, Monique. "Accuracy and Elegance in Cheselden's *Osteographia* (1733)." Accessed online April 8, 2014. http://publicdomainreview.org/2011/08/22/accuracy-and-elegance-in-cheseldens-osteographia-1733/.

Kraft, Eva M. "Christian Mentzel, Philippe Couplet, Andreas Cleyer und die chinesische Medizin (Notizen aus Handschriften des 17. Jahrhunderts)." In *Fernöstliche Kultur*, edited by Wolf Haenisch, 158–96. Marburg: Elwert, 1975.

Kusukawa, Sachiko. *Picturing the Book of Nature*. Chicago: University of Chicago Press, 2012.

——. "Picturing Knowledge in the Early Royal Society: The Examples of Richard Waller and Henry Hunt." *NRRS* 64 (2011): 273–94.

La Berge, Ann. "Dichotomy or Integration? Medical Microscopy and the Paris Medical Tradition." In *Constructing Paris Medicine*, edited by Caroline Hannaway and Ann La Berge, 275–312. Amsterdam: Rodopi, 1998.

La Berge, Ann, and Caroline Hannaway. "Paris Medicine: Perspectives Past

and Present." In *Constructing Paris Medicine*, edited by Caroline Hannaway and Ann La Berge, 1–69. Amsterdam: Rodopi, 1998.

Landwehr, John. *Studies in Dutch Books with Coloured Plates Published 1662–1875*. The Hague: W. Junk, 1976.

Lawrence, Susan C. "Educating the Senses: Students, Teachers and the Medical Rhetoric in Eighteenth-Century London." In *Medicine and the Five Senses*, edited by William F. Bynum and Roy Porter, 154–78. Cambridge: Cambridge University Press, 1993.

———. "Entrepreneurs and Private Enterprise: The Development of Medical Lecturing in Lodnon, 1775–1820." *BHM* 62 (1988): 171–92.

Le Fanu, William. "Anatomical Drawings by Jacobus Schijnvoet." *Oud Holland* 75 (1960): 54–58.

Le Minor, Jean-Marie. "Le cabinet de cires médicales du céroplasticien J. F. Bertrand à Paris (fin XVIIIe–début XIXe s.)." *HSM* 33 (1999): 275–86.

Lemire, Michel. *Artistes et mortels*. Paris: Chabaud, 1990.

Lenoir, Timothy. "Morphotypes and the Historical-Genetic Method in Romantic Biology." In *Romanticism and the Sciences*, edited by Andrew Cunningham and Nicholas Jardine, 119–29. Cambridge: Cambridge University Press, 1990.

———. *The Strategy of Life: Teleology and Mechanism in Nineteenth-Century German Biology*. Chicago: University of Chicago Press, 1989.

Lesch, John E. "The Paris Academy of Medicine and Experimental Science, 1820–1848." In *The Investigative Enterprise: Experimental Physiology in Nineteenth Century Medicine*, edited by William Coleman and Frederic L. Holmes, 100–38. Berkeley: University of California Press, 1988.

———. *Science and Medicine in France: The Emergence of Experimental Physiology, 1790–1855*. Cambridge, MA: Harvard University Press, 1984.

Lichtenstein, Jacqueline. *The Blind Spot: An Essay on the Relations between Painting and Sculpture in the Modern Age*. Los Angeles: Getty Research Institute, 2008.

Lindeboom, Gerrit A. *Dutch Medical Biography*. Amsterdam: Rodopi, 1984.

Lobo, Francis M. "John Haygarth, Smallpox and Religious Dissent in Eighteenth Century England." In *Medical Enlightenment*, ed. Andrew Cunningham and Roger French, 217–53. Cambridge: Cambridge University Press, 1990.

Long, Esmond L. *A History of Pathology*. 2nd ed. New York: Dover, 1965 (first published 1928).

Long, Kathleen P. *Hermaphrodites in Renaissance Europe*. Aldershot, UK: Ashgate, 2006.

Loveland, Jeff. "Another Daubenton, Another *Histoire Naturelle*." *Journal of the History of Biology* 39 (2006): 457–91.

Luyendijk-Elshout, Antonie M. "Death Enlightened: A Study of Frederik Ruysch." *JAMA* 212 (1970): 121–26.

Mackenzie, Ian. *British Prints: Dictionary and Price Guide*. Woodbridge, UK: Antique Collectors' Club, 1987.

MacKinney, Loren. *Medical Illustrations in Medieval Manuscripts*. Berkeley: University of California Press, 1965.

Maerker, Anna. *Model Experts: Wax Anatomies and Enlightenment in Florence and Vienna, 1775–1815*. Manchester: Manchester University Press, 2011.

Mann, Ruth J. "Historical Vignette: Scarpa, Hodgson, and Hope, Artists of the Heart and Great Vessels." *Mayo Clinic Proceedings* 49 (1974): 890–92.

Margócsy, Dániel. *Commercial Visions: Science, Trade, and Visual Culture in the Dutch Golden Age*. Chicago: University of Chicago Press, 2014.

———. "A Museum of Wonders or a Cemetery of Corpses? The Commercial Exchange of Anatomical Collections in Early Modern Netherlands." In *Silent Messengers*, edited by Sven Dupré and Christoph Lüthy, 185–215. Berlin: Lit, 2011.

Martin, Julian. "Sauvages's Nosology: Medical Enlightenment in Montpellier." In *Medical Enlightenment*, edited by Andrew Cunningham and Roger French, 111–37. Cambridge: Cambridge University Press, 1990.

Massey, Lyle. "On Waxes and Wombs: Eighteenth-Century Representations of the Gravid Uterus." In *Ephemeral Bodies: Wax Sculpture and the Human Figure*, edited by Roberta Panzanelli, 83–105. Los Angeles: Getty Publications, 2008.

———. "Pregnancy and Pathology: Picturing Childbirth in Eighteenth-Century Obstetric Atlases." *AB* 87 (2005): 73–91.

Maulitz, Russell C. "In the Clinic: Framing Diseases at the Paris Hospital." *AS* 47 (1990): 127–37.

———. *Morbid Appearances: The Anatomy of Pathology in the Early Nineteenth Century*. Cambridge: Cambridge University Press, 1987.

———. "The Pathological Tradition." In *Companion Encyclopedia of the History of Medicine*, edited by William F. Bynum and Roy Porter, 1:169–91. London: Routledge, 1993.

Mendelsohn, Leatrice. *Paragoni: Benedetto Varchi's "Due Lezzioni" and Cinquecento Art Theory*. Ann Arbor, MI: University Microfilm International, 1982.

Ménétrier, Jacques. "Cruveilhier (1791–1874)." *Æsculape* 7 (1927): 182–87, 8 (1927): 212–16.

Meyer-Ahrens, Conrad. *Wilhelm Fabry, genannt Fabricius von Hilden: Eine historische Original-Skizze*. Berlin: Hirschwald, 1865.

Meynell, Guy. "Francis Bauer, Joseph Banks, Everard Home, and Others." *ANH* 11 (1983): 209–21.

Mooij, Annet. *Doctors of Amsterdam: Patient Care, Medical Training and Research (1650–2000)*. Amsterdam: Amsterdam University Press, 1999.

Moore, Wendy. *The Knife Man: Blood, Body Snatching, and the Birth of Modern Surgery*. New York: Broadway Books, 2005.

Moulin, Daniel de. *A History of Surgery with Emphasis on the Netherlands*. Dor-

drecht: Martinus Nijhoff, 1988.

Mukherjee, Siddhartha. *The Emperor of All Maladies: A Biography of Cancer*. London: Fourth Estate, 2011 (originally published 2010).

Neher, Allister. "The Truth about Our Bones: William Cheselden's *Osteographia*." *MH* 54 (2010): 517–28.

Newsom Kerr, Matthew L. "'An Alteration of the Human Countenance': Inoculation, Vaccination and the Face of Smallpox in the Age of Jenner." In *A Medical History of Skin: Scratching the Surface*, edited by Jonathan Reinarz and Kevin Siena, 129–46. London: Pickering & Chatto, 2013.

Nicholson, Malcolm. "Giovanni Battista Morgagni and Eighteenth-Century Physical Examination." In *Medical Theory, Surgical Practice*, edited by Christopher Lawrence, 101–34. London: Routledge, 1992.

———. "The Introduction of Percussion and Stethoscopy to Early Nineteenth-Century Edinburgh." In *Medicine and the Five Senses*, edited by William F. Bynum and Roy Porter, 134–53. Cambridge: Cambridge University Press, 1993.

———. "The Metastatic Theory of Pathogenesis and the Professional Interests of Eighteenth-Century Physicians." *MH* 32 (1988): 277–300.

Nissen, Claus. *Die botanische Buchillustration: ihre Geschichte und Bibliographie*. 3 vols. 2nd ed. Stuttgart: Hiersemann, 1966.

———. *Die illustrierten Vogelbücher: ihre Geschichte und Bibliographie*. Stuttgart: Hiersemann, 1976.

———. *Die zoologische Buchillustration: ihre Bibliographie und Geschichte*. 2 vols. Stuttgart: Hiersemann, 1969–78.

Nusbaumer, Philippe. *Antoine Chazal, 1793–1854: Vie et œuvre*. Le Pecq-sur-Seine: Nusbaumer, 2012.

Ogilvie, Brian. *The Science of Describing*. Chicago: University of Chicago Press, 2006.

Opitz, J. M., R. Schultka, and L. Göbbel. "*Annals of Morphology*: Meckel on Developmental Pathology." *American Journal of Medical Genetics* 140A (2006): 115–28.

Ott, Katherine. "Contagion, Public Health, and the Visual Culture of Nineteenth-Century Skin." In *Imagining Illness: Public Health and Visual Culture*, edited by David Serlin, 85–107. Minneapolis: University of Minnesota Press, 2010.

Palfreyman, Harriet. "Visualizing Venereal Disease in London c. 1780–1860." PhD diss., University of Warwick, 2012.

Palmer, Richard. "Nicolò Massa, his family and his fortune." *MD* 25 (1981): 385–410.

Pang, Alex Soojung-Kim. "Visual Representation and Post-Constructivist History of Science." *Historical Studies in the Physical and Biological Sciences* 28 (1997): 139–71.

Parapia, Liakat A., and Carolyn Jackson. "Ehlers-Danlos Syndrome—A Histor-

ical Review." *British Journal of Hæmatology* 141 (2008): 32–35.

Park, Katharine. *Secrets of Women: Gender, Generation, and the Origins of Human Dissection.* New York: Zone Books, 2006.

Parshall, Peter. "*Imago contrafacta*: Images and Facts in the Northern Renaissance." *Art History* 16 (1993): 554–79.

Peintinger, Barbara. "Giovanni Alessandro Brambillas 'Appendice': Eine Quelle zur Geschichte des Gesundheitswesen im Josephinismus." Master's thesis, University of Vienna, 2011.

Peitzman, Steven J. "Bright's Disease and Bright's Generation-Toward Exact Medicine at Guy's Hospital." *BHM* 55 (1981): 307–21.

———. *Dropsy, Dialysis, Transplant: A Short History of Failing Kidneys.* Baltimore: Johns Hopkins University Press, 2007.

———. "From Bright's Disease to End-Stage Renal Disease." In *Framing Disease: Studies in Cultural History*, edited by Charles E. Rosenberg and Janet Golden, 3–19. New Brunswick, NJ: Rutgers, 1992.

Peltier, Leonard F. *Fractures: A History and Iconography of Their Treatment.* San Francisco: Norman Publishing, 1990

———. *Orthopedics: A History and Iconography.* San Francisco: Norman Publishing, 1993.

Petherbridge, Deanna, and Ludmilla Jordanova. *The Quick and the Dead.* Berkeley: University of California Press, 1997.

Plarr, V. G. "Matthew Baillie's Diary of Travel in 1788." *British Medical Journal*, 1 (March 17, 1927): 523–24.

Platzker, David, and Elizabeth Wyckoff. *Hard Pressed: 600 Years of Prints and Process.* New York: Hudson Hills Press, 2000.

Pomata, Gianna. "A Word of the Empirics: The Ancient Concept of Observation and its Recovery in Early Modern Medicine." *AS* 68 (2011): 1–25.

———. "Observation Rising: Birth of an Epistemic Genre, ca. 1500–1650." In *Histories of Scientific Observation*, edited by Lorraine Daston and Elizabeth Lunbeck, 45–80. Chicago: University of Chicago Press, 2011.

———. "Sharing Cases: The *Observationes* in Early Modern Medicine." *ESM* 15 (2010): 193–236.

Porter, Roy. *Bodies Politic: Disease, Death, and Doctors in Britain, 1650–1900.* Ithaca: Cornell University Press, 2001.

———. "The Eighteenth Century." In *The Western Medical Tradition*, edited by Lawrence I. Conrad et al., 371–475. Cambridge: Cambridge University Press, 1995.

———. "The Rise of Physical Examination." In *Medicine and the Five Senses*, edited by William F. Bynum and Roy Porter, 179–97. Cambridge: Cambridge University Press, 1993.

Prideaux, Sarah Treverbian. *Aquatint Engraving.* 2nd ed. London: Foyle, 1968.

Puech, Jules-L. *La vie et l'oeuvre de Flora Tristan.* Paris: Rivière, 1925.

Punt, Hendrik. *Bernard Siegfried Albinus (1697–1770): On "Human Nature."*

Amsterdam: Israël, 1983.

Pusey, William Allen. *The History of Dermatology*. Springfield, IL: Charles C. Thomas, 1933.

Ragland, Evan. "Experimenting with Chemical Bodies: Reinier de Graaf's Investigations of the Pancreas." *ESM* 13 (2008): 615–64.

Randelli, Gianni. "Ripetizione degli esperimenti di Michele Troja sella rigenerazione delle ossa." *Physis* 6 (1984): 45–64.

Reckert, Heribert. *Das unbekannte Werk des Pathologen Robert Carswell (1793–1857)*. Köln: F. Hansen, 1982.

Rehbock, Philip F. "Transcendental Anatomy." In *Romanticism and the Sciences*, edited by Andrew Cunningham and Nicholas Jardine, 144–60. Cambridge: Cambridge University Press, 1990.

Reinarz, Jonathan, and Kevin Siena, eds. *A Medical History of Skin: Scratching the Surface*. London: Pickering & Chatto, 2013.

Rey, Roselyne. "Diagnostic différentiel et espèces nosologiques: Le cas de la phthisis pulmonaire de Morgagni à Bayle." In *Maladies, médecines et sociétés*, 2 vols., edited by François-Olivier Touati, 1:185–200. Paris: L'Harmattan et Histoire au Présent, 1993.

———. "L'école de santé de Paris sous la Révolution: transformations et innovations." *Histoire de l'éducation* 57 (1993): 23–57.

Richards, Robert J. "Kant and Blumenbach on the *Bildungstrieb*: A Historical Misunderstanding." *SHPS* C, 31 (2000):11–32.

Risse, Guenter B. "A Shift in Medical Epistemology: Clinical Diagnosis, 1770–1828." In *History of Diagnostics*, edited by Y. Kawakita, 115–47. Osaka: The Taniguchi Foundation, 1987.

———. "La sintesi tra anatomia e clinica." In *Storia del pensiero medico occidentale*, 3 vols., edited by Mirko D. Grmek, 2291–334. Bari: Laterza, 1996

Roberts, K. B., and J. D. W. Tomlinson. *The Fabric of the Body: European Traditions of Anatomical Illustration*. Oxford: Clarendon Press, 1992.

Rodari, Florian, ed. *Anatomie de la couleur: L'invention de l'estampe en couleur*. Paris: Bibliothèque Nationale de France; Lausanne: Musée Olympique, 1996.

Rodin, Alvin E. *The Influence of Matthew Baillie's Morbid Anatomy*. Springfield, IL: Thomas, 1973.

Roemer, G. M. (Bert) van de. "From *vanitas* to Veneration: The Embellishments in the Anatomical Cabinet of Frederik Ruysch." *Journal of the History of Collections* 22 (2010): 169–86.

Rooy, Laurens de, et al. *Forces of Form*. Amsterdam: Vossiuspers UvA, 2009.

Rosenberg, Charles E. "Framing Disease: Illness, Society, and History." In *Framing Disease: Studies in Cultural History*, edited by Charles E. Rosenberg and Janet Golden, xiii–xxvi. New Brunswick, NJ: Rutgers, 1992.

Rosenfeld, Louis. *Thomas Hodgkin: Morbid Anatomist and Social Activist*. Lanham, MD: Madison Books, 1993.

Rudwick, Martin J. S. *Bursting the Limits of Time: The Reconstruction of Geohistory in the Age of Revolution*. Chicago: University of Chicago Press, 2005.

———. "The Emergence of a Visual Language for Geological Science, 1760–1830." *HS* 14 (1976): 149–95.

Sappol, Michael. *Dream Anatomy*. Bethesda, MD: US Department of Health and Human Services, 2006.

Saunders, Gill. *Picturing Plants: An Analytical History of Botanical Illustrations*. 2nd ed. Chicago: KWS Publishers, 2009.

Savio, Pietro. "Ricerche sull'anatomico Guglielmo Riva." *Bollettino storico-bibliografico subalpino* 66 (1968): 229–67.

Schmitt, Charles B., and Charles Webster. "Harvey and M. A. Severino: A Neglected Medical Relationship." *BHM* 45 (1971): 49–75.

Schnalke, Thomas. *Diseases in Wax: The History of the Medical Moulage*. [Chicago]: Quintessence Books, 1995.

Schneider-Hiltbrunner, Verena. *Wilhelm Fabry von Hilden, 1560–1634*. Bern: Hans Huber, 1976.

Schultka, Rüdiger, and Luminita Göbbel. "Präparationstechniken und Präparate im 18. und frühen 19. Jahrhundert, dargestellt an beispielen aus den anatomischen Sammlungen su Halle (Saale)." In *Anatomie*, edited by Jürgen Helm and Karin Stukenbrock, 49–81. Wiesbaden: Steiner, 2003.

Schupbach, William. "Some Cabinets of Curiosities in European Academic Institutions." In *The Origins of Museums*, edited by Oliver Impey and Arthur Macgregor, 169–78. Oxford: Clarendon Press, 1985.

Secord, Anne. "Botany on a Plate: Pleasure and the Power of Pictures in Promoting Early Nineteenth-Century Scientific Knowledge." *Isis* 93 (2002): 28–57.

Seiz, Anneliese. *Johannes Scultetus and sein Werk*. Ulm: L. Merckle, 1974.

Siraisi, Nancy G. *Medicine and the Italian Universities, 1250–1600*. Leiden: Brill, 2001.

———. "'Remarkable' Diseases, 'Remarkable' Cures, and Personal Experience in Renaissance Medical Texts." In *Medicine*, 226–52. Leiden: Brill, 2001.

———. "Signs and Evidence: Autopsy and Sanctity in Late-Sixteenth Century Italy." In *Medicine*, 356–80. Leiden: Brill, 2001.

———. "Vesalius and Human Diversity." In *Medicine*, 287–327. Leiden: Brill, 2001.

Stafford, Barbara Maria. *Body Criticism: Imaging the Unseen in Enlightenment Art and Medicine*. Cambridge, MA: MIT Press, 1991.

Stalnaker, Joanna. "Painting Life, Describing Death: Problems of Representation and Style in the *Histoire naturelle*." *Studies in Eighteenth-Century Culture* 32 (2003): 193–227.

Stijnman, Ad, and Elizabeth Savage, eds. *Printing Colour, 1400–1700: History, Techniques, Functions and Receptions*. Leiden: Brill, 2015.

Stolberg, Michael. "Bedside Teaching and the Acquisition of Practical Skills in

Mid-Sixteenth-Century Padua." *JHM* 69 (2014): 633-61.

———. "The Decline of Uroscopy in Early Modern Learned Medicine (1500-1650)." *ESM* 12 (2007): 313-36.

———. "Metaphors and Images of Cancer in Early Modern Europe." *BHM* 88 (2014): 48-74.

Sturdy, David. *Science and Social Status: The Members of the Académie des Sciences, 1666-1750*. Woodbridge: Boydell Press, 1995.

Sudhoff, Karl. *Graphische und typographische Erstlinge der Syphilisliteratur aus den Jahren 1495 und 1496*. München: Kuhn, 1912.

Swan, Claudia. "Illustrated Natural History." In *Prints and the Pursuit of Knowledge*, edited by Susan Dackerman, 186-90. Cambridge, MA: Harvard Art Museum, 2011.

———. "Making Sense of Medical Collections in Early Modern Holland: The Uses of Wonder." In *Making Knowledge in Early Modern Europe: Practices, Objects, and Texts, 1400-1800*, edited by Pamela H. Smith and Benjamin Schmidt, 199-213. Chicago: University of Chicago Press, 2008.

———. "The Uses of Botanical Treatises in the Netherlands ca. 1600." In *The Art of Natural History: Illustrated Treatises and Botanical Paintings, 1400-1850*, edited by Therese O'Malley and Amy R. W. Meyers, 63-81. Washington, DC: National Gallery of Art, 2008.

———. "The Uses of Realism in Early Modern Illustrated Botany." In *Visualizing Medieval Medicine and Natural History, 1200-1550*, edited by Jean A. Givens, Karen M. Reeds, Alain Touwaide, 239-49. Aldershot, UK: Ashgate, 2006.

Tansey, Violet, and David E. C. Mekie. *The Museum of the Royal College of Surgeons of Edinburgh*. Edinburgh: Royal College of Surgeons, 1982.

Taylor, John. *Nova nosographia ophthalmica*. Hamburg: heirs of Grund and Holle, 1766.

Teacher, John H. *Catalogue of the Anatomical and Pathological Preparations of Dr. William Hunter in the Hunterian Museum, University of Glasgow*. 2 vols. Glasgow: MacLehose, 1900.

Temkin, Owsei. *The Falling Sickness: A History of Epilepsy from the Greeks to the Beginning of Modern Neurology*. Baltimore: Johns Hopkins University Press, 1945.

———. "The Role of Surgery in the Rise of Modern Medical Thought." *BHM* 25 (1951): 248-59.

Théodoridès, Jean. *Pierre Rayer (1793-1867): Un demi-siècle de médecine française*. Paris: Louis Pariente, 1997.

Thieme, Ulrich. *Allgemeines Lexikon der bildenden Künstler von der Antike bis zur Gegenwart*. 37 vols. Leipzig: W. Engelmann et al., 1907-50.

Tilles, Gérard, and Daniel Wallach. "Histoire de la nosologie en dermatologie." *Annales de dermatologie et de vénéréologie* 116 (1989): 9-26.

Tompsett, David H. *Anatomical Techniques*. 2nd ed. Edinburgh: Livingstone,

1970.

Vogt, Helmut. *Das Bild des Kranken*. Munich: J. F. Lehmanns Verlag, 1969.

Wallach, Daniel, and Gérard Tilles. "L'œuvre dermatologique de Pierre Rayer." *HSM* 25 (1991): 279–84.

Walsh, Judith C. "Ink and Inspiration: The Craft of Color Printing." In *Colorful Impressions*, edited by Margaret Morgan Grasselli, 23–33. Washington, DC: National Gallery of Art, 2003.

Warner, John Harley. "American Doctors in London During the Age of Paris Medicine." In *The History of Medical Education in Britain*, edited by Vivian Nutton and Roy Porter, 341–65. Amsterdam: Rodopi, 1995.

Weber, Barbara. "Johann Peter Weidmann (1751–1819) und das Mainzer Accouchement." PhD diss., University of Mainz, 1985.

Weber, Giorgio. *L'anatomia patologica di Lorenzo Bellini*. Firenze: Olschki, 1998.

———. *Aspetti poco noti della storia dell'anatomia patologica tra '600 e '700: William Harvey, Marcello Malpighi, Antonino Cocchi, Giovanni Maria Lancisi, verso Morgagni*. Firenze: Olschki, 1997.

———. *Sensata veritas: L'affiorare dell'anatomia patologica, ancora innominata, in scritti di anatomisti del '500*. Firenze: Olschki, 2006.

Whitley, William T. *Thomas Heaphy (1775–1835): First President of the Society of British Artists*. London: Royal Society of British Artists' Art Club, 1933.

Wilkinson, Lise. "Glanders: Medicine and Veterinary Medicine in Common Pursuit of a Contagious Disease." *MH* 25 (1981): 363–84.

Wilks, Samuel, and George T. Bettany. *A Biographical History of Guy's Hospital*. London: Ward, Lock, Bowden & Co., 1892.

Williams, Elizabeth A. *The Physical and the Moral: Anthropology, Physiology, and Philosophical Medicine in France, 1750–1850*. Cambridge: Cambridge University Press, 1994.

Wilson, Adrian. "On the History of Disease-Concepts: The Case of Pleurisy." *HS* 38 (2000): 271–319.

Winau, Rolf. "Christian Menzel, die Leopoldina und der ferne Osten." *MJ* 11 (1967): 72–91.

———. "Zur Frügeschichte der Academia Naturae Curiosorum." *Wolfenbütteler Forschungen* 3 (1977): 117–37.

Wolfe, Charles, ed. *Vitalism without Metaphysics*? Special issue of *Science in Context* 21 (2008): 461–664.

Young, G. Bryan, and Robert M. Kark. "Richard Bright, Pioneer Epileptologist." *Neurology* 38 (1988): 661–62.

INDEX